To James Rector, and to his mother Dolores, for the tears she cried; to Alan Blanchard and his sons Michael and Kirk Alan, and his daughter Steph, who didn't know; to Donovan Rundle and his wife Jeneth, and daughters Emma Ruth Rundle and Sarah Ray Rundle, and Amy Pieper, his girlfriend in 1969; to Corporal Michael L. Feliciano of the National Guard; and to the other victims and survivors of the battle—demonstrators and bystanders, police, deputy sheriffs, and National Guardsmen—especially the aching whose wounds cannot be nursed. We didn't think it could happen here, but we were wrong.

The Battle for People's Park, Berkeley 1969

Tom Dalzell

Foreword by Todd Gitlin

Afterword by Steve Wasserman

HEYDAY, BERKELEY, CA

The Battle for People's Park, Berkeley 1969

Copyright © 2019 by Tom Dalzell

All rights reserved. No portion of this work may be reproduced or transmitted in any form or by any means, electronic or mechanical, including photocopying and recording, or by any information storage or retrieval system, without permission in writing from Heyday.

All reasonable attempts were made to locate the copyright holders for the materials published in this book. If you believe you may be one of them, please contact Heyday, and the publisher will include appropriate acknowledgment in subsequent editions of this book.

Foreword adapted from *The Sixties: Years of Hope, Days of Rage* by Todd Gitlin, copyright © 1987 by Todd Gitlin. Used by permission of the author and Bantam Books, an imprint of Random House, a division of Penguin Random House LLC. All rights reserved.

Afterword copyright © 2019 by Steve Wasserman. All rights reserved.

Grateful acknowledgment is made to Guy Stilson for permission to reprint "A Night at Santa Rita" by Robert Scheer, which was originally published in the August 1969 issue of *Ramparts* magazine.

Library of Congress Cataloging-in-Publication Data
Names: Dalzell, Tom, 1951- author. | Gitlin, Todd, writer of foreword. | Wasserman, Steve, 1952- writer of afterword.
Title: The battle for People's Park, Berkeley 1969 / Tom Dalzell ; foreword by Todd Gitlin ; afterword by Steve Wasserman.
Description: Berkeley, California : Heyday, [2019]
Identifiers: LCCN 2018047238 | ISBN 9781597144681 (hbk. : alk. paper)
Subjects: LCSH: People's Park (Berkeley, Calif.)—History—20th century. | Student movements—California— Berkeley—History—20th century. | Protest movements—California—Berkeley—History—20th century. | Free Speech Movement (Berkeley, Calif.)—History. | Riots—California—Berkeley. | Radicalism— California—Berkeley—History—20th century. | University of California, Berkeley—History—20th century. | Interviews—California—Berkeley. | Berkeley (Calif.)—Biography—Anecdotes. | Berkeley (Calif.)— History—20th century.
Classification: LCC F869.B5 D349 2019 | DDC 322.4/40979467—dc23
LC record available at https://lccn.loc.gov/2018047238.

Front Cover Photograph: Copyright © Nacio Jan Brown; Berkeley High School students sitting down before National Guard troops at Sather Gate, University of California, Berkeley, May 1969.
Back Cover Photograph: Copyright © Nacio Jan Brown. A military helicopter indiscriminately sprays tear gas over the campus of the University of California, Berkeley, May 20, 1969.
Endpapers: Details from the mural "A People's History of Telegraph Avenue," at Haste Street and Telegraph Avenue. Front: The corner of Telegraph and Haste on "Bloody Thursday." Back: The fatal shooting of James Rector. Mural design by Osha Neumann, painted with O'Brien Thiele, Janet Kranzberg, Daniel Galvez, and many others. Painted in 1976; restored and enlarged in 1999. Photograph copyright © 2018 by John Storey.
Cover Design: Ashley Ingram
Interior Design/Typesetting: Rebecca LeGates

Published by Heyday
P.O. Box 9145, Berkeley, CA 94709
(510) 549-3564
www.heydaybooks.com

Printed in China by Print Plus

10 9 8 7 6 5 4 3 2 1

"Nobody supervises and the trip belongs to whoever dreams."

STEW ALBERT

"Everybody gets a blister."

PEOPLE'S PARK SLOGAN

"If it takes a bloodbath, let's get it over with. No more appeasement."

GOVERNOR RONALD REAGAN

Todd Gitlin

From its beginnings, the white New Left oscillated between two principles. It was started by young Americans, mainly white, as a movement *for others*—a support for black, Cuban, and Vietnamese people who were victims of privation and violence and whose revolt seemed elemental—but over time an impulse that began as altruism spawned a movement *for itself*—a revolt of the white youth who wanted to overcome their own alienations and shape their own lives, as happened in the Free Speech Movement and the counterculture. If the New Left proved unable to straddle the chasm of race or to propose new policies for work or education or welfare in the larger society, its hip wing was at least able to set out models for its own kind: two, three, many Berkeleys.

The fusion of movement and counterculture flourished best in Berkeley, a café-cluttered college town of a hundred thousand people, big enough for urban ailments, small enough to imagine transformed. The Berkeley campus of the University of California attracted a swelling number of young seekers, and the culture was tolerant enough, the climate benign enough, the interstices ample enough to sustain the freak colonies while drawing in fresh pilgrims with every season. Dropouts and visionaries and hustlers—sometimes all three in a single skin—found a place to drop into. More came from the East Coast now—"New York types," the police called them. The Left could be comfortable there, with its own tradition. (After the anti–Vietnam War protests at the 1968 Democratic National Convention in Chicago, the early leader of SDS [Students for a Democratic Society], Tom Hayden, for example, moved to Berkeley and soon became nonleader of a succession of communes that culminated, in 1970, in one called the Red Family, which in turn spawned a child-care operation called Blue Fairyland.) In 1969 Berkeley already had to its credit a full decade (vast time by movement calendars) of protest and cultural ferment: the student political party SLATE, the anti-HUAC demonstrations

Foreword adapted by Todd Gitlin from his 1987 book *The Sixties: Years of Hope, Days of Rage.*

and civil rights sit-ins, the Free Speech Movement, the Vietnam Day Committee, Robert Scheer's antiwar campaign for Congress, hippies, trashings, a long and violent Third World Liberation Front strike, the underground paper *Berkeley Barb*, the nonprofit leftwing radio station KPFA, a Free Clinic (staffed partly by Vietnam medics), a Free Church, free schools, study groups, and collectives of doctors, lawyers, therapists, auto mechanics, filmmakers, gardeners, and architects, and a panoply of student groups. The tradition had become a way of life. The student body had shifted toward the hip and radical, with fraternities and sororities losing half their populations between 1964 and 1972. (Market demand was so slack, one off-campus commune called COPS—Committee on Public Safety—could afford rent on a vacated fraternity house.) The radicals were hipper in Berkeley, the hippies more combative, and there were enough of each, and all the possible hybrids, to feed any utopian vision imaginable.

The search for a confluence was like the search for a holy grail. For all the political ferocity of the time, the movement wanted to go beyond disruption just as the hippies wanted to go beyond private trips. The movement's countercultural side, like the anarchist Wobblies, longed to create the new society in the womb (or ashes) of the old. A superficially plausible (though wrong) sociological argument emerged to bolster that hope: a critical mass of the disaffected young were becoming expert at living off the fat of the economy. Through drugs, rock music, and sexual freedom, the dropouts were attracting straighter students. Against the corporate-military-professional future for which the university was training ground, perhaps what was developing was the embryo of a postindustrial, post-scarcity society, in which work would be undertaken not for the extrinsic reward of the paycheck but for its social good and intrinsic satisfactions. To the hip radicals and the radically hip, dropouts and runaways were the vanguard of the leisure class, and the South Campus area along Telegraph Avenue—with its cafés, repertory cinema, funky shops, dope dealers, wide sidewalks, leaflet-plastered telephone poles, sojourning black people and bikers, and some of the best bookstores in America—seemed to prefigure a society in which the arts and crafts would flourish, and people would sip cappuccino in the morning, criticize in the afternoon, smoke dope and make love at night.

It takes two sides to make a turf fight, and on the other side, Governor Ronald Reagan, the university, and the various police forces were eager to play. To the university administration, hungering for expansion room, the South Campus area looked like crime, blight, and "hippie concentration." Here was the ideal site for new dormitories. When it became apparent that state money was not forthcoming for that purpose, however, the university discovered a "desperate need" for an intramural soccer field, whereupon, in 1967, it rushed the regents into a decision and promptly exercised the authority of eminent domain to buy for $1.3 million three acres of old brown-shingled frame houses just off Telegraph Avenue, four blocks south of the campus. In June 1968, it condemned the houses and demolished them, leaving a muddy, trash-strewn parking lot. This oblong block of blight remained that way, undeveloped and with neither money nor plan for early development, for ten months.

The following April, a prominent local mover and shaker named Mike Delacour conceived the idea of converting the grim space into a park, for in his view the street community needed a turf of its own, a public place for rock concerts and general rendezvous. The tall and lanky Delacour, with shoulder-length hair, had made his way from General Dynamics missile work to Berkeley, where he rolled up his sleeves and went to work for the Vietnam Day

"The radicals were hipper in Berkeley, the hippies more combative, and there were enough of each, and all the possible hybrids, to feed any utopian vision imaginable."

Committee and the Peace and Freedom Party. A practical, hands-on sort, weary of organizational infighting, he crossed over to the hip side of the street and, together with Liane Chu, opened the Red Square dress shop, a few steps away from what was then a parking lot wasteland. There he convened some hip freelance radicals to talk about the idea of a park, and they proved as enthusiastic as he. In a few days' time, and with a few hundred dollars raised from Telegraph Avenue merchants, they carted in a truckload of sod and plants, and proceeded to start digging People's Park in a corner of the vacant lot.

The felt need for a commons, a communal space, outran the organizers' dizziest expectations. Within days, hundreds of people were working in this improvised utopia. Work was joy, not a job. Local longhairs tamped down the sod next to students, housewives, neighbors, parents. Fraternity boys mixed with freaks; professors shopped for shrubs; graduates in landscape architecture came by to propose designs. On weekends up to three thousand people a day came to carry sod, to plant, to install swings, slides, a wading pool, and a sandbox, to cook and eat huge vats of stew and soup, to drink and to smoke marijuana, to play; someone made seven-foot-high letters spelling K N O W, straight out of the animated Beatles film *Yellow Submarine*. Decisions were improvised and casual, sometimes lengthy, but conflicts got resolved, work got done; the proverbial hundred flowers bloomed, yet within a loose overall design. People's Park amounted to the spirits of the New Left and the counterculture in harmonious combination; it was a trace of anarchist heaven on earth. It redeemed visions of the cooperative commonwealth—native peoples tilling the common lands, and seventeenth-century Diggers—from time immemorial. Beneath all the divisions of straight versus hip and student versus nonstudent, People's Park in the Northern California spring of 1969 touched some deep hunger for a common life. It consolidated the community, made it palpable. It was an answer (however fugitive) to the question, "What do you people want?" I wrote in a contemporary essay, in the rhetorical tone of the moment: "As substance and sign of a possible participatory order, as the living and hand-made proof that necessary institutions need not be overplanned, absentee-owned, hierarchical—as such the Park came to stand in as many minds as one tantalizing trace of a good society, as the practical negation of American death, as a redemption worth fighting for."

The freelance Yippie Stew Albert, who had attended Mike Delacour's original meeting, expected at first that the university would let the park be—it was "such a gentle thing," a community project readymade, in his terms, for "cooptation." Even when a reporter put it to him that the university would not stand idly by while squatters infringed upon its property, he thought the worst

that might happen was a mass arrest. Like many in the rank and file, Ruth Rosen, a graduate student in history and the editor of a campus newspaper supplement, saw People's Park as a constructive alternative to futile antiwar street-fighting. The park was no assault on academic activities; as long as it was not menacing, not too flamboyantly druggy, surely the university would look kindly on these constructive labors—after all, they improved the property. Surely the university, still living down the Free Speech Movement and later skirmishes, had no desire to tarnish its name again. Most of the organized Left, the "politicos," avoided the park altogether: it sounded unserious, hippy-dippy; it wasn't the right issue; what did planting tomatoes have to do with the working class or the Vietnam War?

Others, however, expected trouble from the beginning—and savored the possibility of a head-on collision with the university. The provocation was the park itself—a blunt rejection of the faceless, mindless order that officialdom stood for. No sooner had the park decision been made than Frank Bardacke (just acquitted of conspiracy charges stemming from the Stop the Draft Week demonstrations in Oakland in October 1967) wrote one of the classic leaflets of the sixties, "Who Owns the Park?" It was printed over the daguerreotype image of Apache leader Geronimo holding his rifle across his chest, and it eloquently tracked the history of the land from the Costanoan Indians, to the Catholic missionaries who "ripped it off in the name of God," to the Mexican government, "who had guns and an army," to the American government, who "had a stronger army" and who sold it to white settlers, and so down to the "rich men who run the University of California." It ended: "We are building a park on the land. We will take care of it and guard it, in the spirit of the Costanoan Indians. When the University comes with its land title we will tell them: 'Your land title is covered with blood. We won't touch it. Your people ripped off the land from the Indians a long time ago. If you want it back now, you will have to fight for it again.'"

"If they leave us alone, we have a park," Bardacke told me at the time. "If they try to take it back," he said with a grin, "we have a riot!" There were a few acid-saturated Telegraph Avenue habitués ready and eager to fight. But the park people in general were far from pugnacious. They wanted *the actual park*, the experience of community—the university's property rights be damned. Even people who at first grumbled that the park was a gimmick (including Marxists who complained that "workers can't relate to a park") fell in love with it.

"The provocation was the park itself—a blunt rejection of the faceless, mindless order that officialdom stood for."

Ronald Reagan was elected governor in 1966 by playing on two themes: sending "the welfare bums back to work" and "cleaning up the mess at Berkeley." "Welfare bums" was code for African Americans; "the mess at Berkeley" was the student revolt. From the time Reagan arrived in Sacramento, he was busy assuring his rightwing base that he would stand tough against the forces of disorder. During his first month in office, he arranged for the firing of UC Berkeley president Clark Kerr, the by-no-means-radical technocrat whom Reagan blamed for losing control of the campus. When Reagan addressed law enforcement officials in February 1969 (in a document collected for this book by Tom Dalzell), he resorted to a traditional metaphor to describe his mission: to continue "the six-thousand-year history of man pushing the jungle back." "The jungle" was Vietnam; it was the Watts riots and the Black Panthers; and it was People's Park.

To the university administration, as to Governor Reagan, People's Park was nothing more or less than insubordination. Neighbors complained about late-night bongo drumming, public sex, and drugs. Four weeks went by. Governor (and ex-officio UC regent) Reagan thought the way to deal with revolutionaries—and to please Southern California crowds—was to crack down; he had been trying to centralize the regents' (and his own) power over the nine-campus university system. Pressure was mounting on Berkeley chancellor Roger Heyns to assert property rights and *do something*. Efforts to broker a compromise fell afoul of the university's impatience. The regents were to meet next on May 16.

Heyns gave the order. Before the sun came up on May 15, the police sealed off eight square blocks while a crew bulldozed the gardens and threw an eight-foot-tall fence around People's Park. At a noon rally of several thousand on campus, student body president-elect Dan Siegel said, "Go down there and take the park," and the crowd, as if poised for the cue, poured down Telegraph Avenue toward the fence. Some trashed a Bank of America window, street people opened a fire hydrant, the police threw tear gas, rocks were thrown in return (causing no serious injuries)—apparently another round in the long-running fight for control of the South Campus streets. Then a squad of Alameda County sheriff's deputies in blue jumpsuits appeared, the special units who had been dubbed "Blue Meanies" after the pleasure-hating villains of *Yellow Submarine*—such whimsy during those bitter days says something about the spirits of the moment—and amid rampant disbelief the deputies lifted shotguns to their shoulders and opened fire. (Alameda County Sheriff Frank Madigan later defended the decision on the grounds that "the radicals had developed an antidote for tear gas." Governor Reagan's version was that the shotguns were issued after a policeman was stabbed—not seriously—near the fence.) For several hours they emptied their loads of birdshot and buckshot into crowds, they shot people running away from crowds, they shot passersby and reporters, and they fired at students simply walking on or near the campus. After two rocks were thrown from a rooftop—neither coming close to any deputies, according to eyewitnesses—they shot into a group standing on the adjacent roof of the Telegraph Repertory Cinema, cutting down two men: an artist named Alan Blanchard, who was permanently blinded by birdshot, and a visitor from San Jose named James Rector, whose belly was torn apart by a load of buckshot. In all, at least fifty (and by some accounts at least a hundred) demonstrators were shot. Four days later, Rector died.

It was one thing to theorize about the university's way of putting its property to use, but no one had anticipated shotguns. The community went into shock, terror, fury. That night, Governor Ronald Reagan sent three thousand

rifle-bearing National Guardsmen into Berkeley. From a "liberated zone" Berkeley was converted into an occupied territory under martial law: streets blocked off to all but proven residents; bayonets fixed; public gatherings of more than three people prohibited; a nightly curfew. Partisans of the park started a "People's Park Annex" on public land on the other side of town, only to see it torn up by rampaging police. Other tiny instant parks flourished briefly, then were uprooted too. In the course of the next week, a thousand people were arrested (two hundred on felony charges) while demonstrating or leafleting, or simply because they were on the street or in stores during a roundup.

At one point a Berkeley cop shoved Frank Bardacke, hands cuffed behind his back, down on the street, put his gun against Bardacke's head, cocked it, held the gun there—then threw him into the police car, punched him in the ribs, and forced him to sing "The Star-Spangled Banner." One day a National Guard helicopter flew over a huge but peaceful campus rally and, after a perfunctory warning, blanketed the entire campus, all square mile of it (including the campus hospital and nearby schools), with tear gas. Activists bought gas masks and helmets. Some women walked up to the Guards' bayonets and stuck flowers in the barrels of their rifles; people collected stories of Guardsmen flashing the V, and at least one such photo made the rounds. (Tom Hayden at one point walked down a Guard line at the end of a day of demonstrations trying to demoralize them—on the model of tactics used during antiwar protests—with the mantra, "See you again tomorrow, see you again tomorrow...")

On May 30, upward of twenty-five thousand marched peacefully through Berkeley to the park, while the bayoneted Guardsmen lined the fence and police sharpshooters manned the rooftops. A small minority of radicals wanted to tear down the fence with their bare hands; the Guard wouldn't shoot—or would they? Part festive (complete with balloons), part funereal, the demonstration didn't know whether to celebrate or mourn. The more militant demonstrators would come to see May 30 as the day they lost control to liberals and pacifists, as they had in the antiwar movement. The Guard left after seventeen days, but the fence stayed.

No one could resist analogies to Vietnam, for the authorities played the parts they would have been allotted in a New Left scenario of imperial occupation. Photos of a grinning cop lounging on a playground slide brought up images of Ugly Americans in their expeditionary uniforms. Guardsmen posted a sign saying FORT DEFIANCE, bringing Bardacke's leaflet to life. Then helicopters, indiscriminate bombing, the campus as a free-fire zone! Robert Scheer wrote in *Ramparts* magazine that the intramural playing field had amounted to a "'strategic hamlet' of clean-cut soccer players—a positive deterrent to subversion—in the very heart of the enemy camp."

Chancellor Heyns, who ordered the fence installed and then flew off to a conference, leaving events in the hands of the police, called the original land seizure "unjustified aggression," and more than once sounded (as Scheer said) "like a Secretary of State...apologizing for possible excesses of the troops." A grim-faced Ronald Reagan, for his part, maintained that the revolutionaries had left bamboo spikes in the park, and told the regents there were two alternatives only: crush the insurrection or surrender. Heyns maintained he was in the position of a business manager working for "a conservative landlord... confronted with an unauthorized tenant." The radical view was that university officials had fronted for escalation. Scheer made the point that the majority of the regents who had bought the land were appointees of the Democratic

"No one could resist analogies to Vietnam, for the authorities played the parts they would have been allotted in a New Left scenario of imperial occupation."

governor Pat Brown. Just as liberal presidents had fancied that their "limited" war in Vietnam was a way of placating the Right, so had the benign administrators hoped to satisfy Reagan with some ill-considered counterinsurgency. "The policy begins with 'reasonable' men," Scheer wrote, "as it did in Viet-Nam and in Berkeley, but it must always end up with the hawks....However much they demur later on, the Heynses unleash the Reagans." No one felt the polarization more keenly than Fred Dutton, one of the Brown-appointed regents and a former aide to Robert F. Kennedy, who said, "The Board offered repression and no solutions. The center keeps shrinking, and we are the provocateurs." Dutton tried to win the regents from Reagan but got nowhere.

On the street side, the Vietnam analogy was susceptible to different colorations. Talk of self-defense escalated. After the helicopter raid, a few activists approached local Vietnam veterans to find out what kind of gun it would take to shoot down a helicopter, although no one went so far as to procure one, and the Guard helicopters, heavily criticized by other police agencies, didn't return. Some activists procured handguns to keep at home. Usually, though, the rhetoric of self-defense took milder forms. To refute Marxists who sniffed at the park because Berkeley wasn't an oppressed colony, I wrote an editorial for the emergency wallposter *Outcry!*, likening the park people to heroic Vietnamese, and relaying the rumor that the way to keep helicopters away was to fly kites. (What merited attention, though, was the other side of the wallposter: movement artist Frank Cieciorka's full-page drawing of a red rose in the form of a fist smashing through the pavement, which ended up posted in many a Berkeley window.) Others in the movement cautioned against overworking the analogy and forgetting the actual Vietnamese people: "revolutionary communist" Bernardine Dohrn, a leader of the SDS faction soon to be known as "Weatherman," flew in to deliver that message at a rally. Even cooler antiwar heads felt the same way: Professor Franz Schurmann returned from a meeting with National Liberation Front and North Vietnamese delegates to caution the movement against ceding the antiwar issue to liberals and neglecting the terrible air war being escalated by Nixon under cover of Vietnamization.

What did the park mean? Movement heavies claimed moral and even political victory. "We won the war for the children of California," Frank Bardacke exulted, at a time when Governor Reagan's popularity in the state was actually undiminished. In one common revolutionary scenario, repression showed how oppression had worn thin; next would come the preliminary stages of guerrilla war. To Stew Albert, his partner Judy Gumbo, Tom Hayden, and other revolutionaries, this was an auspicious moment to release a "Berkeley Liberation Program" (published in the *Barb* the day of the May 30 march): it

was a call for affinity groups to "make Telegraph Avenue and the South Campus a strategic free territory for revolution"; to "turn the schools into training grounds for liberation" ("students must destroy the senile dictatorship of adult teachers and bureaucrats"); to "destroy the University unless it serves the people"; to "protect and expand our drug culture" ("establish a drug distribution center and a marijuana cooperative"); to "break the power of the landlords"; to "tax the corporations, not the working people"; to "defend ourselves against law and order" ("abolish the tyrannical police forces not chosen by the people...[;] the people of Berkeley must arm themselves and learn the basic skills and tactics of self-defense and street fighting[;] all oppressed people in jail are political prisoners and must be set free"); to "create a soulful socialism" (communes, shared housekeeping, and vanguards "who lead by virtue of their moral and political example" rather than by manipulation); and to "unite with other movements throughout the world to destroy this motherfucking racist-capitalistimperialist system"—all of which amounted to a hodgepodge of revolutionary bravado, radical reform, and a precise mirror image of the Reaganite nightmare. The Liberation Program unwittingly displayed the decline of the movement's vision since the early sixties; although fragments eventually spun off to become part of the program of Berkeley's electoral Left, its shrill and hackneyed phrases failed to speak to, or for, a shell-shocked community.

What got the most publicity, of course, was the call to paramilitary training. The *Berkeley Tribe*, newly split off from the *Barb*, ran a cover photo of a hip young couple in the woods, she carrying a baby, he pointing a rifle. (The headline: "JOIN THE NEW ACTION ARMY!") Gun graphics poured through the underground press. But target practice, however defensively intended, was not an alluring political plank even in Berkeley, where the question of "armed struggle" divided movement groups during the months after the National Guard retreated. Doublethink spread: Act as if this was a revolutionary situation and it would become one. The armed State would see to that; nevertheless, the State was a paper tiger. The State had the guns; the State would wither away. One sign of the phantasmagorical mood was *Ice*, a full-length action film written and directed by Robert Kramer, one of the founders of the underground Newsreel organization and one of its more accomplished and articulate practitioners. Set in an indefinite future (the United States is a police state, the U.S. Army is at war against a Mexican revolution) but shot naturalistically in Newsreel's no-frills style, *Ice* depicted a national network of armed collectives laying paramilitary plans under cover of movement filmmaking. In one scene, the revolutionaries rounded up residents of Washington Square Village in lower Manhattan, as if they were Guatemalan peasants, and lectured them about the impending revolution. Newsreel, alarmed by *Ice*'s "adventurism," refused to release the film under the organization's name. Nonetheless, at living-room screenings, *Ice* had its influence; Stew Albert was among those inspired by the fantasy. In the *Tribe* that summer, only half in jest, he recommended Sam Peckinpah's brutal *The Wild Bunch* as a "revolutionary film" because it showed you had to "pick up the gun."

People's Park also left quite different legacies. It pushed forward what was coming to be known as the ecological spirit. At a campus teach-in during the National Guard occupation, poet Gary Snyder first read his "Smokey the Bear Sutra" ("Smokey the Bear...will protect those who love woods and rivers, / Gods and animals, hobos and madmen....Those who recite this Sutra and then try to put it in practice...will help save the planet Earth from total oil slick..."). The defense of the park linked old-style upper-crust "nature lovers" with Sierra Club mountaineers and political insurgents. But most of the

park lovers were mild souls depressed and horrified by the bloodshed. The last thing they wanted was to "pick up the gun," and if that was what politics was going to require of them now, many preferred to flee politics altogether. (Myself, I went off for my first visit to Yosemite National Park, to get a sense of what was at stake, what had to be preserved.) The park that was supposed to fuse movement and counterculture ended up driving a wedge between them.

What Berkeley parochialism concealed from the movement notables was that People's Park was the last glimmering hope for a glad-eyed movement, one that would be ecumenical, constructive, and combative all at once. Some terrible line had been crossed. "People's Park ended the movement, really," Stew Albert acknowledged. "The repression was so brutal." For those who paid attention to Berkeley, the sense of white exemption died there, a full year before Kent State. And one small incident suggested to me how fatally insular was Berkeley's uprising. Soon after the National Guard went home, some activists, anticipating that hordes of young freaks were going to flood into town for the summer, persuaded the city to lease them (for one dollar) a cluster of abandoned buildings to use as crash pads. The faithful marched there one day to take proud possession of what was to be known as People's Pad. But why were these buildings abandoned? It turned out that their former tenants had been evicted—to make way for redevelopment. Those former tenants were impoverished African Americans, supposedly the other half of a revolution in the making.

Hip self-help was one thing, but a community organized across class and race lines was only hypothetical. Between a murderous State and an indifferent or vindictive majority, the counterculture had bumped up against its limits; as the Marxist jokers said, you could not build socialism in one park. The youth subculture, including its radical segment, was a *sub*culture, an enclave trying to live out "post-scarcity consciousness" in a society crippled by, and obsessed with, scarcity. Liberated territory was a fantasy, but to face that fact head-on would have meant owning up to real limits and vast confusion about the movement's whole trajectory. The movement-for-itself had come far enough to recognize that it was scarcely capable of maintaining itself, let alone making a revolution. The movement-for-others embraced the rhetoric of world revolution but was at a loss for actual allies. There was more repression than revolution, more fear than ebullience. To acknowledge these truths was to feel paralyzed. Denying them made it possible to keep the revolutionary mirage alive. There was much despair, much talk about impending fascism, much fidgety waiting. For what rough beast?

"For those who paid attention to Berkeley, the sense of white exemption died there, a full year before Kent State."

Fascism it was not, although earlier in 1969, Richard Nixon's attorney general, John Mitchell, had declared eagerly: "This country is going so far to the right you won't recognize it." Had Nixon not overreached—criminally as well as morally—Mitchell would probably have been proved right in the near term. As it was, Nixon collapsed, and Ronald Reagan, on the strength of his strongman governorship, was able to extend the meteoric rise that, in 1981, landed him in the White House. The entire Republican Party followed along, engulfing the country in a plutocratic and punitive wave so nasty as to have eventuated in the ascendancy of a vile figure who would later joke that he deserved the Congressional Medal of Honor because in 1969 he had fought his personal Vietnam by avoiding sexually transmitted diseases.

Just as American officials committed war crimes in Southeast Asia with impunity, so did the officials and officers who, in 1969, went to war in Berkeley. It bears remembering, as Tom Dalzell aptly points out, that, after People's Park, "not one person from law enforcement was convicted on any charge arising from the violent suppression of the protest." And so it happens that the next round of violent abuses of power is rendered possible by the failure to hold the perpetrators of the last round accountable.

But that need not be the last word. If, in 1969, the University of California failed to rise to the occasion with what architecture professor Sim Van der Ryn called a "creative response," the fate of People's Park need not be frozen in time as a definitive defeat. Responsibility for the health of the earth also surged forward out of a darkness. So does embattled humanity resist surrender to the crimes and obliterations of history. When the dominant institutions fail, or refuse, to find creative responses to conflicts, new energies and ideas arise from the outside, the edges, the unexpected. As Tom Dalzell and the people quoted in this book show in the pages that follow, memory too may come out of storage to remind subsequent generations. As the San Francisco poet Jack Spicer wrote, before People's Park: "Death is not final. Only parking lots."

And not even parking lots.

Tom Dalzell

The Battle for People's Park, Berkeley 1969, is based on first-person accounts. I avoid the third-person narrative and rely instead on accounts of those who were there and taking part in the events, and on, to a lesser extent, contemporaneous commentary on the events. I conducted many interviews and I drew from writings and quotations from written sources, most regularly the *Berkeley Barb*, UC Berkeley's *Daily Californian,* the *Berkeley Daily Gazette,* the *San Francisco Chronicle,* the *Oakland Tribune,* and the *San Francisco Express Times/Good Times.* The use of contemporaneous documents introduces some ambiguity of tense, as those documents tend to use the present tense whereas the recent interviews tend to use the past tense. This is not the end of the world.

In trying to construct an accurate account of the Peloponnesian War (431–404 BCE) on the basis of eyewitness accounts, the Athenian historian Thucydides acknowledged the serious problems in research when it is limited to interviews with eyewitnesses to important events. He notes in *The History of the Peloponnesian War,* "I did not even trust my own impressions, but the narrative rests partly on what I saw myself, partly on what others saw for me, the accuracy of the report being always tried by the most severe and detailed tests possible. Not that even so was it easy to achieve accuracy about the past, because of the differing accounts of the same occurrences by different eye-witnesses, arising sometimes from imperfect memory, sometimes from undue partiality for one side or the other."

Here, I draw on a wide range of accounts of the forty days and forty nights between breaking ground for People's Park on April 20, 1969, and the large march on May 30. In that period there are events for which the differing accounts are somewhat aligned, but there are others that were seemingly part of a plot device in which various characters provide subjective, alternative, self-serving, and contradictory versions of the same incident. Each reader may triangulate from the voices that I have gathered and use these accounts to determine their own sense of the truth.

I almost always let words stand as spoken. On rare occasions, I note where statements have been flatly contradicted by the record as a whole. Where a quote is presented without a specific attribution, it has been drawn either from an interview I conducted in 2018 or from contemporaneous written statements. A list of interviews and witness statements can be found in the Sources section at the back of this book.

The Crying of Lot 1875-2

People's Park did not come into the world free of context or original sin. There was a setting in which People's Park arose and in which the University of California at Berkeley used deadly force followed by martial law to reclaim it. In the spring of 1969, there was lingering resentment in the South Campus area over the university's acquisition through eminent domain and razing of the houses on the block that became People's Park, first to build student housing for which there was no funding, and then to fulfill a "desperate need" for a soccer field for which there was no demand. There was a persistent feeling among some that the university had engaged in a form of antiradical cleansing by targeting the South Campus area for expansion. The university's stewardship of the vacant lot after demolishing the existing houses was appalling. The lot festered for a year, an eyesore and nuisance.

People's Park occupies most of a city block, bounded by Telegraph Avenue, Haste Street, Bowditch Street, and Dwight Way. It is identified in Berkeley records as Lot 1875-2 or Block 1875-2. Until 1968, ten buildings lined the south side of Haste Street, six lined the west side of Bowditch Street, and ten lined the north side of Dwight Way.

In 1951, the university began to develop the plan that would lead to acquisition and demolition of Lot 1875-2. The 1951, 1955, and 1956 campus plans committed the university to buy large plots of land outside the campus to

develop residential halls, administrative buildings, and specialized sports fields. This approach rejected the vision of William Wurster, an influential architect and architecture teacher at the university who had argued for a "greenbelt of natural beauty" with no buildings around the campus.

The 1956 *Long Range Development Plan for the Berkeley Campus* alerted homeowners that the university would use its power of eminent domain to acquire and then destroy privately owned housing, including that on Lot 1875-2. A decade came and went without the university acting on its plan; it blamed the delay on lack of financial resources. In 1967, the university finally had the money to buy Lot 1875-2, and by this time some of the buildings on the block were in disrepair.

In June of 1968, Cliff Humphrey and other Ecology Action supporters converted a vacant lot at the southwestern corner of Dwight Way and Telegraph Avenue into a park in honor of Chuck Herrick, a founder of Ecology Action, who had been killed in a car accident in May of 1968. The park was officially called the Herrick Peace and Freedom Park, but the *Berkeley Barb* called it a "people's park."

For a few weeks, Ecology Action served free soup and bread at the small piece of "liberated land" in Herrick's memory. Among those who signed a petition at the park were Michael Delacour and his girlfriend Liane Chu. The City dismantled the park without incident.

CHUCK HERRICK
founder of Ecology Action, a nonprofit environmental organization
When land is vacant, we must raise the issue. We must put it to use as a park, a baseball diamond, anything but a lot with a path across it.

ECOLOGY ACTION
The opening maneuver in the campaign against the Berkeley land barons will begin at the new Chuck Herrick Peace and Freedom Park this Sunday at 1 p.m. (Leaflet, June 8, 1968)

ROGER HEYNS
chancellor of the University of California
I think it's very relevant, this long period of time during which this area really deteriorated…very badly, because the people who owned land that we hadn't yet acquired knew it was on the acquisition list, and they didn't keep it up. Sometimes we were slow in tearing down buildings.

G. KERRY SMITH
founder and chief executive of the American Association for Higher Education
The homes were shabby but pleasant. (From *The Troubled Campus*)

The less-than-perfect condition of some of the buildings notwithstanding, young people still favored the housing on Lot 1875-2 to the alternatives. Students were rejecting the newly built high-rise dorms; applications in 1970 for dormitory rooms were only half of what they had been in 1960. Vacancy rates were at an all-time high in the city, and the State was barely breaking even on existing dorms. Berkeley was ranked the lowest of all nine University of California campuses in priority for new housing. Building new dormitories was not pressing.

Besides the physical neglect of some of the properties, Lot 1875-2 was demonized because of its perceived bohemian population. Since at least the 1930s, the area immediately south of campus along Telegraph Avenue had been home to nonconformists.

ROBERT NISBET
UC Berkeley professor of sociology
One reason that San Francisco's storied Bohemia could successfully diffuse through Berkeley was the ring of cheap housing around the campus. Berkeley was a magnet for the nonconformist, *épater-le-bourgeois* types, whether students or nonstudents. The bulk of Berkeley Bohemia lived, thrived, and agonized in the rooming houses found on all four sides of the campus but chiefly on the south side, on Bancroft, Durant, Channing, and Haste. The saga of Berkeley owes much to these rooming houses.

DAILY CALIFORNIAN
UC Berkeley's student newspaper
Quoting a university spokesperson describing Lot 1875-2: "A concentration of hippies, radicals, rising crime, and a drug culture." (February 15, 1969)

ROGER HEYNS
chancellor of the University of California
There was a lot of drug use there, a lot of sexual activity, and just generally a mess. The police were constantly finding runaways and young girls hanging out. It was a real social disorder.

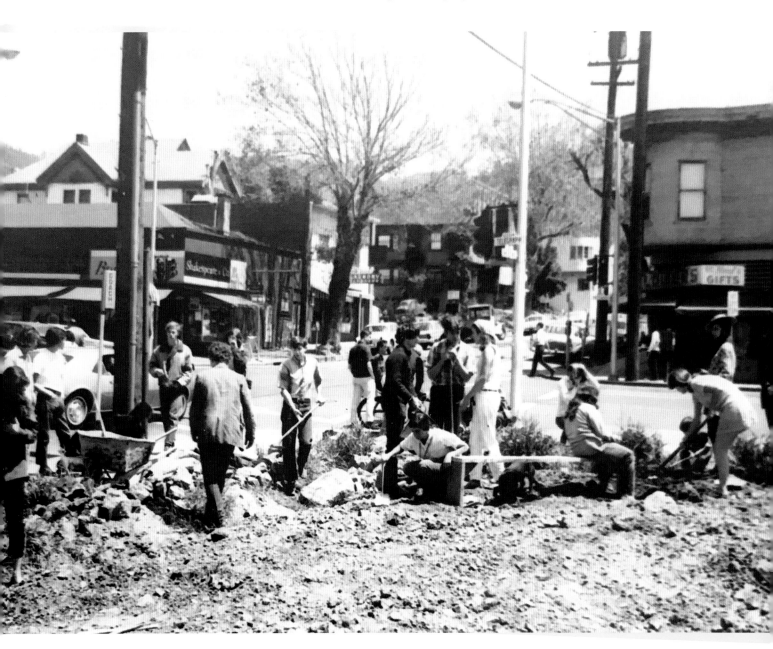

Volunteers at work on what was then known as Herrick Peace and Freedom Park, Telegraph Avenue and Dwight Way, June 1968.

DON MULFORD
member of the California State Assembly
It's a human cesspool. We must get rid of the rat's nest that is acting as a magnet for the hippie set and the criminal element.

FRED DUTTON
regent of the University of California
The demolition was an intentional act against the hippie culture.

In 1966, Berkeley's police chief, William Beall, launched intensive police patrols in the area, leading to numerous arrests for jaywalking, loitering, possession of marijuana, and other nonviolent offenses. The increased vigilance led to statistics showing an uptick in crime, which did not reflect an actual increase.

WILLIAM BEALL
chief of the Berkeley Police Department
We are more than ever convinced that the neighborhood [South Campus] must be completely renewed if it is ever to become a crime-free area in which Berkeley can again take real pride.

WILLIAM HANLEY
Berkeley City Manager
The area is home to the devotees of the drug culture and those that prey on them: the dope pushers, the hoodlums, the shakedown artists, and the pimps.

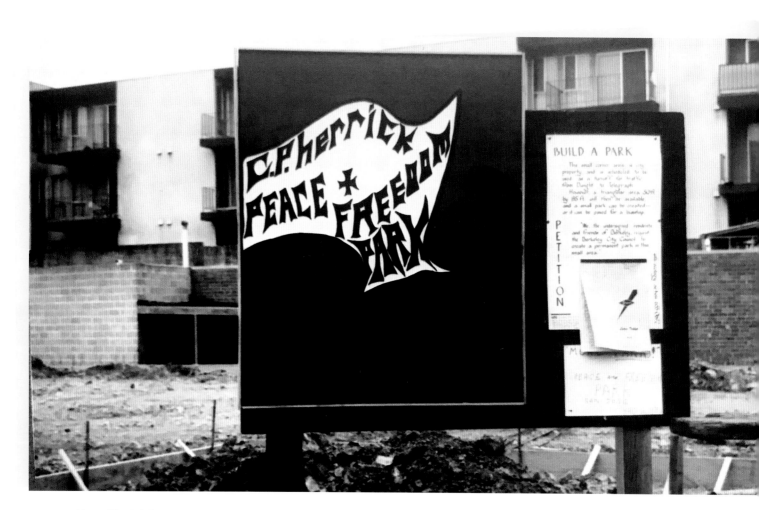

Above: Herrick Peace and Freedom Park, Telegraph Avenue and Dwight Way.
Right: A City of Berkeley bulldozer dismantles the park, June 1968.

In December 1967, the university served three-day eviction notices on those who lived on Lot 1875-2, a breach of an earlier promise that the evictions would not take place as students prepared for finals. All but two buildings were demolished by July 1968. The remaining two buildings were moved, one west toward Telegraph Avenue on Dwight Way, the other to a residential neighborhood. Homeowners, landlords, and tenants fought a losing battle against what one student called "the University's severe case of manifest destiny" (*Daily Californian,* February 15, 1968).

The plan for student housing on the lot was soon abandoned due to cost and lack of student interest. Instead, on April 4, 1969, the university's Outlay Review Board asserted a "desperate need" for a soccer field and confirmed that it had a high priority for funding and therefore could be built as planned.

FRANK BARDACKE
UC Berkeley graduate student and People's Park cofounder

The rulers of the university, like rulers everywhere, are completely incapable of understanding their own problems and have to blame their problems on outside agitators. This is the area where they said the outsider agitators came from, the South Campus area, and they decided in 1966 that as long as this area remained, that there would never be peace on the campus, because this area nurtured resistance. (From the 1969 Newsreel documentary *People's Park*)

NINA WAX
film editor for KQED television

While I was at Cal in the early 1960s, for two semesters I lived in one of the houses on Bowditch that was torn down by the university. There were five bedrooms, so I had roommates. The area was not rundown at all. It was like the rest of the South Campus area, full of families and renters and life. I moved on well before the evictions. It was a beautiful and comfortable house.

WAYNE COLLINS
UC Berkeley graduate and casual stevedore worker

I lived on Regent Street just south of Dwight. The houses that were demolished were not at all bad; it was not a case of urban blight. The two places where I lived on Regent were far worse than anything that got demolished. They were the two sleaziest buildings in Berkeley.

DHYANI (JENNIFER) BERGER
UC Berkeley graduate student in biology

By 1969, I lived in an apartment at 2538 Hillegass Avenue, a block from the site of People's Park. I walked through that vacant lot and the park as it evolved every day on my way to campus. I had an affinity with that space because after I arrived in Berkeley from Kenya in 1967, I used to have dinner with friends in an old house that was demolished, creating the derelict plot that became People's Park. I have fond memories of those cozy gatherings in that old house with friends from around the world.

KENNETH HALIBURTON

I remember the nice neighborhood that was there. I recall visiting at one apartment house with multiple stairways that was a bit like a maze. We entered via the fire escape. Cool buildings. The university tore the block down to try to crush the student movement, which they felt they could do by "developing" the area. For some reason this block was held to be a central area of rabble-rouser tenants. Maybe because it had nice housing? Southside was where people wanted to live.

JACAEBER KASTOR
eighth-grader at Willard Junior High School

My brother had a friend Jim whose family lived on Haste Street between Telegraph and Bowditch. I played there often. It was a typical Berkeley residential block with nice houses and yards and backyards, not like student rentals. Jim's family lost their house to the university and it was demolished.

JIM CHANIN
UC Berkeley undergraduate student

I arrived in Berkeley at the end of the summer of 1967. I was transferring from George Washington University and had spent the Summer of Love living in Haight-Ashbury. I came to Berkeley before classes started. I got off the bus at Shattuck and Dwight without a place to live. I carried my heavy suitcase east on Dwight until I came to a house with a FOR RENT sign in the window. That was 2523 Dwight Way, and I rented a room there until I was evicted in December. In December, I was told that I had to vacate the house because the university wanted me out. I went to the university offices and demanded to know why I was being kicked out right in the middle of finals. They said that they had done a survey and found no students living in the house. That survey obviously didn't include knocking on the door and talking to the people who lived there.

DAILY CALIFORNIAN

Larick, evicted from his home at 2510 Haste, became a student faced with a tragic-comic plight. A year and a half earlier, he and his family had been forced to leave another house in the area to make way for a parking lot. Tired of "running away from parking lots," Larick was also critical of the University for timing his 1968 eviction right in the middle of finals. (May 20, 1969)

DAILY CALIFORNIAN

Anonymous landlady: "Mr. [Jack] Schappell [Assistant Real Estate Officer for the University of California] told me that the University was razing the block to get rid of the hippies. But I don't believe there are any hippies here."

Second anonymous landlady: "Mr. Schappell has offered me only half of market value for my

An Ecology Action poster for the Chuck Herrick Peace and Freedom Park, 1968.

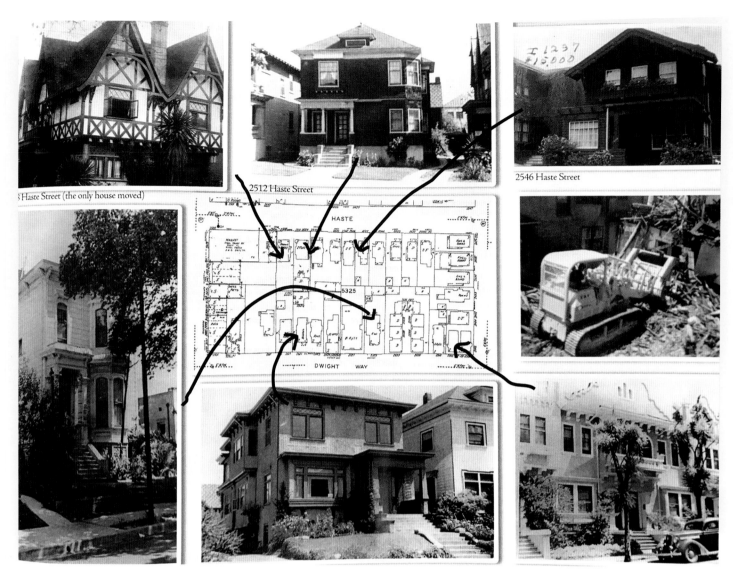

A map and photos show six of the buildings that made up Lot 1875–2 before demolition in 1968.

place. Where am I going to find another with what I get?"

Mrs. Herrenbrucks (mother of five): "We have been offered nowhere near what we will need to find another house." (February 5, 1968)

MICHAEL LERNER
UC Berkeley graduate student in philosophy and chapter president of the activist group Students for a Democratic Society (SDS)

This is just the most obvious and obnoxious example of what the University does in total disregard for the welfare of its students. Why do the dormitories hold students to a one-year contract if so many are trying to get in [to the dorms]? Another question is why isn't the University buying up places like this and providing cheap places for students to live instead of spending a great deal of money to build dormitories in which

nobody wants to live. Students fled the dormitories for this type of housing. (*Daily Californian,* February 5, 1968)

I arrived in Berkeley in 1964. I did my undergraduate work at Columbia, but that campus was not then politically active. I encountered the Free Speech Movement in the fall of 1964 and ended up on the Executive Committee representing a group I formed opposing amnesty for Nazis. I took part in the Vietnam Day Committee teach-in and the troop train protest, and I was an unindicted coconspirator in Stop the Draft Week. For a while I lived on Haste Street above Telegraph. My roommates over time included Reese Erlich, Jerry Rubin, and Phil Ochs. The house and the block were not rundown at all. We were evicted for the house to be demolished, and my anger about that informed my feelings about People's Park.

RICHARD EHRENBERGER
architect

[In 1956,] I came...from Nebraska, via two years in the armed services, to study architecture [in Berkeley]. I attended the City College for a year and then entered the architecture program at Cal. My wife and I had a baby and I didn't want to rent anymore, so we ended up buying 2548 Haste Street from Mrs. Osburn for $26,500. I couldn't qualify for a loan, so we did a hypothecation agreement. Mrs. Osburn took $500 off the price when I agreed to keep the furniture and clean out the basement.

It was a beautiful brown shingle designed by the Newsom Brothers in the early 1900s. I saw no decline in the block. There were all kinds of people on the block, all ages, families with children, professors and plumbers, people from other countries. There was great friendship and generosity on the block. The houses were kept up except for the one on Dwight that was built in the early 1960s and eventually moved west toward Telegraph when the block was demolished. It was red-tagged many times during construction, and as far as I could see was the only structure of blight in the area—and it was retained.

There was a brown-shingle rooming house next to us where some [student] movement leaders lived. One day my wife came home and a scruffy young man was sitting on our porch writing in a notebook. She told him that it was private property. He said, "I guess that means you'd like me to move." He said it politely and did leave. That night we went to a concert at the Berkeley Community Theatre and recognized the scruffy young man as Bob Dylan.

In the summer of 1968 a representative of the university knocked on my door and said that they were going to buy my house through eminent domain. He warned me to leave all the fixtures in the house, including fixtures that I had added. I did some research on eminent domain and learned that they could take the land but not the house, so I decided to move the house.

On the morning of the move, August 8, 1968, I woke up in my bed to the jolt of the house moving over the curb. We had canceled a party for the move, but an impromptu one happened anyway. We had fifty-seven men, women, and children in the house all the way down Telegraph, up Alcatraz, and left on Claremont. The movers were Hawaiian Mormons. When we passed the St. Augustine church on Alcatraz, mass was letting out and the priest was at the door blessing his parishioners. As the house crept by, he offered a blessing to the house by making the sign of the cross. The poor Hawaiian Mormons ducked to avoid the blessing. We had a nonstop party with balloons and streamers and music.

In the spring of 1969 I went by the vacant lot where all the houses had been to ponder. You could see the outline where our house had been by the vines that had covered the house coming up for a fresh start along the outline of where the house had been.

REESE ERLICH
suspended UC Berkeley undergraduate student and a reporter for Ramparts magazine

I lived in one of the houses that was torn down on Haste Street. It was a brown shingle that had been divided into several apartments. Michael Lerner lived on the ground floor, and my future wife Liz and I lived in the rear of the second floor. The house and neighborhood were not rundown. It was a typical brown-shingle, single-family-home type of neighborhood—exactly like the housing that exists today a few blocks away in the South Campus area. We moved out of the house before the evictions and demolition of the homes.

HOWARD DRATCH
UC Berkeley graduate student in political theory

I knew the old homes on the block that became People's Park. They tore down some really nice old homes and left a mud hole. I was appalled.

After the demolition of the twenty-four buildings, Block 1875-2 degenerated into an alternately mud-soaked and mud-baked vacant block that served as an impromptu parking lot. It was marked by ruts, garbage, weeds, old exposed foundations and basements, abandoned cars and car parts, detritus and rubbish and rubble and debris. Three Cal professors wrote in the *Nation* of June 23, 1969, that "no private corporation with such a fallow site on its hands would have left it an open eyesore and liability to trespass and appropriation by the public."

HUBERT LINDSEY
street preacher
From the spring of 1968 to 1969, the lot, muddy during bad weather and unfenced, served as a parking area, a receptacle for abandoned cars, and a hangout for the street society, hippies, and drug trafficking. I often preached there on Saturday night. (From *Bless Your Dirty Heart*)

SIM VAN DER RYN
UC Berkeley professor of architecture
Just one block off the postcard-ready Telegraph Avenue lay a festering eyesore—two square blocks of neglected land, a muddy pit of tire ruts, brimming with soured spring rain, it was an irritating reminder to the neighborhood of a university plan and process gone wrong. (From "People's Park: An Experiment in Collaborative Design," in *Design for Life*)

FRANK BARDACKE
UC Berkeley graduate student and People's Park cofounder
It was a dirty old block, used as an informal parking lot for over a year. (From the 1969 Newsreel documentary *People's Park*)

HENRY WEINSTEIN
UC Berkeley law student and a reporter for the Daily Californian
After the apartments on that property were razed, the land lay barren like a swamp, used as a parking lot, until a group of people started to build on it, trees, shrubs, swings. (*Daily Californian*, May 20, 1969)

BRIAN O'BRIEN
UC Berkeley graduate student in microbiology
We moved to Berkeley in 1962 and had seen quite a bit by the time of People's Park. In 1969, we were living on Virginia Street and had four children, ages four through nine. We saw the vacant lot where People's Park would be. You couldn't miss it. It seemed like a jab at the community designed to piss people off.

DOVE SHOLOM SCHERR
third-grader at Emerson Elementary School
My first memory of People's Park is from the winter before the park was built and the land was just a swamp filled with old cars and trash. After a big rainstorm, I went to the lot with friends, all of us barefoot and without parents. There were enormous puddles that seemed like oceans. We threw a mattress into a big puddle and some planks and played pirates on the open sea.

"It seemed like a jab at the community designed to piss people off."

JACAEBER KASTOR
eighth-grader at Willard Junior High School
As kids, we knew the South Campus area and the campus like the backs of our hands. My mother was an artist who hung out at the Piccolo [coffee house] that became the Med [Caffe Mediterraneum], and we'd find her there. My dad taught at Cal and so we knew the campus well. When the university knocked down all the houses on the block that became People's Park, the basements were left in the ground.

My brother and I and our friends played in the basements for days, exploring and going through things that had been abandoned there. There were big piles of debris and then the basements. It was super cool; great for boys.

CAROL GORDON
UC Berkeley undergraduate student
I have such a love of nature. During my years at Berkeley, I would take time to go to my favorite places on campus near a creek, under a tree,

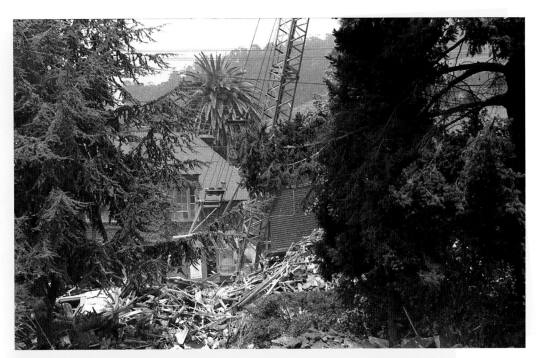

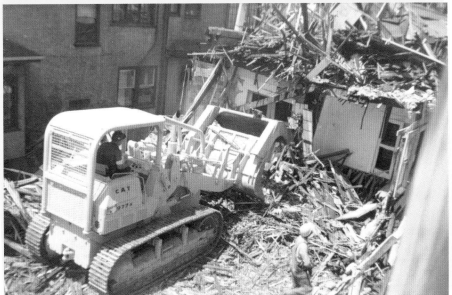

Above: A wrecking ball demolishes a structure on Lot 1875-2.

Left: A bulldozer clears what's left of a house on Lot 1875-2.

or in an open field to experience some of her light, her beauty, and her peacefulness. I also always enjoyed my walks through the residential areas close to the campus, as I found the unique architectural character of the historical homes amidst trees so beautiful and inspiring. I was sad when I discovered that many homes were being demolished to make way for the university's development plans. I recall hearing that one or more famous architects had designed at least several of those homes. September 1968, a few months after the homes had been demolished, it was the beginning of my third year of university, and I rented an apartment in a four-plex at 2538 Hillegass Avenue. I was less than a block away from a now-vacant plot of land being reserved for the university's development plans. However, the plans had been delayed, and the graveyard of those beautiful homes had become an ad hoc rut-filled dirt parking lot. I remember thinking, as I walked by on my way to classes, how sad it was that those beautiful homes had been sacrificed for this.

PAUL MORUZA
sixth-grader at Willard Junior High School
My family lived on Dwight Place in the Panoramic Hill neighborhood, but the family also owned an old-fashioned boarding house, the Chateau de Longpré, at 2545 Hillegass Avenue. Every morning, I would walk down from our house to the Chateau, have breakfast, and help bus dishes. I was vaguely aware of the People's Park block before the houses were demolished. They were typical Berkeley houses from the early 1900s. After they were demolished, it seemed like the land was abandoned for a couple years until the park started being made.

ROBERT TRACY
UC Berkeley professor of English
I knew a number of people who lived in the houses that were demolished in the block that became People's Park. One professor, Dr. Sellers, lived there. It was widely believed that Joseph Knowland, [then vice president] of the *Oakland Tribune*, was the driving force behind the demolition of the block, which he believed was a hotbed of radical activity. I was deeply troubled by the fact that the evictions took place just before finals, which was very disruptive for the students.

Before Michael Delacour launched what became People's Park in April 1969, the idea of a community park had been kicking around.

BERKELEY BARB
a weekly underground newspaper
Bill Miller [activist-owner of the General Store on Telegraph Avenue and a cofounder of the park] petitioned for the transformation of the block on Telegraph into a carless promenade for a sole Sunday afternoon. The city would issue a bond to fill the street with dirt and plant trees. At the same time, it would buy land in the back of existing shops and build parking lots there. (March 3, 1967)

SIM VAN DER RYN
UC Berkeley professor of architecture
[Van der Ryn recalls that, before the houses of Block 1875-2 were razed in 1968, he asked why, if Vice Chancellor Earl "Budd" Cheit couldn't] be dissuaded from demolishing people's homes,...[he didn't] at least make some of the land available to people on the street to make a place of their own, and to take some of the pressure off a crowded Telegraph Avenue.

INSTANT NEWS SERVICE
daily newsletter of the People's Press Syndicate

Frank Albanese, owner of the Forum coffee house on Telegraph, called *Instant News Service* to lay this down about the UC. Frank and other merchants talked to university officials several months ago to ask them to fence in the lot where People's Park was later built. The merchants felt that the mud-hole was becoming an unhealthy place for the local residents. The university replied that they did not have enough money to fence in the lot, and further, that they had no plans for the land for two or three years. (May 19, 1969)

TELEGRAPH AVENUE CONCERNS COMMITTEE LETTER TO WILLIAM C. HANLEY, BERKELEY CITY MANAGER

In recent years, a new group of young people has arrived in the area, drawn by activist student excitement and inexpensive housing in or near the area. Common to the group are its youth, transiency, and rejection of conventional middle-class mores. Needs for gathering places, constructive activity, health services, and housing, which the University has in large part met for its students, are largely not being met for these young people.

Three areas have been examined closely as being potentially valuable to use for art and cultural activities, social events, public meetings, and general activities.

The last site would be...virtually the entire block bounded by Haste, Bowditch, Dwight, and Telegraph. It is presently vacant and the University has no immediate plans to proceed with student housing as shown in the University's current Development Plan. The University has for a number of years considered a playing field as an interim use. Since the entire parcel wouldn't be needed for the uses suggested by the Committee, the possibility of leasing the area excess over that required for a minimum playing field—that is, sharing this parcel with the University—should be actively explored.

Recommendation: THAT THE CITY OF BERKELEY AUTHORIZE THE PLANNING AND DEVELOPMENT OF A MINI-PARK AND/OR CULTURAL PLAZA IN THE OPEN AREA BEHIND THE FORUM AND CONTIGUOUS TO THE OPEN SPACE OWNED BY THE UNIVERSITY OF CALIFORNIA. (October 28, 1968)

SAN FRANCISCO EXPRESS TIMES

The empty lot behind Pepe's [a pizza joint on Telegraph between Haste Street and Dwight Way] would make a good park—why don't we use it? (March 31, 1969)

"When land is vacant, we must raise the issue. We must put it to use as a park, a baseball diamond, anything but a lot with a path across it."

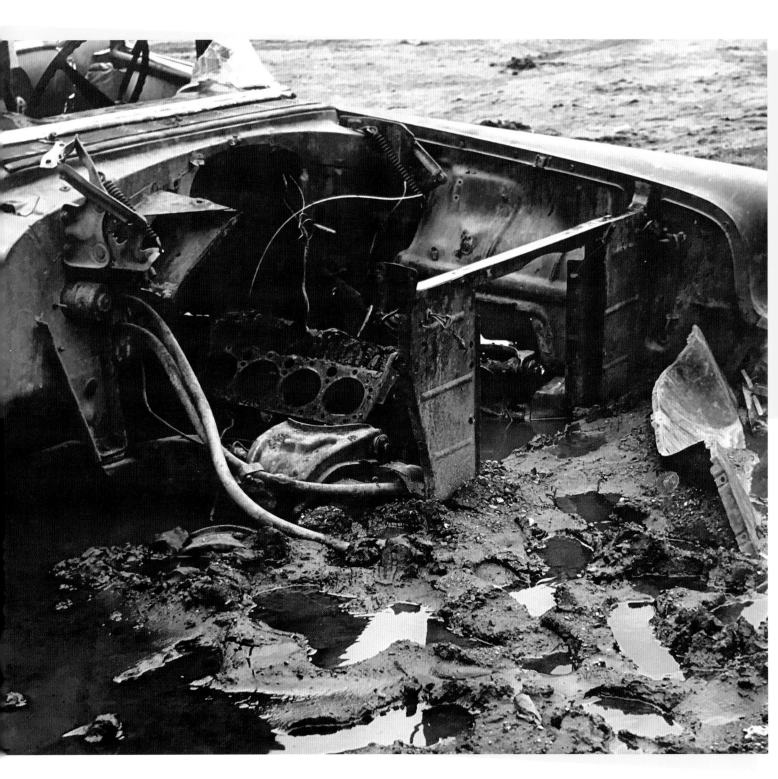

The condition of Lot 1875-2 under the stewardship of the University of California, after the demolition of the houses.

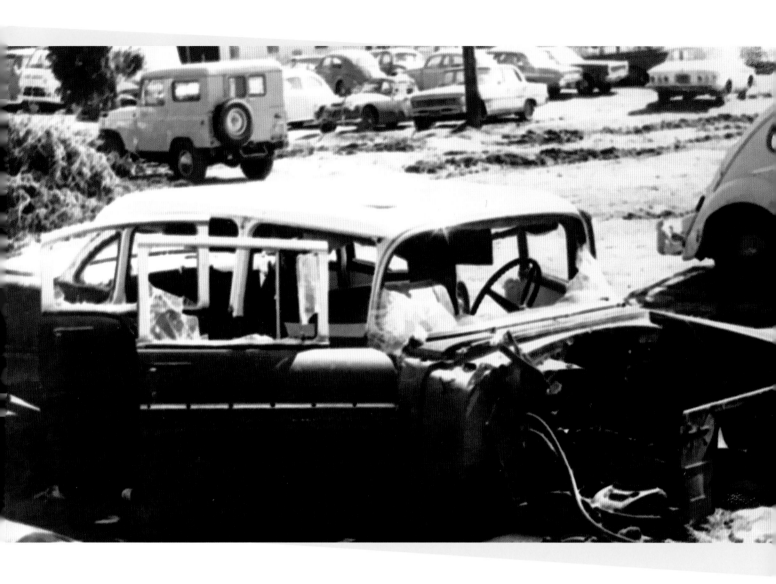

"The graveyard of those beautiful homes had become an ad hoc rut-filled dirt parking lot."

"That mess in Berkeley"

Part of the context in which People's Park arose was Governor Ronald Reagan's attitude toward the university and what he called "that mess in Berkeley." Reagan had launched his political career in 1966 with an assortment of dog-whistle issues. He railed against welfare cheats ("send the welfare bums back to work") and urban rioters. He vowed to repeal the California Fair Housing Act of 1963, better known as the Rumford Act, a significant and sweeping law protecting the rights of African Americans and other people of color to purchase housing without being subjected to discrimination. Reagan argued that "if an individual wants to discriminate against Negroes or others in selling or renting his house, he has a right to do so." Last but not least, he demonized Berkeley's student peace activists, professors, and the University of California itself. When Reagan began his gubernatorial campaign, his strategists advised him that he—who was best known at the time for costarring with a chimpanzee in the 1951 comedy *Bedtime for Bonzo* and for his longtime paid shilling for General Electric— could not afford to embrace anti-intellectualism by attacking the University of California, and they buttressed their position with polling, which didn't show student unrest at Berkeley registering as a public concern. Reagan knew better: "I don't care if I'm in the mountains, the desert, [or] the biggest cities of the state, the first question is, 'What are you going to do about Berkeley?' And each time the question itself would get applause."

He ran a scorched-earth campaign against the University of California, especially the Berkeley campus. In May 1966 he described Cal as a "refuge for communism and immorality." He called for former CIA director John McCone, who had led the investigation into the 1965 Watts riots for President Lyndon Johnson, to choose fifteen prominent men willing to serve on a committee to investigate controversial student problems at Berkeley. The university's Board of Regents, Reagan proposed, would then pick five from the group who would write a report that the regents could, in the end, deal with as they saw fit. Reagan explained the idea: "It is my belief that the people of California have a right to know all the facts about charges of communism, sexual misbehavior, and near anarchy on the campus of the University of California at Berkeley." Time and again he told his audiences that he would "clean up that mess in Berkeley." He was especially horrified by Berkeley's "sexual orgies so vile that I cannot describe them to you." In his stump speech, he made a call for action in Berkeley: "Will we meet the students' vulgarities with vacillation and weakness, or will we tell those entrusted with administering the university we expect them to enforce a code based on decency, common sense, and devotion to the high and noble purpose of the university? A small minority of beatniks, radicals, and filthy speech advocates [are bringing] shame to a great university." These views found an echo of enthusiasm among a broad swath of the electorate. He was elected with 65 percent of the vote, a wide margin.

Less than a month after Reagan was sworn in as governor, he attended his first meeting of the regents and wasted no time; he immediately fired University of California president Clark Kerr, who had been too accommodating for Reagan's taste during the Free Speech Movement. And Reagan didn't let up on Berkeley during his first two years in office. Vice Chancellor Budd Cheit,

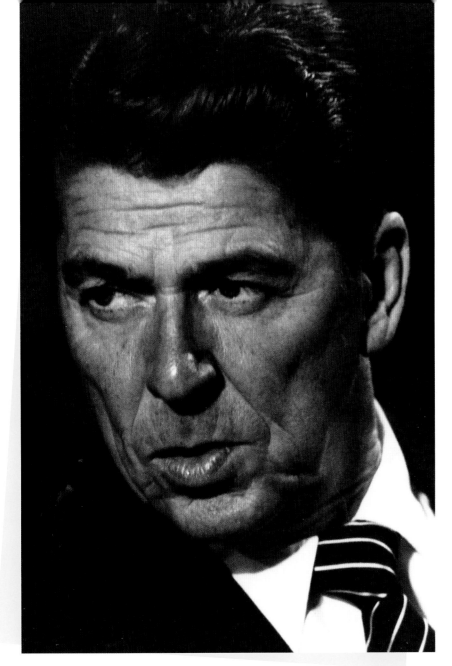

Governor Ronald Reagan, with his eye on "that mess in Berkeley."

who would play a central role in People's Park, understood Reagan's appeal: "Incidents of campus disruption and reports about what was going on here—often exaggerated reports—became a standard part of his campaign rhetoric. Reagan also argued that the faculty was too permissive, or supportive, of the students. One of his great skills was to understand popular feeling. He really tapped into the discontent people felt about what was happening on the campus. I have no doubt that this was a big factor in his election as governor."

Reagan visited Cal in January 1969, a few months before People's Park came to life, and when his limousine drove onto campus, it was not well received. The headline of the lead front-page story in the *San Francisco Chronicle* of January 18, 1969, was "EGG THROWERS AIM AT REAGAN."

As he entered office, Governor Reagan fully embraced Pentagon plans to increase the role of the military to deal with social uprisings on college campuses. In the winter of 1967–68, the Pentagon had created plans to deal with civil disturbances in urban ghettos, college campuses, and factories on strike. Operation Garden Plot, as it was named, substantially increased the role of

the military in responding to social uprisings by students, minorities, and trade unionists, and the Garden Plot plan recognized that "federal military intervention may be required to preserve life and property and maintain normal processes of government." There were regional variations: Operation Cable Splicer was the set of contingency plans applicable to the states of California, Oregon, Washington, and Arizona. Each region was directed to conduct war games to practice and refine its plan. The Pentagon created the Directorate of Civil Disturbance and Planning Operations to oversee the plans.

In May 1968, military and law enforcement representatives met at the National Guard Training Center at the California Military Academy at Camp San Luis Obispo for a seminar on the control of civil disturbances—the program designed to prepare the participants for a future war game. On February 10, 1969, Governor Reagan joined military, local, state, and federal officials at the Governor's Orientation Conference at the El Dorado Hotel in Sonoma. There he kicked off the western regional exercise that would take place the next month.

RONALD REAGAN
governor of California
You know, there are people in the state who, if they could see this gathering right now and my presence here, would decide that their worst fears and convictions had been realized—I was planning a military takeover. (Remarks on Operation Cable Splicer during the Governor's Orientation Conference, February 10, 1969)

CHARLES O'BRIEN
California chief deputy attorney
If the Constitution prevents the police from gathering political intelligence, then the Constitution goes too far. This is a revolution, and anything goes. A civil disturbance anywhere in this state is an attack on the state itself. (*New Times* magazine, November 28, 1975)

LYNN DAVIS "BUCK" COMPTON
deputy district attorney of Los Angeles
Free speech, civil rights, [and] rights to assembly have all become clichés. (*New Times,* November 28, 1975)

SINCLAIR WALTER "CLAIR" BURGENER
state senator from San Diego
If this was going on in this spirit, they were certainly pulling the wool over the eyes of the invited guests. Well, I'll be damned! This is what I call subversive. (*New Times,* November 28, 1975)

ED MEESE
chief of staff for Governor Reagan
This is an operation, this is an exercise, this is an objective which is going forward because in the long run it is the only way that we will be able to prevail. (*New Times,* November 28, 1975)

In March 1969, National Guard officers, army advisers, senior police and sheriff officers, and private executives took part in an elaborate war game. The scenario is that an imagined arrest and shooting spark a riot. Dozens of radicals flown in on a chartered flight are picked up at the airport by twenty separate vehicles, and what follows is the ambush of several police cars, the attempted assassination of the mayor, the bombing of local armories, the destruction of vehicles and ammunition stocks, the gathering of thousands of people in the streets, hoarding of water in certain areas, and sniping of fire trucks. Outside law enforcement is called in but can't control the riot. The National Guard is called in but can't control the riot. The army is called in and finally controls the riot.

The Conference of the Emergency Planning Council met in Sacramento on May 9, 1969, to review the March war game exercise. Gaps that were identified included communication between the military and law enforcement, a delay in mobilizing the military, and a shortage of antiriot equipment. In less than a week, Reagan would launch an all-out offensive against People's Park, using tactics and strategies learned from Operation Cable Splicer.

Bad Moon Rising

At the time of People's Park, Berkeley had been experiencing protest marches and rallies for more than five years. Until the summer of 1968, however, protests in Berkeley had been nonviolent, and the police reaction had been restrained. Neither the Free Speech Movement nor the several activities of the Vietnam Day Committee in Berkeley had involved violence by demonstrators or provoked any significant level of police violence. The San Francisco Police responded to the protests against the House Un-American Activities Committee (HUAC) in 1960 with manhandling and fire hoses (inspiring chief of police Bull Connor to use fire hoses against civil rights protestors three years later in Birmingham, Alabama), and the Oakland Police responded to Stop the Draft Week demonstrations in October and December 1967 with batons, mace, and tear gas, but it had not happened yet in Berkeley.

In the summer of 1968, a series of street battles raged on Telegraph Avenue. The original *casus belli* was a demonstration in support of striking French students and workers organized by Peter Camejo and the Socialist Workers Party. Berkeley police broke up the rally and the battle was on. Over the next three nights, police attacked protestors, and protestors threw bricks and bottles at the police. The police used tear gas on a crowd for the first time in Berkeley history. Berkeley Police Department captain Charles Plummer said of the tear gas: "It was a big decision to make. It was an unheard of thing to do on the West Coast. The gas didn't solve the problem. It scattered them, but then they re-formed in small pockets, three or four to a group." The *Daily Californian* in an editorial thought that the incident showed "how easily the police can completely take over a community" and concluded that "the police state is here today." The Berkeley-Albany chapter of the ACLU reported that Berkeley police were "mentioned overwhelmingly as having engaged in incidents of unjustifiable physical force compared to other police forces present."

The demonstrators gave as well as they took. On June 29, Captain Plummer admitted, "We took an awful beating." This wave of protest culminated with a large, peaceful rally of perhaps five thousand people on a city council–sanctioned shutdown of Telegraph Avenue on July 4, 1968.

A second round of violent disturbances took place on Telegraph from August 30 through September 9, 1968, protesting the police riot at the Democratic National Convention in Chicago. Tear gas, police beatings, sweep tactics, and unfounded arrests were normalized in Berkeley.

The major protest in the fall quarter of 1968 centered around the university's decision that students taking the Experimental Social Analysis 139X

class taught by Eldridge Cleaver, Minister of Information for the radical Black Panther Party, would not be given academic credit. There were two sit-ins and several hundred arrests at Sproul Hall and then Moses Hall on campus. There was little property damage and few brawls with police to speak of. But that all changed in the next quarter, with the Third World Liberation Front strike.

In January 1969, black activists at Cal joined forces with the Mexican American Student Confederation, the Asian American Political Alliance, and the Native American Student Alliance under the banner of the Third World Liberation Front, inspired by the example set at San Francisco State College (now University). They demanded creation of a Third World College and increased opportunities for and control of minority-related programs by minority students. Additionally, the Mexican American Student Confederation pushed for university support of striking grape workers in Delano, a position that Governor Reagan had rejected.

The groups called a strike, which escalated and then entered a spiral of violence as police tried to suppress the action with force. On February 5, 1969, Governor Reagan proclaimed a "state of extreme emergency," which permitted the use of California Highway Patrol officers and the National Guard. Law enforcement seemed less reluctant to use violence against students of color than they were against white students.

In early March, Chancellor Heyns agreed to most of the strikers' demands, including the creation of a Department of Ethnic Studies. A month later, People's Park would arrive.

"This is a revolution, and anything goes. A civil disturbance anywhere in this state is an attack on the state itself."

WHO OWNS THE PARK?

Someday a petty official will appear with a piece of paper, called a land title, which states that the University of California owns the land of the People's Park. Where did that piece of paper come from? What is it worth?

A long time ago the Costanoan Indians lived in the area now called Berkeley. They had no concept of land ownership. They believed that the land was under the care and guardianship of the people who used it and lived on it.

Catholic missionaries took the land away from the Indians. No agreements were made. No papers were signed. They ripped it off in the name of God.

The Mexican Government took the land away from the Church. The Mexican Government had guns and an army. God's word was not as strong.

The Mexican Government wanted to pretend that it was not the army that guaranteed them the land. They drew up some papers which said they legally owned it. No Indians signed those papers.

The Americans were not fooled by the papers. They had a stronger army than the Mexicans. They beat them in a war and took the land. Then they wrote some papers of their own and forced the Mexicans to sign them.

The American Government sold the land to some white settlers. The Government gave the settlers a piece of paper called a land title in exchange for some money. All this time there were still some Indians around who claimed the land. The American army killed most of them.

The piece of paper saying who owned the land was passed around among rich white men. Sometimes the white men were interested in taking care of the land. Usually they were just interested in making money. Finally some very rich men, who run the University of California, bought the land.

Immediately these men destroyed the houses that had been built on the land. The land went the way of so much other land in America—it became a parking lot.

We are building a park on the land. We will take care of it and guard it, in the spirit of the Costanoan Indians. When the University comes with its land title we will tell them: "Your land title is covered with blood. We won't touch it. Your people ripped off the land from the Indians a long time ago. If you want it back now, you will have to fight for it again."

BERKELEY GRAPHIC ARTS

The Park Is Born

The conventional narrative about the founding of People's Park is that a small group of men and women met at Michael Delacour and Liane Chu's Red Square dress shop on Dwight Way in April 1969 and, in a *deus ex machina* fashion, came up with the idea for a park. This much is true: On April 15, 1969, Michael Delacour, a blue-collar antiwar activist and ubiquitous figure on Telegraph Avenue, held an organizing meeting about the park at Red Square. Present were Wendy Schlesinger, Liane Chu, John Algeo, Doug Bogen (later known as Doug Cooper), Paul Glusman (head of the one-man organization Concerned Stalinists for Peace), Stew Albert, Judy Gumbo, and Curtis Rosa (universally referred to as "the Old Carpenter"), who had a shoji screen business. They agreed to build a park in the rutted-out, busted-up vacant wasteland that Lot 1875-2 had become.

Wendy Schlesinger visited Telegraph Avenue merchants, asking for donations. The money she raised would be used to buy sod. Stew Albert, writing under the name "Robin Hood's Park Commissioner," took the idea to the pages of the *Berkeley Barb,* Max Scherr's underground weekly:

> Hear Ye, Hear Ye.
> A park will be built this Sunday between Dwight and Haste. The land is owned by the University which tore down a lot of beautiful houses in order to build a swamp.
> The land is now used as free parking space. In a year the University will build a cement type expansive parking lot which will fiercely compete with the other lots for the allegiance of Berkeley's Buicks.
> On Sunday we will stop this shit. Bring shovels, hoses, chains, grass, paints, flowers, trees, bull dozers, top soil, colorful smiles, laughter and lots of sweat.

At one o'clock our rural reclamation project for Telegraph Ave. commences in the expectation of beauty.

We want the park to be a cultural, political, freak out and rap center for the Western world.

All artists should show up and make the park their magical possession. Many colored towers of imagination will rise above the Forum [the Espresso Forum coffee shop on the corner of Telegraph and Haste] and into the future of reality. Pastel intertwining the trees and reflecting sun, all Berkeley energy exploding on the disappearing swamp. The University has no right to create ugliness as a way of life. We will show up on Sunday, and we will clear one third of the lot and do with it whatever our fantasy pleases. We could have a child care clinic or a crafts commune which would communicate its wares by having medieval-style fairs, a baseball diamond, a rock concert, or a place to think and sleep in the sun.

This summer we will not be fucked over the pigs['] "move-on" fascism[;] we will police our own park and not allow its occupation by imperial power.

Come to the Dwight and Haste mud flat at one o'clock on Sunday, prepared to work[,] and bring your own food picnic. When we are exhausted we knock off for rock music from "Joy of Cooking" and whatever bands show up.

"Nobody supervises and the trip belongs to whoever dreams."

Signed,

Robin Hood's Park Commissioner

The idea went public and it went big and it went fast. Jon Read, Mike Lyon, Art Goldberg, Frank Bardacke, William Crosby, "Big Bill" Miller, and "Super Joel" Tornabene joined the core committee that would build and defend the park. Several hundred volunteers came to the site on Sunday, April 20, and from the start, the park attracted a cross-section of political radicals, straights, hippies, and street people. Between April 20 and May 15, 1969, thousands of people spontaneously transformed the eyesore of a vacant lot into a pleasant and relaxing, if slightly chaotic and messy, park. Volunteers laid sod, planted flowers and trees and bushes, built an amphitheater, laid out winding brick paths, and installed swings and play structures.

The Free Speech Movement had been a democratic centralist organization layered on a substructure of participatory democracy, with both the core central leadership group and the Executive Committee democratically selected from among representatives of all campus organizations. People's Park, by contrast, was built and defended with a leadership model that was far less centralized than the Free Speech Movement. The diversity of the park movement, which included differing levels of political experience and understanding, made a centralized leadership model impossible.

Design of the park was also decentralized. If you had an idea, you acted on it. At a meeting at Bill Miller's house, architect Sim Van der Ryn reported *Berkeley Barb* editor Max Scherr as saying that "there should be an overall plan to ensure some sort of esthetic standard." Scherr's concern was dismissed by the group, who believed that "a plan was contrary to the spirit and purpose of a park wherein each person could be creative and get others to work on an idea if he could convince them of its values."

SAN FRANCISCO CHRONICLE

INSTANT PARK IN "LIBERATED" BERKELEY LOT: Berkeley street people "liberated" a parking lot yesterday with grass (the backyard variety), flowers and a lot of cheerful hard work. More than 200 youthful habitués of Telegraph Avenue plunged into the effort on the unpaved lot owned by the University of California between Haste Street, Telegraph, Regent and Bowditch streets. They vowed to defend it from the ravages of the gasoline-powered intruders.

The self-appointed public works platoons showed up with shovels, a variety of plants, some 300 square yards of sod and a bulldozer.

The sod, a spokesman said, had been purchased with money gained from an informal contribution drive among friendly merchants. The bulldozer was rented, and a young man in a sporty cowboy hat wheeled it professionally to grade and fill sections of the lot.

Many of the workers doffed their shirts in the warm sun and swept clumps of long hair from their eyes as they bent to shovel and rake and plant.

By 2 p.m. a shady glen, floored with lush grass and a sprinkling of flowers, had been created within a small grove of trees at the northeast corner of the lot. That spot, the street people vowed, marked the beginning of a weekly plant-in until the entire block-square park is finished.

As the young people toiled, carefully laying and rolling down sod, adding an artistic touch with a plant or a shrub here and there, two young Berkeley policemen wandered up with curious expressions.

"What are you doing?" one them asked in a neighborly tone.

"We're making a park, man, want to help?" came the reply from a growing cluster around the officer. (April 21, 1969)

TIM FINDLEY
for the San Francisco Chronicle

THE PEOPLE BEHIND THE PARK: Wendy Schlesinger: the pretty little spark plug of People's Park...Mike Delacour: the digger-like dilettante of Telegraph Avenue...Super Joel: part-time people's jester, he is considered a major representative of the "street people"...Charles Palmer: cool headed and businesslike...Frank Bardacke:

from Northwest Passage (UPS)

HEAR YE, HEAR YE

A park will be built this Sunday between Dwight and Haste. The land is owned by the University which tore down a lot of beautiful houses in order to build a swamp.

The land is now used as free parking space. In a year the University will build a cement type expensive parking lot which will fiercely compete with the other lots for the allegiance of Berkeley's Buicks.

On Sunday we will stop this shit. Bring shovels, hoses, chains, grass, paints, flowers, trees, bull dozers, top soil, colorful smiles, laughter and lots of sweat.

At one o'clock our rural reclamation project for Telegraph Ave. commences in the expectation of beauty.

We want the park to be a cultural, political, freak out and rap center for the Western world.

All artists should show up and make the park their magical possession. Many colored towers of imagination will rise above the Forum and into the future of reality. Pastel intertwining the trees and reflecting the sun, all Berkeley energy exploding on the dis- appearing swamp. The University has no right to create ugliness as a way of life. We will show up on Sunday and we will clear one third of the lot and do with it whatever our fantasy pleases. We could have a child care clinic or a crafts commune which would communicate its wares by having medieval-style fairs, a baseball diamond, a rock concert, or a place to think and sleep in the sun.

This summer we will not be fucked over by the pigs "move-on" fascism, we will police our own park and not allow its occupation by imperial power.

Come to the Dwight and Haste mud flat at one o'clock on Sunday, prepared to work and bring your own food picnic. When we are ex- hausted we knock off for rock music from "Joy of Cooking" and what- ever bands show up.

"Nobody supervises and the trip belongs to whoever dreams.
Signed,
Robin Hood's Park Commissioner

Stew Albert's call to action to build the park in the *Berkeley Barb.*

Left: Michael Delacour, boilermaker and People's Park cofounder.
Below: Paul Glusman, student activist.

Right: "Super Joel" Tornabene, activist and Yippie (on left), and "Big Bill" Miller, activist-owner of the General Store on Telegraph Avenue and cofounder People's Park.

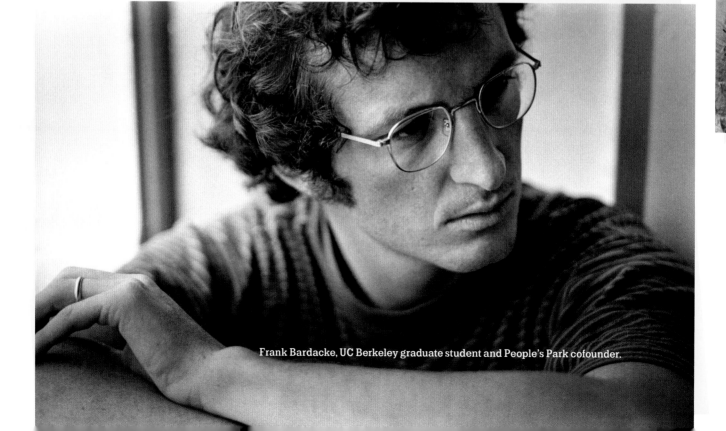

Frank Bardacke, UC Berkeley graduate student and People's Park cofounder.

Clockwise from top: Wendy Schlesinger, feminist, eco-activist, and People's Park cofounder; Liane Chu, co-owner of the Red Square dress shop and a People's Park cofounder; Curtis "The Old Carpenter" Rosa, owner of a shoji screen shop and a People's Park cofounder; and Judy Gumbo, Yippie and People's Park cofounder, and Stew Albert, Yippie and People's Park cofounder.

a useful and experienced march leader and an often-quoted theoretician...Tom Hayden, usually arrives late, if at all, and quietly stands in the background. (May 30, 1969)

MICHAEL DELACOUR
boilermaker and People's Park cofounder

One night I thought about that parking lot for a rock band. We went up and tried it, but the lot was too muddy. So I called Jon [Read, a landscape architect] and asked him to come over and suggest how we could clean it up. He said "sod," and bang, that was it. (*San Francisco Chronicle*, May 30, 1969)

I knew most of the people who I invited to that first meeting at Red Square from hanging out drinking coffee at the Med[iterraneum café]. Bill Miller's General Store was right around the corner from Red Square, and I saw him a lot.

Stew Albert I'd known from antiwar demonstrations and from the sit-in at Moses Hall during the Cleaver controversy. Super Joel ran with the "Red Rockets," a group of young teenagers, including my daughters, who hung out on Telegraph between Haste and Dwight.

CRAIG OREN
for the Daily Californian

WOULD-BE UNIVERSITY PARKING LOT BECOMES "POWER TO THE PEOPLE PARK": A revolution started Sunday at the corner of Bowdich and Haste. A group of about 200 street people, students, and activists brought appropriate weapons—shovels, rakes, hoses and a bulldozer—to their fight against a University-owned mudflat in the South Campus area. (April 22, 1969)

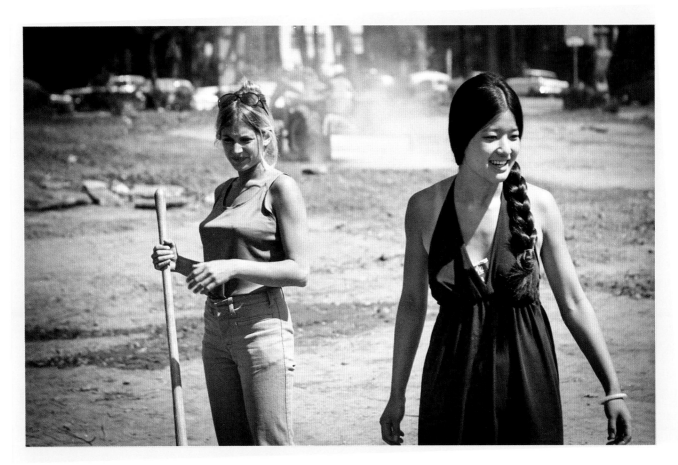

Wendy Schlesinger and Liane Chu, April 20, 1969, the first day of building the park.

"That first day was fun. It was chaotic, and fun. There was lots you could do. There were no supervisors. You did what you felt was important."

JUDY GUMBO
Yippie and People's Park cofounder
That first day was fun. It was chaotic, and fun. There was lots you could do. There were no supervisors. You did what you felt was important. Almost the whole *Barb* staff was there working. We did it for the sake of doing it, for the experience of the moment. We didn't think that far ahead or about what would happen.

PAUL GLUSMAN
student activist
Mike Delacour stood head and shoulders above everyone else in initiating the park. He said, "Let's build a park on Sunday," and nobody believed him. But on Saturday he had a truck of grass sod parked in front of the Med and was scouring around Berkeley for the shovels.

RUTH ROSEN
UC Berkeley graduate student in history
In the evenings, they danced to rock music, hoping to demonstrate, peacefully, the meaning of the slogan "Make love, not war." It was utopian, naive, silly, but surprisingly inspiring. It gave people worn down by the seeming futility of antiwar protests a glimpse of community life. At the very least, it was a harmless alternative to violent anti-war activity. (*Los Angeles Times,* August 7, 1991)

I was living on Fulton and would bike past the park to work. I thought, "This is quite lovely." Faculty were there planting trees and flowers. Faculty wives were planting. Kids were playing on swings. It was very nice. We knew that we couldn't stop the war, but this showed what life could be like if we created a society. It was

a magical fusion of the anarchistic street culture and the radicals of the New Left. Jon Read was a special person. He did a beautiful job planning and teaching people how to plan the park. He had no intention to create or provoke confrontation.

RESOLUTION PUT FORTH BY THE FACULTY OF UC BERKELEY'S COLLEGE OF ENVIRONMENTAL DESIGN
The spontaneous development of a community park offers our faculty and students an opportunity to study an ongoing process of participatory design. (May 15, 1969)

STEPHEN SHAMES
UC Berkeley undergraduate student and photographer
I was a senior at Cal during People's Park. I chose Cal because of the Free Speech Movement. I was involved in the Vietnam Day Committee activities, first as a demonstrator and then as a photographer. I got my first camera in the summer of 1966. Max Scherr saw me on Telegraph Avenue and on the spot offered me a job with the *Barb*. I became the photographer for the Black Panthers in 1967, and Bobby Seale became a mentor. I ran for ASUC [UC Berkeley's student government] and won, but I couldn't stand the meetings and egos. I decided that I would be an artist for the revolution. Through my photography, I got to know many local and national movement leaders. I watched and photographed the building of People's Park. It was not my thing, but I supported it. I especially remember the food cooked in garbage cans.

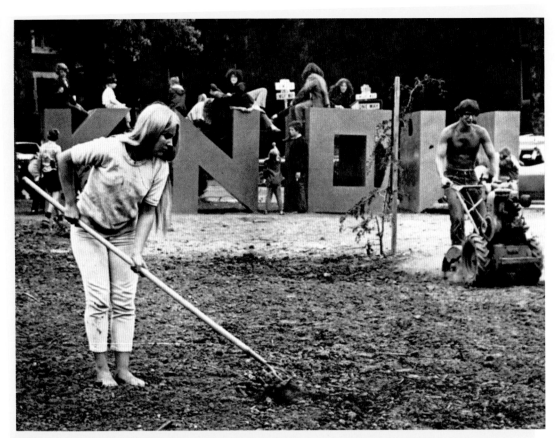

A large expanse in the park being prepared for sod.

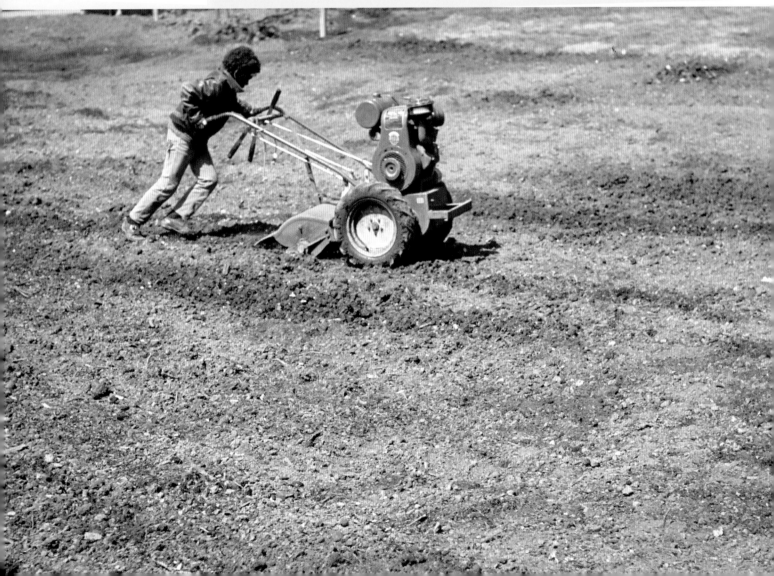

SETH KATZMAN
dropout from San Jose State

I worked on the park some but mostly just enjoyed it. I loved being there. For a very short time it was a paradise, showing our socialist, collectivist ideal.

DHYANI (JENNIFER) BERGER
UC Berkeley graduate student in biology

I walked through every day, joined those who were planting flowers and trees, hung out and chatted, sat on the grass and watched the world go by.

CHARLIE PALMER
UC Berkeley undergraduate student and president of the Associated Students of the University of California (ASUC)

When People's Park started in April, I was exhausted from all of the events of the year and I was limping toward graduation in December. The park was spontaneous. My wife at the time, Mary Louise, was very taken with the park and helped with the planting.

BRIAN O'BRIEN
UC Berkeley graduate student in microbiology

My wife Trudy and I thought that the planting at People's Park was a neat idea, to have a community garden right there in the middle of South Campus near the university. Bob Mishell was a professor of immunology. He studied molecules secreted by microbes that might improve the response of humans or animals to vaccines. He and his wife Barbara were big supporters of building the park and were there all the time. If you were on the third floor of the Life Sciences Building where he had his office, he was sure to enlist you in bringing plants to the park.

STEW ALBERT
Yippie and People's Park cofounder

There were no speeches or long debates. Several hundred Berkeley Free Men showed up for work on the mud swamp between Dwight and Haste in back of Telegraph, and if you stopped working for five seconds, somebody grabbed your shovel and said, "It's my turn." All sorts of straight and freaky people showed up at the park. First the land was bulldozed and then we shoveled the rocks and assorted shit into the barrels. For the first time in my life I enjoyed working. I think

Passing rolls of sod to lay in the park.

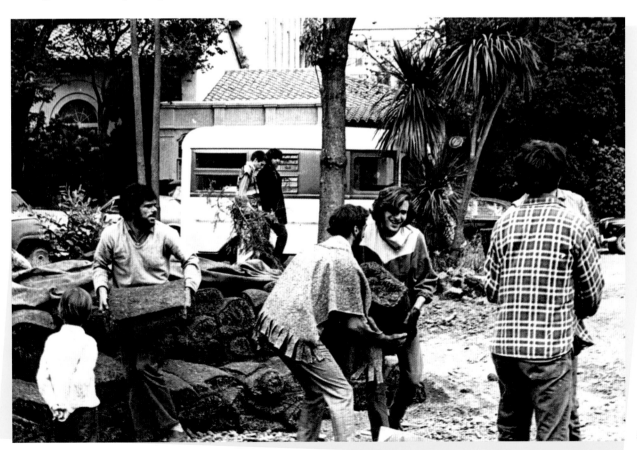

lots of people had that experience. Ever since I was eighteen I hated every job and either quit or was fired. But this was something different[;] with aching back and sweat on my brow, there was no boss. What we were creating was our own desires, so we worked like madmen and loved it. (*Berkeley Barb*, April 25, 1969)

GARY SNYDER
poet
Now it is time for us symbolically to become Indians—people of this land—and take America back from west to east. People's Park is the first piece of liberated territory on America and I hope we keep going and take the whole thing. (Speech at the environmental teach-in at UC Berkeley on May 28, 1969)

JONDAVID BACHRACH
UC Berkeley undergraduate student and ASUC senator
I came to Berkeley in the fall of 1967. I was more of a hippie than a politico. My basic philosophy was that if everybody could just be nice the world would be a better place. I was a senator in ASUC; I think that I was elected in 1968.

I demonstrated in Oakland during Stop the Draft Week. I had never seen so many police and demonstrators in my life. On January 12, 1968, I was arrested in the demonstration against Dean Rusk and the Johnson administration's policy on the war in Vietnam at the Fairmont Hotel in San Francisco. I went to hear Eldridge Cleaver, Bobby Seale, H. Rap Brown, and Stokely Carmichael speak. I supported the Cleaver protests in the fall of 1968 and the Third World [Liberation Front] strike in early 1969—"Ashes to ashes / Dust to dust / We hate to shut it down / But we must must must." In February 1969, during the Third World strike, police lobbed a tear gas canister through the front window of my third-floor apartment. It damaged my guitar, and the smell of tear gas was pervasive for weeks. I couldn't vent or get rid of the smell. I called the police and fire department for advice, but they refused to help.

In 1969, I lived on Regent Street and hung out at People's Park before it was fenced in. The idea was that the park should be for everyone, not just people with money. It had strong symbolic value and was just plain a pleasant place to hang out. My strongest memory of the park is playing frisbee. There were many people attracted to the park who didn't have a political bone in their body.

REVEREND RICHARD YORK
Berkeley Free Church
I declare this place decontaminated from poisons, claims, and lies, from the abomination that defiles. The demons have returned to nothingness, from which they came. Earth, water, air, and fire witness our liberation. (From the consecration of the park, May 11, 1969)

PAUL GLUSMAN
student activist
Come Sunday or any day. We will have free food, bands, possibly movies after dark, wine and dope. (*Good Times,* May 14, 1969)

WENDY SCHLESINGER
feminist, eco-activist, and People's Park cofounder
The park did not have a father or mother or an elite group of leaders; the park "jes' grew" because it was the right idea in response to an obvious wrong that needed to be fixed. Right in the middle of anarchist, polarized, confused Berkeley, people got themselves together instantly, without any director. No one of us, be she or he, big or small, could have unloaded the tens of tons by him- or herself. But together an exhausting task turned into an exhilarating frolic. (From *The Whole World's Watching*)

LES SHIPNUCK
UC Berkeley undergraduate student
It was hard not to get swept into the enthusiasm of making the park. I had never seen anything like it. I worked on the park a little. It was really something.

ROGER HEYNS
chancellor of the University of California
There are fifty people who referred to various disturbances. These people were just as unhappy with the park as Mr. Bardacke and some of the others were happy with it. ("The Big Four State Their Cases," a live broadcast on KPFA radio and KQED television of a meeting between four representatives of factions debating the future of Lot 1875-2, May 26, 1969)

The Reverend Richard York of the Berkeley Free Church consecrating the park, May 11, 1969.

ROBERT TRACY
UC Berkeley professor of English

I walked by the site where People's Park was built every day on my way to campus and so I saw the beginnings of the park. On Sundays, we would take our children to the park to play. People were there working on the park, rolling out sod, planting flowers, laying out paths.

RONALD REAGAN
governor of California

What has not been widely reported is that petitions signed by forty-eight permanent residents in the immediate neighborhood of the property protested the existence of the so-called park and asked for "prompt action" to clear the property so it could be used for the university. (Speech in response to the killing of James Rector, May 23, 1969)

The gathering of unsavory characters had so frightened many of the housewives in the neighborhood that they wouldn't even walk down the street to go shopping. (Speech, June 13, 1969)

BRUNO COON
tenth-grader at Berkeley High School

I was a teenager during the People's Park development and destruction. I spent several weekends building the park because I stayed with a friend a couple of blocks away.

WENDY SCHLESINGER
feminist, eco-activist, and People's Park cofounder

The park was a place where we could work together, where we could do our thing. We didn't have hired labor carrying out orders. They could create instead of sitting around isolated, harassed. (Remarks given before the memorial service for James Rector, May 25, 1969)

ALAN COPELAND
photographer

We used the land. We hadn't tested and analyzed the soil. We planted things and they grew. We hadn't run a feasibility study. We had enough labor, freely given, to build the park. We had no budgets. We found the money and materials we needed in our community. We had no organization, no leader, no committee. The park was built by anyone and everyone, and we, all of us together, worked it out. It was an incredibly good feeling, building that park. In this country of cement and steel cities, better suited for its machines than for its people, we made a place for people. At a time when only experts and committees, qualified and certified, are permitted to do things, we did something ourselves, and did it well. For all of us, hip and straight, the park was something tangible that we had done, something that drew our community together. The park was common ground. (From *People's Park*)

ART ECKSTEIN
UC Berkeley graduate student in history

I started graduate school at Cal in the fall of 1968. I was more of a hippie than a politico, but I had friends who were political. I went to see the making of People's Park a few times. It was a typical hippie thing—messy and disorganized but calm. One thing is that I didn't see a lot of street people there, or anywhere in Berkeley yet, for that matter. My thinking was the land wasn't being used until the people who made the park started working on it, and it was a good purpose. In my thinking of the time, what they were doing was a life trip, which was better than a death trip.

ROGER HEYNS
chancellor of the University of California

There were aspects of it that were beautiful and there were parts of it that were not. ("The Big Four State Their Cases," KPFA radio, May 26, 1969)

FRANK BARDACKE
UC Berkeley graduate student and People's Park cofounder

There were no fights, no assaults. We policed ourselves. We were together. I'd bring my son every morning to play on the slide. I'm proud of the fact that we had Loni Hancock [a longtime

activist who would later be elected to the Berkeley City Council and eventually become mayor] there with us. ("The Big Four State Their Cases," KPFA radio, May 26, 1969)

BOBBY SEALE
chairman and cofounder of the Black Panther Party
We got to have some Panthers down here working[;] this is really socialistic. (*Berkeley Barb*, April 25, 1969)

You mean you just took that land without asking anyone? (Quoted by W. J. Rorabaugh in *American Hippies*)

MICHAEL DELACOUR
boilermaker and People's Park cofounder
David Hilliard and Bobby Seale [both leaders of the Black Panther Party] came to see the park when we were building it. That was the only time that they came. I related well with Hilliard. We were both blue-collar guys.

FRED DUTTON
regent of the University of California
I believe that the planting of the park by the students was a constructive act—because they did it with their own hands and at their own cost and their own initiative, and that should be encouraged.

GRACE DILLEY
People's Park neighbor
With good will, with united effort, merchants, residents, architects, ministers, long hairs, short hairs, young, old, black, white, brown, yellow, hardworking[,] enthusiastic Berkeleyans are together building something they all need. (Letter to the editor, *Berkeley Daily Gazette*, May 16, 1969)

DENISE LEVERTOV
poet and UC Berkeley professor of English
The Park was a little island of peace and hope in a world made filthy and hopeless by war and injustice. (Letter to the editor, *Daily Californian*, May 16, 1969)

PAUL GLUSMAN
student activist
Jon Read was the only person who knew what he was doing building the park.

NIKKI BAUMRIND
thirteen-year-old student at the Anna Head School for Girls
I didn't play there when it was a vacant lot. It was grotesque and unsanitary. But I vividly remember the construction. I was a student at Anna Head when the land was taken by UC. My mom was just upset that her parking was displaced by the upstart park. I was grossed out by the latrines and smells. I remember my sister digging to build the park.

TOM HAYDEN
activist and cofounder of Students for a Democratic Society (SDS)
Stew Albert and Judy Gumbo, two of the most political Yippies, drew me into this creation of "turf." I helped a little with the manual labor, enjoying this refreshing respite from the usual wars with the system. Many political radicals viewed the park as a hippie cop-out from serious revolutionary work, and a lively debate developed over where the lifestyle component fit into one's agenda. (From *Rebel: A Personal History of the 1960s*)

SOL STERN
reporter for Ramparts magazine
I first came to Berkeley in 1961 to work on my doctorate in political science. I was in Berkeley off and on for the next decade. I consider myself to have been a radical journalist, not a radical activist. In 1962, Robert Scheer, David Horowitz,

Top right: Bobby Seale, chairman of the Black Panther Party, visits the park. On the far left is Yippie activist Stew Albert. Max Scherr (balding with a beard), publisher of the *Berkeley Barb*, is in the center of the photo above Seale's head. Tony Ryan, a Bay Area activist and employee at Moe's Books, is on the far right.

Bottom: Park volunteers use a lawn roller to remove air pockets and ensure that the roots of the sod are in contact with the soil beneath.

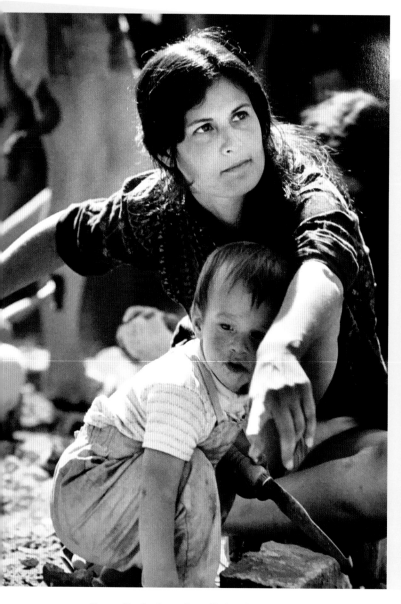

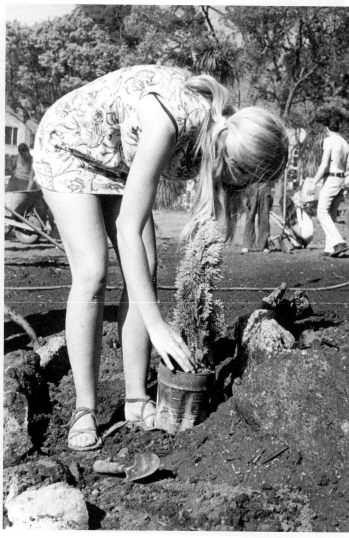

Nancy Bardacke and son Ted in the park.

❝I remember that it was warm and that the boys and girls were beautiful. It was so Berkeley.❞

Maurice Zeitlin, Phil Roos, and I founded *Root and Branch: A Radical Quarterly.* It lasted two or three issues. In the later 1960s, Bob Scheer, who had been recruited by [journalist] Warren Hinckle, recruited me to work on *Ramparts,* a glossy, illustrated political and literary magazine of the New Left. After I left *Ramparts* I freelanced. I missed the Telegraph Avenue battles in the summer of 1968 because I was living in San Francisco and was covering the McCarthy campaign, the assassination of Senator Robert Kennedy, and the Democratic Convention in Chicago. I also missed the Third World Liberation strike in early 1969 because I was living [elsewhere].

Of all the founders of People's Park, I knew Frank Bardacke and Mike Delacour the best. Bardacke and I had been friends since he got to Berkeley, and we lived together for a while at the Fisherman's Commune. Delacour and

I spent time together. I admired his hard work in the park, leading by example. He did a lot of good work there. I hung out at the park a few times. I liked rock and roll and went to concerts at the Fillmore but was not attracted to the hippie culture. I was very skeptical of the claims by some that rock alone could produce revolutionary change. I had fun at the park, and even did a little work a few times. I remember that it was warm and that the boys and girls were beautiful. It was so Berkeley. I loved Berkeley. I don't remember attending a single meeting about strategy, if there were any. I was called the "Zelig of the New Left" because I was at so many important New Left events. So it was with People's Park, but of all my sixties involvements, it had the least impact on me.

I wasn't all that impressed with my friend F. J. Bardacke's poster [featuring Apache leader Geronimo and text that asked, "Who owns the park?"]. I found the poster to be very romantic, the notion that we can be saved by the land and by imbibing the spirit of our Indian forefathers. I am not a romantic.

Text of Frank Bardacke's "Who Owns the Park?"

Someday a petty official will appear with a piece of paper, called a land title, which states that the University of California owns the land of the People's Park. Where did that piece of paper come from? What is it worth?

A long time ago the Costanoan Indians lived in the area now called Berkeley. They had no concept of land ownership. They believed that the land was under the care and guardianship of the people who used it and lived on it.

Catholic missionaries took the land away from the Indians. No agreements were made. No papers were signed. They ripped it off in the name of God. The Mexican Government took the land away from the Church.

The Mexican Government had guns and an army. God's word was not as strong.

The Mexican Government wanted to pretend that it was not the army that guaranteed them the land. They drew up some papers which said they legally owned it. No Indians signed those papers.

The Americans were not fooled by the papers. They had a stronger army than the Mexicans. They beat them in a war and took the land. Then they wrote some papers of their own and forced the Mexicans to sign them.

The American Government sold the land to some white settlers. The Government gave the settlers a piece of paper called a land title in exchange for some money. All this time there were still some Indians around who claimed the land. The American army killed most of them.

The piece of paper saying who owned the land was passed around among rich white men. Sometimes the white men were interested in taking care of the land. Usually they were just interested in making money. Finally some very rich men, who run the University of California, bought the land. Immediately these men destroyed the houses that had been built on the land. The land went the way of so much other land in America—it became a parking lot.

We are building a park on the land. We will take care of it and guard it, in the spirit of the Costanoan Indians. When the University comes with its land title we will tell them: "Your land title is covered with blood. We won't touch it. Your people ripped off the land from the Indians a long time ago. If you want it back now, you will have to fight for it again."

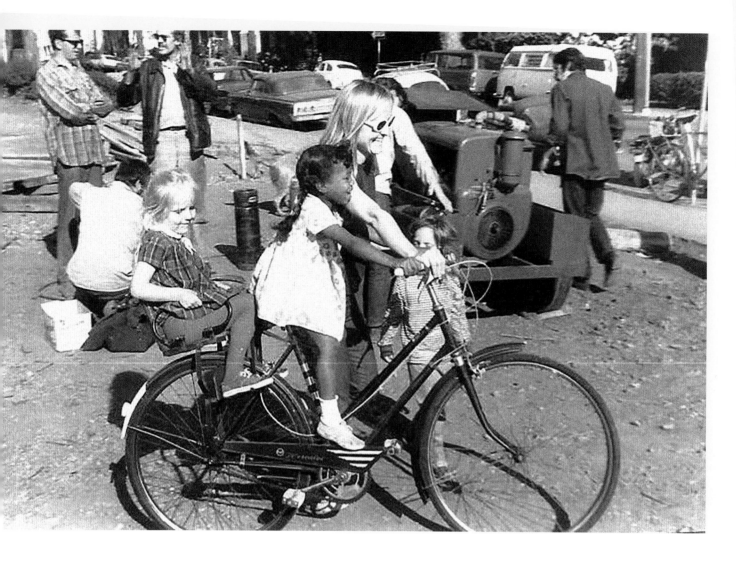

DAN SIEGEL
UC Berkeley law student and incoming president of ASUC

I lived only a few blocks from People's Park, on Bowditch between Durant and Channing. Guy Saperstein [a fellow law student] lived next door, and Bob Avakian organized the Revolutionary Communist Party between the two houses. I walked through People's Park a couple times. It was lovely, but I was by no means a hippie and it was a very hippie scene. My goal in life was to bring the war in Vietnam to an end, and I saw People's Park as something of a sideshow.

JIM CHANIN
UC Berkeley undergraduate student

I had been in Berkeley since the end of the summer of 1967. I took part in the first wave of Stop the Draft Week in October. I sat down at the Induction Center with the intention of getting arrested. When I saw the Oakland Police beating people sitting with me, I wondered, "Can the police really do this?" I also decided that I wasn't interested in being beaten, so I ran. I supported the Sproul Hall and Moses Hall sit-ins in the fall of 1968 and was very involved in the Third World Liberation Front strike in the spring of 1969. I wasn't involved in the work that built People's Park, but I visited it a few times. I was still angry that the university had evicted me from my house on Dwight Way in December. The park was lovely.

RON YANK
UC Berkeley professor of rhetoric and a leader of Students for a Democratic Society (SDS)

I had no contact with the building of People's Park. Of the group of leaders of the park construction, the only one I knew was Paul Glusman. In the SDS, we jokingly said that we did not believe in socialism in one park [a riff on the Stalinist "Socialism in One Country" theory adopted by the Soviet Union]. Many in SDS thought that the park was ridiculous. We did not believe in cultural revolution and saw the park as cultural.

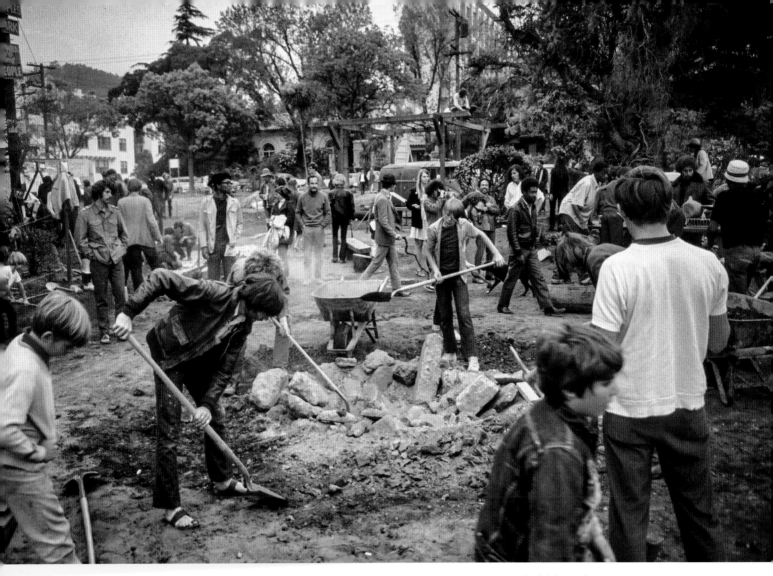

A weekend crowd working to build the park.

FRANK BARDACKE

UC Berkeley graduate student and People's Park cofounder

We planted grass here—people's grass, not ruling-class grass. By the second or third weekend, old people, young people, straight people, hippies, blacks, revolutionaries, every conceivable kind of American from this area came to work in the park. You can't really describe it to anybody who didn't see it. (From the 1969 Newsreel documentary *People's Park*)

JEFF CRUMP

tenth-grader at McKinley High School

One reason People's Park quickly became a gathering place was due to the increasingly tense atmosphere on Telegraph. Drug dealers, burned-out junkies, and speed freaks populated the street in growing numbers. Many of the original people that hung out on the street had left. What was obvious was that the Telegraph street scene was over. What had begun as the Summer of Love had turned into a violent and ugly scene.

LAUREN COODLEY

UC Berkeley undergraduate student

We were establishing open spaces. I didn't work building the park, although in the summer I did work at the Annex [a second park built by People's Park supporters] at Hearst and Grove [now Martin Luther King Jr. Way]. I got to know Michael Delacour and his ex-wife Leslie and his girlfriend Wendy Schlesinger, [but] especially Leslie. She had a great sense of humor and sense of irony. Wendy was intimidatingly beautiful. In the counterculture, as in high school, beautiful women had more power and credibility.

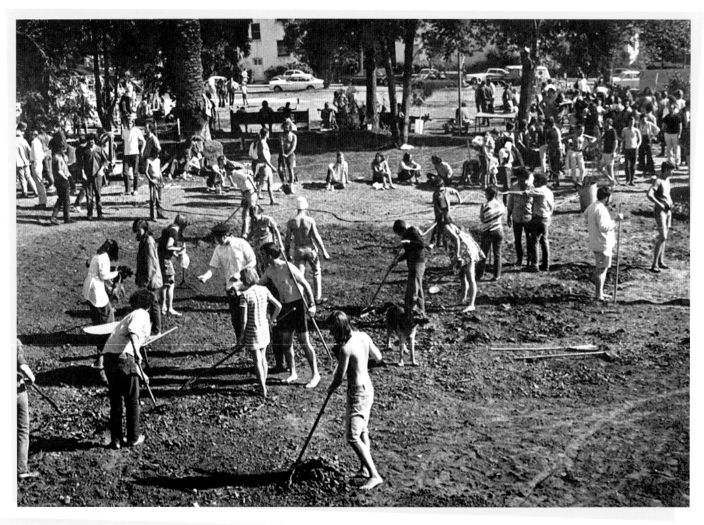

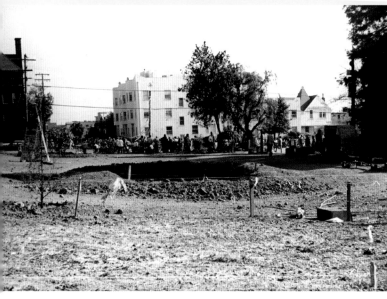

Preliminary excavation for a fishpond that was never built. The idea was voted down and an amphitheater was built instead. In the background of the bottom left photo, volunteers are meeting to discuss the next day's work.

The poetry-reading platform built by recent graduate student Glenn Angell. After the park was seized and fenced off by the university, Berkeley police officers returned the lumber used for the platform to Angell.

DAVE SEABURY
eleventh-grader at Berkeley High School

I was a student in the Community High School at Berkeley High. It was experimental, and all of Berkeley was our classroom. My friends and I were observers of many of the Berkeley riots. I didn't participate, I just observed.

I think that I may have helped roll out sod. It was a pretty cool scene. They had taken a piece-of-shit mud pit and turned it into something pretty great. It seemed like it appeared very fast, almost overnight. I didn't hang out there that much; it was just one of many things going on in my life.

DAVE MINKUS
UC Berkeley graduate student in sociology

I arrived in Berkeley in 1961. My father was a teacher who was fired after taking the Fifth in front of HUAC. I was a radical, had friends in the International Socialists, but was never affiliated with any sectarian group. I was arrested in Sproul Hall during the Free Speech Movement, [and] took part in Vietnam Day Committee activities and the Moses Hall sit-in during the Cleaver controversy.

The park was very liberating. I saw it as a metaphor of a time of magic, reflecting the optimism and appreciation of doing something concrete and doable in the midst of the dragging on of the war. It was leaderless.

The sod was amazing; it transformed the northeast corner into lush grass under mature trees. There was good spirit in those weeks of park building. People gave a variety of things in support of the park makers. Tools and plants appeared to further the activity, and there was an active collection of money to pay for the turf. I helped make the stew twice in garbage cans. The process was simple: "We need food. Let's make stew." People brought vegetables and we made soup. It reminded me of "Stone Soup," the old folk story in which hungry strangers convince the people of a town to each share a small amount of their food in order to make a meal that everyone enjoys. The park was a living example of the value of sharing.

LONI HANCOCK
activist and candidate for Berkeley City Council

I think this park is the greatest thing going in Berkeley. (*Berkeley Daily Gazette,* May 16, 1969)

LOUIS J. DE DEAUX
student at Merritt Junior College

On Valentine's Day 1969, I rotated home after 411 grueling days in Vietnam. I'd graduated from St. Mary's College High School in 1965, and upon completion of an extended tour of duty as a combat engineer, I returned to fulfill my dream of attending Cal-Berkeley. Also to find Pam Stone, the gal who'd Dear John'ed my sorry butt during boot camp. My grades weren't good enough, and first I had to successfully navigate the UC transfer program at Merritt Junior College, obtaining my AA in June 1970. That is where I met firebrand activists Angela Davis, Huey and Melvin Newton, and Felipe Luciano, who one fine day in the spring of '69 recruited me to join the movement for People's Park. So off I went, full of piss and vinegar, brown beret and all. As the saying also went back then, "The joint was jumping and the mamas were pumping." I remember the veggie garden, acrid scent of Michoacán ragweed, and good vibes galore. Never to forget: the topless coeds doing the cool jerk to a rock band atop a flatbed.

GLEN ANGELL
recent UC Berkeley graduate student

By April 1969 I was spending a lot of time at the Med with Liane Chu and her radical friends. I went to work on building the park that first day and many days after that. I took the money that I had earned working on a professor's boat and bought the supplies I'd need to build a poetry-reading platform. I sketched it out and built it with my brother Steven and a few friends. One of the really wonderful things about the park was that people just poured out of the neighborhood to help. There was an older Russian man who lived nearby. He was very enthusiastic and helped us with the poetry-reading platform. People debated projects. One day, people started to excavate for a fishpond. I stood in the bottom of the pit and told people that a water feature was not a good idea because it would be messy and a danger for children. They agreed with me and the fishpond was never consummated. I remember sitting across Bowditch outside the very beautiful Maybeck Christian Science church and watching the park come together, slowing down and taking in how very special the whole thing was and thinking that it would not last forever.

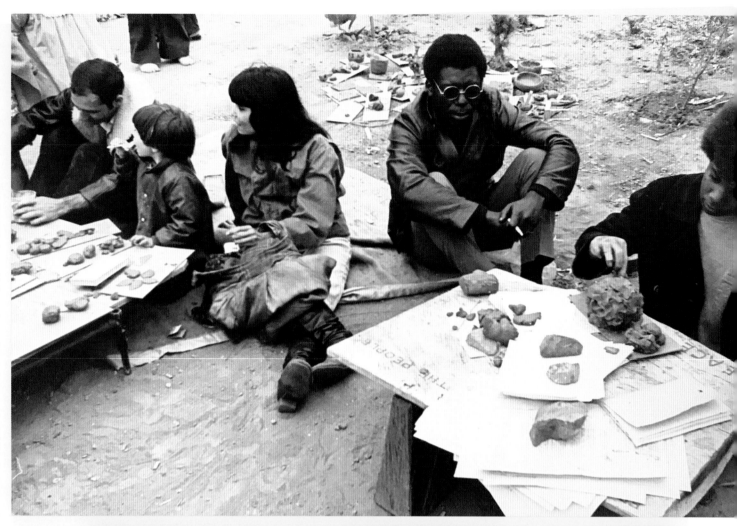

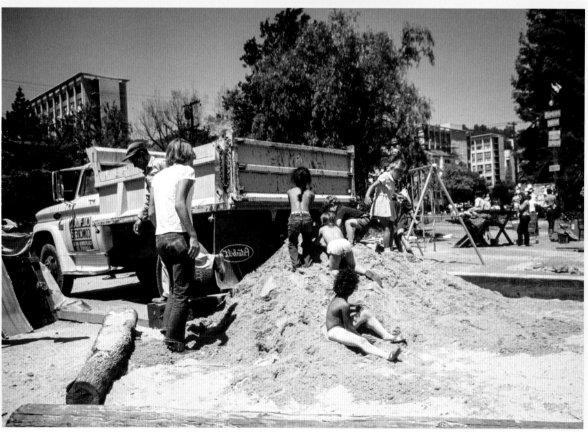

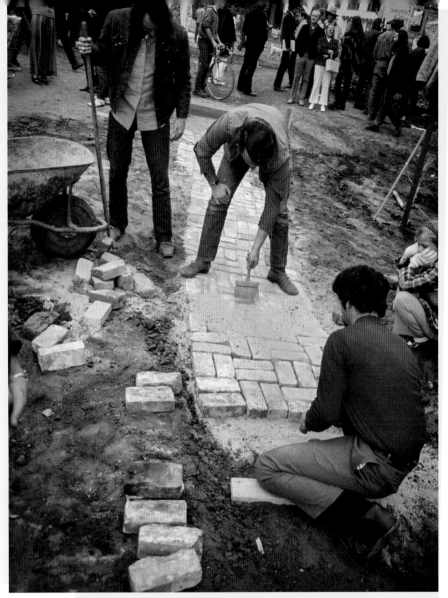

"They had taken a piece-of-shit mud pit and turned it into something pretty great."

Near left: Laying a path early in the building of the park.

Far left, top: Families working on clay art projects in the park.

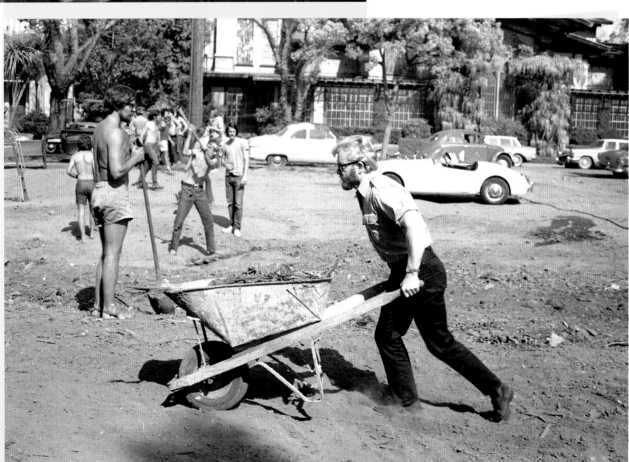

GEORGE CSICSERY
UC Berkeley undergraduate student

My family arrived in the United States in 1951, refugees from communist Hungary. I attended a Hungarian boarding school outside Buffalo, New York, and then came to Berkeley as a sheltered seventeen-year-old. I rejected the Left's embrace of Fidel Castro, the Viet Cong, and North Vietnam, but I was against the war. I considered myself an anarchist. I was involved in Stop the Draft Week, where it appears that the police stole my Zeiss camera. I liked the street anarchist poems of Berkeley and befriended the Telegraph Avenue characters. I identified with the street. I knew Mike Delacour and Super Joel and so heard about the park right away. I spent a lot of time at the park. I had loved the idealism of the Summer of Love in San Francisco, especially the Diggers, and found the same spirit at People's Park. There was limitless idealism at the park, and the opportunity for limitless sex. I planted a few trees and did a little work, but mostly picked up girls.

PETER HABERFELD
attorney with the National Lawyers Guild

I was really attracted to the making of the park. I didn't understand why there was such a scene over the park. The reaction of the State was just amazing.

PAUL VON BLUM
attorney and a UC Berkeley lecturer in rhetoric

I was not opposed to People's Park, but I didn't support it either. I was not attracted to the hippie movement. We had a war to fight, and a park where you could sit down and groove was not what I really cared about. Paul Krassner and Abbie Hoffman [cofounders of the Yippies] were always trying to bridge the divide between hippies and radicals.

RICK FEINBERG
UC Berkeley undergraduate student

I saw the building of the park but didn't participate. I don't remember a lot of conversation, if any, in the Young Socialist Alliance about the park. Personally, I was fascinated seeing the process, even though I didn't anticipate that it would change society. Still, it was neat to see the way people worked together to build a collective environment based on empathy.

ANDREW PHELPS

I was a regular at the Med. A few days before April 20, Michael Delacour brought a flyer and explained to us his plan for the coming Sunday. The text of the flyer was:

> On Sunday, April 20, at 1:00 p.m. the southeast part of the lot east of the 2400 block of Telegraph (between Haste and Dwight) will be made into a People's Park and Meeting Place. This torn-up desolate area will be made green and alive again; ground will be smoothed, grass planted, benches put in, and sculptures erected.
>
> Help make this happen. Bring yourselves, your shovels, your hoes, rakes, hoses, grass, ideas, instruments, anything. Everyone in the community has something to offer; what we need is a place to get together and give to each other. Only a place we make together can serve our own interests.

I helped build the park in a minor way. They roasted a pig and I had a piece. The pig was in honor of the Black Panther Party and Huey P. Newton, where Michael saw collaboration in a political sense.

JON READ

architect and People's Park cofounder

The sod was magic—it was all good fun. The police were witnessing something they never thought possible—freaks doing work and liking it. The mood was so lighthearted, thanks somewhat to that old favorite, Red Mountain Wine, that I got a full load of debris with the loader and held it over the police car. [Delacour's idea of the park] made sense on a number of levels. Not the least of which, according to Mike, was that it could serve as a common ground where radicals could cavort with the nearby sorority honeys. Mike wanted a ball field in one corner, but they never got around to making the bases. Some people didn't want to water the sod. They used to plunk it down and create a bog, or miss areas and not notice it until it had wilted. Coping with the hard reality was beyond the discipline of many, especially Art Goldberg [activist and Free Speech Movement leader], who constantly made a botch of it. Novel handshakes and saying "groovy" and "right on" is all very nice, but making a real change is hard work. (Quoted by Joseph Lyford in *The Berkeley Archipelago*)

JOHN SIMON
poet

It is difficult to go back to the spirit of those days, when at first even the police were reasonably friendly. ("The Big Four State Their Cases," KPFA radio, May 26, 1969)

Like who knows how many thousand others, I got involved in the battle of People's Park when somebody handed me a shovel and said, over there, we're breaking it up so we can lay sod down. Packed by weight of years of houses and months of cars, the hard earth barely yielded to any tool, had an oily blue sheen in the sunlight where it was cut. This was Sunday, April 20, behind Telegraph Avenue in Berkeley. I worked steadily for 20 minutes, then wandered through the diligent crowd. Now I see how the Chinese build dams. No idle tools, and some dude in a cowboy hat was grading the bumps and hollows on a rented bulldozer. Wine bottles passed, lemonade, and joints from hand to hand. By dusk a rock band was playing and several hundred

square yards of park had been laid down under old trees. In the next three weeks I came back time after time, bringing trees, poems and most of the children on my block. (From "People's Park: Just the Beginning," in *Liberation* magazine, July 1969)

MICHAEL LERNER
UC Berkeley graduate student in philosophy and chapter president of Students for a Democratic Society (SDS)

I was actively involved in the building of People's Park. It had been a ridiculous eyesore before work on the park began. The park became a manifestation of the human spirit. It showed the power of imagination and liberation, of collective action.

JOHN BISHOP
novelist and photographer

For me it was not a big deal. I went a few times, took a few pictures, but it was an enterprise that attracted mimes, and besides, I was writing my novel. (From johnbishopexperience.com)

RANDY KEHLER
staff member of the War Resisters League

I come from a background of passive, non-violent resistance. I was working on a master's degree at Stanford in 1967 when Roy Kepler, Joan Baez, and Ira Sandperl invited me to witness nonviolence in action at the Stop the Draft Week demonstration at the Oakland Induction Center on October 16, 1967. I was so inspired by what I saw that I stepped in and was also arrested. After that, and perhaps because of that, I was offered a job with the War Resisters League in San Francisco. As part of that job, I was given housing in the Berkeley hills. In May 1969, Mandy Carter and I and others at the War Resisters League set up a table at People's Park. I built a brick oven for baking bread, and we took that to the park. We handed out literature about war and peace. We left the table and oven and literature there overnight. When the university occupied the park, our table and literature and the oven were confiscated and never returned.

JANE SCHERR
partner of Max Scherr, publisher and editor of the Berkeley Barb

At the time of People's Park, I was living on Oregon Street. The offices of the *Berkeley Barb* had moved to University Avenue, but Max and I still did some *Barb* work out of Oregon Street. My children, Dove and Apollinaire, were eight and five at the time of the People's Park kerfuffle. From the start of the park, they were drawn to it. I would send them to play there as long as they wanted. They walked to the park and spent

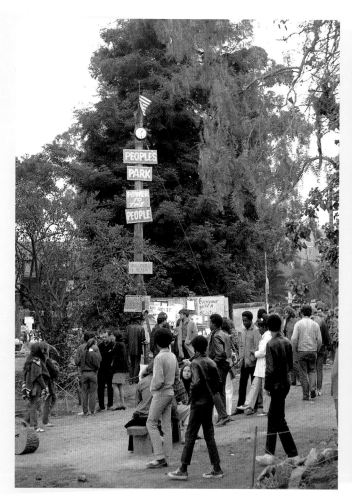

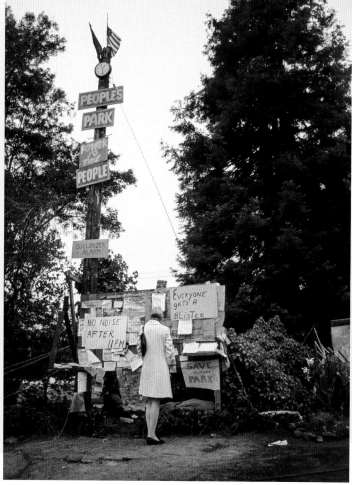

The signs painted by Howard Dratch and the bulletin board made by Curtis Rosa. To the left of the pole, from left to right, are Berkeley High School's student body president, Steve Wasserman, with his sister Sherry, his father Al, and his mother Ann.

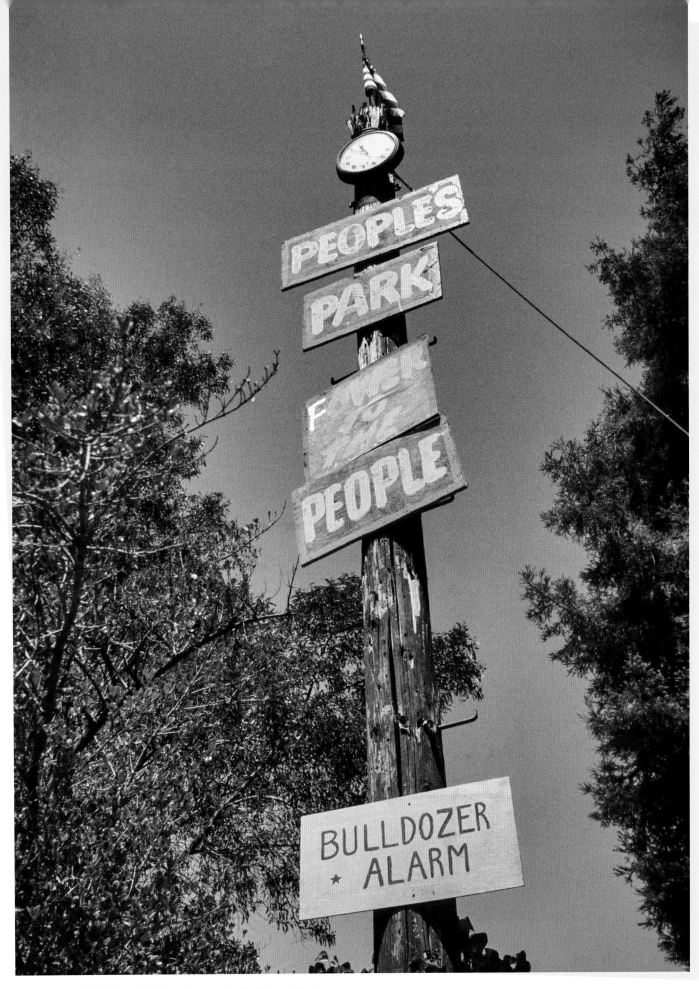

The original People's Park sign, painted by Howard Dratch.

Musicians with a hammer dulcimer and flute. The woman on the lower left of the photo used the street name "Frankie." She and Apollinaire Scherr, the five-year-old daughter of Jane and Max Scherr, formed a special bond during the three weeks that the park existed.

happy times there. It was safe, healthy, mellow, communitarian, and caring. Dove was in third grade and stopped going to school altogether as long as the park was still there. I think that there was more to be learned at the park than in school.

DOVE SHOLOM SCHERR
third-grader at Emerson Elementary School and daughter of Max Scherr, publisher and editor of the Berkeley Barb

I went to the park almost every day from when it was started until it was fenced off. I didn't go to school at all that spring. There were all kinds of theories going around about education, like Summerhill [a school founded on the principle of student-led learning], theories that held that experience was the best way to learn. I felt so free. I remember saying to myself, "I'm free! No fence around me! I can go and play!" I planted strawberries at the park and made a little bamboo fence around the plants. I would check on my plants every day. One day, I saw sprouts coming out of the bamboo shoots. My fence was growing! I remember the rolls of sod and how they smelled as they were laid. To this day, the smell of rolls of sod takes me right back to People's Park. The feeling was of joy and freedom. It was an expression of happiness, a fun place to play. My little sister Apollinaire would come with me. There was a woman named Frankie, and my sister was very close to her. She followed her around and Frankie responded. I made a drawing of the park before and after the university fenced it in. Before, people were holding hands and dancing; it was colorful. After, there was a National Guardsman with a crew cut and a pig with a gun, handcuffs, and a baton.

GOOD TIMES
Telegraph Avenue edition

Good weather, Saturday and Sunday afternoon in the empty lot behind the Avenue (between Dwight and Haste)—bring things to plant, share. Sunday afternoon Joy of Cooking [a local band] will play, free park dedicated to Vietnam dead, no permit needed. (April 18, 1969)

GOOD TIMES
Telegraph Avenue edition

BULLDOZER RUMOR Tues. morning helped us organize. If you want to be contacted super fast if/when they try to rip off the park, leave your phone number with the TALF [Telegraph Avenue Liberation Front] people at their store in the alley back of the Forum. Also the park can use whatever makes lots of noise or light, e.g. foghorn, bell, flares, in case of emergency. ALSO NEEDED: STEEL of any description, scrap ok, to be welded into many things[:] kids toys, watts tower, etc. TOOLS are badly needed, especially short on PICKS, shovels, wheelbarrows, need a tree pruner and power tools. The 10-year-olds can dig power to the people, they want a jungle gym, slides, crawlies, more swings, sand[,] etc. LUMBER is cool and can be ripped off. (April 30, 1969)

GOOD TIMES
Telegraph Avenue edition

DOZERS were actually coming in last week, says inside chancellor's aide. The land doesn't belong to UC. It doesn't belong to us, either. But we care for it, it is in our care, because we love it and relive with it. We can defend the land with great power because we care for it. Last Sunday some people physically hassled the cat cooking[;] they demanded soup now instead of stew in an hour. Our brothers and sisters are not waiters and janitors in a capitalist society. (May 14, 1969)

LIANE CHU
co-owner of the Red Square dress shop and a People's Park cofounder

The first day was one of the great days of my life. There weren't enough tools, so people waited their turn. There were no bosses. Like Stew Albert said, nobody supervises and the trip belongs to whoever dreams. There was no plan. You did what you were inspired to do.

JANE JACOBS
author and activist

When you built and used and defended your People's Park, you touched a terribly sensitive nerve because, at one stroke, you sliced away the liberal pretensions of fascist planning. For the past quarter-century, the universities, cities, and other institutions of the Establishment have cynically but successfully used parks as their excuse for land grabs and for ruthlessly uprooting helpless people. In the name of parks, lazy liberals were easily conned into complicity with these crimes. In the name of parks, bulldozers

were used like tanks, and with impunity, against the civilian population. Now the fraud is laid bare. The Establishment kills its youth when they dare create an honest park by the people and for the people. What you did was direct and beautiful and very brave. You affirmed that parks are for people and much more: that the world is for people. I love you. Be brave but do be careful too. Against armor and sadism your weapon must be ingenuity. Bless you. (Message to the UC Berkeley ecology teach-in, May 29, 1969)

PAUL GOODMAN
social critic
The grim sarcasm is that the little park, in both its idea and its method, would be regarded in many schools and perhaps in Berkeley itself as a textbook gem of urban landscape architecture. (*Instant News Service*, May 29, 1969)

WAYNE COLLINS
UC Berkeley graduate and casual stevedore worker
I heard about the park from Michael Delacour, and I helped him distribute leaflets about building the park. I worked on the demolition part of building the park—busting up old foundations

and abandoned trash. I have a vivid memory of Jon Read on a bulldozer, helping clear all the debris from the field.

JENTRI ANDERS
UC Berkeley graduate student in anthropology
It was when I read Bardacke's leaflet that I began to get interested in the People's Park issue. (From *Berkeley Backlog*)

LEIGH STEINBERG
UC Berkeley undergraduate student
A combination of students and street people had begun erecting a gorgeous new park with trees, flowers, and shrubs on vacant land belonging to the university. We felt the park now belonged to us—hence, the "People's Park." That's exactly what we did—or at least tried to do. (From *The Agent*)

JACAEBER KASTOR
eighth-grader at Willard Junior High School
When the park was being built, it was one of the more interesting things going on. I was there pretty much all the time. The cool kids whom I admired were there. It was a pretty young and

A group collaborating on making soup or stew in a trash can.

Volunteers making soup or stew in galvanized trash cans. In the Bob Dylan shirt is Berkeley High School student Stacey Gleason, daughter of Ralph Gleason, *San Francisco Chronicle* music critic and a founder of *Rolling Stone* magazine.

longhair scene that didn't attract my mother and her friends. It was pretty effing funky. There were little areas with different things—benches and play equipment and flowers and a fire pit and cooking food. It was definitely a place where a lot of people were getting a buzz. There was no schedule, no regulations, just kind of helter-skelter. There were some deep thinkers there, and some ignorant out-of-towners, too, who just wanted to score and ball. It was a little edgier after dark, a wild zone. I didn't get a Kumbaya vibe at night, more in-your-face. It was a safety valve for the campus and Telegraph. There was a juvenile delinquent edge to it.

ART GOLDBERG
UC Berkeley graduate and Free Speech Movement leader
I was back in Berkeley after taking and passing the bar in Los Angeles. The State Bar Examining Committee had blocked my admission to the bar on the ground of moral turpitude because

of my arrests in campus and civil rights demonstrations. I was very active in the Free Speech Movement as an undergraduate, but never joined any organization, even SDS. We were snobs and thought that SDS was an outsider group, that we were "better" than SDS. I was at the park all the time when it was being built. Michael Delacour talked with me about the idea very early and I supported it from the start. It was the height of the meeting of hippie love and political activity. There was a big pot of soup every day, made communally. It couldn't have been better, a hippie utopia. The bigger it got, the more outside right-wing pressure there was to stop it. They couldn't let our utopia succeed.

REESE ERLICH
suspended UC Berkeley undergraduate student and a reporter for Ramparts _magazine_
I was there the first day that people started building the park, rolling out the sod. I was there frequently until the fence went up. To some degree, almost all of the young people on the Left were influenced by the counterculture—the dope, sex, and music. Still, I didn't identify as

A PROCLAMATION

When the sane people don't do it, when all the good middle class people don't do it, then the madmen have to do it, and the madmen say that we're going to have freedom of we're going to have chaos; we're going to be part of the total destruction of America or we're going to be part of the liberation of America.

--Eldridge Cleaver

A NEW BERKELEY is being planted in People's Park. Creating the Park has been the most spontaneous and positive event in the emerging showdown between the Industrial-University Machine and our Revolutionary Culture. We have struggled for Rights, for Space, and now we struggle for Land. We need the Park to Live and grow, and eventually we need all of Berkeley.

The Machine cannot "contain" us because we're stealing everybody's children. They cannot suck us dry and wear us out because we nourish ourselves by working together everyday. They cannot stand having us on the Avenue, near the University, they cannot stand our Life resisting their Expansion of Commerce. They want us to give up trying to live, they want us out of town, they want us dead. If they can get away with it, they will seize the land, arrest us by the hundreds, use gas on the Avenue like it was DDT.

We become stronger everyday. Our continued planting in the park, backed by a united front of community support, might win for us. But if this strategy fails, we are not left only with the romantic finale of "going down with the park". We can let them know the consequences before they send the bulldozers.

WE TAKE A SOLEMN OATH to wage a war of retaliation against the University if it begins to move against the Park. We are prepared to defend ourselves and the Park if other methods fail. If the University attempts to reclaim $1.3 million dollars worth of land now claimed by the people, we will destroy $5 million dollars worth of University property. We will not strike until the University proves by concrete deeds--such as the sending of surveyors of posting trespass notices--that it intends to take back our Park. But we will strike before they rip off the Park with their goddamn bulldozers.

If we fight the same way we work--together in teams, with determination we will win. Get together with the people you've worked with, and take an oath like ours. Figure out how to save the Park and save yourselves: from cameras, clubs, gas and anything they throw at us.

NO SURVEYORS

NO FENCES AGAINST THE PEOPLE

NO BULLDOZERS

BE MASTERS OF SILENCE, MASTERS OF THE NIGHT

WITH SHOVELS AND GUNS

POWER TO THE PEOPLE AND THEIR PARK

BY MADMEN

THAT PATCH OF GROUND... CALLED PEOPLE'S PARK

a hippie, more as a political activist. There was definitely an anarchist, back-to-the-land tinge to People's Park. Nobody knew where it was going to go. There was no active support of the park by the orthodox Left because it didn't pit workers against bosses or the masses against warmongers. We were angry at the university for having forced people out of the houses because they wanted to build dorms and then didn't. The university had left the land empty for a year.

CAROL GORDON
UC Berkeley undergraduate student
In the spring of 1969, on a beautiful, sunny Sunday, in the late morning or early afternoon, I was walking down Hillegass on my way to campus. As I approached Dwight Way, I came across something unexpected and wonderful. I saw people of all ages working together to transform that deserted piece of land into a "People's Park." I was delighted. They were bringing life back to that piece of earth and making it a living entity again. My heart was filled with joy, and my face wore a huge smile. What a beautiful

Far left: A proclamation by a group calling itself "Madmen" threatens to avenge the taking of the park by the university. The statement was distributed via leaflet (shown) and also appeared in the *Berkeley Barb*.

Left: A collection of drawings and poems celebrating building the park.

Below, top: Some members of the counterculture in Berkeley began using "brother" and "sister" as forms of address in 1968.

Below, bottom: A rough-drawn map of the park in early May.

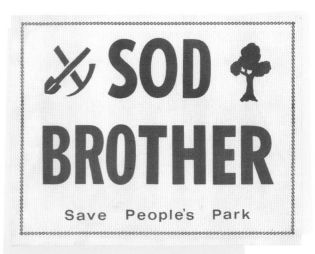

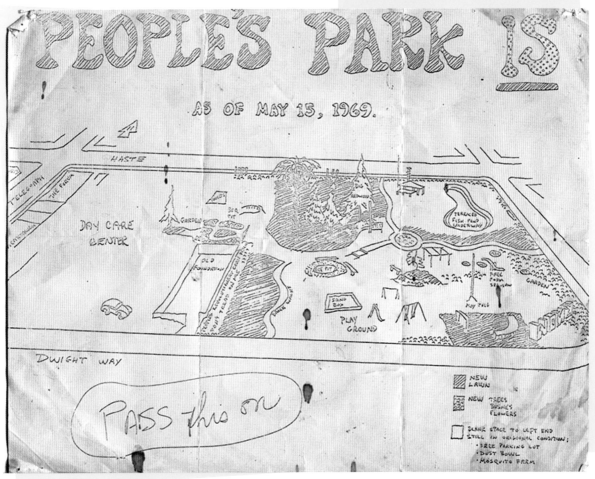

homage to those beautiful homes that once lived on that land. On that Sunday and the days that followed, I walked through the park, taking it all in. I watched as rolls of sod were being laid down, a garden being created, a big pot of food being cooked over a fire for a community feed, a child's swing set and a "People's Park" sign being erected, and a community bulletin board for announcements being put up. It was energizing, and I felt optimistic and hopeful as I saw young and old in our community work together cooperatively to create something positive and beautiful. Although I did not lend a hand I was delighted that it was happening, and certainly felt supportive of their People's Park creation and happy that I lived so close to it.

HOWARD DRATCH
UC Berkeley graduate student in political theory

I was at the park the first Sunday and took part in the unloading of the sod. When we had it put down, we all stood back and said, "Wow, we just created a lawn. Amazing!" It was a "Eureka!" moment. I was at the park a few days after work started with a small group of people. Somebody said, "Let's make a sign." Another said, "What should it say?" Somebody suggested, "It should be about power to the people," and right away somebody else said, "It should say that this is People's Park." I went home to my apartment on Fulton and used the bright yellow and orange paint that I had used for my hippie kitchen to make the People's Park sign. It was spontaneous and propitious. The park was a bright light, something positive within a sea of destruction. We had been protesting the war for four years in Berkeley and just wanted something that was good and hope-inspiring.

DAVID MCCULLOUGH
former UC Berkeley graduate student

I was a dropout from the doctoral program in philosophy, doing political work and writing movie reviews for the *San Francisco Express Times*. I was maybe still an officer of Local 1570, the teaching assistants' union, because I think we had a strike in 1969. In October that year I went to work full-time at Western Electric in Oakland to do rank-and-file organizing. Michael Delacour told me about his idea for creating what was later called People's Park. I knew something about the successful shutdown of Telegraph Avenue on April 9, 1967, which also relied on many people doing things with no direction from above. I told Mike, "Forget it. It will never work." That shows what I know. Never underestimate the power of the people.

When we came to the park we were pleased to see elderly women planting flowers, children romping, wooden play structures and art objects being erected, and a communal kitchen in progress. The kitchen, like all the outdoor communal kitchens I experienced that were created in public places in those days, was a token of what would be a good life but totally inadequate to be a real part of one. I did not hear of anyone becoming sick, thankfully.

> **"The park was a bright light, something positive within a sea of destruction. We had been protesting the war for four years in Berkeley and just wanted something that was good and hope-inspiring."**

Sim Van der Ryn
UC Berkeley professor of architecture

Sim Van der Ryn—architect, author, and educator—has been integrating ecological principles into the built environment for more than forty years. He spent thirty-five years as professor of architecture at UC Berkeley and was an enthusiastic supporter of People's Park. At times, Chancellor Roger Heyns looked to Van der Ryn as a liaison with park supporters, and several times he tried to broker a compromise through Van der Ryn. Collected here is some of what Van der Ryn had to say about People's Park.

> I was amazed to see what for nine months had been a dusty, rutted parking lot now transform, with sod and flowers, into a pleasant place to be. (From "Building a People's Park," in *Design for Life*)

> I think People's Park is a great idea. The university just seems to be mad they didn't think of it first.
> Each day ended with another open design session where decisions and revisions were made for the following day. There was no formal plan or organization. This was the grand experiment. (From "People's Park: An Experiment in Collaborative Design," in *Design for Life*)

> This was really participatory design in action. The people created an organizational structure that was far more effective and efficient than the cumbersome machinery of the university and the other public agencies. In building the park, no one gave orders. For example, an oval that had started to be a fishpond then became an amphitheater after several on-site debates about the hazards of children falling into ponds and the difficulty of keeping the water fresh.

> Our position from the beginning has been that the People's Park represented an interesting and important phenomenon that called for a creative response by the university. (Interview with Jeffrey Inaba, *Volume* 24, "Counterculture," March 22, 2011)

In September 1968, Van der Ryn and political economist Robert Reich published *Notes on Institution Building*. The following excerpts illustrate his thoughts on the idea of a radical planner, a concept that came to fruition with People's Park:

> "Modern living" sections of media feature the audacious dreams of a futurist society, but the most important ad hoc solutions are seldom examined seriously. What physical, environmental forms can truly assure innovation?

> The radical planner concentrates on new methods of linking resources with needs, and often rejects society's values, assumptions, and goals for his own vision of healthy social interaction.

> In the process of radical planning, barriers between client/user, administrator, and planner are broken down. The planner becomes all three. His commitment is total, direct, passionate.

> The plan itself must be capable of abrupt changes, *ad hoc* modifications, and on-the-spot reversals.

Van der Ryn was deeply committed to the community design of the park and was so disenchanted with the university's destruction of the park that he left Berkeley.

WENDY SCHLESINGER
feminist, eco-activist, and People's Park cofounder
People want to fight pollution and have a place to take their young children. They yearn for the altruism and communality of an environmental salvation–based religious congregation. Also, they want a break from the negative task of fighting the government against a war that shows no sign of abating.

"A REPORT ON THE 'PEOPLE'S PARK' INCIDENT"
Probably we will never know just what the precise motivations of the park developers were, mainly because they remained unarticulated even to themselves until confronted with the necessity of explaining their actions to people who had not understood what they had done. (Report prepared for the UC Academic Senate, May 26, 1969, by Frederick Berry, UC Berkeley associate professor of geology; Thomas Brooks, UC Berkeley assistant professor of English; and Eugene Commins, UC Berkeley associate professor of physics)

BERKELEY TRIBE
People's Park was the beginning of the Revolutionary Ecology Movement. It is the model of the struggle we are going to have to wage if life is going to survive at all on this planet. (March 13–20, 1970)

CHARLIE PALMER
UC Berkeley undergraduate student and president of ASUC
Sure, there are a couple of heavies who rub their hands and look for trouble, but the students are not so naive as to be manipulated. The park is a symbol of something we built ourselves. We were never consulted about whether we wanted an athletic field. (*Los Angeles Times*, May 30, 1969)

WILLIAM BEALL
chief of the Berkeley Police Department
They don't care about the park. The park is irrelevant. This city has one near it. It's the cause célèbre. We've had five blowups in a year. Each one is getting worse. The people want revolution. What really is happening is that the street people are trying to induce students to join them because they need bodies. (*Los Angeles Times*, May 30, 1969)

The shaded eastern end of the lot early in the building of the park.

MICHAEL DELACOUR
boilermaker and People's Park cofounder

It meant many things to many people. There's a lot of ingredients in the park. The park is a place where free speech, including music, dancing, and public speaking, can take place without permission from campus officials. It was a way to recapture the spirit of the early days of events at Provo Park [formally known as Civic Center Park, located across the street from City Hall and Berkeley High School].

FRANK BARDACKE
UC Berkeley graduate student and People's Park cofounder

It was a mud hole, a dangerous place. People came on and parked their cars. The people in that area built a park. It was a beautiful park with sod, a children's area. They built a stage, a wading pool. It was a beautiful expression of community. Against the wishes of the university community, the university is trying to take the land away. ("The Big Four State Their Cases," KPFA radio, May 26, 1969)

Of course it's a revolutionary challenge to property rights. There is—or there ought to be—a notion that property rights come second to property use. We used it, they didn't. A group of people took some corporate land owned by the University of California that was a parking lot, turned it into a park, and then said we're using the land better than you used it and it's ours.

REVEREND RICHARD YORK
Berkeley Free Church

We shall build our new society on the vacant lots of the old. (*San Francisco Chronicle*, May 30, 1969)

WALLACE JOHNSON
mayor of Berkeley

The park started in a San Francisco newspaper on March 31 [a reference to a suggestion in the March 31 issue of the *San Francisco Express Times* that a park be built behind Pepe's restaurant on Telegraph]. It meant many things to many people. ("The Big Four State Their Cases," KPFA radio, May 26, 1969)

MIKE CULBERT
editor of the Berkeley Daily Gazette

[The park is] an engineered, contrived, phony, dishonest, agitprop event [by] the same tired old "revolutionary" groups and individuals, and the university bumbled along into another well-greased trap. (May 14, 1969)

 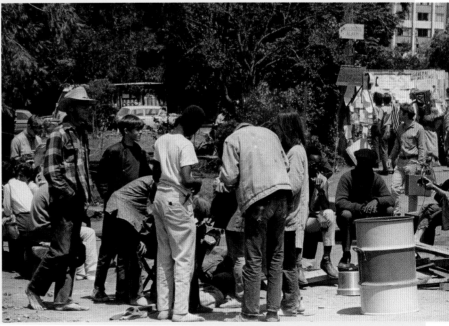

Left: Volunteers on April 20, the first day. Across Haste Street is the Anna Head School.
Right: A midweek gathering at the park, with conversation and music.

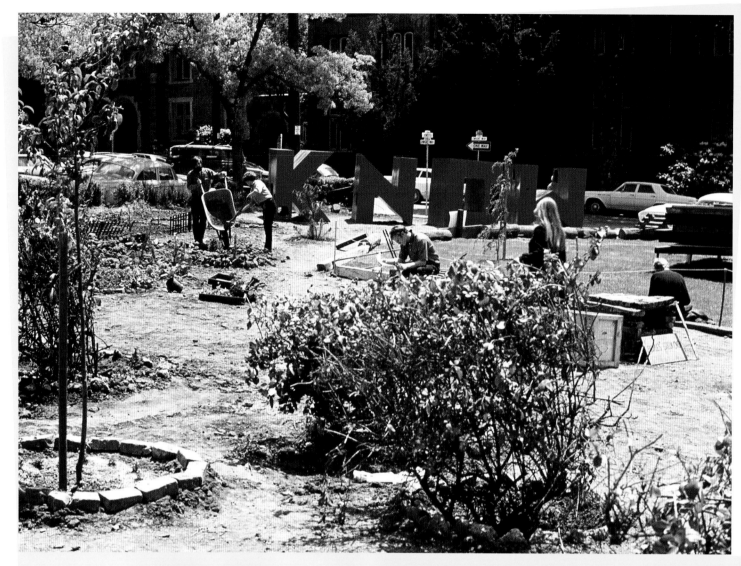

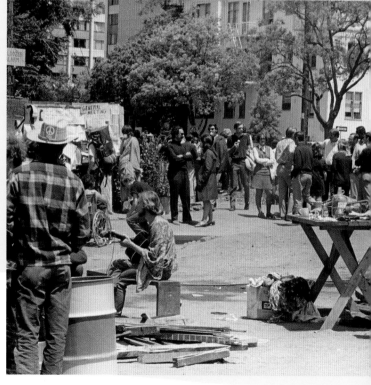

Top: The origins and significance of the "KNOW" letters are shrouded in urban legend and mystery.

Right: A weekday gathering in the park, looking toward the northeast corner of the lot.

DON MITCHELL
cultural geographer

The founders of the park probably did not have a worked-out "theory" of public space. But it is awfully clear that, given experiences in the civil rights movement, the Free Speech Movement, and the escalating tensions on U.S. campuses (and everywhere else) in the late sixties, as well as the growing backlash to "bulldozer redevelopment," they did have a good sense of three things: (1) that the fight for civil rights, against the war, etc., was a fight over *territory*—the space to act and make demands; (2) the need for *open* space in cities—and to halt the complete takeover—and makeover—of cities by big institutions like UC and big capital; and (3) the importance of an *ethos* of user-development and user-control.

What I find important is that each of these tendencies have come to be incorporated in our later theories of public space—which is to say that the founding of, and struggle to retain and retain control over, People's Park (like Morningside Heights in New York City and a number of other places) has significantly *shaped* our theorizing, rather, perhaps, than the other way around. For me it has been studying the histories of the Free Speech Movement and People's Park and now much more (public forum law, struggles in favor of homeless rights, protest policing, etc.) that has led me to my ideas about public space. It has not been theory that has led me to People's Park.

JOHN SEARLE
UC Berkeley professor of philosophy

The fact remains that at bottom I believe that the People's Park movement was extremely cynical on the part of the demonstrators. They wanted a confrontation. What mattered was getting people out in the streets demonstrating. There was no vision, no articulate philosophy, no conception of social organization and social change. There were a series of emotional moments, a series of passions, a series of desperately important issues. But you can't beat something with nothing. (From *Berkeley in the Sixties,* a 1990 documentary produced and directed by Mark Kitchell)

JOHN DEBONIS
member of the Berkeley City Council

I have been informed by intelligence sources that this is not the spontaneous concept of Berkeley's "street people," but was conceived and is being directed by a clandestine revolutionary group specifically to precipitate major confrontation with the police and the University administration. (Letter to DeWitt Higgs, chairman of the UC Board of Regents, May 7, 1969)

CRAIG PYES
UC Berkeley undergraduate student

I transferred to Cal after starting at Nevada Southern University and the College of Marin. I organized a radical group at NSU, Student Political Action, after being radicalized by a friend at San Jose State. When I started at the College of Marin, I got very involved in the Third World [Liberation Front] strike at San Francisco State. I joined the SDS and was part of the Joe Hill caucus, which advocated a working-class outreach. The RYM [Revolutionary Youth Movement] members of the SDS denounced us as liberals. I started at Berkeley in 1969. I affiliated with the Radical Student Union. Paul Glusman was one of the prominent members of the RSU, and he gave us periodic updates on People's Park. While I did not take part in building the park, I thought that it was a good idea and a pleasant, joyful experience, part of a new world order. I saw the park as the ultimate prop to engage non-radicals in Berkeley and to radicalize them when the inevitable State reaction to the park happened.

RONALD REAGAN
governor of California

Obviously a phony issue seized upon as an excuse for the riot. (*San Francisco Chronicle,* May 16, 1969)

ART GOLDBERG
UC Berkeley graduate and Free Speech Movement leader

For most participants, it was a calculated political act designed to put the expansionist and repressive university up against a wall. This is the beginning of resistance. After a couple of weeks the kids won't let anybody take away their park. We will do what's necessary to defend it.

ELDRIDGE CLEAVER

Minister of Information of the Black Panther Party

The only way we were going to get serious about a revolution was when we had something in the soil. We have it—the People's Park—and its avenging angels are everywhere.

PAUL GLUSMAN

student activist

I know that some people say that we built the park to provoke the university. I think that the university's handling of the land was a provocation. They demolished perfectly good houses and bulldozed the block for soccer fields that nobody wanted. Of course it was because radicals lived in the South Campus area. They left a fucking mud hole for a year and a half. What happened was inevitable; we said that we were going to make a park, and we knew that they would eventually try to stop it.

PAUL SAMBERG

reporter for the **Liberation News Service** *and* **Rat Subterranean News**

We grabbed some land and held it. We worked on it and fought for it. We seized what was private and ugly and transformed it into something public and beautiful. We were shot at. (From *Fire!: Reports from the Underground Press*)

DAVID LODGE

novelist and visiting professor to UC Berkeley from Great Britain

The basic strategy of such militants is to encourage demonstrations that will provoke the authorities (university administration, the police, etc.) to an extreme display of force, thus confirming the revolutionary thesis that an allegedly democratic society is in fact totalitarian, repressive and intolerant, maintained only by violence. (From "The People's Park and the Battle for Berkeley," in *Write On*)

JENTRI ANDERS

UC Berkeley graduate student in anthropology

Most of the participants I knew saw it as our chance, perhaps our last chance, to try to heal our society with a loving constructive action rather than destroy it in bloody revolution. It

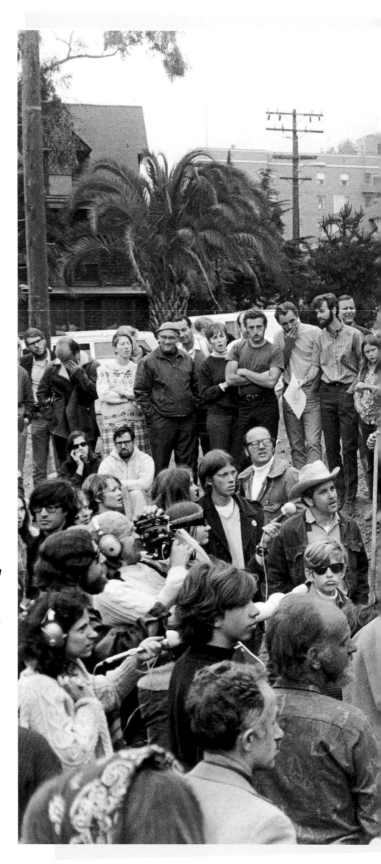

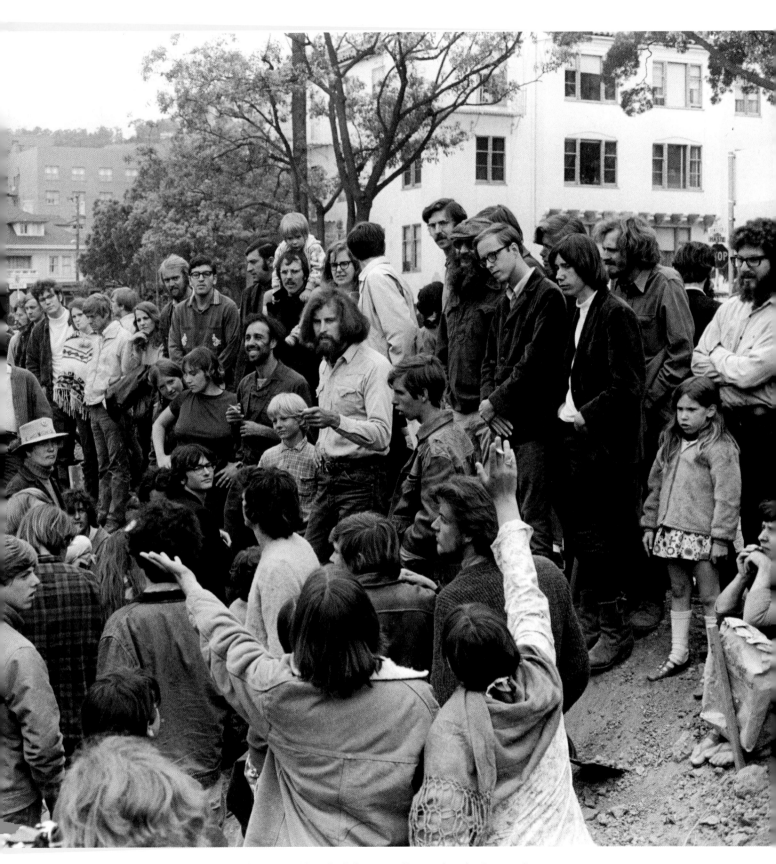

Park volunteers gather at the corner of Haste and Bowditch Streets to discuss plans for the next day. *Berkeley Barb* publisher Max Scherr (bearded with a cap) is just to the right of center on this page.

was like a dying plant that uses its last energy to bloom just before its last gasp. An almost unprecedented community spirit emerged as people of all classes and walks of life worked together on the park and used it. (From *Berkeley Backlog*)

WALTER NESBITT
forestry superintendent for the City of Berkeley
I personally think the Park is a great idea. It's a very constructive project and it's much more attractive than the mudhole that was there previously. (*Rat Subterranean News*, a New York–based underground newspaper, May 13–19, 1969)

STEW ALBERT
Yippie and People's Park cofounder
We decided to seize the unused land and rebuild the community by transforming the ugly eyesore into a people's park. The People's Park became my nation, my home and my poem. The labor of building the park gave me the chance to check

my guns at the door and put harassing FBI agents out of mind in order to devote myself to the serious task of creating Utopia. There was a shortage of shovels, and we argued over who could use them and when. Abbie Hoffman had a similar response when [my partner] Judy and I brought the touring, federally indicted Yippie [Hoffman] onto the grounds of People's Park. "This is what we're all about. It's what I'm doing, too. It's fucking beautiful." (From *Who the Hell Is Stew Albert?*)

HUBERT LINDSEY
street preacher
I could see where the whole situation was headed and talked many times about it with Stewart Albert, a close friend of [political activist] Jerry Rubin and one of the park developers. "You are not developing a park," I told Albert. "You are developing a battleground. You are trying to get someone killed while you talk about peace. You're a bunch of hypocritical devils, and if you have your way, blood will be spilled over this park." (From *Bless Your Dirty Heart*)

MICHAEL ROSSMAN
Free Speech Movement activist

Everybody was just desperate for some positive thing to do—something that could actually in a positive way give some public evidence, some polity evidence, to all the love and wonder that was brooding inside. We just wanted so much to make an affirmative gesture that wasn't an empty clenched fist against the oppressor but actually planted something in the ground that could grow and could bear forth into the world the kinds of health that we felt gathering inside ourselves, intertwined with all the craziness and death of American society at that point. (Interview with filmmaker Claire Burch for *People's Park of Berkeley: Then and Now*)

JULIA STEIN
UC Berkeley graduate

After graduating UC Berkeley in 1968, I returned to Berkeley to visit friends in May 1969. I had gotten arrested during the Free Speech Movement in 1964 and had seen how the mainstream press had attacked our nonviolent Free Speech Movement. In our first nonviolent antiwar march in 1965, Oakland cops got on the rooftops and pointed shotguns at us. The march leaders turned away from marching into Oakland, instead leading the marchers to camp overnight in a Berkeley park, where the campers were tear gassed.

Arriving back in Berkeley on May 10, 1969, I stayed at my friend Susan's apartment on Southside. I immediately heard about the building of People's Park and walked a few blocks to the park, seeing twenty people planting bushes and flowers. I walked into the park May 12, helping to put in more shrubs, seeing that the park was almost finished being built with walkways through the green shrubs and flowers. I liked the high energy of all the people busy planting the bushes and shrubs in the park, and it seemed rather wonderful to be part of planting the park. (From "Attacking the Non-Violent Berkeley Movement in the 1960s")

SANDRA DU FOSSE
People's Park neighbor

On that first Sunday when the park was started, I got there at about five o'clock. My children had been there most of the afternoon. The grass was laid under the clump of trees, a flower grotto had been started, it seemed almost a hundred people were digging with picks, shoveling, raking, hoeing—working with a joy and hunger that hit me. If I had been asked the week before to help do this thing I would have thought it couldn't be done. I would have said no, sadly. At five o'clock on that first Sunday I wept, shamed by my over-thirty defeatism; filled with a singing at this living, sweating, beautiful humanism, grateful that "they" started it. I am so tired of negation, protests, demonstrations, violence and hate. The creating of this park is a surge of everything that is best in people—joy, caring, growing, sharing, creating, being. (Letter to the editor, *Daily Californian,* May 19, 1969)

> ❝We decided to seize the unused land and rebuild the community by transforming the ugly eyesore into a people's park. The People's Park became my nation, my home and my poem.❞

REVEREND RICHARD YORK
Berkeley Free Church

In two years as a priest to the Berkeley street people, I have never seen anything so creative, so offering in hope for a new vocationalism, as the People's Park. Even the most minimal sociological sophistication would have told us to encourage and cooperate with it. I can only conclude that creativity is the last thing our Establishment wants to see on the street—that beginning viable alternative lifestyles are the ultimate threat to the demonic institutions of our exploitative and violent society. (Address at a People's Park meeting held at the Berkeley Community Theatre, May 25, 1969)

WENDEL BRUNNER
UC Berkeley graduate student in public health

Everyone who planned the park loved it and the idea and wanted to see it grow, bloom, flourish, and make people happy. No one I knew wanted violence. But some of the planners were realistic enough to know that the park would almost certainly be attacked and would likely be destroyed.

Excerpt from the poem "People's Park"
by Julia Vinograd

Our blood planted this place.
It's ours.
If they bulldoze People's Park
the blades of grass will fly like knives.
The torn rosebushes will scream like man-
 drake root,
and red fires will start in each red petal,
in every garbage can and every star.
The big floppy sunflowers will throw stones,
and the ants climbing their thick green
 stalks
will throw stones,
and the out of season tomato patch
will throw stones and unripe bottles...

JULIA VINOGRAD
poet

I was here for People's Park. I lived just across the street from it in a room at the Berkeley Inn. The Park was almost my front yard. I couldn't have avoided it if I'd wanted to. The Park caught the local politicians by surprise, and they didn't really approve. They thought we should all be out protesting Vietnam and not wasting our time on some silly little issue. But we'd been against so many things it was intoxicating to be *for* something for a change, to plant a whole block of yes

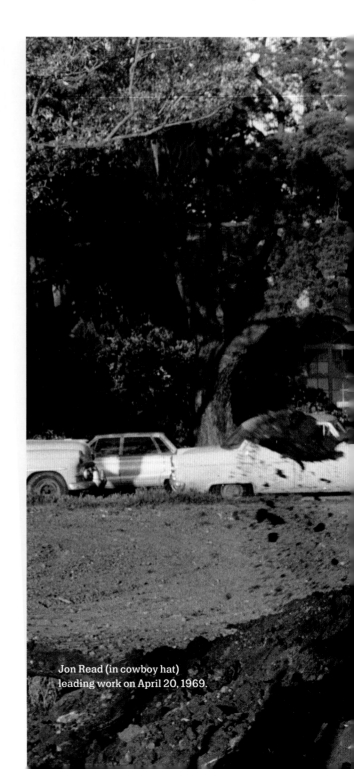

Jon Read (in cowboy hat) leading work on April 20, 1969.

and be able to look at it afterwards and say, "That wasn't here before us."

To begin with there wasn't much trouble. The first night we lit a fire. The Berkeley cops came and said, "Put it out." Someone asked why. "'Cause you can't have a fire at night unless you got stones around it." "Oh, OK." We put the fire out, got some stones around it, relit it, and when the cops came back they saw the stones and said, "Oh, OK." The drummers played late into the night around the fire. A church was being torn down across town and donated some pews for park benches. Even one of the newspapers had an article claiming "at last those street people are doing something useful." There were roses, and—because it was Berkeley—a revolutionary corn garden, and the slogan was "Everybody gets a blister."

As well as being a local poet, I'm known as the Bubblelady. And that got started as part of People's Park. There was going to be a riot the next day, but I was a pacifist and didn't want to throw stones and besides I'd probably miss. At the same time[,] I was angry and wanted to throw something. I decided I'd blow soap bubbles all night in the park, and if they wanted to arrest

Above: Filmmaker and *Berkeley Barb* movie reviewer Lenny Lipton (left) and Yippie radical Stew Albert.

Right: Scenes like this led rightwing Berkeley City Council member John DeBonis to compare People's Park to a "hobo jungle."

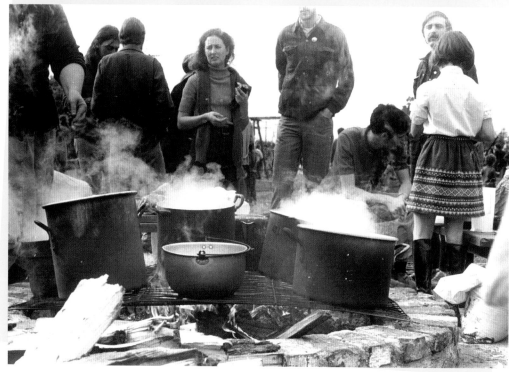

me for it, fine. I bought two large bags full of bottles. There were two rookie cops in the park, and I marched up to them and announced my intentions. They pretty much shrugged.

I started making bubbles and after a while one of the rookies asked if they could try. I told myself this wasn't happening, didn't say anything out loud, and handed them each a bottle. They started a contest. "Mine's bigger than yours." "Yeah, but look at mine go, it's the motion that counts." I quote. After about twenty minutes of this, a cop car with a real cop in it turned the corner, saw us all blowing bubbles, and screeched to a halt. (I think he thought I'd dosed his rookies. This was the sixties[,] when everyone, including the cops, believed some morning we'd all wake up with the water supply dosed and everyone stoned.) Anyway, he ran up to us, checked out the rookies, and damned if one of them didn't try to hand him a bottle. He said he didn't play childish games and stalked off, while the other rookie commented, "He's just scared 'cause his would be too small to see." Again I quote.

I'd only planned a one-night symbolic protest, but I hadn't expected this much reaction. And from cops. I started carrying bubbles with me to see what would happen, and I discovered they could both heckle and applaud. Little kids came running up to me and saying, "Bubble? Bubble?" I'd make bubbles for them and they'd chase them, but if I didn't have a bottle they'd say, "No bubbles?" and look sad. Pretty soon I always had bubbles and wound up a lot more famous as the Bubblelady than I was as a poet. Oh well. Bubbles don't help anyone, don't solve any social problem, and are totally unimportant. But I'd never realized it was so easy to make people happy. (Reprinted from "Memories of the 60s," with the permission of the author)

JERRY RUBIN
activist, organizer of the Vietnam Day Committee, and cofounder of the Yippies
Like a Chinese commune, thousands scraped cement from old bricks which others then used to create winding mosaic paths.

One group built a barbecue.

Another created a playground.

Some people made music on cans and drums, guitars, flutes, harps, recorders, voices and bodies.

Others made films.

Free food every day. Rock bands played.

It was a theater for the free play of creativity, energy and community. All of the art and life force of the underground culture swelling in pure love.

Within five minutes after you'd go to the park, you'd be stoned....

Every day middle-class people from the Berkeley hills left their children to play with us. People came to the park to plant their own trees.

Hippies, students, yippies, fraternity boys, sorority girls, Panthers, middle-class people, everybody grooved in their own park.

"Hey can I plant a corn patch?"

"It's up to you. You decide."

"Hey, can I put some swings in?"

"Outasight."

There was no Master Plan. Nobody gave orders. Some people wanted to turn the huge pit in the middle of the park into a swimming pool; others wanted to have a fish pond. Everybody working on the park got together in a town meeting and debated it for a few hours and voted to have a fish pond. (From *Do It!: Scenarios of Revolution*)

VANESSA DELACOUR
eleven years old and a student at the Longfellow School, and David Delacour, ten years old (speaking as one)
We had been living in Berkeley for around two years when People's Park got going. We didn't see anything as political; we were too young for that. We just experienced things as they happened, through the eyes of a child but shaped by our parents Mike and Leslie. We knew many of the leaders of the park movement as friendly and supportive adults in our lives—Bill Miller and his wife Liz, Curtis Rosa (who taught me [David] how to read), Super Joel, Doug Bogen, and others. We were very much at home on Telegraph Avenue, although it was a few years later when we became active in the scene in front of Rag Theater and were part of the Mini-Mob, the younger version of the Red Rockets. We knew the campus and South Campus like the back of our hand—the alleys and back doors and shortcuts and paths and even the steam tunnels under campus. We didn't like the heroin addicts on Telegraph and actually harassed them when they were shooting up in the Telegraph Hilton, and we knew the bad cops and the good cops. Kid Cop

was the best cop on the whole force. He watched out for us and took care of us.

We knew the People's Park block because our dad worked and lived at the Red Square dress shop on Dwight, right next to the lot. We remember riding in a truck to Vallejo or Vacaville or Suisun to buy sod for the park and all the people who were helping make the park. We remember the stew that they made. I [David] remember a pig being roasted underground. The park was a great thing for kids.

We were around on May 15. Either our dad or Bill Miller or Super Joel told me [David], that things were getting rough and that I should leave. I did; I went to Bill Miller's house on Warring Street.

I [Vanessa] was on the roof of the Cinema Guild below Dwight, watching what was going on down on Telegraph between the demonstrators and the Blue Meanies [sheriff's deputies]. It got scary and I got out of there before the Blue Meanies opened fire and Alan Blanchard was blinded.

Our older sister Kathy had stolen a fire hydrant wrench from the fire department and opened the hydrant on Telegraph and Haste a fair amount for kids to play in. On Bloody Thursday she opened it all the way and people directed the high-pressure water at the cops.

We remember the National Guard in town with their bayonets and the nasty rolls of barbed wire on the street. I [David] had a plastic billy club and I posed next to a line of National Guardsmen with their bayonets on the Memorial Day march. There was an iconic photo taken of me.

Looking back, it is just amazing what happened all around us when we were kids. We were friends with the Black Panthers and hung out at Timothy Leary's house with his son Jackie. We were there on Telegraph for all the riots and we saw all kinds of things hanging out on the 2400 block with our friends in the Mini-Mob. We were at Altamont and snuck under the stage so that we were right up front as the Hells Angels got wasted on STP and then started fighting. People's Park was just one of many amazing events.

> **"Looking back, it is just amazing what happened all around us when we were kids."**

Jane Scherr with *Berkeley Barb*'s publisher, Max Scherr.

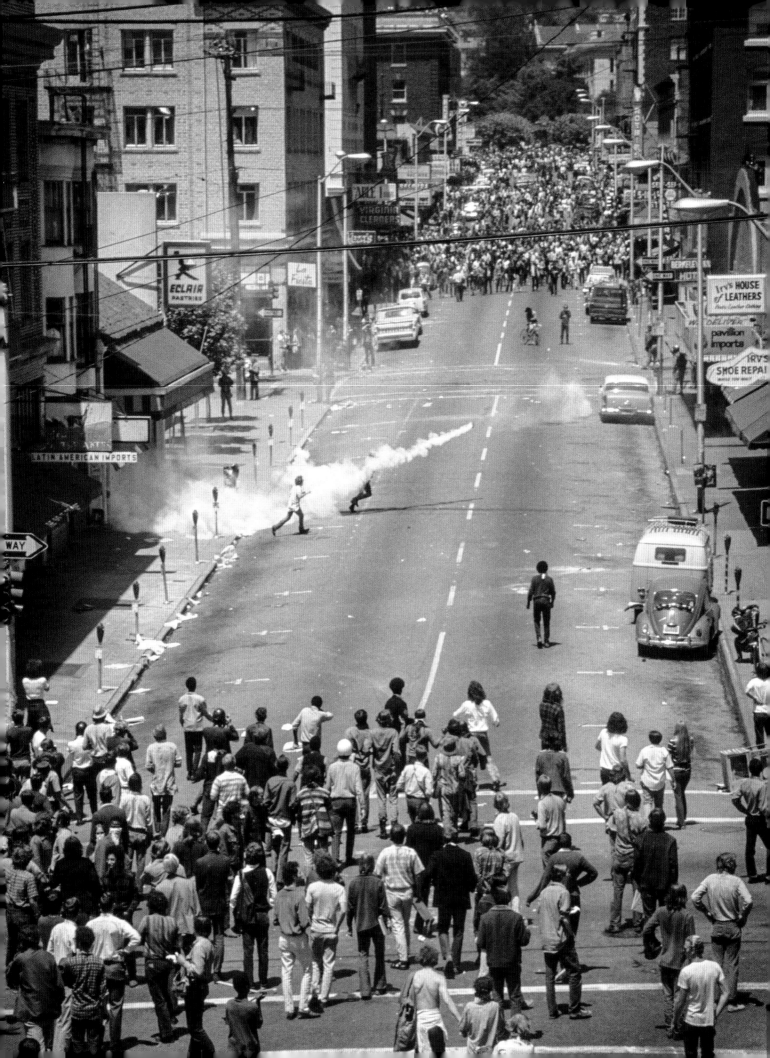

Bloody Thursday

For three weeks after ground was broken, the university took no action to stop what was taking place in People's Park. Chancellor Roger Heyns, in a speech on May 23, explained: "We considered the fact that there might be trouble in that area and decided to treat the matter gently. We had permitted parking there and saw no reason why the land could not be enjoyed until our work began." Early on, it seemed that the university might even have been endorsing the park. On April 30, the university issued a statement that was quoted in the *Berkeley Daily Gazette* on May 1: "No one can live in this area without appreciating the need for open green spaces and park facilities."

On April 29, a rumor that the university was dispatching bulldozers to the park at 6:00 a.m. swept through park supporters by means of the Dozer Alert, a phone tree set up by Marsha Haines, branching off from Haines, Bill Miller, the *Barb,* and the Free Church's switchboard. Park partisans arrived at the site at 5:30 a.m. No bulldozers appeared, so the activists improvised a sunrise ceremony to drive out the evil spirit of Vice Chancellor Budd Cheit.

What *did* happen on April 29 was that Chancellor Heyns met with Vice Chancellor Cheit and members of both of their staffs. The official minutes of that meeting state: "Decision to meet with advocates and announce that UC was going to proceed with its planned field plus willingness to modify UC plans to incorporate different activities, need to establish ground rules for use of this land, etc. *Decision to fence in property and carefully remove all newly added materials (sod, swings, plants, etc.) and offer the park builders an alternate site for placement of these materials.*" (Emphasis added.)

Both Chancellor Heyns and Vice Chancellor Cheit left Berkeley and were not present on May 15, when the next significant action took place.

About seventy-five park supporters stood vigil in the park on the night of May 14. At 4:45 a.m. on May 15, hundreds of California Highway Patrol and Berkeley Police Department officers arrived at the park. Lt. Robert Ludden of the Berkeley Police told the supporters, "You are on university land. If you don't disperse, you will be arrested for trespassing. Remove yourself outside the police lines to avoid arrest and any difficulty." All but three of the

Looking north on Telegraph, with Dwight Way in the foreground and the crowd being pushed back from Haste Street.

supporters dispersed; the three who didn't were arrested without incident and charged with trespassing.

The first fencing company truck and a bulldozer arrived at 5:50. The police supervised as workers erected an eight-foot-tall chain link fence around the park, again without incident. The bulldozer destroyed many of the new plantings near the park perimeter, and police continued the destruction once the fence was established.

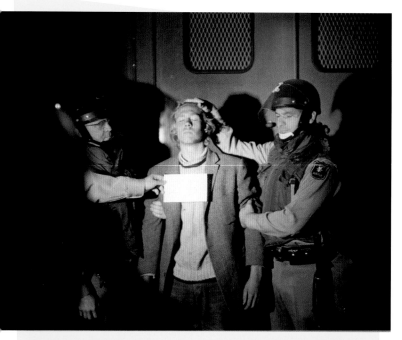

Two of the park supporters who refused to leave the park in the early morning of May 15 and were arrested. John Jekabson, a photographer, was driving past the park on his way to San Francisco to oversee the printing of the *Barb* when he saw the arrests taking place.

FRANK BARDACKE
UC Berkeley graduate student and People's Park cofounder
I was not in Berkeley for what instantly became known as Bloody Thursday. I was on a speaking tour that [attorney] Charles Garry put together to raise money for the Black Panthers, with either Bobby Seale or David Hilliard, both Black Panther leaders. I was in New York, staying in Jerry Rubin's apartment. I came back to Berkeley immediately.

WALLACE JOHNSON
mayor of Berkeley
The whole operation was so unspectacular, including the start of fence placement by a contractor, that I left the scene convinced that no retaliation was planned before noon, when a rally had been announced for Sproul Plaza. (Quoted by Joseph Lyford in *The Berkeley Archipelago*)

PAUL MORUZA
sixth-grader at Willard Junior High School
On May 15, I walked by the park on my way to the boarding house on Hillegass. I saw that the police had put a fence up, and it was just plain exciting to an eleven-year-old boy.

HOWARD DRATCH
UC Berkeley graduate student in political theory
On May 15 I got a phone call as part of the Dozer Alert phone tree. I got down there early as workers strung the fence on recently set posts. Crews installed the fence around the park. It was a mixture of horror and impotence. People were in shock, not knowing what to do. Rage was present and building, even before Dan Siegel's speech.

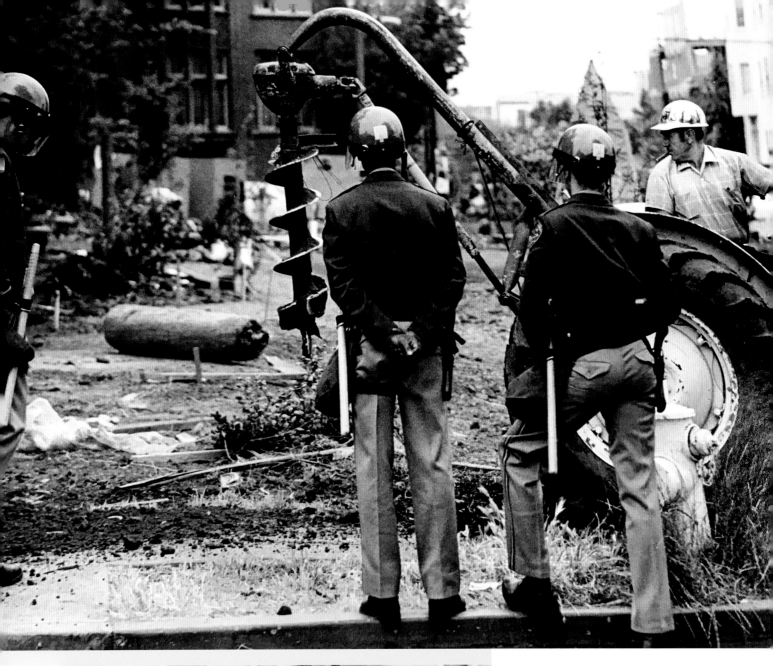

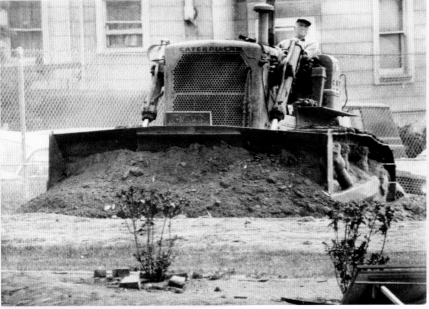

Above: Berkeley police officers watch as a chain link fence is erected around People's Park on May 15, 1969.

Left: After the park was fenced in, contractors using heavy equipment destroyed most of the park's landscaping and hardscaping.

DAN SIEGEL
UC Berkeley law student and incoming president of ASUC

On May 15, I went outside to pick up the newspaper. I looked south down Bowditch and saw a lot of CHP officers. I immediately knew what had happened. I was pissed off.

STEPHEN SHAMES
UC Berkeley undergraduate student and photographer

On May 15, I got a phone call saying, "The pigs are coming! Come to the park!" I went to the park and it was fenced in. I took what became an iconic photograph of cops sitting on the swings from a playground set at the park.

ANNA RABKIN
Holocaust survivor and housewife

Opposed to the Vietnam war, a stay-at-home mom, what could I do to help the peace movement? I joined a political action telephone tree. We rallied people to write letters, lobby legislators and march against the war and nuclear proliferation. One day I got a call for a different type of action. "Go with your children to People's Park. We are supporting the students. They are protesting against the university's installation of a fence around the Park."[...]

I arrived at the park with Mark in the stroller and Michele at my side; families had been encouraged to attend the rally to show community support for keeping the space open and accessible to all. A huge crowd had gathered; students, townies, families with children. I was chilled by the sight of tough-looking armed California Highway Patrol officers taking up positions around the park. In their high leather boots, they reminded me of Nazi stormtroopers.

Otherwise it was a peaceful scene. Hippies were sticking flowers through the newly erected chain link fence, while protesters were trying to start a dialogue with the police. Soon Alameda County Sheriffs, the "blue meanies," arrived. Suddenly we heard *crack, crack, crack.* The air was filled with a yellowish, eye-tearing, nose-stinging cloud. Screams of "Pigs!" mingled with shouted instructions, "Cover your faces,"

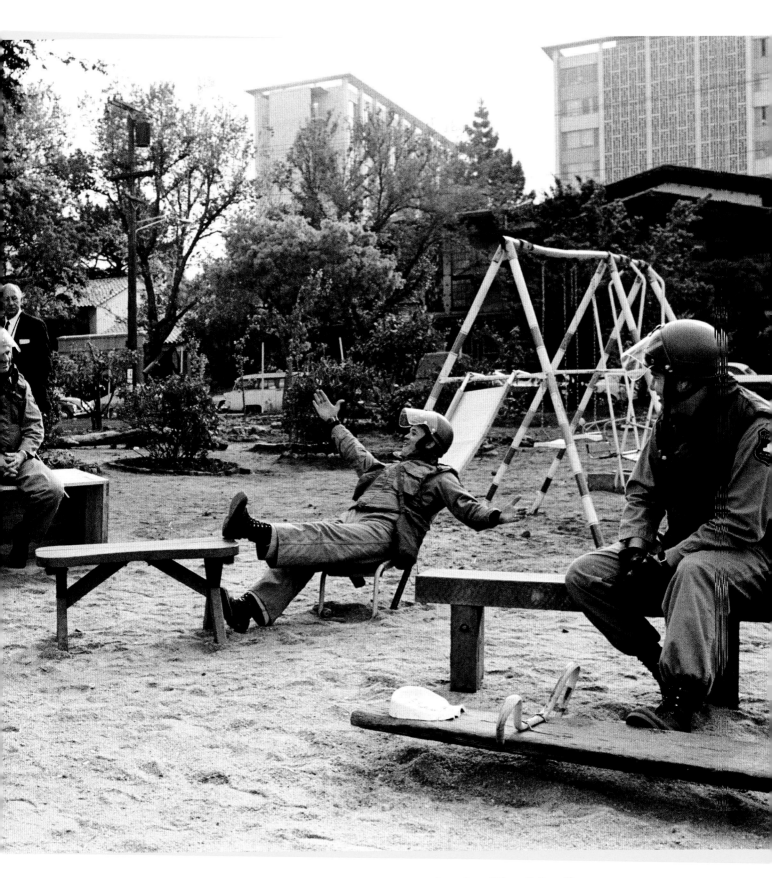

After seizing and fencing the park, a few calm hours passed before the noon rally on Sproul Plaza. Police officers who had expected trouble in the morning encountered none and instead relaxed in the park playground.

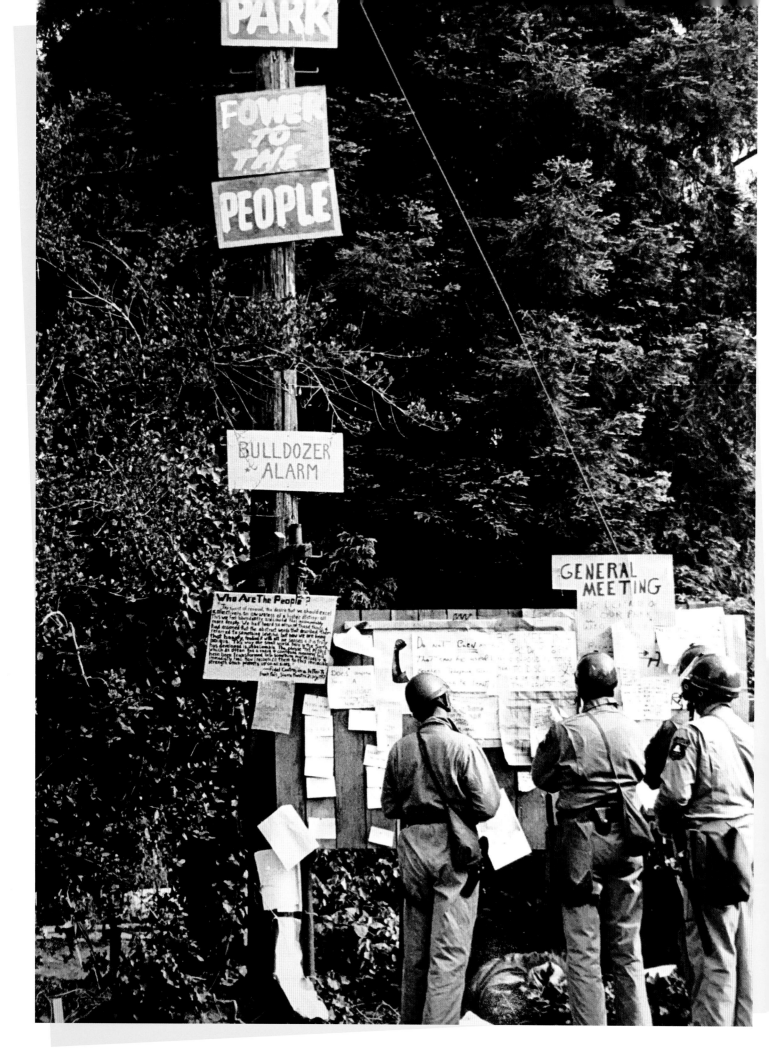

as people surged away from the fence. Someone gave me some wet cloths to put over our noses. I wove the stroller in and out of the crowd [and] tried to persuade a woman at one of the nearby university offices to let us in; she shooed us away. We finally made it to campus, where the air was clear, and we made our way home. The furor had Mark and Michele totally confused and frightened. I was livid. How could I have been so thoughtless and put them at risk? (From *From Kraków to Berkeley: Coming Out of Hiding—An Immigrant's Search for Identity and Belonging*)

GLEN ANGELL
recent UC Berkeley graduate student
Some time after the university took the park, a university police officer came to the commune where I was living with a letter telling me to come to the park and to pick up my private property, meaning the poetry platform that I had built. I did as directed and was let in through a gate in the fence. I disassembled the poetry-reading platform, loaded the lumber into a VW bug, and took it away.

DAILY CALIFORNIAN
Thus, the possibility of an imminent destruction became a reality. A meeting was held in the park yesterday where a group of people decided not to defend the land with their bodies, primarily because that tactic had not worked in the past. Instead they decided to treat the park as a "political candidate," to promote support in the entire Berkeley community through an intensive publicity campaign and widespread canvassing. The electric "bulldoze alarm" failed to operate, but a set of triangles and bells were sounded to alert local residents. Those keeping vigil also alerted nearby dormitory residents to news of the impending fence by setting off fire alarms in the dorms. (May 16, 1969)

R. E. HULL
sergeant with the University of California Police Department
Everything went awfully easy.

CHARLIE PALMER
UC Berkeley undergraduate student and president of ASUC
There is overwhelming student and faculty support for the concept of a park. Eighty-five percent of nearly fifteen thousand students voted in favor of that.* ("The Big Four State Their Cases," KPFA radio, May 26, 1969)

SAN FRANCISCO CHRONICLE
81% of the park's neighbors support the park. (May 27, 1969)

STANLEY GLICK
scholar
The opinions of 85% of the students who had voted in the ASUC referendum, of the majority of the faculty, [of] the neighbors of the park, of the Berkeley City Council and [of] the University administration were negated by sixteen wealthy, powerful, and conservative Regents. (From *The People's Park*)

FRANK BARDACKE
UC Berkeley graduate student and People's Park cofounder
This is a question of how property is used, who makes the decision, who controls property. A few men are defying the entire university system. ("The Big Four State Their Cases," KPFA radio, May 26, 1969)

SHELDON WOLIN
UC Berkeley professor of political science
The university failed to take the next step dictated by rule-governed behavior—seeking an injunction.

ROGER HEYNS
chancellor of the University of California
[An injunction] would be ineffective under the circumstances and would not avoid the kind of trouble we sought to prevent.

Left: Shortly after seizing the park on May 15, police officers read the bulletin board made by Curtis the Carpenter.

* More specifically, 12,719 out of 14,969 votes cast were in favor of the park.

ROBERT TRACY

UC Berkeley professor of English

I participated in English department meetings and sessions of the Academic Senate about the park. Tom Parkinson was one of the leading advocates of the park in the English department. In 1962 he was shot in the face while meeting with a graduate student who was [himself] killed by [the] rightwing crank who was upset by Tom's support of the students in the HUAC riots. He organized readings by Beat poets in the 1950s, supported the Free Speech Movement, and in general was the conscience of the English department. He was a vocal advocate in our department for the park. So was Charles Muscatine, a Chaucer scholar who was fired for refusing to sign a loyalty oath and who was reinstated after winning in court. He too was a supporter of the park.

PAUL SAMBERG

reporter for the Liberation News Service *and* Rat Subterranean News

It was hard to believe. This was the end of the park; no more. We could do nothing. We could mobilize no one for its defense. After all the plans, all the vows to "go down with the park," or lie in front of the bulldozers, or harass the workers, the park was taken from us without resistance. And there was nothing we could do about it. Total defeat.

DOVE SHOLOM SCHERR

third-grader at Emerson Elementary School

I was angry when they fenced in the park and tore it up. It was wrong; they had stolen it. My mother woke me up in the middle of the night of Bloody Thursday and told me that they had taken the park. You could smell tear gas.

JACAEBER KASTOR

eighth-grader at Willard Junior High School

When they put the fence up, it was simply a bummer for me. I didn't understand the politics or issues, just that they had fenced off the park that had been a good scene. They got the fence up and destroyed the park really quickly, in a day.

CAROL GORDON

UC Berkeley undergraduate student

Eugene was an astrologer and Jill created beautiful, unique jewelry. We had become friends, and they moved into our garage to live and work. Somehow they had learned that the police were going to erect a fence around the People's Park early in the morning. Eugene decided to organize a midnight event the night before the police invasion. My roommate and I walked with Eugene and Jill to the park before midnight. Many others joined us. There was a good-sized gathering. Eugene arranged us in astrological sign order seated on benches. I remember, as he was doing this, turning around to look at the people sitting behind me. As I did, I saw a man holding a movie camera filming all of us. I felt quite paranoid because of that, wondering who he was and what he was going to do with the film. Eugene then led us in a chant. We recited all together, over and over again, *Nam-myoho-renge-kyo*. In the Buddhist faith tradition, to believe in the Mystic Law and chant *Nam-myoho-renge-kyo* is to have faith in one's unlimited potential. To chant *Nam-myoho-renge-kyo* is to bring forth the pure and fundamental energy of life, honoring the dignity and possibility of our ordinary lives. After our chanting, we left and went home. As I walked to campus the next morning, I saw the police and the fence erected around that beautiful People's Park. It made me so sad. The People's Park had special meaning for me. As a cooperative

> **"It was hard to believe. This was the end of the park; no more. We could do nothing."**

"community" endeavor it aligned with my values. But then we watched political forces bring it crashing down. At first, they directed the police to enclose the park with a fence surrounding it and then to engage in a war against the park and its supporters. This was unfolding as I was about to graduate. What a sad closure for me.

DHYANI (JENNIFER) BERGER
UC Berkeley graduate student in biology
When we heard that the university would destroy and fence the park, people tried different things to prevent that. Eugene, a guy who lived in our garage on Hillegass, organized a meditation the night before the police were scheduled to fence off the park. He believed in the power of positive energy and wanted to harness community power and so influence decision makers. I remember holding hands in a circle chanting in the dark, a moment of hope. To our sorrow the fence went up the next morning. Some of us tried to talk to them [the police] and ask them to stop. They weren't always aggressive, but they were under orders.

ROGER HEYNS
chancellor of the University of California
Nobody promised anybody any twenty-four-hour notice. It was necessary that all development on the property stop. All I asked for was, "Let's stop and talk it over." This did not preclude further discussion of these matters. I did not know specifically when it [the fence] was going up. Confrontation was announced in advance. The decision about when it was going to go up was to minimize confrontation. I began a process of discussion. There were lots of people who were interested in green space, not playing fields. ("The Big Four State Their Cases," KPFA radio, May 26, 1969)

The decision was to erect a fence, which was intended, really, to buy us some time, to cut down on the social complaints, to satisfy the city. I don't think that any of us were delighted about the decision to put up the fence. Logistically it was a great success. We got the darn thing put up.

Activist and journalist Paul Jacobs speaking to the crowd in Sproul Plaza on May 15, 1969.

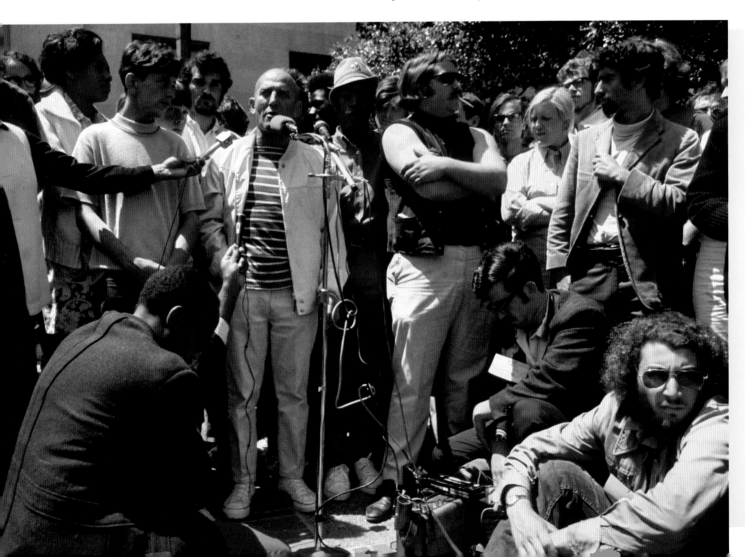

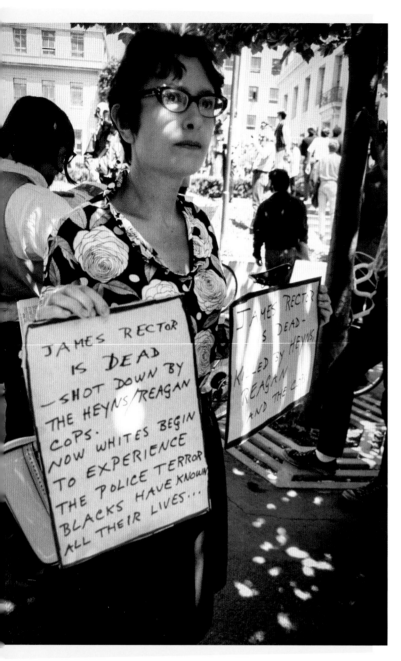

Poet and UC Berkeley professor Denise Levertov on campus the week after she spoke on May 15 at Sproul Plaza.

BUDD CHEIT
executive vice chancellor of the University of California

We also acted on the advice of counsel that if we did not assert our ownership rights, they would become clouded. (*Daily Californian*, May 19, 1969)

OPEN LETTER TO CHANCELLOR ROGER HEYNS FROM THE REVEREND RICHARD YORK OF THE BERKELEY FREE CHURCH

Chancellor Heyns has issued a statement concerning People's Park which baffles the imagination. As pastor to the community which built the Park and as one of the churches which dedicated it last Sunday, we must respond. The Chancellor has based his argument and decision on money and legality and has completely failed to deal with the reality of the New Community in its midst, a community which has lived in the South Campus for several years and will, we confidently believe, be here for many years to come. Perhaps he did not realize that leaving the land unused was an open invitation to this community to build a park in it. Now he does. The people of this community and other Berkeley citizens have been talking about the need for a park in the South Campus for nearly a year. When a new community enters a society, the old community must learn to adapt itself to it. We asked Chancellor Heyns, do you really want to declare war on this community at this time? It is ready to live with you possibly for the next fifty years; are you ready to live with it? There are higher principles involved here than property, deeds and checks. The young citizens of the South Campus and their clergy do not want to occupy your cyclotron or tower. We do not propose to cut down your redwoods or befoul your brooks. We respect your living area. Would you like to respect ours? We do your Board of Regents the favor of acting as if it is a community. How about ours? You bend over backwards to placate other interests in the state and city. You defend the dubious legality and unquestionable immorality of the Atomic Energy Commission. How about trying to understand us?

It is untrue, Chancellor Heyns, that no one seems to be happy about the Park, as you said. We believe it has received and has deserved a widely based support in the community. Have you seen the madness of people enjoying it? Have you talked to the garden societies and the

merchants and the members of city government and the people who have donated plants and money? It is time that the oppression and selective law enforcement used on our community and the university come to an end. Young people are not welcome on the streets. You've made that clear. They have created, by their own initiative, a park—now they are not welcome there. You can't have it both ways. And the dream of some of the citizens that the youth community can be driven out is a futile and racist dream. We at the Free Church are committed to resisting the selective oppression of our people, which is not unlike the oppression of our black ghettos.

Be assured, Chancellor Heyns, if arrests are made and the Park is destroyed, many leading Berkeley citizens will be among [those arrested]. Be assured that some of the clergy will be among them. And don't expect creative initiative to arise from the street community again for a long time.

You have a duty to this community. It is in your hands to determine whether it will turn to tearing down or building up, street fighting or a new vocationalism. No matter what your beneficent motives, inflexible paternalism doesn't work in the ghetto, and it will not work here. We will be surprised if your intramural field ever is actualized. (Speech, Sproul Plaza, UC Berkeley, May 15, 1969)

PROCLAMATION BY "MADMEN" IN THE BERKELEY BARB

A NEW BERKELEY is being planted in People's Park. Creating the Park has been the most spontaneous and positive event in the emerging showdown between the Industrial-University Machine and our Revolutionary Culture. We have struggled for Rights. For Space, and now we struggle for Land. We need the Park to live and grow, and eventually we need all of Berkeley.[...]

WE TAKE A SOLEMN OATH to wage a war of retaliation against the University if it *begins* to move against the Park. We are prepared to defend ourselves and the Park if other methods fail. If the University attempts to reclaim $1.3 million worth of land now claimed by the people, we will destroy $5 million worth of University property. We will not strike until the University proves by concrete deeds—such as the sending of surveyors or posting trespass notices—that it intends to take back our Park. But we will strike before they rip off the Park with their goddamn bulldozers.

If we fight the same way we work—together, in teams, with determination—we will win. Get together with the people you've worked with, and take an oath like ours. Figure out how to save the Park and save yourselves: from cameras, clubs, gas and anything they throw at us.

NO SURVEYORS
NO FENCES AGAINST THE PEOPLE
NO BULLLDOZERS
BE MASTERS OF SILENCE, MASTERS OF THE NIGHT
WITH SHOVELS AND GUNS
POWER TO THE PEOPLE AND THEIR PARK
(*Berkeley Barb,* May 9, 1969)

"Young people are not welcome on the streets. You've made that clear. They have created, by their own initiative, a park—now they are not welcome there. You can't have it both ways."

"Go down there and take the park"

By 9 a.m. on May 15, the park's negotiating committee had put out a leaf-let announcing a noon rally on campus. Word of the police occupation of the park and erection of the fence spread quickly through a telephone tree and word of mouth. By noon, several thousand park supporters had gathered at UC Berkeley's Sproul Plaza, which had been reserved by Michael Lerner and the New Left Forum for a rally about the Middle East crisis. The *Daily Californian* of May 11 reported that Lerner had scheduled Paul Jacobs, a prominent Bay Area writer and activist, and Jean-Pierre Salanic, an attorney from Nice, France, to speak. In the late morning on May 15, Lerner and park leaders agreed to modify the agenda and the focus of the rally in light of the day's events.

Speakers at the rally included Lerner, poet Denise Levertov, Paul Jacobs, the Reverend Richard York, and Leslie Russell, of the campus AFSCME (American Federation of State, County and Municipal Employees) union. Incoming student body president Dan Siegel stepped into history, urging that the crowd go "take the park." Activists Shari Whitehead and Tom Hayden were scheduled to speak after Siegel, but that was not to be, as after Siegel's speech the crowd turned and marched south on Telegraph.

MICHAEL DELACOUR
boilermaker and People's Park cofounder
I got to Sproul Plaza at about ten o'clock, assuming that we would have a rally there. Michael Lerner had a permit for speeches about the Mideast situation. We strong-armed him into giving us the second hour.

MICHAEL LERNER
UC Berkeley graduate student in philosophy and chapter president of Students for a Democratic Society (SDS)
On May 15 I had a permit for an event on Sproul Plaza. We had formed a Committee for Peace in the Middle East, and it had been our plan to announce formation of the committee on May 15. By ten o'clock in the morning I realized that there were more pressing issues because of the park. I didn't want to risk discipline for changing the purpose of the rally, so I started with a speech about the historical struggle for land in the Mideast and the parallels with the People's Park issue. As the rally got going, the leaders debated what action would be announced. They also debated who was going to deliver that

message, because that person was sure to be arrested. The general consensus was that there should be a protest outside the park, but nobody had violence in mind. When Dan Siegel made his speech, all the plans went out the window.

SHARI WHITEHEAD
member of the Liberated Women of Berkeley
Inasmuch as this has been a meaningful and creative work experience, and insofar as the Park is a free space where peoples can feel liberated, we are going to organize a community march to the Chancellor's office. (*Berkeley Daily Gazette*, May 16, 1969)

PAUL JACOBS
investigative reporter, social critic, and radical activist
[Jacobs recalls having said on May 15:] "I came here to speak about the war in the Middle East but it looks as if a war is going on right here in Berkeley."

I spoke briefly, trying to bring the fight about the People's Park into a general perspective. (From *Between the Rock and the Hard Place*)

DENISE LEVERTOV
poet and UC Berkeley professor of English

To the Park
to the park:
ringed with police
bulldozers have moved in
barely awake, the people—
those who had made for each other
a green place—
begin to gather at the corners
their tears fall on sidewalk cement.
the fence goes up, twice a man's height.
everyone knows (yet no one yet
believes it) what all shall know
this day, and the days that follow:
now, the clubs, the gas, bayonets, bullets. the
 war
comes home to us...

A faculty strike might help. We might not restore the Park to the People, but we might at least give some sign that all those books, all those poems, all that philosophy, all that body of civilized knowledge we are paid to transmit *means* something. The Park was a little island of peace and hope in a world made filthy and hopeless by war and injustice. (May 15, 1969, "From a Notebook: October '69–May '69")

REVEREND RICHARD YORK
Berkeley Free Church
The park is even stronger than universities. As followers of Jesus, we are committed to stand with that spirit—the spirit of the poor and alienated trying to create a new world on the vacant lots of the old.

CHARLIE PALMER
UC Berkeley undergraduate student and president of ASUC
I was not in Berkeley on May 15. I was at UCLA for a student government meeting. I immediately returned to Berkeley, where a very happy, positive thing—People's Park—had turned into a nightmare, which was remarkably bizarre. We the leaders of ASUC had chosen Dan Siegel to lead ASUC for the academic year after my term. He had gone to college on the East Coast, was in law school, and he seemed like a strong pick.

DAN SIEGEL
UC Berkeley law student and incoming president of ASUC
I arrived in Berkeley in the fall of 1967 and entered the school of law, which was then known as Boalt. I was involved as a legal monitor for Stop the Draft Week protests in October 1967. I wore my Brooks Brothers jacket with a white armband. An Oakland cop hit me on the head, which radicalized me. I worked in Charles Garry's office on the legal defense of the Oakland Seven [the activists charged with conspiring to mount violent antidraft protests], and then worked on the Movement Against Political Suspensions, the Vietnam Commencement (I was the student speaker at the commencement), the street battles on Telegraph Avenue in the summer of 1968, the Eldridge Cleaver protests, and the Third World Liberation strike. In the summer of 1968 my parents visited from New York and I took them to walk around Telegraph Avenue, which meant that they got tear-gassed. I was briefly a member of SDS. When [the] Progressive Labor [Party] took over the SDS chapter, I joined the newly formed Radical Students Union.

"As the rally got going, the leaders debated what action would be announced. They also debated who was going to deliver that message, because that person was sure to be arrested."

Dan Siegel, law student and incoming president of the Associated
Students of the University of California, UC 's student government.

On May 15, people just assumed that there would be a rally at noon—there was every day. I was in the ASUC office looking down on Sproul Plaza. Jondavid Bachrach, a member of the student senate, told me that I should speak. I went down to the plaza. The heavies were going to speak after me to explain the plan. I gathered my thoughts for a few minutes and then spoke. I had no notes and was not sure what I was going to say beyond outlining the history, explaining the issue, and saying that some form of protest would be appropriate, expecting that the rally would continue with more speakers. This is what I said:

> [Chancellor] Roger Heyns does not want you to think that you can control your lives. That's why he is tearing it down. For seven months he allowed a mud puddle to exist and let people use the land for their purpose—parking their cars. But when some other people found a better way to use that land by building a park, Heyns suddenly said a soccer field is what he wanted. In effect, Heyns is saying that it will be [his] park "by any means necessary" because he doesn't want anyone to doubt who is the boss of the university.
>
> Now we have not yet exactly decided what we are going to do. But there are some plans. I have a suggestion: Let's go down to People's Park, because we are the people. But a couple of things—a couple of points I would like to make: If we are to win this thing, it is because we are making it more costly for the university to put up its fence than it is for them to take down their fence. What we have to do, then, is maximize the cost to them, minimize the cost to us. So what that means is, people, be careful. Don't let those pigs beat the shit out of you. Don't let yourselves get arrested on felonies. Go down there and take the park.

The police shut down the sound system as I was speaking. The speech was being tape-recorded even when the microphone went dead, and on the tape you can hear Michael Lerner and Tom Hayden criticizing me for sending people away. It was not my duty to send people into action and I didn't feel like I had.

I had a pretty good idea that I was going to be arrested for what I had said. I laid low for a few days, talked with my father about posting bail, and then turned myself in. I was charged with violating section 404.6 of the Penal Code, incitement to riot.

Mal Burnstein represented me on the criminal charges and I was acquitted. I came within a few votes of being expelled. After I graduated from law school, the State Bar concluded that I was unfit to practice law because of three speeches I gave, including the May 15 speech. I had to go all the way to the California Supreme Court to be admitted to practice law.

People's Park was one in a long chain of events where the issue was whether students and the community would be empowered to make decisions about their community. That was the case in the Free Speech Movement and it was with People's Park. It was always about who's making decisions for the community.

"Let's go down to People's Park, because we are the people....Don't let those pigs beat the shit out of you. Don't let yourselves get arrested on felonies. Go down there and take the park."

MAL BURNSTEIN
attorney for Dan Siegel

I graduated from law school in Berkeley in 1958. Ed Meese [chief of staff for Governor Reagan] was in my class. Then, as later in life, he was a conservative jerk. I went to work for Bob Treuhaft and Doris Walker, practicing poor-people's law. I, along with Henry Elson, Norman Leonard, and Charles Garry, defended the large group arrested during the Free Speech Movement. In 1968 I was part of the legal defense team for the Oakland Seven, along with Charles Garry and Dick Hodge. I was not a major player. All seven were acquitted. I represented Dan Siegel on the charges coming out of his speech at Sproul Plaza on May 15. He is a very smart man and was not an easy client. In my closing argument, I told the jury that to understand what Dan meant when he said "take the park" they should look at the dictionary definition of "take." There is nothing in the definition of "take" about acting criminally. What Dan meant was that the crowd should make a statement about keeping the park public, about converting it to use by the people. I didn't have any jury consultants, I just made a logical argument about what Dan meant and what he didn't mean. He was acquitted.

CALIFORNIA SUPREME COURT

Petitioner testified that the language used by him in this speech was not a call to any particular action at all except insofar as it urged the crowd to move to the location of the park and peacefully demonstrate its opposition to the action taken by the university; that the concluding statement of the speech, urging the crowd to "go down there and take the park," was not a call to violence but a call to undertake the first phase of an ongoing demonstration of public disapproval which would hopefully result in the return of the "park" to those who had begun to develop it; and that it was not contemplated by him or any of the rally's organizers that petitioner's speech would conclude the rally but rather it was expected that further speakers would come forward after petitioner with specific proposals for action. We are satisfied that there is a reasonable basis for concluding that none of petitioner's speeches in fact advocated unlawful violence. (*Siegel v. Committee of Bar Examiners*, 1973)

JONDAVID BACHRACH
UC Berkeley undergraduate student and ASUC senator

I was part of the leadership for the rally on Sproul Plaza on May 15, and I believe that I spoke briefly. I urged Dan Siegel to speak, as he was the incoming ASUC president. I knew Dan, and the ASUC leadership had been impressed with the fact that he came from the East Coast, not California. I admired his intelligence but had been publicly critical of him in the *Daily Californian*.

JENTRI ANDERS
UC Berkeley graduate student in anthropology

I must confess I was startled to hear that suggestion from such a mainstream representative. In fact, I remember everyone near me being first startled, then electrified. (From *Berkeley Backlog*)

LETTER TO DAN SIEGEL, INCOMING PRESDIDENT OF ASUC, FROM DAVE VAN SCIVER, EXECUTIVE DIRECTOR OF THE BERKELEY CHAPTER OF YOUNG AMERICANS FOR FREEDOM

You chose to ignore the abundant warnings of danger and with your cry "take the park" created a situation that resulted in one death and numerous serious injuries to students, police, and bystanders. For this we hold you responsible.

Since Thursday the situation has deteriorated to the point where reasoned discussion is impossible[,] with a future that portends even worse. For this we hold you responsible.

Governor Reagan has been forced to re-affirm and strengthen his state of emergency proclamation and suspend numerous rights of the Berkeley citizenry. A pall of oppression has descended over the city. For this, we hold you morally responsible.

We respectfully request that you voluntarily refrain from taking office when the present Student Body President stands down. (May 20, 1969)

The rally crowd leaves Sproul Plaza, marching south on Telegraph Avenue toward People's Park.

The March Down Telegraph Avenue

After Siegel's exhortation at Sproul Plaza, several thousand students and park supporters turned south and began marching down Telegraph toward People's Park, three blocks away. Although the police were not prepared for a large march, they halted the protestors before Haste Street so they could not reach People's Park half a block to the east. A fire hydrant was opened and the police responded with batons and tear gas. Some marchers threw rocks, bricks, and bottles, and some hurled tear gas canisters back at the police.

Acting on behalf of Governor Reagan, Chief of Staff Ed Meese assumed control of the situation. He called in police from other jurisdictions, eventually bringing the number of police on Telegraph Avenue to almost eight hundred. Governor Reagan claimed several days later that the demonstrators "overran whole squadrons of police and they beat and stomped them." The evidence does not support this claim, or his claim that the deputies with shotguns were stepping over the bodies of their downed comrades.

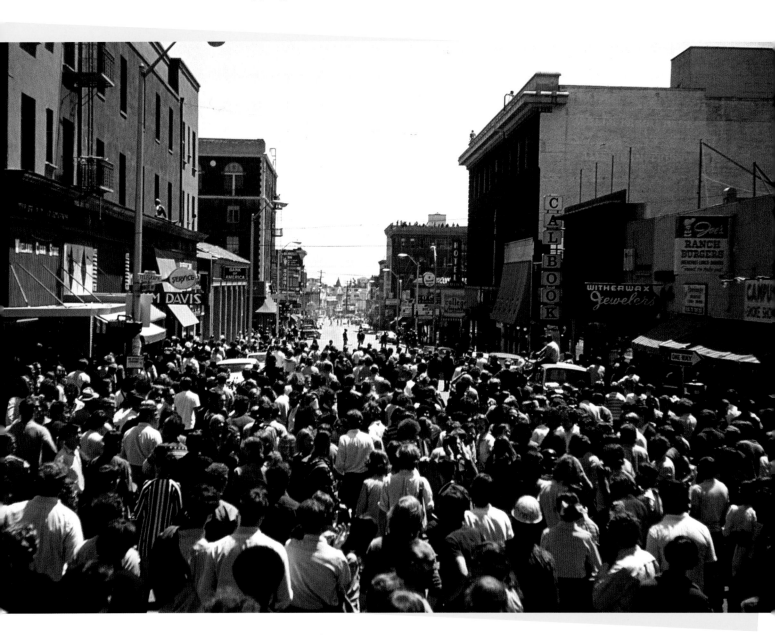

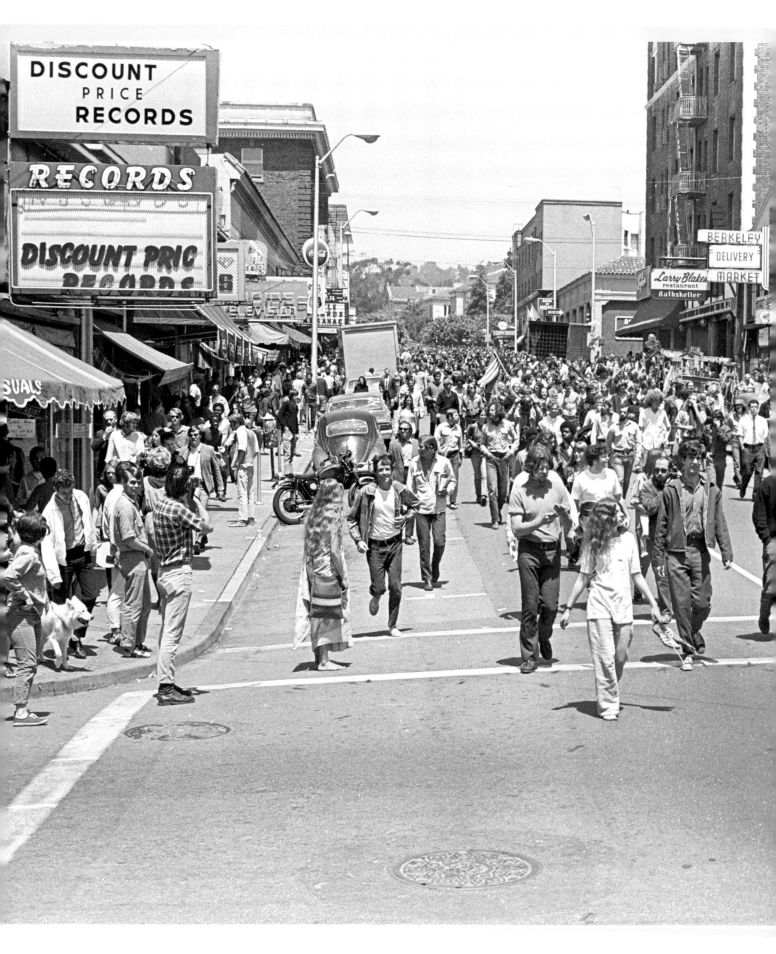

Part of the crowd crossing Channing Way, heading south toward People's Park.

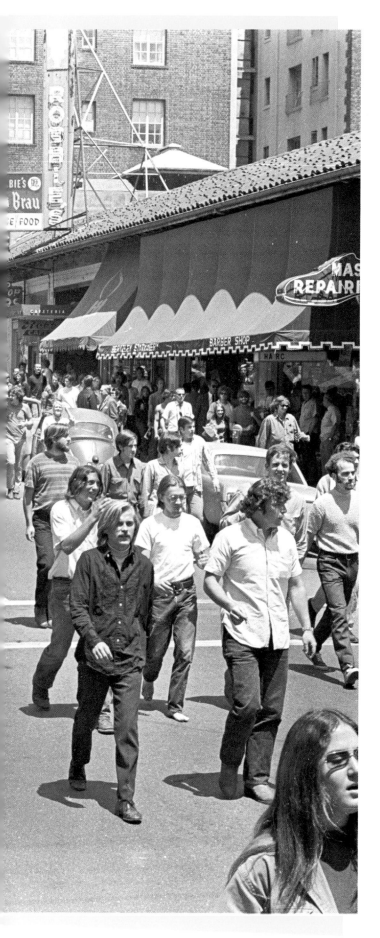

DAN SIEGEL
UC Berkeley law student and incoming president of ASUC
I marched at the rear of the crowd. I made it as far as Haste Street, where the crowd was stopped by police. The crowd was mellow. They ambled. At Haste, things changed. Rocks and bottles were thrown from the demonstrators, and the police got very aggressive. I walked back to the ASUC office.

MICHAEL LERNER
UC Berkeley graduate student in philosophy and chapter president of Students for a Democratic Society (SDS)
I marched until Haste Street. When people at the back of the march started throwing beer bottles, I remember thinking that it wasn't smart and that perhaps they were provocateurs. At about two in the afternoon I left to teach a class at San Francisco State. It all happened very quickly and was a surprise. That night, somebody shot two bullets through my window into my bedroom, hitting about five feet above where I was sleeping.

DENNY SMITHSON
reporter for KPFA (broadcasting live)
Suddenly there was water...The water from the hydrant is being directed at the police...Bottles are flying in now. More rocks...More rocks are flying out of the crowd now at the Highway Patrol...Rocks, bottles, you name it. The police have retreated around the corner. Which means, of course, that it won't be long until they come back in force...In amazing numbers there are things being tossed...The police are withdrawing now back up Haste. People are still running toward that intersection throwing rocks, bottles, whatever. More tear gas, but most of it seems to be going back in the wrong direction toward the police...There's a nurse in a nurse's uniform being beaten by the police. (May 15, 1969)

MICHAEL DELACOUR
boilermaker and People's Park cofounder
I marched to Haste. There was no plan, no leadership for the march. It was very unplanned. Somebody opened the fire hydrant, a typical feature in marches and demonstrations and riots on Telegraph. I was told that it was my daughter Kathy, but I didn't see it happen. What was different this time was that instead of waiting

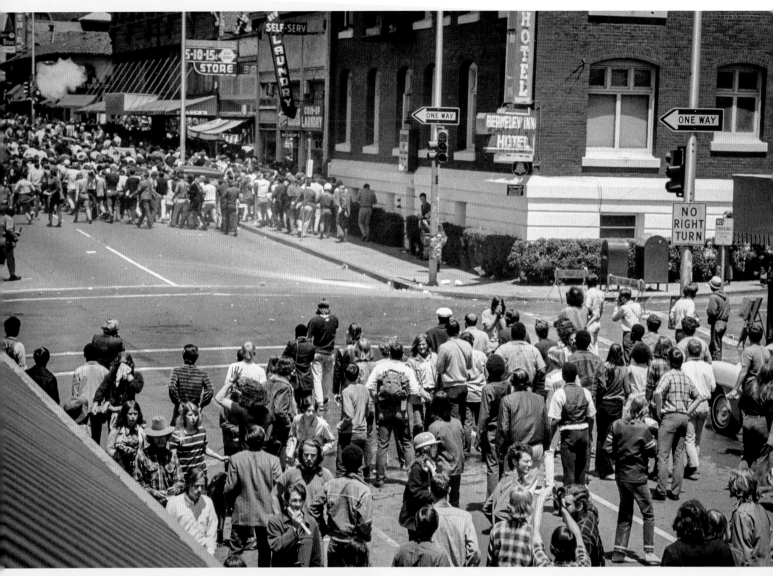

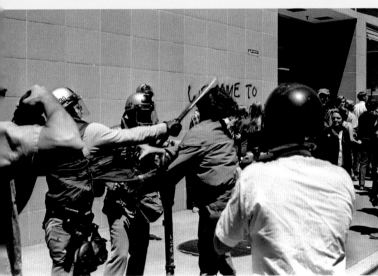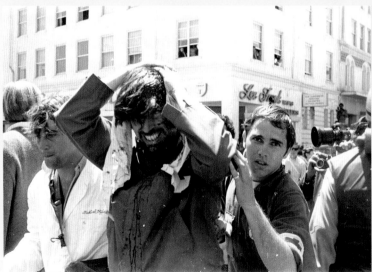

Top: A crowd at Telegraph Avenue and Haste Street, looking north. The brick building on the corner is the since–demolished Berkeley Inn.
Right: A police officer turns off the fire hydrant opened by protestors at Haste Street and Telegraph Avenue.

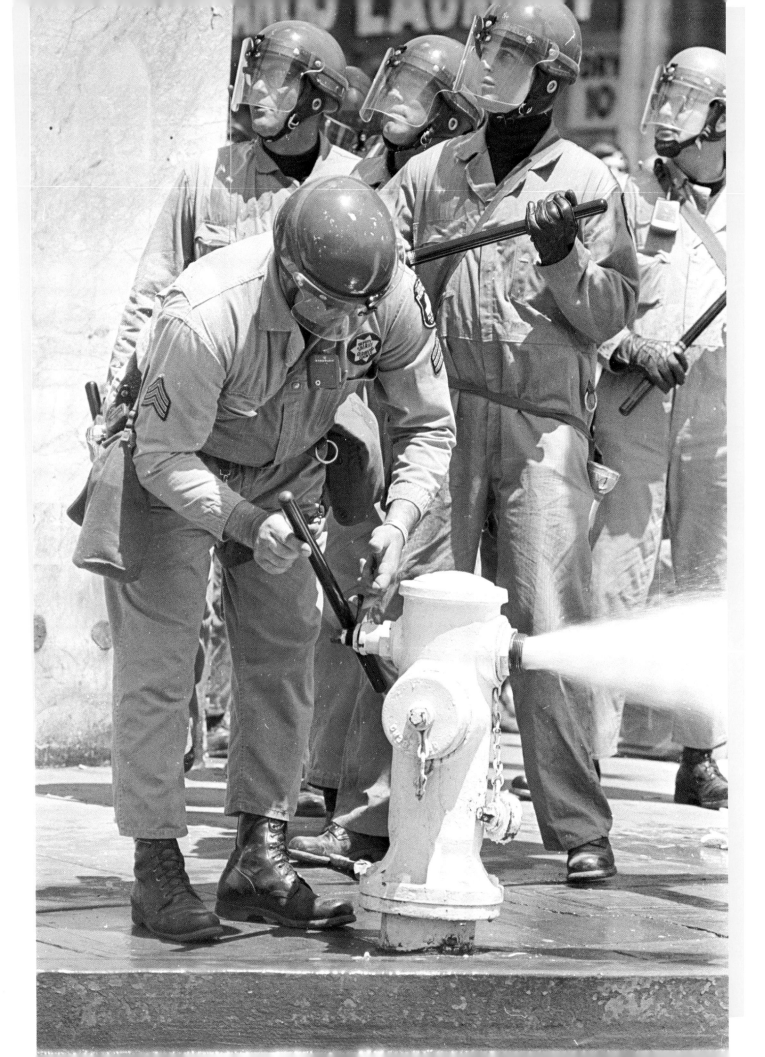

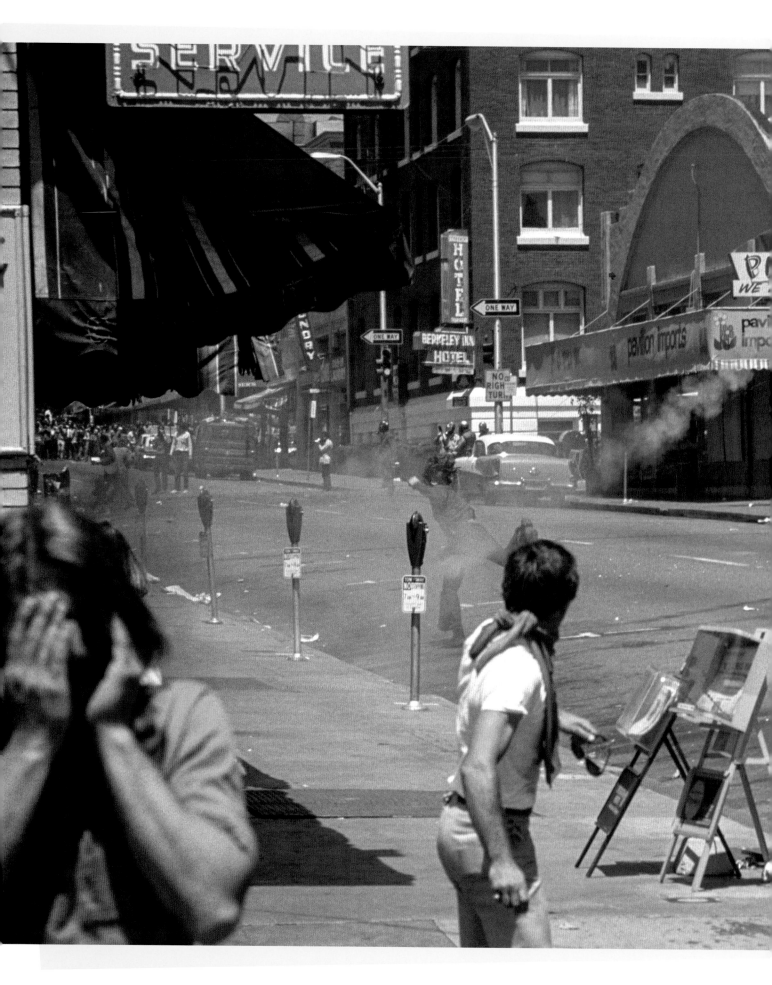

Looking north on Telegraph Avenue from Dwight Way.

a long time for the fire department to come and close the hydrant, the police had a wrench and shut it down fairly quickly. I got to Dwight [Way] before the shooting started. There was no plan at all. A lot of the police aggression was taken out on the Granma bookstore at 2509 Telegraph, just south of Dwight, which was operated by the Socialist Workers Party. I don't think that there is any coincidence here. James Rector was on the Granma roof.

The tear gas started up and things got more out of control. I didn't see many rocks or bottles or bricks or any rebar being thrown by the demonstrators, but I did see demonstrators picking up tear gas canisters and throwing them back at the police. Nothing I saw up to this point was any different than many other Berkeley riots I had seen over the last few years. I was suddenly convinced that the police would raid my apartment. I ran down to the apartment at Francisco and Grove [now Martin Luther King Jr. Way] and hid my weed and then came back up to the campus. By then, the San Francisco Police Department Tactical Squad was shooting indiscriminately at anything that moved on campus.

JUDY GUMBO
Yippie and People's Park cofounder
We thought that the university would cave in because the park was such a wonderful idea for the people. We were naive about the politics, about Reagan and his bloodbath quote and how he was using Berkeley as a demon in his campaign. The gas hit the Ashby house [where Judy and Stew and Tom Hayden lived]. We found a bullet hole in the bottom window the next morning. We were on Telegraph. My women's group and I were going to have a rally on Sproul, but everything turned into the park. When the gas and shooting started, I don't remember feeling fear. We were really angry and militant. I remember feeling "Fight back."

STEVE LADD
UC Berkeley undergraduate student
I gravitated to others who were committed to draft resistance and nonviolent protest. During People's Park we were the only peaceful, nonviolent group [of its kind] on campus. I was in Sproul Plaza when Dan Siegel spoke. I marched down Telegraph toward the park. I'd tell the police, "You're not helping here." If a cop was

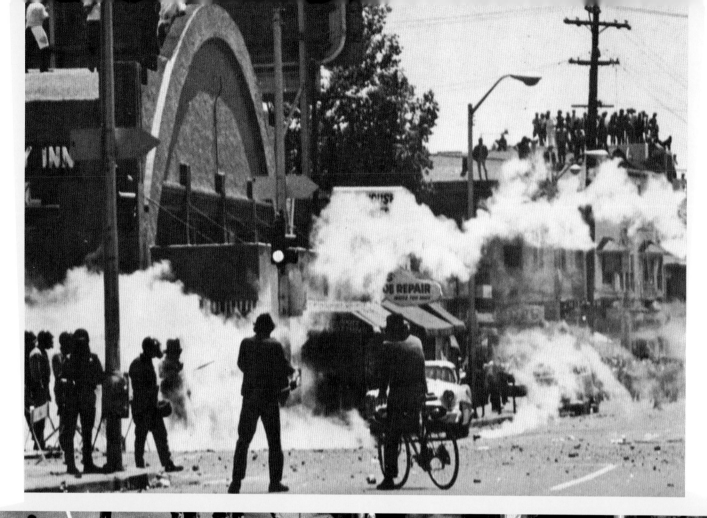
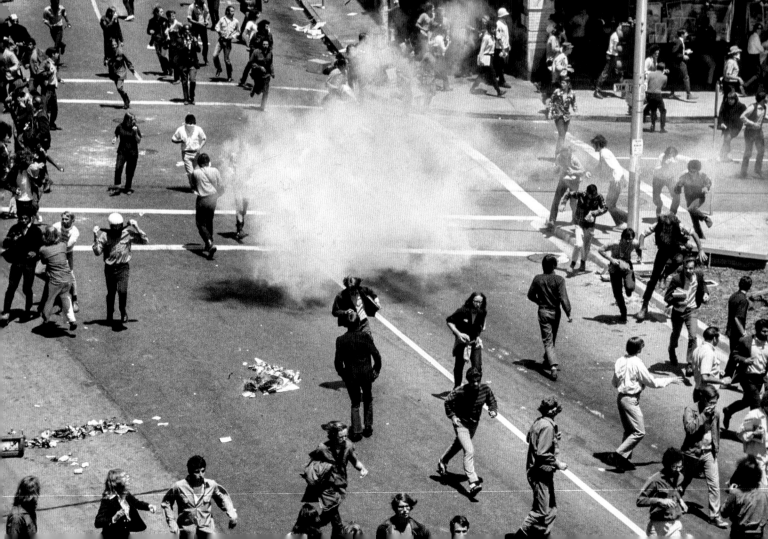

"When the gas and shooting started, I don't remember feeling fear. We were really angry and militant. I remember feeling 'Fight back.'"

charging a demonstrator, I would try to place myself as a buffer, to disrupt it. The Bank of America still had windows. They got smashed. Again. There were so many riots—one every semester, it seemed. It's a miracle that I lived through it.

ART ECKSTEIN
UC Berkeley graduate student in history
On May 15, I had breakfast with friends and then went to Sproul. I don't remember how we learned that the university had fenced the park or that there would be a rally. I went to the rally but don't remember any of the speakers or speeches. I joined the march but didn't get very far before people ahead of me turned and ran. I ran back to campus, through Sather Gate to Dwinelle Hall. There were Alameda County sheriffs in their blue jumpsuits marauding through campus, shooting at anything that moved. The behavior of the demonstrators on Telegraph that day was no more serious or violent than what I had seen over the last year.

STEPHEN SHAMES
UC Berkeley undergraduate student and photographer
Berkeley had seen a lot of riots in the year before People's Park, and People's Park on May 15 was no worse than the Third World Liberation strike riots until the deputies starting shooting. Only the police violence was worse.

SETH KATZMAN
dropout from San Jose State
I had gone through a number of Berkeley riots, and what happened on May 15 was no worse than a typical Berkeley riot except for the police response.

DHYANI (JENNIFER) BERGER
UC Berkeley graduate student in biology
I was at the rally in Sproul Plaza and went with the crowd down Telegraph Avenue. I was photographing, but I think I turned back before the tear gas and shooting started. As a foreign student [from Kenya] I strategically limited my activism at times.

BRUNO COON
tenth-grader at Berkeley High School
I was at the fence and in the wave of marchers that came from Dan Siegel's speech calling for us to "go and take back the park." We pushed at the fence and it was surprising to feel it collapse in front of us, like it was made of wax. I also remember watching people tear up the asphalt out of the streets to arm themselves as the various cops and sheriffs arrived to fight us. At one point, I and someone I didn't know were being chased by a cop. We dove into a little side yard and I started to climb over a fence. I looked back to see the cop beating the other guy into the ground with a stick, and with every stroke the cop shouted, "DISPERSE! DISPERSE!" It truly seemed like he was insane.

DAVID LANCE GOINES
Free Speech Movement activist and printer
I participated in the People's Park demonstrations by printing innumerable leaflets and protest posters, which largely precluded my physical participation, with the exception of getting tear-gassed with my girlfriend at the Telegraph Repertory Cinema, running for safety into the first house we came to, and sneaking back home to avoid confrontation with the roaming packs of sheriffs and National Guardsmen. Aside from that, [I was] pretty much behind a printing press without much of a break.

Left, top: Looking south on Telegraph Avenue from Haste Street. Note the crowds on rooftops just south of Dwight Way.

ROBERT CARTER
eyewitness

I had never seen the People's Park and heard it was really beautiful, so I hitchhiked over from San Francisco late Thursday morning. When the people got to Haste it turned into a scene right out of *The Battle of Algiers*. The pigs started using tear gas, beating people, and people were running and being run down and busted by the pigs, so I got out of there and ran down Haste. (*Berkeley Barb*, May 30–June 5, 1969)

PETER BARNES
reporter for Newsweek

When youthful citizens can be wantonly gassed and beaten all because of a small, unauthorized park, what has happened to America?...[The police displayed] a lawless brutality equal to that of Chicago, along with weapons and techniques that even the authorities in Chicago did not dare employ: the firing of buckshot at fleeing crowds and unarmed bystanders, and the gassing—at times for no reason at all—of entire streets and portions of the college campus.

MARGARET PLOUSE
history teacher at Willard Junior High School

We teachers at Willard Junior High School are protesting the use of tear gas and pepper gas in front of Willard Junior High School on Thursday, May 15. We feel that the indiscriminate use of tear gas is unjustifiable. The use of tear gas around a public school is irresponsible. The police were carrying out pursuit and punishment when the large groups had already been dispersed. We should have been warned that tear gas was going to be released. We do not feel that we were in any way protected by the police. Without warning there was tear gas in almost all the classrooms. Eyes burned, throats scratched, students and teachers did not know what to do. It was a very chaotic and frightening situation. School was dismissed so that the children could go home. Tear gas was released and students had to return to the school. The children went through a terrifying experience. (KPFA radio, May 21, 1969)

SOL STERN
reporter for Ramparts magazine

I was standing in the crowd on Telegraph, doing nothing. A policeman grabbed me out of the crowd, threw me in his car, and told me I was under arrest. My friends bailed me out that night and the charges were summarily dismissed at the time of my arraignment.

SCOTT JOHNSON
medic for the Berkeley Free Church

Police were in the area around the Student Union and the Sproul steps and in the plaza. They started tear-gassing students who were around the fountain area and in front of Sather Gate. Alameda [County] sheriffs and CHP burst through the southwest door of the Student Union and started throwing and shooting tear gas canisters out into the lobby, and a few were shot upstairs. I saw them shooting tear gas from shotguns, and they were shooting them upstairs. The gas was thick. The bathroom was full of gas. At least one canister was tossed into the bathroom. There is no window in the bathroom, only a vent. I saw ten or twelve people in there. Some were staggering around blind and violently coughing. Out near the bridge the police were shooting concussion grenades. About two minutes later we heard a loud cracking coming from the northwest corner of Sproul. It was birdshot coming through the trees. People were screaming. The police, mainly San Francisco, probably Tactical Squad, were shooting at us.

STEVEN ERIC WHITE
unemployed

At about 4 p.m. I was at Tijuana Joe's on Telegraph. A young man was being forcibly held by several officers. After they had gotten him down to the pavement, I saw blows from the policeman's clubs striking him on the legs and other parts of his body. He was yelling out in pain. The young man's name was Tony Prescott.

GENE ALAN SCOTT
UC Berkeley undergraduate student

I was coming home from school, west on Channing. The shout "Get him!" came from a police car. Three policemen jumped out of the car. A young man slipped on the asphalt in the parking

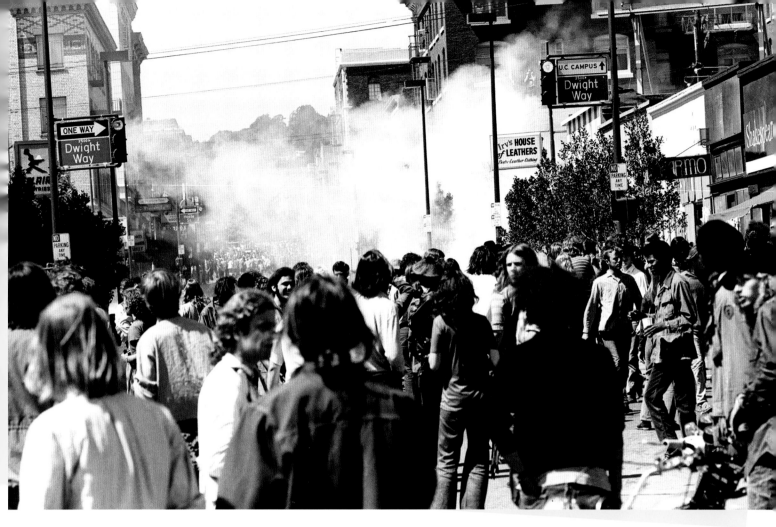

A crowd of people seemingly unaffected by the tear gas released a block north of them.

lot. He was on his back with his hands raised very quickly, saying, "I give, I give." The first two policemen to reach him grabbed an arm to hold him down, and about two seconds later a third police officer ran to him and slid into him with a knee.

ERROL WADDELL
UC Berkeley undergraduate student
I was in a class in Dwinelle Hall when the police and demonstrators entered the plaza. After the plaza had been cleared, the police were still throwing canisters. When a canister was thrown at the steps of Dwinelle, a man dressed in a white shirt attempted to knock it with a stick away from the building to keep the gas from collecting in the hall. He kicked it away. The police in blue uniforms caught him and began to club him repeatedly and needlessly. They dragged him away; he was not able to walk himself.

> **"When youthful citizens can be wantonly gassed and beaten all because of a small, unauthorized park, what has happened to America?"**

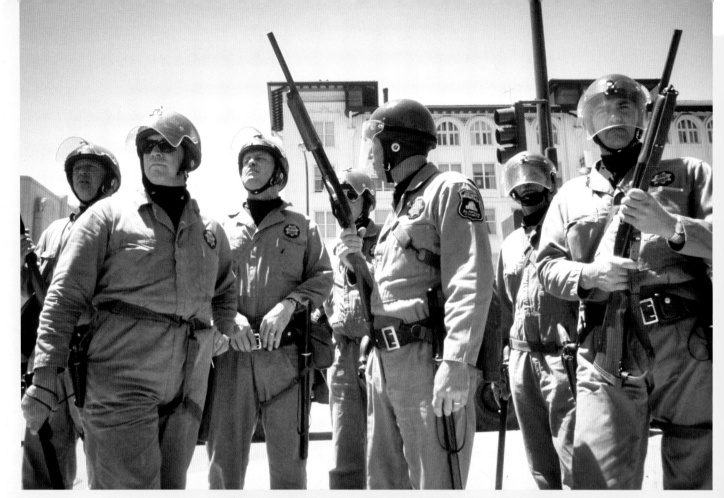

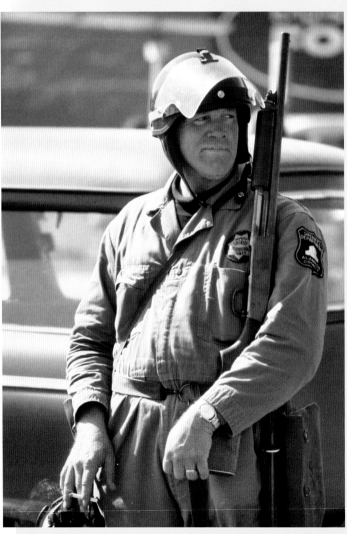

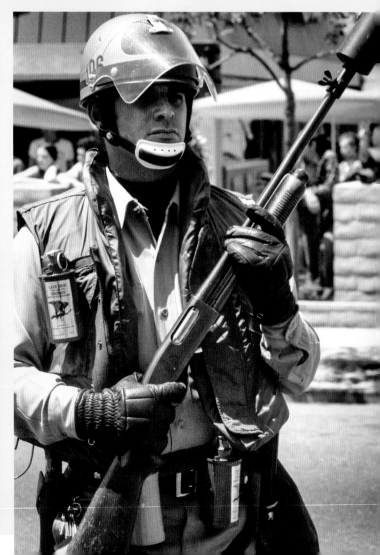

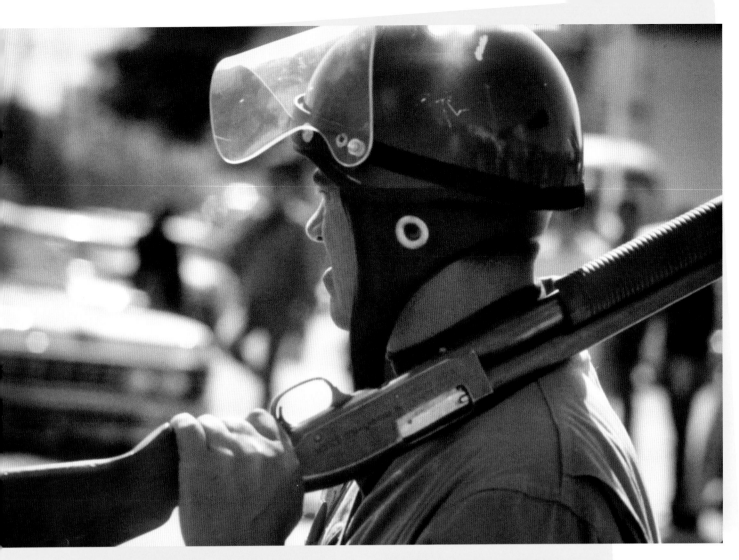

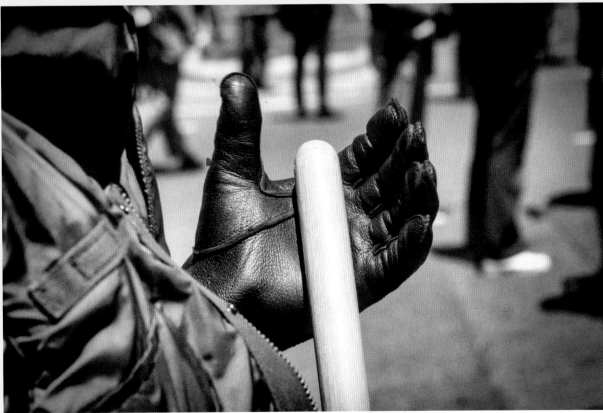

Alameda County sheriff's deputies were dubbed "Blue Meanies" by protestors, referencing characters from the Beatles' animated film *Yellow Submarine*.

PETER WARD

UC Berkeley undergraduate student

I was taking a Math 128B midterm exam in Dwinelle Hall, room 350, between 2:00 p.m. and 4:30 p.m. I saw police throw tear gas canisters toward the front entrance to Dwinelle Hall. Then I saw a young man kick an exploding canister toward the center of the plaza in front of Dwinelle Hall. A policeman ran quickly toward the young man, who ran toward the steps of Dwinelle Hall. He tripped over a low curb on the northern side of the steps and fell headlong with his glasses flying. The policeman who was pursuing him caught up with him. While the young man was crouching, the policeman hit him with a riot stick on his head. Several other policemen ran up, and several of them also hit him with riot sticks all over his body. They took him toward Sather Gate.

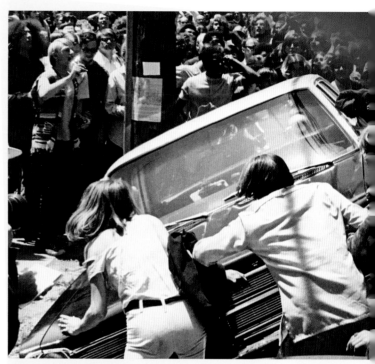

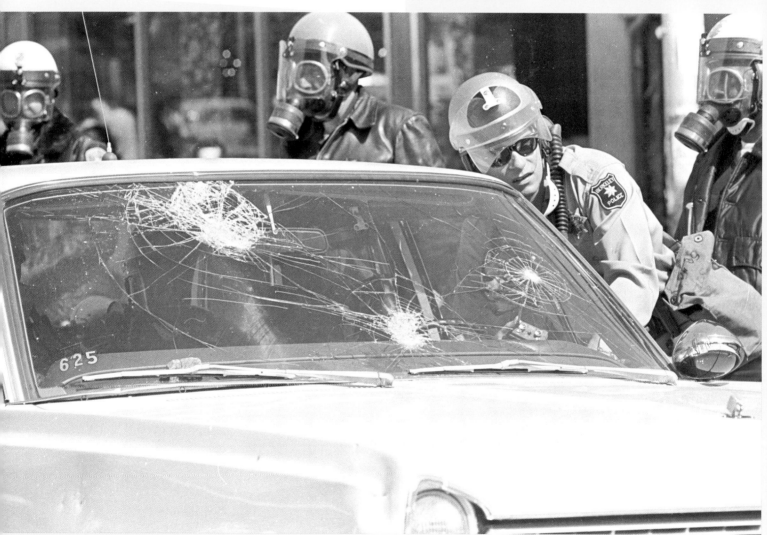

KATHLEEN DAILEY
UC Berkeley undergraduate student

At about 3:30 I was standing on the grass facing Sproul Plaza in the vicinity of Sather Gate. Three policemen moved in my direction and some of the bystanders scattered. One was chased and caught near Sather Gate. His head was pinned back with a club by one policeman. A second policeman hit him in the crotch with his club. People asked the victim his name, but the club was gripped so tightly that he couldn't speak. As they took him away, one of the three remaining policemen hurled a canister into the group of onlooking bystanders. There was absolutely no provocation for this action.

Left, top: Demonstrators rock a City of Berkeley car on Telegraph Avenue between Dwight Way and Parker Street. Left, bottom: A broken windshield on a City of Berkeley car. Below: A City of Berkeley car flipped over and on fire at the corner of Telegraph Avenue and Parker Street.

HENRY WEINSTEIN
UC Berkeley law student and a reporter for the Daily Californian

I came to Berkeley as a freshman in 1962, a liberal Democrat from the San Fernando Valley. At orientation I joined SLATE, and I stayed with SLATE for my undergraduate years. I was elected to ASUC as a SLATE senator. In my first year, I got involved with civil rights demonstrations by CORE [the Congress of Racial Equality] and the Emergency Committee to Aid Migrants. I supported the Free Speech Movement, the Vietnam Day Committee activities, Stop the Draft Week, the Cleaver demonstrations, and the Third World [Liberation Front] strike. I went to work as a reporter for the *Daily Cal* in February 1968 while a second-year law student. It was a great time to be a student journalist for a paper that published five issues a week. I interviewed Eldridge Cleaver, who was at the height of his radical brilliance.

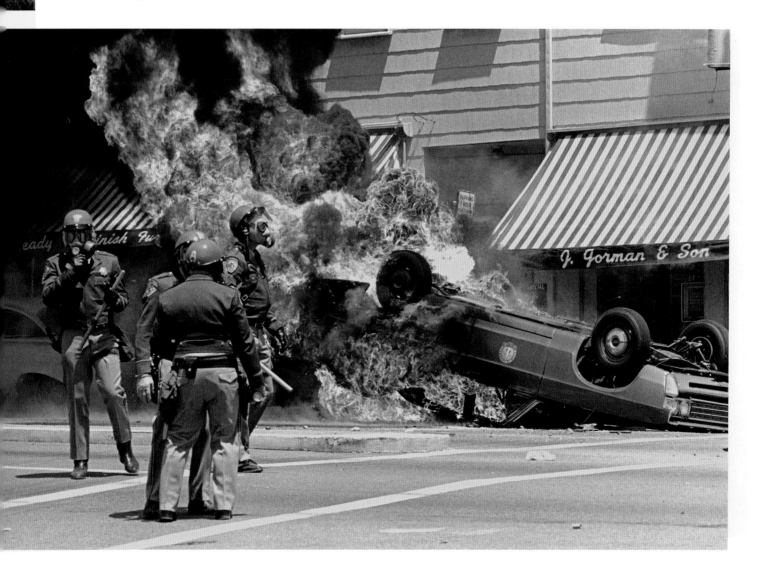

He said, "You white kids are on a extended field trip against your parents." I didn't feel that way, but it was a perceptive observation. I also attended the [anti–Vietnam War] protest at the Century Plaza in Los Angeles on June 23, 1967. The police brutality there was a real eye-opener. The Oakland Police during Stop the Draft Week were also very violent—I ran and I ran fast.

I saw the riots on Telegraph on May 15. I had seen plenty of Berkeley riots, and a few months earlier had seen tear gas used by the police for the first time during the Third World Liberation strike. When the Alameda County sheriff's deputies brought shotguns out on May 15, I knew that we were in new territory.

RICHARD DREW
manager of Gnoman Copy Service
In the midafternoon, my wife and I were walking toward my store on Durant Avenue, near the parking lot by Sy's Charbroiler. I saw a man running toward me on the sidewalk with two policemen (I believe they were CHP) in pursuit. One of the two police threw his nightstick at the person's legs; it hit him and bounced off. The second policemen drew his service revolver and leveled it at the person's back. The man under pursuit immediately stopped and was apprehended. He offered absolutely no resistance. He asked one of the policemen why he was arrested. The policeman punched him in the jaw. He was put in the back of the paddy wagon. We picked up the book that the man had been carrying. His name was Ezio Maiolini.

ANDREW BLASKY
UC Berkeley graduate student in English
A young man about twenty was leaning on a car between where I was standing at the southwest corner of Channing and Telegraph and the corner. A policeman came up behind him and, catching him by surprise, caught him in a headlock with his nightstick. As far as I could tell, the young man wasn't doing anything. The street was not crowded, nor was there any violence going on. The policeman was using a rough choking hold.

HOWARD DRATCH
UC Berkeley graduate student in political theory
I came to Berkeley in September 1967 for graduate school after doing my undergraduate work and getting radicalized at the University of Wisconsin and serving as a VISTA volunteer for a summer in Washington, D.C. At Berkeley I was part of the Radical Student Union, where radical politics and a counterculture ethos and a sense of humor mixed and mingled.

I took part in the Telegraph Avenue demonstrations in the summer of 1968, the Eldridge Cleaver protests in the fall of 1968, and the Third World strike in the spring of 1969. I was used to Berkeley riots. There were implicit rules of engagement between the police and demonstrators—nobody would get seriously hurt. It was a kind of musical drama. It was not unlike the ritualistic Japanese Noh theater. Until People's Park, we all lived within the parameters of

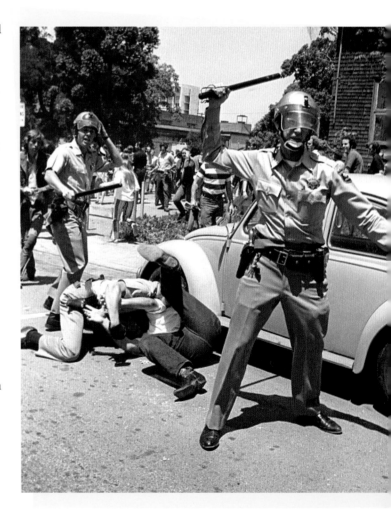

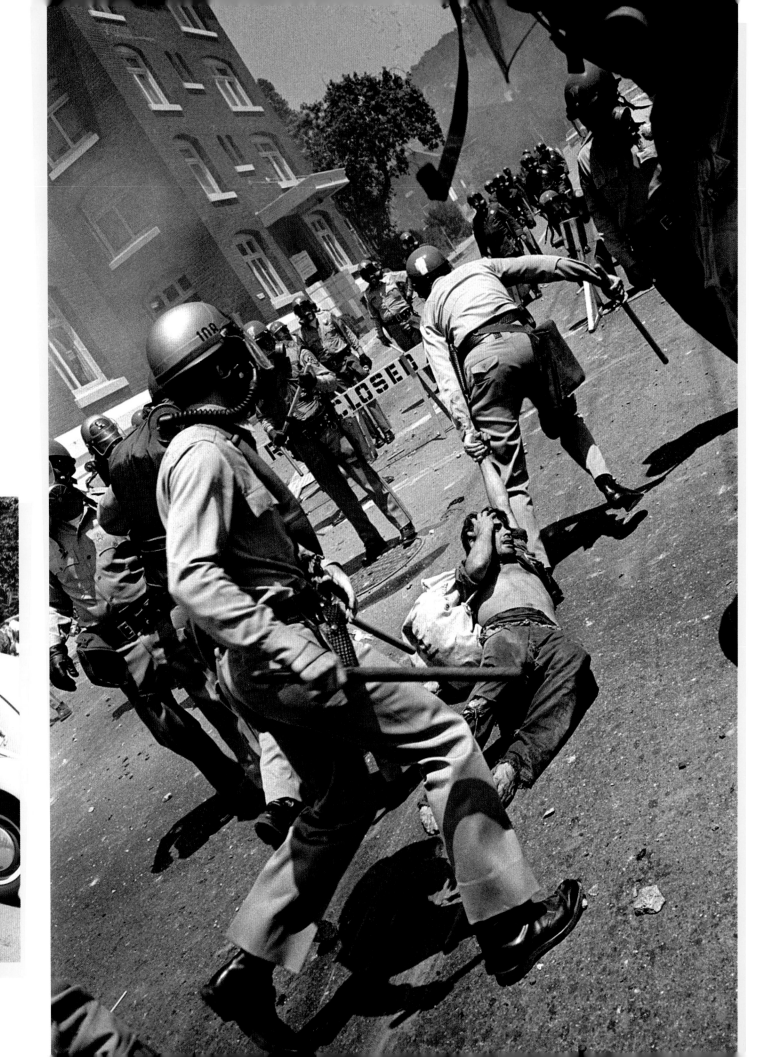

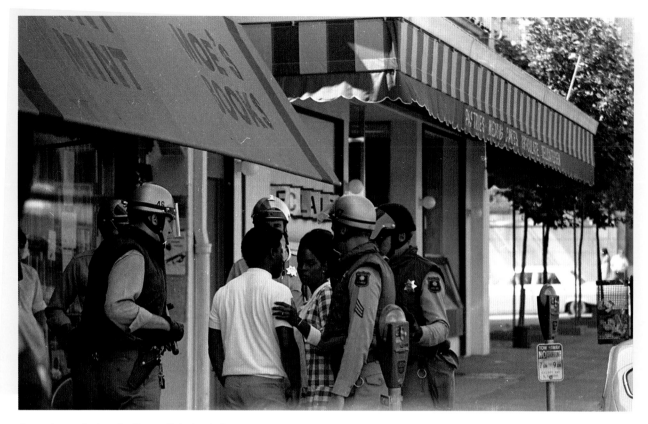

A couple comfort each other on Telegraph Avenue in front of Moe's Books.

normalized adversarial behavior. Things got a little tough with the Third World Liberation strike, and tear gas was used for the first time. I was working as a teaching assistant to a professor who didn't support my desire to hold my class off campus.

After Siegel's speech, the crowd surged down Telegraph. When I got to Telegraph and Dwight, I saw that the police response was serious—much more serious than the typical Berkeley riot. The riot rules of engagement had changed, and it was a real confrontation. It was not clear to me who started things, but the police had guns and were using them and we didn't. Mao Zedong said that power comes from the barrel of a gun. If that is true, the police had all the power on May 15.

PAUL MORUZA
sixth-grader at Willard Junior High School
I was in a music appreciation class at Willard. At about the same instant, the whole class started feeling severe stinging in their eyes. The entire school quickly filled up with tear gas. This created a complete panic in the classroom. Teachers wet towels and helped the students wipe off their eyes. Some of the students got sick. It was very frightening. There was a sense that things were really falling apart. That night, we sat on the deck of our home and watched Berkeley and Telegraph Avenue below. There was a clear view of Telegraph, and we could see tear gas canisters being thrown back and forth.

HUBERT LINDSEY
street preacher
On Telegraph Avenue I tried to stop the crowd, warning, "Go back. You're going to get hurt. This is not a park. It's a battleground. Blood will be shed." (From *Bless Your Dirty Heart*)

BARBARA RHINE
UC Berkeley law student
I arrived in Berkeley for law school in 1966. I was active with the National Lawyers Guild and took part in demonstrations for Stop the Draft Week and the Third World Liberation Front strike. I was gone for the summer of 1968 trying to go to Cuba. I was arrested in Mexico City and taken to an airport. I was sure that I was going to be shot, but I just was put on a plane back to the United States. I was part of the May 15 People's Park march. All I can say is that all hell broke loose. There was tear gas everywhere. We hid Dan Siegel, who we knew, in our basement that night; he was afraid that he was going to be arrested. The National Guard came the next day and were there for a couple weeks. The feeling that we were

a city under military occupation was very real and depressing. As a result of all the chaos, our final exams were canceled.

JIM CHANIN
UC Berkeley undergraduate student
I was driving down University Avenue to go to the offices of the ILWU [International Longshore and Warehouse Union] and get dispatched for night-shift work when I saw a long line of CHP cars speeding up University [Avenue] from the Marina. I didn't know what was going on, but I wanted to find out. I made a U-turn.

I got to Sproul Plaza in time to hear Dan Siegel's speech. I joined the march down Telegraph and made it to Cody's [bookstore] at Haste. A cop threw a plastic tear gas grenade at me and it hit my face. I fell to the pavement in agony. Volunteers from the Berkeley Free Clinic helped me wash the tear gas off. Meanwhile, protestors were throwing rocks, bricks, and bottles at the police. I didn't see anything come down from the roofs, just from the street.

I made it to Dwight Way. There were three or four cops in a squad car. A woman demonstrator taunted them and called them cowards, and then she lifted an uprooted stop sign and smashed the police car. I saw Blue Meanies starting to shoot and I ran. I went down Dwight, north on Dana, and then back toward Telegraph on Haste. As I was coming up Haste, a Blue Meanie leveled his shotgun, aimed at me. I turned, ran, and felt impact on my back. I assume that his shotgun was loaded with rock salt.

When we reached Haste, a row of cops blocked access to the park. These were the hated Alameda County sheriffs who loved to come to Berkeley and beat up the "rich kids." Someone opened a fire hydrant, and many hands guided the water directly onto the line of cops. A guttural growl arose from the ranks of the Blue Meanies and they surged forward. They quickly drew out their shotguns and began shooting rock salt into the faces of the crowd.

JEFF CRUMP
tenth-grader at McKinley High School
The school grounds were covered in a cloud of tear gas, and enraged cops were shooting shotguns indiscriminately into the crowd. Outraged teachers were trying to stop the cops from entering the school and chasing fleeing students. One of them stood up to a group of armed cops and the veins in his neck stood out as he screamed, "This is a school; you can't shoot into here. Stop shooting; this is a SCHOOL!" Joe turned to me and said, "You get the fuck out of here. Go home NOW!!!" I needed no further encouragement.

LAUREN COODLEY
UC Berkeley undergraduate student
I had secretly applied to Cal from my home on the Philadelphia Main Line, where my family had moved before my senior year in high school at Lower Merion. I very much felt part of my generation. We were angry; we understood everything, while people over thirty understood nothing. We were young, away from home, part of a rebellious youth movement. I took part in the Eldridge Cleaver and Third World Liberation Front demonstrations—any demonstration that was going on, I was there. I didn't have friends in the Movement, and didn't join any sectarian group. Street action was much more compelling to me than ideology or dogma. On May 15, I was on Telegraph marching toward the park when police charged. There was tear gas everywhere. An older woman had fallen to the street. I sheltered her, got her up, and walked her to her home on Delaware Street. She had herbs in her garden. She gave me some lemon thyme. To this day I associate lemon thyme with that afternoon. When the university turned things over to the Alameda County Sheriff's Department, I felt betrayed. It was head-spinning times, tragic. In the end Reagan used the backlash against students at Berkeley in his campaigns.

WES "SCOOP" NISKER
reporter and newscaster for KSAN radio
It seemed like every day there was tear gas. There were street battles every day. I came across a group of eight guys wearing football helmets who were preparing for the street, putting on oven gloves to throw back gas canisters. There was definitely a mix of male hormones and real politics. They swallowed a tab of blotter acid, shared a group hug, and then headed off for their afternoon street battle.

MEGAN (HESTERMAN) THYGESON
tenth-grader at Berkeley High School

My friend Danza [Squire] and I had nothing to do with building the park but readily took on the role of young activists. Convention had been unraveling since junior high, and we considered ourselves part of the antiestablishment movement, smacked upside the head with the need to change the world.

White roses tucked behind our ears, we joined the swell of bodies that pivoted from Sproul Plaza toward the south end of campus, and like an enormous caterpillar, crawled down Telegraph toward the park on Dwight. People of all ages—a stewpot of bell-bottoms, army jackets, miniskirts, and love beads—marched shoulder to shoulder, chanting, "We want the park, we want the park." We passed the Campus Smoke Shop, Layton's Shoes, Fraser's HomeGoods, and the Forum, where people engaged in deep conversation over hand-rolled cigarettes and bitter espressos.

Older guys with long hair and ratty beards held bullhorns to their mouths. Berkeley streets hissed with lewd commentary from dirty old men, but these guys were upstanding protestors.

"Take back the park!" they yelled.

"Take back the park!" we responded.

Fists pumped the air, punching holes in the sky. I can't be sure if we were truly concerned about this controversial little plot of land or just swayed by counterculture frenzy.

As we approached the park, people waved banners and torches, yelling, "Power to the people!" "Off the pigs!" Rocks flew. Police in flak jackets, armed with tear gas launchers and shotguns, formed a human barricade. They were anything but the friendly public servants of my childhood.

Several demonstrators had turned on a fire hydrant at the corner of Haste and Telegraph, and when police intervened to shut it off, they were pelted with rocks and bottles.

"Let's get out of here," [I said as] I stumbled west away from the park, my breath coming in clipped waves. I lost hold of Danza's elbow. Her face got sucked into the roaring crowd. I tried to get back to Danza, but the surge of the crowd tugged at me. Without Danza's protection, I felt defenseless.

> ❝**Take back the park!' they yelled. 'Take back the park!' we responded.**❞

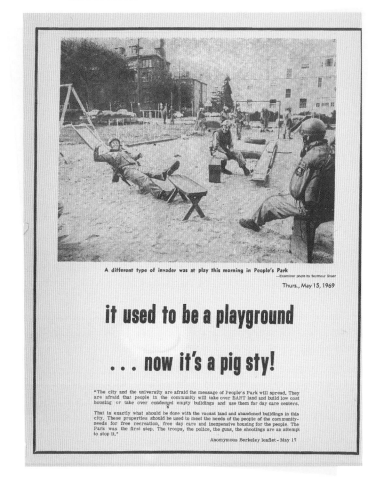

A different type of invader was at play this morning in People's Park
—Examiner photo by Seymour Snaer
Thurs., May 15, 1969

it used to be a playground

. . . now it's a pig sty!

"The city and the university are afraid the message of People's Park will spread. They are afraid that people in the community will take over BART land and build low cost housing or take over condemned empty buildings and use them for day care centers.

That is exactly what should be done with the vacant land and abandoned buildings in this city. These properties should be used to meet the needs of the people of the community—needs for free recreation, free day care and inexpensive housing for the people. The Park was the first step. The troops, the police, the guns, the shootings are an attempt to stop it."

Anomymous Berkeley leaflet - May 17

Far right: The cover of Max Scherr's *Berkeley Barb* from May 16–22, 1969, features a photo of his five-year-old daughter, Apollinaire.

Berkeley Barb

VOL. 8, NO. 20, ISSUE 196, MAY 16-22, 1969
2042 UNIVERSITY AVE., BERKELEY, CA. 94704, 849-1040

204

15c BAY AREA *25c ELSEWHERE*

PIGS SHOOT TO KILL-- BYSTANDERS GUNNED DOWN

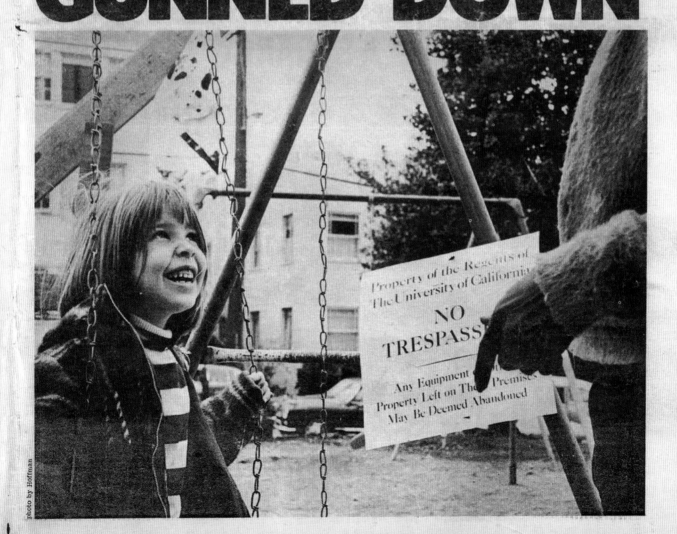

photo by Hoffman

Property of the Regents of The University of California

NO TRESPASS

Any Equipment or other Property Left on These Premises May Be Deemed Abandoned

DAVID LODGE

novelist and visiting professor to UC Berkeley from Great Britain

The behavior of the police on Thursday, May 15, and the way they were armed, suggests that they were ready and eager for a showdown. (From "The People's Park and the Battle for Berkeley," in *Write On*)

GLEN ANGELL

recent UC Berkeley graduate student

I took part in the march down Telegraph on May 15. When the confrontation with the police started, I saw people getting carried away and doing things that they wouldn't ordinarily do and wouldn't be proud of. I left the demonstration before things got really bad, demoralized. The beauty of the park and all the pretty girls and the sweet times there were overshadowed by the violence of the day.

PETER BERGEL

peace activist

I found myself out alone trying to keep people from throwing rocks at cops who had guns aimed at them, directing traffic away from tear-gassed areas, and helping tear-gassed people escape from the melee. (Quoted by Michael Doyle in *Radical Chapters*)

ADMINISTRATIVE COMMANDER OF THE ALAMEDA COUNTY SHERIFF'S DEPARTMENT

The riot was out of control and there was a grave possibility that some law enforcement officers could be killed. (From *The "People's Park": A Report,* California Governor's Office)

PAUL VON BLUM

attorney and a UC Berkeley lecturer in rhetoric

I came to Berkeley in 1964 to start law school at Boalt. I had been active with SNCC [the Student Nonviolent Coordinating Committee] in the South since 1962 and been arrested in a CORE [Congress of Racial Equality] demonstration in San Diego. The judge hearing my case knew that I had been admitted to graduate school in political science and to law school. At the sentencing, he gave me a choice—sixty days in the county jail or three years at law school. I took law school, but resented being forced out of political science.

I took part in the Free Speech Movement. I was in Sproul Hall for the sit-in but left before arrests were made because I didn't want my probation revoked in San Diego. I spoke on the steps of Sproul Hall in favor of Eldridge Cleaver in the fall of 1968 and the 139X [Experimental Social Analysis course] controversy. I was admitted to the bar by the time of the Third World strike, and I worked out of Legal Central, which is what we called our impromptu collective of attorneys housed in a dumpy little bungalow south of campus. Most of the work involved arraignments and bail reduction or "own recognizance" hearings. I'd demonstrate and then go back to my office in Dwinelle Hall and change into a jacket and tie if I had to teach or go to court.

On May 15 the police were out of control. I went to my office at Dwinelle and there were police shooting at people on campus. There was tear gas everywhere, including, as I recall, in Dwinelle Hall itself. I dismissed my class and told my students to leave. For me, the issue was no longer the park, it was the police brutality. That, more than the occupation of the park, angered me and motivated me. My father was the only member of his family who survived Auschwitz, which was the seed of my politics—never let fascists get a toehold or you will pay the price.

RONALD REAGAN

governor of California

You use whatever force is necessary. (From *The "People's Park": A Report,* California Governor's Office)

DAVE SEABURY

eleventh-grader at Berkeley High School

I was near the front of the march as we left Sproul Plaza. It seems to me that the minute the march hit Telegraph, windows started getting smashed. When the police started with tear gas, I ducked down a side street to the west. We high school kids knew the campus and Telegraph like the back of our hand. I came up to Telegraph at Dwight and knew right away that it was getting really crazy. A car was upside down and on fire, but I didn't see any violence by demonstrators toward the police and nothing being thrown down on police from the rooftops. The girl that I was with said she had some pot at home, so we left and went to her house to get high. I'm guessing that I left only a few minutes before James Rector

was shot. When we got back to Telegraph, people were freaking out and we got out of there. For me, what was different about this riot was the presence of so many cops from different jurisdictions—the Highway Patrol, Alameda [County] Sheriffs [Department], and San Francisco.

JON READ
architect and People's Park cofounder
I took off at full speed down the avenue and arrived at the corner of Telegraph and Haste ahead of the crowd. There was a formation of twenty or so uneasy-looking Berkeley police blocking that street. I had on a suit and tie for protection. It was something like a dream. The crowd arrived and people waited for something to happen. Someone I knew from earlier demonstrations, who was not a pacifist, to my knowledge, walked out and stood in front of the police facing the crowd. My better sense told me to join him and call for a silent vigil or something. It seemed like a pretty weak idea at the time, and I just stood there. A couple of people I never saw before turned on a fire hydrant. Then a few rocks came from in back of the crowd. The scene started to take on that sickening slow-motion quality like an accident.

There were only a few minutes in which the mob could have been restrained. By restrained I mean to convince the group to tell the people in the back to stop throwing the rocks. In retrospect, I regret deeply that I didn't try; and that the whole situation took me by surprise, that I wasn't prepared for the obvious eventualities. I had been telling others for years to think it out like a chess game, and here I was standing on a corner and not knowing what to do. There were no leaders to stop the violence. Without exception those I saw throwing rocks and trying to hit policemen were punk types I had never seen before.* (Quoted by Joseph Lyford in *The Berkeley Archipelago*)

* Although some sources suspected the police of using provocateurs to incite violence, those claims have never been proven. FBI files show, however, that confidential informants infiltrated the leadership circle of the park, including the May 20, 1969, park leadership meeting at Bill Miller's house at 2528 Warring.

ED MEESE
chief of staff for Governor Reagan
The police lacked the number of people and they didn't have all the equipment. People's Park was a particularly violent thing where people who were involved there were trying to kill police officers. They were throwing sharpened spikes from rooftops down onto the police. (Quoted by Seth Rosenfeld in *Subversives*)

GEORGE CSICSERY
UC Berkeley undergraduate student
About twenty minutes after the shootings south of Dwight, which I witnessed, I was walking down either Haste or Channing toward Telegraph. A line of Alameda County sheriffs stood between Telegraph and me. We continued walking toward them so they raised their shotguns. It was like a moment from the Civil War or the Battle of Waterloo, the line of troops with their weapons raised in unison. They shot, seemingly into the ground in front of us. The man to my right and the man to my left went down. I was grazed on my little finger. Another marcher and I grabbed the arms of one of the men who was down and dragged him to one of the nearby dorms, where medics began to treat him.

I went to campus, where life was going on as if nothing were out of the ordinary. I was covered with the blood of the man I had dragged, as well as my own blood. I tried to make them understand that something really terrible was going on only a few blocks away, that they were shooting people. People didn't or wouldn't understand. That was the prevailing insanity of the afternoon.

I had been in crowds before where the police attacked, such as Stop the Draft Week. There were unwritten rules about how far the demonstrators would go and how far the police would go. The police broke those unwritten rules with the level of their brutality.

JOHN BISHOP
novelist and photographer
Writing the novel was not paying anything, and a few weeks earlier a friend told me the Nutritional Science Department needed subjects. It paid $25 per test meal and would not involve suction tubes deep in the alimentary canal, so I dropped by the lab to apply. Based on the results I was invited back to do a baseline test meal with three

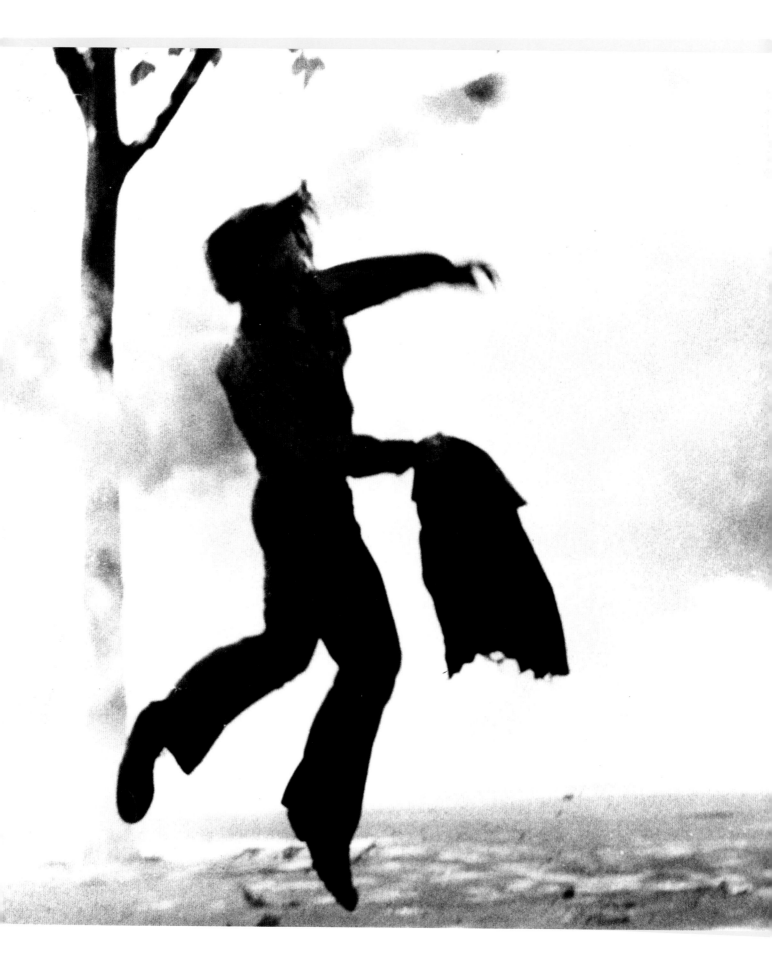

other breathers the morning of May 15. We had to inflate the foil bags at intervals for the next eight hours, which involved blowing through a three-foot-long glass tube filled with calcium carbonate. After a few hours, the lab got pretty boring, so we took our empty bags and desiccation tubes out for a walk, ended up at the rally, and joined the march to the park. The 159 Berkeley and UC police assigned to protect the park were not up to the task. But everything was good-natured, a carnival. (From johnbishopexperience.com)

JOHN E. JONES
lieutenant with the UC Police Department
Two thousand persons marched to the Park and attacked the police. Several hundred protesters assaulted the police with bricks, rocks and bottles from the ground and roof tops. The Deputies of the Alameda County Sheriff's Department first responded with tear gas and then with bird shot fired from shotguns, but still lost many of the battles. Order was not restored until several hours later when the number of police officers reached 729 from agencies all over the Bay Area. In that one afternoon, 111 police officers were injured, including one C.H.P. officer who was knifed in the chest. (From "History of People's Park," revised August 2006)

RANDY KEHLER
staff member of the War Resisters League
All hell was breaking loose on Telegraph. There were armed police in the street and clouds of tear gas. I tried to escape the gas by running south toward Oakland, just to get away from it.

JANE SCHERR
partner of Max Scherr, publisher and editor of the Berkeley Barb
I marched on May 15. This was the first protest in my life that I wholeheartedly supported. The children were very important to me. The park was new and beautiful and wonderful, and I supported it with all of my heart. I marched with Stew Albert, who was experienced in demonstrations and could spot trouble before it happened. We stayed safe.

Some demonstrators threw rocks and bricks at police, and when tear gas canisters landed near them, they threw them back.

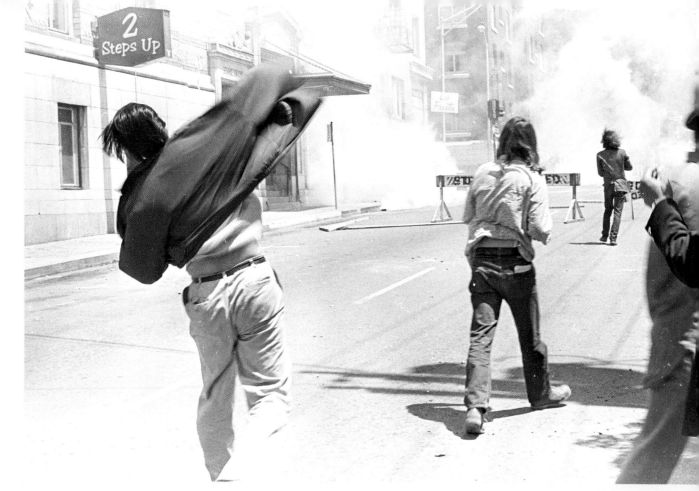

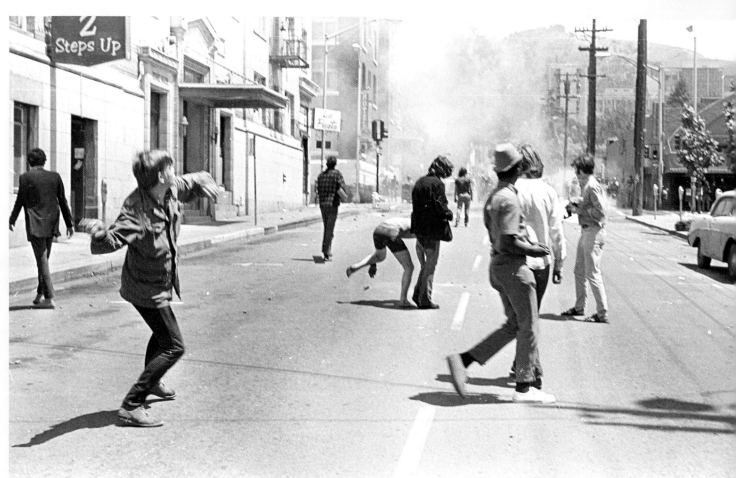

116 THE BATTLE FOR PEOPLE'S PARK, BERKELEY 1969

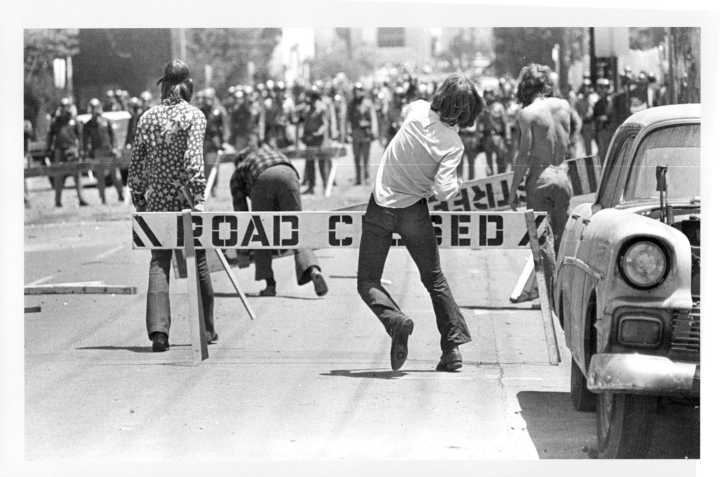

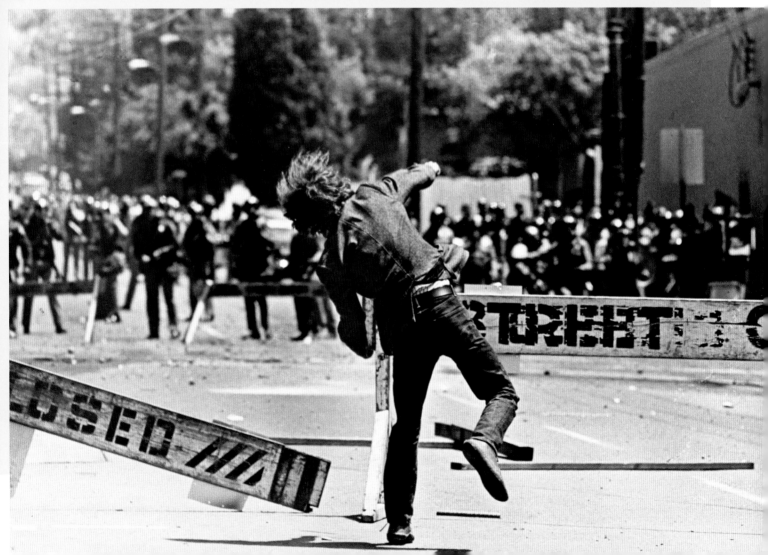

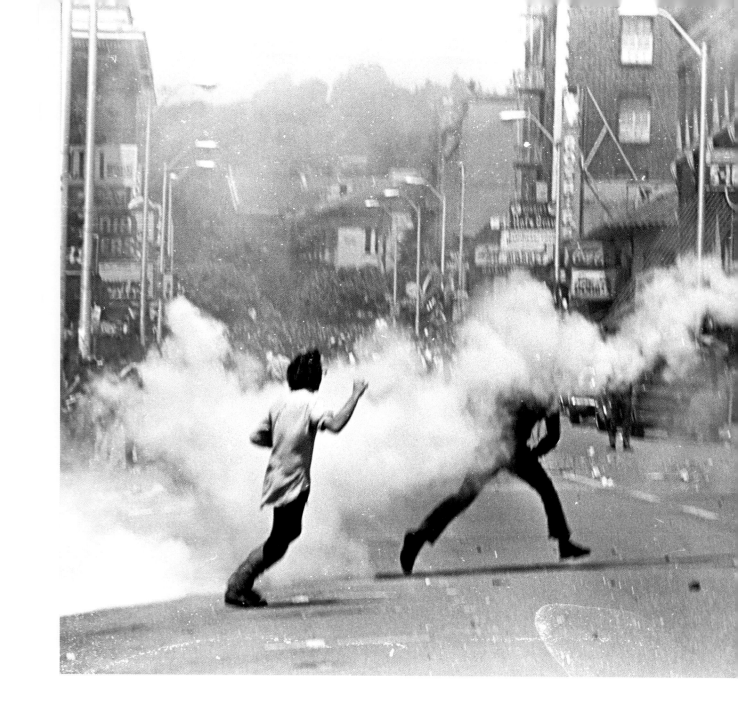

"All hell was breaking loose on Telegraph."

ART GOLDBERG
UC Berkeley graduate and Free Speech Movement leader
As the march moved south on Telegraph, I split off down a side street when the shooting started. There were sheriffs shooting at us. I dove behind a fence and narrowly avoided being shot.

JACAEBER KASTOR
eighth-grader at Willard Junior High School
I was in Spanish class, sitting near the back of the class. Suddenly, the teacher and the kids in the front row starting coughing and sneezing at the same time, standing up in distress. I had no idea what was going on. Then the gas hit me. My eyes burned bad. I jumped out the ground-floor window and kids were running around. A police jeep with a contraption that looked like a small cement mixer on it was driving south on Telegraph, spraying a super-thick cloud of tear gas. We backed off right away. After this there were shreds of tear gas canisters all over the school baseball field. The boys would gather the shreds and put them in a paper bag. They were still off-gassing, and so when you opened the bag a puff of tear gas would come off. This I know because my friends did it to me—tear-gassed by my own friends!

LEIGH STEINBERG
UC Berkeley undergraduate student
The police, in all their regalia (helmets, gas masks, and shields), were ready for us, firing shotguns and swinging their nightsticks. They

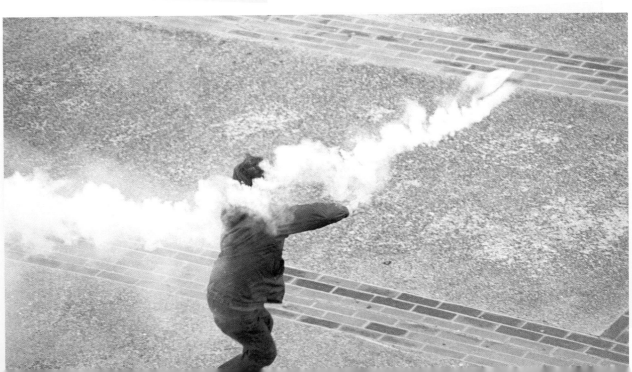

fired tear gas from their guns, threw it, and sprayed it out car exhausts. We had no chance. (From *The Agent*)

EUGENE SCHOENFELD
physician and a columnist (writing as "Dr. Hippocrates") for the Berkeley Barb
The police charged to the Durant intersection. Fleeing demonstrators and the police knocked down an elderly white-haired lady in front of Larry Blake's restaurant. Several students huddled around her long, slender form, stretched full length on the sidewalk. I walked across Telegraph intending to help her but was met by an eerie sight: an armed figure peering through a gas mask and waving a club. "Get out of here!" he shouted through the mask. "I'm a doctor and I want to help that woman," [I said]. He ran toward me club extended and I split. My laboratory assistant was on Ward and Telegraph when she attempted to escape the gas by running into a small building on a lot owned by Cunha Pontiac. One of the Cunha employees drove her out, shouting, "Get out, get out, you deserve everything you're getting."

DAN PORTER
eyewitness, eighteen years old
We stopped and turned around and looked. A jeep came toward us, spraying pepper gas. We ran into an alley. I got about half way down the alley when my right leg just came into the air. I fell against a wall to my right. I tried to get back to my feet but I couldn't. It was just too painful. [My friend] Fred came back to help me but by this time the jeep was gone. They just shot and left. I was hit four times in the right leg and once in the left with what I think was double-aught buckshot. The doctor says I may have some nerve damage. It was really cold. They could have told us to halt, but they just pulled up and started spraying gas and shooting. (*Los Angeles Times*, May 30, 1969)

REESE ERLICH
suspended UC Berkeley undergraduate and a reporter for Ramparts magazine
I was part of organizing the rally at Sproul Plaza on May 15, but I don't remember details. I joined the march south on Telegraph and was shocked by the brutality of the police. I had been in Berkeley as a student since February 1965 and

was gradually radicalized from liberal Democrat to Leftist. I had taken part in Stop the Draft Week in Oakland, in October 1967, and had seen how tough the Oakland police were. The reaction of law enforcement on May 15, especially the Alameda County Sheriff's Department, was a new level of brutality. I saw protestors turn over a City car, stick a burning rag in the gas tank, and run away expecting that it would blow up like in the movies. It didn't, but it did catch on fire. I was gone by the time the sheriffs got their shotguns out. That whole day, I never saw stockpiles of rocks, bottles, or rebar, and I saw nothing being thrown down on police from the roofs.

EDDIE MOORE
employee at J. Gorman & Son Furniture
All the officers went back up the driveway when they left the car; the protestors went to throwing rocks into it and all the windows didn't break out. I don't know where they got the big piece of iron, but they got a big piece of iron and broke the rest out. When the rest of the windows were out of the car, all of the protestors went back and bunched up, and about fifteen or twenty of them came and turned the car over. Then the fellow across the street came out after they turned it over and reached into his pocket and got matches and scratched one and threw it in the car, and that's when the fire started. Then he ran back over to his house and went in and no one has seen him since—until the next day, when he came out again.

FRED ROSS, JR.
UC Berkeley undergraduate student
Ronald Reagan was governor of California; he had won election in part by demonizing student demonstrators. I had participated in antiwar marches, Stop the Draft [Week] demonstrations, and the United Farm Workers grape boycott. I was not involved in the protests to save People's Park before Bloody Thursday.

That spring I had a part-time job at Botts Ice Cream Shop on College Avenue near Ashby, across the street from the Elmwood movie theater. Mr. Botts was very conservative, but he loved to talk about politics with his student employees. One afternoon in early May, Mr. Botts called me into his office before my shift started. He and I enjoyed bantering and arguing about the issues of the day. He told me that if I were arrested

for protesting, he would bail me out of jail. He explained that during the Free Speech Movement, Ian Underwood had been an ice cream scooper too, and when he was arrested Mr. Botts bailed him out. Underwood went on to play piano with Frank Zappa and the Mothers of Invention. I thanked Botts for the offer.

On what became known as Bloody Thursday, I had a midterm exam on campus. As I left the exam with my girlfriend Nancy Welch, I had no idea that all hell had broken at the park nor that Rector had been shot.

We were walking down Channing near College Avenue when I saw several helmeted cops surround a student and start pushing him around. I asked one of the officers, "What did he do?" The officer immediately replied in an angry tone, "Get moving." I apparently did not move fast enough, because the next thing I felt was the officer jabbing my back with his baton. I whirled around and asked why he'd hit me with his baton. Several officers surrounded me and put my arms behind my back as they placed me under arrest and handcuffed me. This was my first of many arrests.

I heard some students shout down at the cops from the nearby dorm, asking why I was being arrested. I was taken to the Berkeley jail. Remembering Mr. Botts promising to bail me out, with my one phone call I reached Mr. Botts. I told him I had been arrested, was calling from jail, and asked could he bail me out. He said he would send one of my coworkers right away but asked that I come directly to the shop because he wanted to hear the whole story. In less than an hour, I was released on bail. Mr. Botts seemed to enjoy the story of my arrest for interfering with an officer and resisting arrest. I was lucky to have been bailed out that day. Many others who were arrested later in the day ended up being transferred to Santa Rita and experiencing terrible conditions.

It turns out that my father was arrested in Oakland the same day as part of a United Farm Workers protest at Safeway.

N. LASAGNA
reserve officer with the Berkeley Police Department
Reserve Officer Paul A. Koehn and I were assigned to a fixed traffic post at the intersection of Telegraph Avenue and Parker Street on May 15, 1969. We had parked the city pool car on the east half of the intersection to help us control the flow of northbound traffic. Sometime between 2:30 p.m. and 3:00 p.m., a large number of people approached the intersection from the north on Telegraph Avenue. When the people saw us they started to throw large rocks, red bricks, and bottles at us. Officer Koehn and I stood in the intersection for maybe ten or fifteen minutes.

The situation got worse, so we left the intersection and went to the Cunha Pontiac body shop parking lot, where we were forced to take cover behind a parked car. It was our feeling that the crowd would leave us alone if we were out of their way. The crowd continued to throw the rocks and bottles at us while we were behind the parked car. During this time I was struck on the back of my left hand by a red brick thrown at me by one of the demonstrators. Our position in the parking lot was too hazardous to maintain. We both felt that our lives were in danger and that we would have to move to a safer position to stay alive.

We noticed that the doors of the body shop were open. We worked our way over to the body shop, ducked inside, and told the men working there to close the doors, as the crowd would follow us in and tear up the place. The men closed all of the doors of the body shop, and one of the men in the shop called, "There goes the car." We climbed up a stairway in the shop so we could look out the windows. We watched the crowd throw rocks at the car and then turn it over on its top. The car caught fire. How it started I don't know.

At this point the tear gas that the other officers were using against the crowd drifted into the shop and forced us to climb down the stairs to get out of it. The mob then started to throw rocks and bottles at the doors of the body shop. We stood next to the door so that if anything was thrown through the windows it wouldn't hit us. After several minutes the crowd was moved out of the way by the sheriff's deputies and the California Highway Patrol. I left the paint shop and was taken to the hospital by an unidentified Berkeley police officer.

Reserve Officer Koehn drew his revolver at one point when we were in the parking lot. One of the crowd ran toward us shouting, "Pig—Pig—get the Pig!" The crowd started to follow the one that was yelling. Reserve Officer Koehn drew his revolver and leveled it at the man who was yelling. The man immediately ran from the area.

FREDERICK F. CLARK
special-delivery messenger for the United States Post Office

[Statement taken by a post office supervisor:] Mr. Clark advises that around 2 p.m. he was stopped by heavy crowds at the intersection of Bancroft and Telegraph. Several people tried to create a way through for him; everyone was suggesting ways he could go. Finally a girl decided to sit on the hood of his vehicle. Then someone told him the air had been let out of both his front tires and mud put in the gas tank. He was finally able to back slowly out of the intersection east up Bancroft. With both front tires flat, he had no steering control at all and finally stopped in the street approximately where Barrow Lane comes into Bancroft Way. He stayed with the truck. Two postal inspectors arrived at approximately 4:30 p.m. Mr. Clark mentioned that he thought he was not bothered too much because he has a full beard and long hair.

CAROL GORDON
UC Berkeley undergraduate student

I don't recall if classes were being held or not during this time. I remember the masses of people heading for the park after the rally and of thinking that I needed to just go home. I wanted to be safe and was afraid of being part of that big crowd. My eyes still have the memory of the tear gas experience and how they stung. I think I was in shock that a university would tear-gas its students. Now looking back, it seems even crazier. What kind of communications is that? Not good.

GREIL MARCUS
writer for Rolling Stone magazine

I remember taking the class I was then teaching to watch the police erect a fence around the park lot; I remembered thinking it odd that the cops were wearing flak jackets. I remembered how my wife, then pregnant, had a short time later walked down Telegraph Avenue, trying not to look at the county sheriffs who were aiming shotguns at her from the windows of their cars; I remembered standing in my bank when a man rushed in to announce that people were being shot down in the streets only blocks away; and I remembered, in a flash of faces and explosions, the fights that followed. (*Rolling Stone,* May 18, 1978)

CRAIG PYES
UC Berkeley undergraduate student

In late April, Paul Glusman told us at the Radical Student Union meeting that the university was going to move on the park in a few days and that there would be a showdown. I was living in Lagunitas and came down early on the day when the university was supposed to make its move on the park. Nothing happened that day. A few days before May 15, Glusman told the RSU meeting that the showdown was going to happen on May 15. Since it hadn't happened as predicted earlier, I didn't make a special trip down. When I got to Berkeley in the late afternoon, it looked like a war zone. I saw people with pitted, bleeding faces from shotguns using either rock salt or birdshot. It looked like a full-blown pitched battle had taken place.

I stayed in Berkeley that night and ran around in what was left of the riot. Berkeley was a city under siege. One advantage that we had is that we knew every hiding place and shortcut in Berkeley, and we knew the apartment houses where you go in the front door on one street and leave by the back door on another.

I don't think that there necessarily were provocateurs involved in People's Park. We had people who were more than willing to throw rocks from the back of a crowd. I researched and outed Rolando Solis as an undercover agent from the Berkeley Police Department who had infiltrated our groups, but he did not act as a provocateur. A few months later we outed another undercover cop as we planned for the Bastille Day demonstration [to tear down the chain-link fence surrounding the park]; fortunately he wasn't there when we made the plan to bake bolt cutters into bread to get them to the park without the police seeing them.

D. W. LINDENAU
sergeant with the Berkeley Police Department

I was struck on the helmet with a heavy object. The helmet was knocked off and rolled for twenty feet. The blow stunned me, and my head and neck ached for the rest of the day. Later, while at the hospital with other officers injured, the physician looked at the hole in my helmet and said that it was his opinion that I would have been killed instantly if I had not had the helmet on.

OFFICER ANSLEY
Berkeley Police Department

We stacked about three hundred red bricks in the street which had been pulled up by the rioters from the sidewalk and planters nearby and thrown at the officers. A city crew was called to haul them away.

OFFICER CLIFTON
Berkeley Police Department

There was a group at Dwight and Dana with a fire hose. They shot the stream of water through the broken windows of the passing patrol cars. We had no windshield.

LIEUTENANT HEALY
Berkeley Police Department

When we arrived at Eshleman Hall, we were subjected to a heavy barrage of rocks and what appeared to be pieces of concrete.

D. JOHNSON
inspector with the Berkeley Police Department

There were hundreds of pieces of rocks, concrete, bricks, and bottles all over the street from the intersection of Dwight and Telegraph south to Blake. During the incidents, when a police officer would go down as a result of a rock, the crowd would cheer and this would be followed by additional volleys of rocks.

OFFICER KNOX
Berkeley Police Department

At one time, I saw a demonstrator atop a tall building on Dwight drop a large chunk of cement toward a BPD officer. The object came very close to striking him.

OFFICER HOEPPNER
Berkeley Police Department

The stream of water from the fire hydrant was directed at our forces, and most of us got very wet. About this time missiles started flying from the crowd and a continuous barrage of rocks, bottles, bricks, and short lengths of water pipe, and twelve- to eighteen-inches-long lengths of reinforcing rod started. I felt our lives were in danger due to our small number of about thirty-five officers and the odds against us. Had the crowd decided to rush us, they could have overwhelmed us in hand-to-hand combat. The mood of the mob was such that I personally believe they would have committed homicide.

SERGEANT PURSLEY
Berkeley Police Department

It appeared as though the whole area was literally raining rocks. The majority of the projectiles appeared to be coming from rooftops and balconies.

EUGENE LARSON
employee at J. Gorman and Son Furniture

I have a friend who had a store up there. Right above his store is an apartment. He showed me one apartment [where] there must have been a half a ton of concrete junk. I am sure that you know there are several buildings that were being demolished, and I saw the steel reinforcing rods—I'd say they cut them into twelve-inch planks and then sharpened both ends, which makes a pretty good spear, dagger, or whatever you want to call it.

"I saw people with pitted, bleeding faces from shotguns using either rock salt or birdshot. It looked like a full-blown pitched battle had taken place."

Berkeley Barb

VOL. 8, NO. 21, ISSUE 197, MAY 23-29, 1969
2042 UNIVERSITY AVE., BERKELEY, CA. 94704, 849-1040

204

15c BAY AREA *25c ELSEWHERE*

How James Rector Was Killed

(pages 2, 3, 4)

photo by Bill Paul

The Killing of James Rector

Alameda County sheriff's deputies blocked Telegraph Avenue south of Dwight Way to impede demonstrators from reaching the park by going east on Dwight. A small group of demonstrators reached the intersection from the west and met the deputies, who resorted to tear gas. Demonstrators overturned a City car and set it afire.

When they ran out of tear gas, the deputies turned to shotguns, some loaded with nonlethal birdshot and some loaded with buckshot, which has an effective lethal range of fifty yards.

James Rector watched the demonstration from the roof of Granma Books, at 2509 Telegraph. There is little in the public record about Rector. He was twenty-five years old and had graduated from Santa Clara High School in San Jose. He served in the Air Force for almost two years and received a general discharge. He was not a student at Cal.

No civilian witness saw Rector throw anything at the deputies below. In a photograph of him in the minutes before he was shot, neither he nor anyone on the roof with him was throwing anything or preparing to throw anything. Some saw a young man a few roofs to the south throw something down at the deputies. He missed. And yet several of the deputies below spun around and blasted the roofline with buckshot. Rector was hit and fell to the roof.

Rector was taken to Herrick Hospital, where surgeons removed his spleen, part of his pancreas, his left kidney, and parts of his small and large intestines.

On Monday, May 19, at 10:12 p.m., James Rector died. The hospital announced that he died "suddenly, peacefully, and very unexpectedly" from buckshot lodged in his aorta.

Governor Reagan immediately launched a campaign to smear and demonize Rector. Rector had been arrested for burglary in December 1968 with a small amount of marijuana in his possession, which Reagan took to mean that he was a "registered narcotic addict." A disassembled rifle and electronic equipment used for making free long-distance calls were found in the trunk of his car, facts that Reagan cited seemingly as justification for his killing.

A coroner's jury heard two days of testimony, deliberated for thirty-eight minutes, and concluded that Rector's death had been a justifiable homicide by an unknown and unidentifiable Alameda County sheriff's deputy.

There was no large memorial service for Rector. Several hundred park supporters gathered in Tilden Park on May 25. The service was traditional and religious, although it also featured some modern elements, including the songs. Selections performed at the memorial included Pete Seeger's "Last Night I Had the Strangest Dream" and "Where Have All the Flowers Gone?" and Bob Dylan's "Blowin' in the Wind."

JAMES RECTOR

I was on the roof and looked down and saw a policeman aiming what appeared to be a scattergun at me. I turned to run and was shot in the left side. (Quote as reported by one of the doctors who performed emergency surgery on Rector; *San Francisco Chronicle*, May 21, 1969)

MICHAEL MEO

UC Berkeley undergraduate student

For about half an hour we were on the roof of the Granma bookstore at the intersection of Telegraph and Dwight; there was a standing order among the watchers on the roof not to throw anything, not to say anything, not to do anything

to antagonize the police. We watched silently as they beat up groups of demonstrators below and blanketed the area with tear gas.

At the fish and chips place at Blake and Telegraph a crowd penetrated onto the Avenue; the police replied this time with shotguns. At first we didn't believe that they were shooting at unarmed people. "What the hell is that?" we asked each other. Somebody suggested it was rock salt. Then a group of four, five, or six police in the middle of the block raised their guns to shoot. James Rector saw the policeman aiming at his face. He turned his back and began to run; he was too late. Three pellets caught him in the lower left back, and he crumpled onto the roof.

I was standing beside him when he fell. I still didn't believe that there had been any shooting[;] perhaps Rector had sprained his ankle. But

Street preacher "Holy Hubert" Lindsey said that he warned James Rector to stay away from the demonstration on May 15. He was prone to making unfounded claims.

when I got to him he couldn't breathe and when I lifted up his jacket there were three bullet holes in his back. We had to stop Rector from going into shock. Myself and two other guys lifted his legs so the blood would flow to his head, we positioned him more comfortably and told him to breathe deeply and evenly, and we wrapped him in blankets to keep him warm. It was a near thing; when he reached the hospital Rector's blood pressure was zero.

First we called Herrick Hospital for an ambulance, but they said to call the police, for they had control of the ambulances. Then we called the police, but the secretary told us Rector had been throwing things at the cops and hung up. Desperate, we shouted down to the Avenue, "There's a man shot up here! Get an ambulance!" The cop slowly climbed the stairs to the roof, took a lot of notes, refused to lend Rector a gas mask, and left.

But eventually an ambulance did come; the ambulance people refused to go climbing over rooftops to retrieve Rector; they handed us the stretcher instead. We lifted Rector onto the stretcher, strapped him down as gently as we could, and lifted him back to the opposite rooftop. When the ambulance drove away they refused to say which hospital they were going to. (*Instant News Service*, May 21, 1969)

HUBERT LINDSEY
street preacher
Some of the demonstrators began going to the roofs of buildings. I met James Rector. "Get out of here," I told him. "You may get hurt." He made no reply but continued on his way. (From *Bless Your Dirty Heart*)

FRANK NEWMAN
former dean of UC Berkeley law school and later appointed associate justice of the California Supreme Court
They had hundreds of sheriffs out that day, not trained policemen; they were deputies, mostly friends of politicians. Alameda County bought them blue overalls. This was the time of the Beatles, so they immediately became known as the Blue Meanies [from the animated Beatles film *Yellow Submarine*]. They used to line up all the way to Sather Gate.

Dolores Rector

Dolores Rector visited her son at Herrick Hospital on Saturday, May 17. He had been upgraded to fair condition, and doctors were optimistic. She spoke with the *San Francisco Chronicle* the day after he died.

Nobody can bring Jim back to life. But I want to make sure nobody capitalizes on his death—the demonstrators or anybody else. That would be a mockery. Why must there be all this violence over a park? A death instead of flowers? Nobody is safe.

He told us he just wanted to see what was happening. He and another young man he met there—Michael Meo, a history major—were on the roof, just looking, when they saw an officer pointing a shotgun at them. Jim said he couldn't believe it was aimed at them. They hadn't done anything wrong[;] they hadn't thrown anything. There wasn't anything to throw. Then he said he heard a fusillade of bullets, turned sideways and got caught in the back with the slugs. One pierced his heart, I'm told.

The other young man, Mike, had ducked to the roof floor. Then, when he saw what had happened, he tried to save Jim's life by wrapping his shirt around the wound to stop the bleeding. He called to the police: "You've hit somebody!"

The police, they didn't do anything for Jim. They just came up to the roof and asked a bunch of questions about what Jim and Mike were doing there, then left. By the time an ambulance came, 25 minutes later, Jim had zero blood pressure, the doctors told us.

Jim was a terribly sensitive boy with lots of common sense. He had a hundred million things he was going to do with his life. Oh, he planned to get married one of these days but he said it would have to wait until he could afford a wife. He figured college could wait, but he had lots of interests—psychology and all the things he loved to do with his hands, mechanical things. He loved animals, especially. Animals followed him all his life. I remember when he was a little kid he had a pet rooster that would ride on his tricycle and would wait all day for him to come home from school.

And now it's all over, his short life, and for what? Believe me, Jim wasn't any agitator. He just liked life. Why, he hardly ever talked unless he had something constructive to say. (*San Francisco Chronicle*, May 21, 1969)

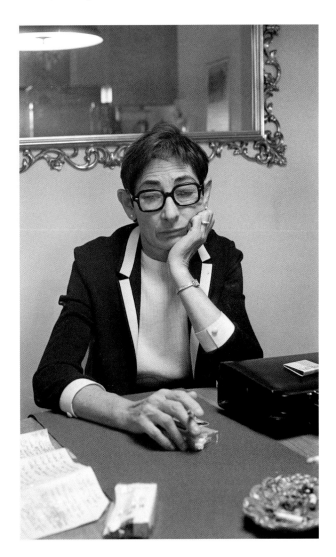

Dolores Rector Clifford, the mother of James Rector.

JENTRI ANDERS
UC Berkeley graduate student in anthropology

It gives me shivers to this day to think I might have been looking right at the man who was shot minutes later. I remember well looking at that roof, where there was a large number of people watching the street. We watched that roof for at least 15 minutes. If anything had been thrown from it we would have seen it. We did not see anyone throw anything. The people on the roof were spectators, at least while we were watching. (From *Berkeley Backlog*)

RICK FEINBERG
UC Berkeley undergraduate student

I enrolled at Cal in 1964. I was drawn to Berkeley by Mario Savio (who went to the same high school that I did in Queens) and the Free Speech Movement. My first political action was the Vietnam Day Committee march to Oakland, where we stopped at the Oakland border and were beaten by Hells Angels as the Oakland Police watched. I took part in Stop the Draft Week a few months later. I was arrested in the Sproul Hall sit-in in support of Eldridge Cleaver and his course; I was placed on academic probation for that. In early 1969 I was arrested for taking part in a picket line at Sather Gate in support of the Third World Liberation strike. For that I was suspended for a semester and barred from campus. I complied with the ban and stayed off campus for the semester, including the time of People's Park. In 1968 and 1969, I was a reporter for the *Militant*, a publication connected to the Socialist Workers Party. On May 15, I was working in the Young Socialist Alliance office on the second floor at 2509 Telegraph. The Granma bookstore was on the street level and James Rector was on the roof above. I heard commotion on Telegraph, but I continued working. I did not go out on the street. We later heard that someone had been shot on the roof.

GREGORY D. MOUSESYAN
eyewitness, fifteen years old

I was sitting on the roof of the second building south of Dwight Way to avoid being in the street or physical danger created by a police confrontation. There were about five or six people on the same roof. No one on the roof had any kind of implement or weapon in their possession.

Nothing was thrown from the roof. About three or four buildings south on Telegraph, a group of about fifteen officers turned in our direction and about half raised shotguns. I yelled, "They're going to shoot up here," and turned to scramble on my hands and knees to get out of sight. I noticed a young man lying on the roof, ten or fifteen feet away. Once I got to the next roof, I looked back to see blood near the young man, and another man was next to him, calling us on the next roof to get an ambulance. I went to the apartment to use their phone to call the ambulance. Three other people were in the apartment at that time who also appeared to have been shot.

LEONARD N. JOHNSON, JR.
deputy with the Alameda County Sheriff's Department

I may have been the one who shot James Rector. I saw three people on the roof. One of them reared back his arm to throw and I fired. (*Long Beach Independent Press Telegram*, July 12, 1969)

LONG BEACH INDEPENDENT PRESS TELEGRAM

Three persons, including two utility company employees, said a volley of rocks rained down on officers before the shooting. Eight other civilian witnesses testified that those on the rooftops were peaceful except for one unidentified man who threw a rock despite warnings not to. (July 12, 1969)

TODD OLSON
UC Berkeley undergraduate student

I saw an individual standing along the edge of the roof looking down to Telegraph Avenue. He did nothing but stand. Just before he fell he clutched at his chest and right side with both arms, remaining standing for several seconds. Then he sank to the ground. Two men from the building south of the one on which Rector was standing came over to help him and examine him.

PETER OWENS
UC Berkeley graduate student in chemistry

Somebody opened a fire hydrant on Haste. A squad of sheriff's deputies forced their way to close the hydrant. As they were closing it, I

noticed rocks and other projectiles were being thrown at them. I hurried to my apartment on the corner of Telegraph and Dwight. There I watched two separate groups of people confront the police on that corner. Both groups were mainly voicing vocal protests, and most of the projectiles that I saw hurled at the police appeared to be thrown by the same approximately dozen people from both groups. About two carloads of Sheriff's Department deputies appeared without warning to raise their shotguns and fire at the fifteen to thirty people on the roof [from the Granma Books roof down to and including the roof of the Telegraph Repertory Cinema]. At no time in the previous hour had I witnessed any projectiles thrown from any of these roofs. About thirty seconds after the shots, people were bending over James Rector lying on the roof. For approximately fifteen minutes, all calls of help from the roof were ignored.

LAWRENCE RICHE
deputy with the Alameda County Sheriff's Department
[Speaking about using a helicopter machine gun in Vietnam:] We couldn't see what it was that we were firing at, but it was just any time before you came in to land you'd clear the area around your landing strip....I felt like I was back in Vietnam again. I was not shooting indiscriminately. I was shooting where the rocks were coming from. (Quoted by Seth Rosenfeld in *Subversives*)

KATHRYN BIGELOW
UC Berkeley research assistant in zoology
Rector was looking over the edge with three other guys. Someone threw a rock from another apartment building. Rector had been on the roof

James Rector, dressed in black on the roof of Granma Books at 2509 Telegraph, several minutes before he was fatally shot.

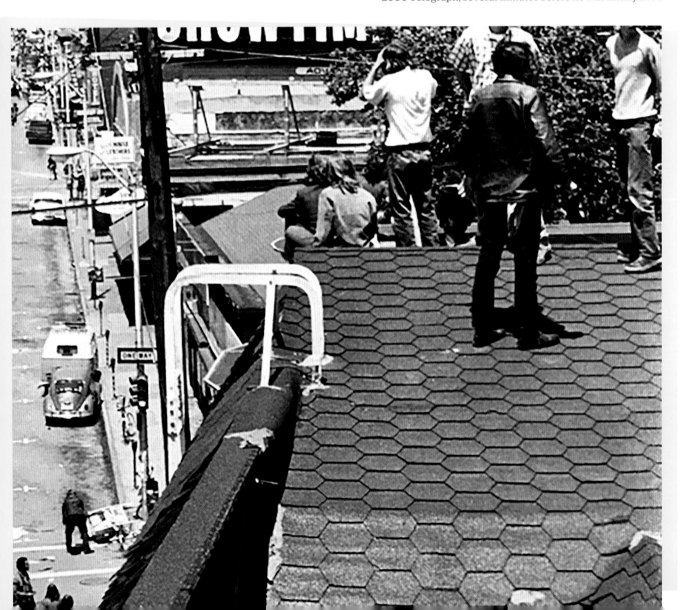

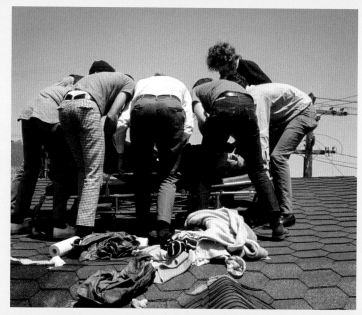
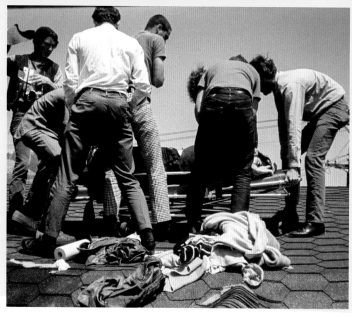
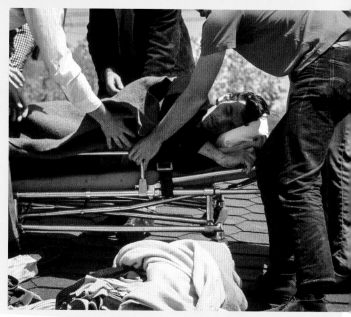

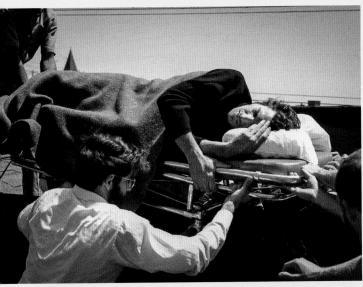
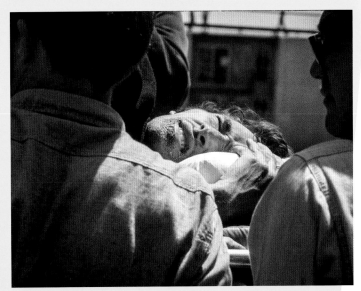
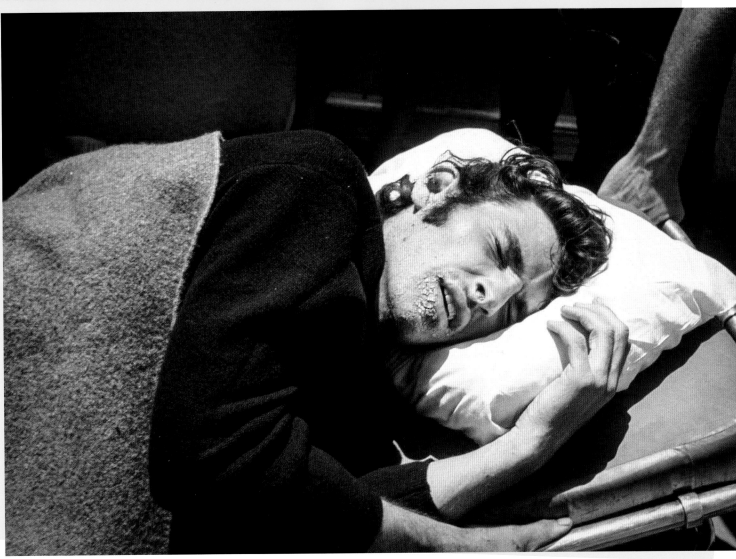

Rector fell where he was shot. He did not, as police claimed, fall to the street from a fire escape. The ambulance crew would not go out on the roof where Rector lay. Bystanders helped move him off the roof.

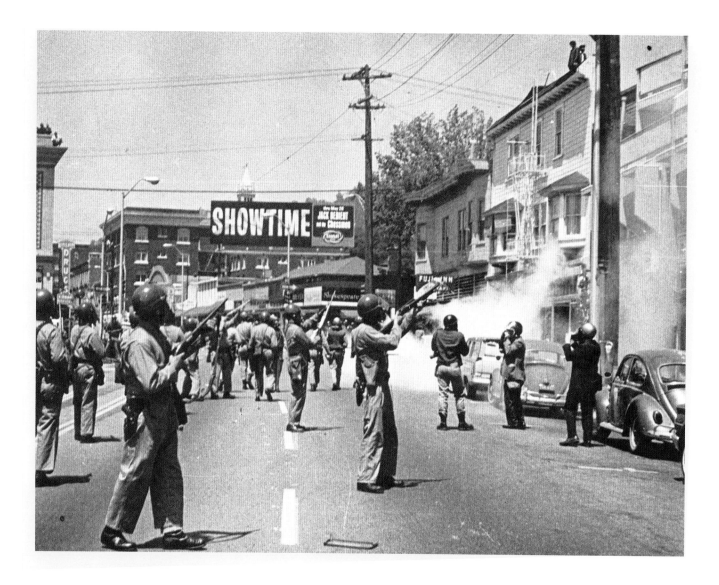

trying to get out of the way. I saw him at the moment he was hit. I saw his back arch, as the shot hit, just like Vietnam. He fell really hard. He would have fallen off the roof if two other guys hadn't grabbed him.

BERKELEY DAILY GAZETTE
The Police sources said...Rector was standing on the fire escape and was about to throw cement when they fired. They also said Rector fell to the ground from the fire escape and suffered serious injuries from the fall.* (May 21, 1969)

* The police officers' claim that Rector fell from the fire escape was false.

SAN FRANCISCO CHRONICLE
Houchins said he would produce civilian witnesses at the appropriate time who would say they saw Rector throw materials from a Berkeley building at officers. (Quoting Tom L. Houchins, chief of the Criminal Division for the Alameda County Sheriff's Department, June 19, 1969)

BERKELEY DAILY GAZETTE
The scene where James Rector of San Jose was shot and killed was described by Berkeley officers on the scene as "one of total riot involvement." Objects were being thrown from rooftops, two cars had been set on fire, barricades of everything mobile on or off the street had been erected, with a torch set to it. Even a tree had been set afire, police said. (May 29, 1969)

TOM LUDDY

manager of the Telegraph Repertory Cinema

Originally I thought that what I heard was a tear gas discharge. When I saw no smoke I turned around and noticed blood streaming down the face of one of my employees, Jim Carr. When I asked the police for help to move the injured down to an ambulance, he told me, "That's what happens when you fuck around." (*Berkeley Barb,* May 24–30, 1969)

OFFICER HUBER

Berkeley Police Department

The crowd would surge forward and back, taunting verbally and with gestures, and throwing anything they could lay their hands on. If the crowd came forward on us, we couldn't have prevented them from doing their will. The crowd was upwind, and our gas equipment was not effective on them.

Someone on the roof at 2519 Telegraph called down that someone had been shot. With a squad of officers, I went through the building and onto the roof. About fifteen to twenty people were on the roof, and I asked where was the injured person. I was directed to the roof of 2511 Telegraph, where four or five persons were rendering first aid. I immediately called for an ambulance and informed the people standing around that we would go downstairs and direct the ambulance. We all departed down the stairs but could not get out at street level due to the barrage of rocks and pieces of concrete coming from the roof. I yelled to them to cut it out, we were helping them, but this was to no avail. We held our position until the ambulance came, not more than ten minutes after I called for it.

ANONYMOUS SURGEON AT HERRICK HOSPITAL

This young boy had picked up three slugs—the sort of thing you'd expect from a machine gun. But it wasn't. It was buckshot from forty feet. His belly was just ripped apart. (From "Dialectics of Confrontation," by Robert Scheer, *Ramparts,* August 1969)

JAMES RECTOR'S NURSE AT HERRICK HOSPITAL

One ordinary hard-nosed bullet wouldn't have caused all that damage. (From *A People's Park Chronology,* by Gar Smith)

SAN FRANCISCO CHRONICLE

Yesterday morning, a forensic surgeon retrieved three buckshot pellets—each measuring one-third of an inch in diameter—from Rector's chest cavity....[Alameda County Sheriff Frank] Madigan has given conflicting descriptions of the ammunition. He once described it as No. 8 size birdshot and then again as No. 9 size birdshot. On each occasion he said the type he was referring to was the "only" shotgun ammunition issued. (May 21, 1969)

NANCY BARR

ACLU volunteer

He [Rector] didn't look like a dirty hippy, but just a tired man. (*Daily Californian,* May 21, 1969)

OAKLAND TRIBUNE

Some 300 then went to the University of California campus and made plans for a rally at 1 p.m. today at Herrick Hospital because of rumors that one youth pelted with birdshot in Thursday's wild disorders had died. The rumor is untrue, the hospital said. The youth did suffer abdominal wounds but by last night was no longer in critical condition. A spokesman for Herrick Hospital denied the rumors vehemently. "We have been swamped with calls about James Rector," he said, adding that "he is alert" and has been visited by his parents from San Jose. (May 18, 1969)

HERRICK HOSPITAL

He suffered heart failure and despite a team in intensive care using artificial respiration and drugs, they were not successful; he died at 10:13 p.m. Monday [May 19]. (*Daily Californian,* May 21, 1969)

THOMAS HOUCHINS
field commander for the Alameda County Sheriff's Department
There were probably some innocent victims who suffered gunshot wounds. (*San Francisco Chronicle*, June 19, 1969)

ROGER HEYNS
chancellor of the University of California
I deeply regret the death of James Rector. At a moment like this, I, like everyone else, am driven to ask what can be done to bring an end to the senseless violence that has produced not only death but injuries to students, law enforcement officers, and innocent bystanders. (*Daily Californian*, May 21, 1969)

RONALD REAGAN
governor of California
The death of James Rector should again serve as a bitter lesson that violence and revolution will lead to nothing but chaos and further bloodshed. (*Daily Californian,* May 26, 1969)

Once the dogs of war are unleashed, you must expect things will happen.

What is going on in Berkeley is not only a threat to our youth but a menace to our whole land. (Speech at the Italian Federation in San Francisco, May 19, 1969, quoted by Seth Rosenfeld in *Subsersives*)

The time to have stopped it was when the students first blocked a police car on the campus. The administration should have taken the leaders by the scruff of their necks and kicked them out, and it should have put the rest of them back to work, doing their homework. (Quoted by Matthew Dallek in *The Right Moment*)

KATHLEEN OSBORNE
personal assistant to Governor Reagan
It really bothered him [Reagan] because they were students, and he just didn't want to cause any harm to young people.

ED MEESE
chief of staff for Governor Reagan
James Rector deserved to die. If a guy was trying to kill a policeman, he should expect to get shot. He wasn't up there as a spectator. (*Los Angeles Times*, June 26, 1980)

FRANK MADIGAN
Alameda County Sheriff
The choice was essentially this: to use shotguns—because we didn't have the available manpower—or retreat and abandon the City of Berkeley to the mob. That's the way the game has to go. We had reason to believe that the radicals have developed an antidote for tear gas.

HENRY BREAN
chief radiologist at Herrick Hospital
The indiscriminate use of shotguns is sheer insanity. (From "Dialectics of Confrontation," by Robert Scheer, *Ramparts*, August 1969)

STANLEY GLICK
scholar
It is ironic, to say the least, that those officers who were clearly threatened with serious injury did not find it necessary to employ firearms for their safety, but that the Sheriff's deputies, the least vulnerable unit, freely used their weapons. (From *The People's Park*)

"Once the dogs of war are unleashed, you must expect things will happen."

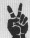 **INSTANT NEWS SERVICE**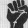

1703 GROVE 841 - 6480

COURTESY: Good Times, Free University of Berkeley, Jelly Roll Press

| Vol. 1, No. 1 | Page 1 | Sunday May 18, 1969 |

— thanks to Berkeley Graphic Arts —

TWO PEOPLE ARE ON THE CRITICAL LIST AND COUNTLESS OTHERS
HAVE BEEN INJURED BY POLICE BILLY CLUBS AND BUCKSHOT.

Silent Vigil

1pm

HERRICK HOSPITAL

Wear black. Meet at Oxford and University at 1 pm Sunday.
March silently to Herrick Hospital to mourn our dying brothers.

If Oxford and University is blocked, go directly to Herrick,
on Dwight near Shattuck.

MEDICAL HELP

FREE CHURCH
2200 Parker (at Fulton)
549 - 0649

The Free Church has doctors and
registered nurses on duty 24 hours a day.
They can handle any injury not requiring
expensive hospital equipment. People
whose life is in immediate danger should
be taken to a hospital in an ambulance.
Otherwise, injured people should go to the
Free Church. The Free Church has many
capable medical people.

If it is absolutely necessary to go to a
hospital, go to Highland Hospital in Oakland,
Alta Bates in Berkeley or Cowell for UC

students. Avoid going to Herrick in
Berkeley. They are slow, and there are
police there who will bust those injured
with gunshot wounds.
Always seek the advice of a medic.

THE FREE CHURCH NEEDS ANY AN
ALL MEDICAL SUPPLIES, ESPECIALL

adhesive tape	baggies
eyewash	rubber gloves
eye pads	food
4 x 4 gauze pads	money!
scissors	

The Daily Californian

Vol. 202, No. 36 The University of California, Berkeley, California Tuesday, May 20, 1969

Riot Victim Dies

National Guard Sweeps Onto Campus; Clouds of Tear Gas Spread in Plaza

James Rector, a 25-year old
student, shot during Thursday's
riot died last night at Herrick
Hospital.

A hospital spokesman confirmed Rector's death at 10:12 last
night. The cause was listed as
"acute heart failure."

Rector, who was admitted to
Herrick in critical condition
Thursday with an "abdominal
gunshot wound," By Sunday afternoon his condition was listed
as "fair" and hospital officials expressed optimism about his chances for survival. Rector's wound
resulted in "perforated stomach,"

removal of spleen; partial removal of pancreas; removal of left
kidney; and portions of large and
small bowell removed."

There was a bullet in his liver
and he received three wounds in
his left flank.

There will be a day of mourning with a silent march through
the campus and into the city
starting at noon in Sproul Plaza.

By JOE PICHARILLO
and
MICHAEL HALL

National Guardsmen yesterday
moved on to campus in large

numbers for the first time, repeatedly sweeping crowds of students from Sproul Plaza while
fellow guardsmen and local police covered the area with clouds
of tear gas.

Photo by GROVE WICKERSHAM

BLOODIED . . . One demonstrator who did not move fast
enough to satisfy police sweeping a street near Shattuck
Monday was clubbed on the head.

Mayor Suggests New Park Site

By STEVE DUSCHA

Academic Senate Sets Meeting on Park Crisis

By CARLA LAZZARESCHI

Photo by GROVE WICKERSHAM

HASSLED AGAIN . . . After being beaten on the head, a demonstrator was repeatedly
shoved and jostled by police clearing a sidestreet off of Shattuck Avenue.

Students to Vote

Supreme Court Overturns Pot Conviction

(Continued on page 36)

LOS ANGELES

FREE PRESS

Newspaper

25¢

PROF. CLAYTON GEERDES
1727 NOE ST.
SAN FRANCISCO, CA 94131

Synergy in the cinema

Kicking the Heroin habit

Noguchi case: Assassination cover-up?

| Volume 6, Issue #254 | $5.00 PER YEAR | In two parts: Part One Copyright 1969 The Los Angeles Free Press Inc. | WE 7-1970 | May 30--June 5, 1969 |

6000 attempt to reclaim People's Park

CLAY GEERDES

On Thursday morning, May
15, 1969, Berkeley's "People's
Park" at the corner of Haste
and Bowditch was destroyed by a
construction crew operating under the orders of UC Chancellor
Roger Heyns. The few people
who had maintained an all night
vigil in the park were arrested
for trespassing and a large wire
fence was built around the entire
area (at a cost of $5,000). Anticipating retaliation from the dispossessed people for whom the
park had become a second home
during the past few months, the
Chancellor made sure the area
was amply guarded by 200 police
officers. All morning people
(Please turn to Page 5)

IN COLD BLOOD

JAMES RECTOR

1944-1969

50,000 to march for People's Park

FROM OCCUPIED BERKELEY

D-Day for Governor Reagan,
the University of California and
the people of Berkeley starts
this Friday, just about noon.
The People's Park Committee
has called for a mass march to
People's Park to protest the
presence of National Guardsmen and a chain-linked fence—
both of which surround the park.
The Memorial Day march, which
is expected to draw 50,000 protestors, is scheduled to begin
at Tilden Park at the intersection of Hearst and Grant Streets,
and from there proceed through
the streets of Berkeley to
People's Park.
(Please turn to Page 5)

James Rector was treated
at Herrick Hospital.
By Sunday, May 18, he
had been upgraded to
fair condition. He died
suddenly the next day.

"Damn all apologies and extenuations. We can't go around shooting our own kids....You don't defeat the instigators and the agitators with sawed-off shotguns."

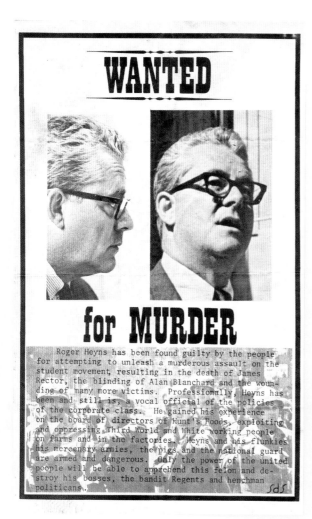

Many held Chancellor Roger Heyns responsible for Rector's killing. Leonard N. Johnson, Jr., was one of the deputies who had shot to clear the roof on May 15, and he originally thought he might have been the person who killed Rector.

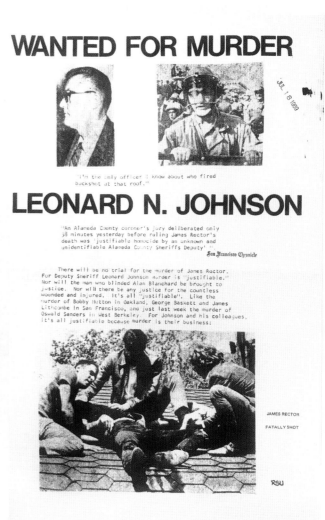

MICHAEL ROSSMAN
Free Speech Movement activist
Rector, noun, the priest of a parish; a teacher, usually of religion; here the first of the white brothers fallen for a public place. Though he wandered the park with anonymous sweat, there is some dispute concerning the sanctity of his martyrdom, in part because he was quiet and lately from San Jose and you did not know him. (From *Poem for a Victory Rally in a Berkeley Park*)

FRANK BARDACKE
UC Berkeley graduate student and People's Park cofounder
There are no words that can make any sense out of death. There is no better way to die than among friends, among brothers, among comrades, fighting for something they believe in. There is no better way to die because there is no better way to live. We're not afraid to live so we're not afraid to die. (Remarks given at the memorial service for James Rector, May 25, 1969)

GUSTAV SCHULTZ
pastor of the University Lutheran Chapel
The death of James Rector was the beginning, and hopefully the end, of the martyrology of People's Park. But his death has become very much an integral part of the park's mythology.

EDITORIAL
Daily Californian
No amount of rock throwing, no amount of taunting could justify this kind of vicious attack. It is clear some people are never so happy as to spit on their hands and have a good fight on behalf of The Revolution—which is defined, usually, as the same old political garbage. (May 16, 1969)

DICK NOLAN
syndicated columnist
Damn all apologies and extenuations. We can't go around shooting our own kids. Absolutely nothing else is relevant to the tragedy in which young James Rector was cut down and killed by buckshot....You don't defeat the instigators and the agitators with sawed-off shotguns. When you resort to sawed-off shotguns you have lost to the agitators. And the agitators know it. And everybody knows it....We are in a weak position trying to argue that "we" didn't authorize or now condone Madigan's buckshot or Reagan's bayonets. We are reduced almost to pleading. (*San Francisco Examiner*, May 22, 1969)

EDITORIAL
Berkeley Daily Gazette
WERE THINGS THAT DESPERATE? For the first time in Berkeley history, guns have been fired by police into crowds of demonstrators. We

The memorial service for James Rector in Tilden Regional Park, May 25, 1969.

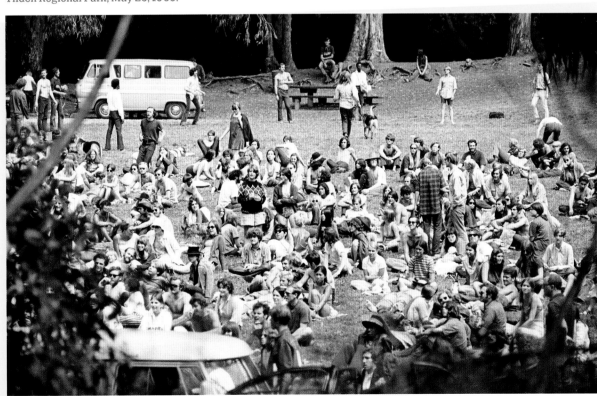

realize it is all too easy to second-guess persons in command, but the nagging question in our minds is who gave the order and why. There can be no doubt about the fact that innocent spectators, including newsmen, suffered injuries from guns Thursday. We do not question that at times circumstances become so desperate that police must use guns, even at the cost of possible injury to the innocent. Our question is, "Were things that desperate Thursday?"

The University of California Regents yesterday apologized for the injury caused to persons not responsible for the trouble. Evidence emerged yesterday to the effect that various policemen and police jurisdictions had serious doubts as to the wisdom of the use of guns.

The *Gazette* wonders why, after the dangerous situations which have arisen in Berkeley's past, the decision was made to resort to guns in this incident. We do not preach on the subject, but we do believe the press and the public have the right to the answer. Police cannot, as is their custom, remain mute as to their motives. The University of California administration must also fill in some blanks if anyone is ever to piece the current situation into some kind of perspective. Chancellor Roger W. Heyns told the Berkeley Academic Senate several meetings ago that he did not know how persons could continue to write off to youthful idealism what had become a "predictable pattern" of confrontation. If the chancellor holds to this insight, why did he not immediately identify the "People's Park" as an engineered effort at confrontation and act on that insight? Also raising questions as to the UC administration's credibility was the statement of the chancellor's second-in-command that the university would not "take any action in the middle of the night" to reclaim its property. All was to be open and above-board with specific prior announcements. Such was not the case.

One also wonders why, if the university did not have money to develop the park at budget time, they suddenly found the funds. Finally, the *Gazette* wonders why the so-called "street people" and large numbers of the college generation would allow themselves to become part of power plays larger than their understanding? Only a fool could believe the idea for a park was accidental. There can, however, be no doubt that the spirit of most who built the park was spontaneous and without malice. (May 17, 1969)

WENDEL BRUNNER
UC Berkeley graduate student in public health

I don't mean to be sanguine about Rector's death. It was a life brutally snuffed out, and a tragedy.

But for me, the talk about whether People's Park was violent, or more violent than the Free Speech Movement, or if the whole project was too provocative of violent response, or not, misses the point.

There was already an enormous amount of violence going on. And if we couldn't directly see it, I could certainly feel it. The 1-A draft card in my pocket let me know that some people wanted to drag me into it and make me a killer too. I felt we were at war—and in war, there are casualties. We all marched out to "take back the park." Then, "*Eine Kugel kam geflogen...*" ("A bullet came a-flying," as the song "The Good Comrade" goes). It could have hit me; instead, it got Rector. The Battle of Hamburger Hill was going on at the same time in Vietnam, where more than a thousand people were killed in a frontal assault on a hill of no strategic value. Rector was one of hundreds who died that day.

The Blinding of Alan Blanchard

Just south of the roof where James Rector was shot was the roof and penthouse apartment of the Telegraph Repertory Cinema, which showed foreign and art films. On May 15, the theater was scheduled to show Gérard Philipe in *The Idiot* (1948) and Mark Donskoy's *The Childhood of Maxim Gorky* (1938).

On May 15, theater owner George Pauley, manager Tom Luddy, and Alan Blanchard, a carpenter working at the theater, were standing on the roof of the building watching the demonstration on Telegraph below. There has been no claim that Blanchard, Luddy, or Pauley were involved in throwing objects down onto deputies in the street. In the same sequence of events in which James Rector was killed, deputies on Telegraph with shotguns turned to the rooftops. Blanchard was struck full in the face with birdshot and permanently blinded.

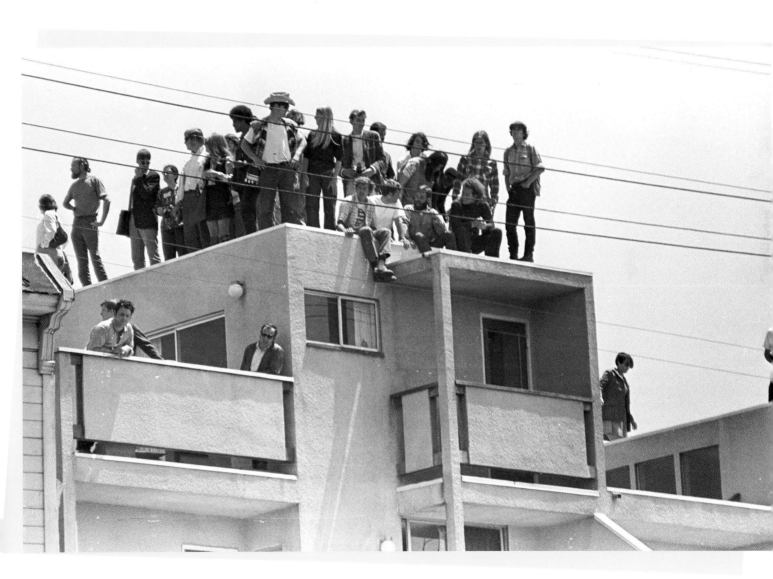

A crowd of bystanders on the roof of the Telegraph Repertory Cinema at 2519 Telegraph, where Alan Blanchard was working as a carpenter.

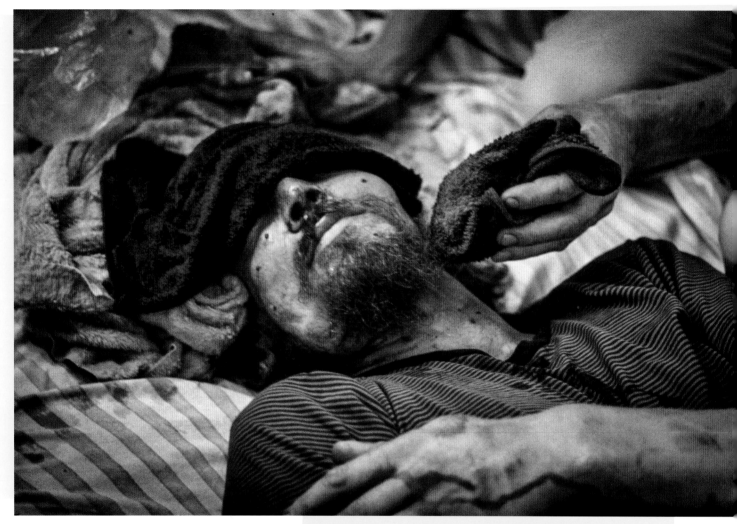

Above: Alan Blanchard lying wounded.

Right: Blanchard with his daughter Steph in 1975. She did not learn how he lost his sight until 2014, fifteen years after he had died.

ANONYMOUS WOMAN

I work at the Telegraph Repertory theater. We went out on the sun deck to see what was going on down on the street. They shot the owner of the theater in the head. They hit the carpenter of our theater, who happens to be an artist—he's a painter and a sculptor. I just came from the hospital. The buckshot exploded in one eye and lodged in the brain, and the other eye has about a 10 percent chance of regaining vision. In other words, he's totally blind for the rest of his life and there's a really strong possibility he will lose his hearing. (KPFA recording of a Berkeley Coalition meeting at Merritt College on May 16, 1969)

GEORGE PAULEY
co-owner of the Telegraph Repertory Cinema

Around 2 p.m., there were about 20 or 30 persons on this roof. We had been on the balcony but moved to the roof to watch. Pretty strong winds were blowing the tear gas away and it didn't seem effective. Officers were in the street below us when we saw this red-haired kid with a rock. We yelled, "If you throw that rock, they'll shoot tear gas up here." He threw the rock anyway. It didn't hit any of the officers in the street, but they fired at least three volleys up here. (*Los Angeles Times*, May 30, 1969)

SHEILA GRANT
employee of the Telegraph Repertory Cinema

This kid on the roof next to our building picked up a brick or something and looked like he was going to throw it at the police. Alan [Blanchard] and George Pauley [co-owner of the Cinema] started shouting at him to put it down. George, in fact, threatened to go over there and sock the kid if he threw it. The rest of us—there were about eight people on the sunroof starting to try to get down because we knew something was going to happen if the kid threw that brick. We thought it would be tear gas. The next thing I was conscious of was the sound of guns. I looked around and saw George bleeding from the back of his head. Alan had taken it right in the face. His eyes have already been operated on twice and the doctor at Herrick says there's only a 10 percent chance of saving some sight in one of them. There's nothing left in the other one; it just exploded. The doctor also said there are pellets lodged in his brain.

STEPH LUNA
daughter of Alan Blanchard

I was born on May 15, 1975, the first child of my father, Alan Blanchard, and my mother, Sharon Wagonner. My parents divorced after eleven years of marriage, when I was eight.

Although blind, my father was creative and encouraged creativity and learning in my brother and me. He taught me how to make a kite reel, how to use a vice grip, and how to drill.

He died of pancreatic cancer in 1999. In 2014, I started to do online research about him. I learned that he had been blinded on May 15, 1969, by an Alameda County Sheriff's Department deputy who was suppressing a demonstration in support of People's Park. This was a shock to me. My father had never told me this. He said that he had been welding at work and that an accident sent shrapnel into his eyes and blinded him.

I also learned that he'd had a young son at the time he was blinded. This was a complete surprise, that he had been married before he married my mother and that I had a brother.

I confronted my mother about how he was blinded and his previous marriage and son, and I asked her why she never told us. She was as surprised and shocked as I had been. My dad had never told her these things.

I went through his papers when he died in 1999 and there was nothing referencing what had happened. I know almost nothing about his life before he was blinded.

JACAEBER KASTOR
eighth-grader at Willard Junior High School

Alan Blanchard was a painter and a friend of my mother's. They saw each other at artist parties. She was really hit hard by his blinding.

LIANE CHU
co-owner of the Red Square dress shop and a People's Park cofounder

I made at least one shirt for Alan Blanchard. All I can tell you is that he was a kind, gentle Englishman.

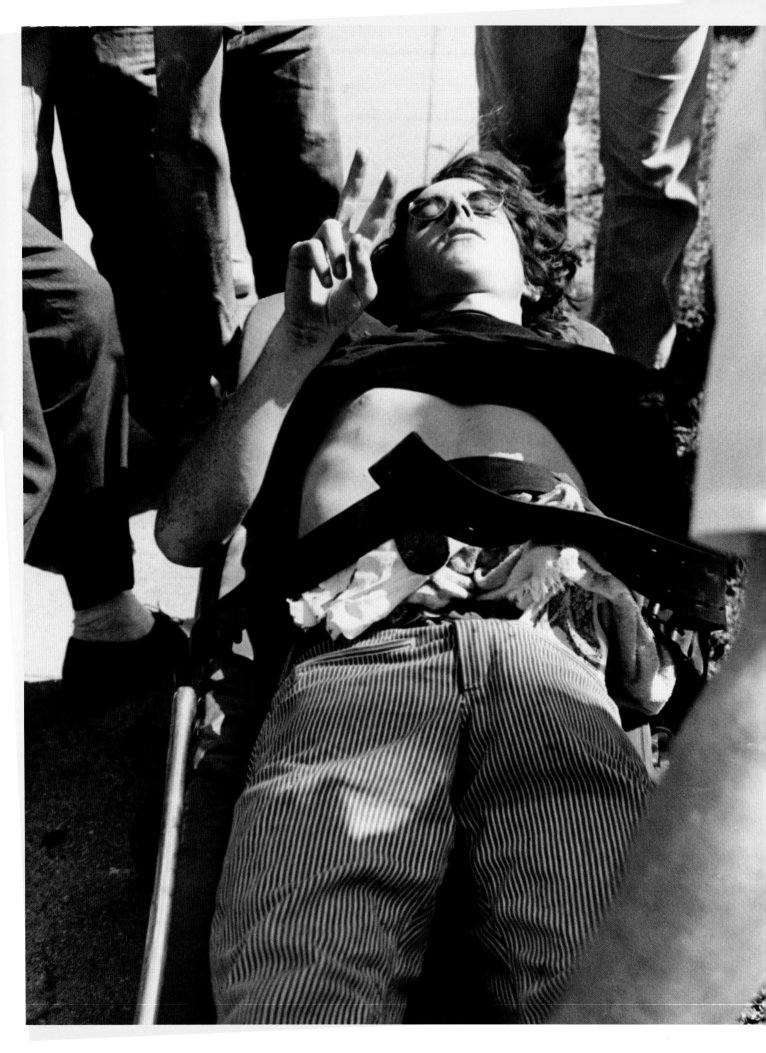

The Wounding of Donovan Rundle

DONOVAN RUNDLE

UC Berkeley undergraduate student

I was gut-shot. When you get gut-shot multiple times, struck by a cluster of buckshot pellets, and the extent of the injuries and surgeries are severe, you die. Shock, loss of blood, sepsis...my chances were grim back then. And the pain continues [as of summer of 2018, when Rundle was interviewed for this book].

I was born in Santa Monica, raised in Los Angeles. We lived on a large watershed district, surrounded by untouched chaparral wilderness—home to cougars, bobcats, coyotes, rattlers, and deer. I was a mountain child, happily running the game trails, uneasy in the flat grid stretching out far below, beyond the reservoirs. I was akin to a little Indian who would have to be brought to heel by the power-possessing beings of the white man's world.

I was raised as a Presbyterian, and we had a close-knit congregation. Our minister, who lived three doors down, had a fine reproduction of Salvador Dalí's *Crucifixion* (*Christ of Saint John of the Cross*) hanging above the mantel on a rough-stone chimney surround. I remember as a small boy lying under the piano and looking at Dalí's depiction of the crucifixion. I'm not a Christian per se, however there was power emanating from Dalí's portrayal, and Jesus's messages of "love thine enemy" and forgiveness have helped me deal with the awful atrocity that befell me. The notion of theodicy (a word invented by the philosopher Leibniz), which puzzled that small boy, has evolved into an understanding I can live with. Theodicy speaks to the question of why, in the unfolding of an infinite mystery, seemingly bad things happen to people who don't seem to deserve their fates. Everyone must reach their own understanding, if they bother to think about such things at all.

Left: First-quarter freshman Donovan Rundle flashing a peace sign as he is removed from the house on Chilton Way, where he was taken after being shot by Alameda County sheriff's deputy Lawrence Riche.

I graduated from University High School in January of 1969. I was at the top of my class in English literature and journalism. I was all-city track.

I started at Cal in April 1969. For the months between my graduation and matriculating at Cal, I was Jack Kerouac, dharma-bumming my way around the United States. I hitchhiked to New Orleans with my pal J.J., worked a couple weeks in a jazz club, and then hitched north to Philadelphia and New York. Hitching back to California, we ran into a serious blizzard in Kansas. We hopped a freight train loaded with new cars. Although we couldn't find a car with the keys in it, which would allow us to start the car and run the heater, at least we were out of the elements. That trip ended in Berkeley, where my older sister had been going to school for a couple years. I read Leonard Cohen's *Beautiful Losers* on that trip. We felt a kind of freedom, although we didn't really know much about what freedom actually meant—a question for Socrates, perhaps.

I had done a lot of hitching. It started by trying to beat the school bus on the long haul down to the institutions of "education" on the flatlands. By the time I was fourteen or fifteen I hitched down to the Newport Pop Festival, and when I was sixteen I hitched up to Big Sur, more than once. One of the hazards of hitching was being rousted by the police for no lawful reason at almost any time or place. I was told that I looked like a young John Lennon, with my little round glasses and thrift store outfits, and I guess I had a satirical attitude they didn't like. Hendrix said, "You can't dress like me," and I loved to wear colorful, unique outfits that drew attention from "the fuzz." For balance, I have to add that we were aided once by a California Highway Patrol officer when we ended up stranded in a convoluted, dangerous freeway intersection. So, it wasn't a universal thing with the cops. We ran across some nice ones in New Orleans, too. Then again, we were thrown into jail in Texas just for the way we looked. Texas and the South in 1969 were places where you would still find "whites only" drinking fountains. Cowboys had

fun trying to hit us with empty beer bottles from their speeding pickups. And I had kin in Texas! It was like a separate country back then.

When I was fifteen, my sister took me to a demonstration against President Johnson and the Vietnam War at the Century Plaza Hotel. The police rioted, savagely beating some protestors. I saw a cop beating a pregnant woman into a culvert. I knew then and there that I didn't ever want to be in a situation like that again. Since those days I've had friends who were police officers. But those were hard-knock times—"the generation gap" was in effect, and the Vietnam War was dangerously divisive. My take was that Vietnam was a civil war for self-determination. My dad was a Douglas MacArthur, "my country, right or wrong" kind of guy who seemed to me disappointed by being just a little too young for World War II. We had a lot of family who were military, going back to the Revolution.

At Cal, I lived in Smyth Hall, part of the Smyth-Fernwald housing complex on upper Dwight. I walked by People's Park as it was being built every day on my way to campus, and sometimes cut through the park to get down to Telegraph. I liked the scene. It became a nice neighborhood park, much needed in the community there. My sentiments lay with those who were in support of the park and who wished to preserve the park. I went to a couple of the meetings. I was a concerned citizen. I think it could have been worked out in a much more intelligent

and civilized manner than the way in which it was finally resolved. That said, I had no interest in fighting over it.

On May 15, I was in Sproul Plaza for the speeches and I took part in the march south on Telegraph until the march turned into pitched street fighting. After catching a dose of CS gas I said to myself that I had seen this before. I thought that the campus would be the safest place at that time. I went up to the North Campus area, and I had a copy of *The Tempest* with me that I was reading for Comparative Literature, and I just sat around and read that on campus, on a patch of lawn not far from the chancellor's house.

After a while the sounds of shooting stopped and I walked south on Telegraph. It appeared to me that the police had the situation in hand. I stopped at a hot dog stand and bought a hot dog. Everything seemed pretty normal except for a burned-out car and debris on the street. I stopped to check out the burned-out car. I guess that this car had accounted for the pillar of smoke I had seen earlier from campus. It was quiet, though—no more rioting. That was a relief to me. I wanted to get home and feel safe.

I got to Dwight and turned to go up to my dorm, but I couldn't pass an Alameda County deputy with a tear-gas-dispensing machine that looked like a leaf blower. He was herding people west onto Parker Street with some kind of toxic gas. I could see absolutely no reason for this

"It felt like I'd been hit in the gut with a sledgehammer. The buckshot used on me was packed in a 12-gauge shell that holds nine double-aught pellets....I am still carrying lead in me."

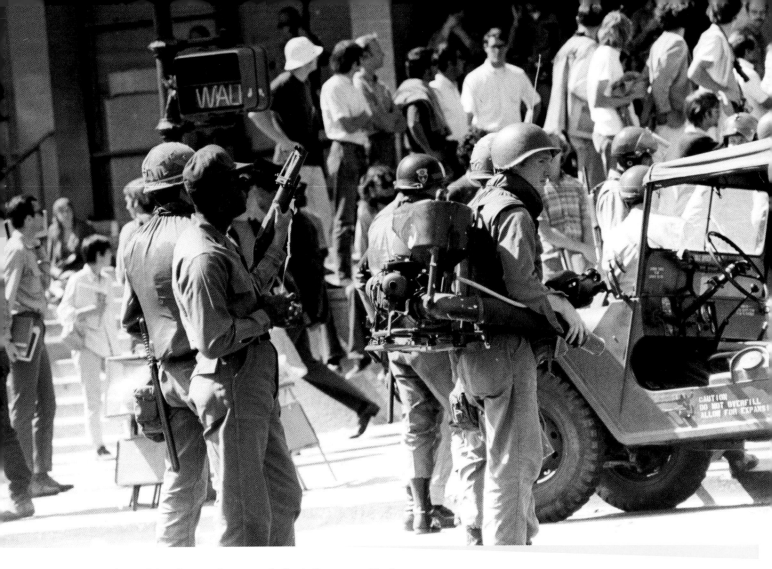

A "pepper fogger" that dispersed tear gas, similar to the one used by the
Alameda County sheriff's deputies to drive Donovan Rundle west of Telegraph.

since there was no trouble in the vicinity and very few people. I followed the small crowd to Parker. No order was given to disperse; no orders were given to the people by the police whatsoever. The machine ran out of fuel, sputtered, and shut off. The ten to twenty people who were being herded turned around and applauded. It was a spontaneous eruption of mild applause. In applauding, my feeling was more whimsical than heavy. It was a whimsical thing to do, applauding rather than shouting obscenities or something like that. I thought it was a more civilized way of expressing my admitted pleasure at the demise of a pepper-fogger. As far as I could see they were just fogging for the heck of it, just because they dug it, they enjoyed it.

I was the closest person to the officers. At no time did I see any missiles thrown at the officers. Alameda County Sheriff's Department deputy Lawrence Riche was about twenty yards away from me, shotgun at the hip, pointing skyward.

But then I saw him drawing a bead on me. I had given him no provocation to point a loaded weapon at me. My father had trained me with guns, and my last thought before the shot was that you should never point a gun at someone. In the split second before I was hit I prayed that the shot was rock salt. He aimed so carefully that I could have hit the deck in time to save myself, but I didn't even imagine that he would shoot. He gave no prior warning of any sort, nor any order to move on.

It felt like I'd been hit in the gut with a sledgehammer. The buckshot used on me was packed in a 12-gauge shell that holds nine double-aught pellets. Each is about the size of a .32 caliber bullet. I was shot in the gut with five or six of these. One or more passed all the way through my abdomen. One lodged in my pelvis and emerged over a year later. I am still carrying lead in me. One hit David Moor, standing just behind me, in the thigh. As I fell, I saw my hand covered

with coursing blood and bone chips. It had taken a pellet also.

I was semiconscious and in shock. I crawled behind a car four or five feet away. I learned later that Mario Savio had been on the block and that he came to hover next to me, placing himself between Deputy Riche and me. His action was heroic and he helped mobilize the people who would save me from bleeding out then and there. Good and brave people succored me in those desperate minutes. People carried me inside a house. I hope they put down some plastic, or an old sheet or something, because I was an oozing mess. I got in touch with a very vivid memory of these good people recently, and the hope they inspired in me gave me a little bit of courage to hang on to, and to somehow have the presence of mind to flash that "peace" sign at someone who pointed a camera at me as I was carried to the ambulance. Someone heard a bystander say, "I hope you die, you fucking hippie," as I was loaded into an ambulance. I heard that ambulances were being dispatched for injured peace officers only.

A priest wanted to give me last rites. I was wearing a small St. Christopher medal and he figured I was a Catholic, and likely to die. I was at Herrick Hospital for some time. (I don't recall how long, actually.) I was unconscious much of the time, fighting peritonitis for my life. Then I was transferred to Cowell Hospital on campus. Somehow, as I remember it, my sister figured out that I was being transferred. I have a vivid memory of her taking my hand as I lay on a gurney—I think it was when I was transferred. It was so encouraging and loving.

Immediately after the shooting, the night of May 15, I underwent an exploratory surgery of my intestines, [and] surgery where they completely removed my intestines and resectioned those areas that were perforated. I am not certain as to the exact number of perforations. I think it was around five or six. Also I underwent some surgery on my left hand for several broken bones and a severed tendon. I had a colostomy as well that first night.

My father and I did not have a good relationship. He came to Berkeley, although I can't recall seeing him, but he couldn't believe that I hadn't done something criminal, either right then when I was shot or earlier. Mom, however, stood vigil over me for some time, and claimed to hear me utter, "I have a thousand steps to climb."

On May 20, I woke up at Cowell Hospital with a beautiful spring day outside the large open windows. Incredibly, the National Guard Sikorsky helicopter dispersing CS gas seemed to fly directly over the hospital, quickly filling the rooms with CS gas. I caught a dose of the gas right there in bed with my guts hanging out in a colostomy bag. The patients, especially the older ones, completely panicked. I remember the constant shouts of "Inhalation therapy!"

I lost interest in literature, in everything that had meant anything to me. I foundered, dead to life as I'd known it. My brain was twisted with pain. The only thing that made sense was music, even though I had no musical training. On May 15, that one round passed through the longitude of my hand, from the web of my thumb to my pinkie, breaking every bone along the way. I had a surgery on it, and was supposed to have another, but my body would simply not tolerate more surgery at that time and began producing keloid at surgery sites. Later, I did have more surgeries. My doctor said that playing the piano would be good for my hand. This gave me an excuse to pursue music. That's my main instrument still.

After a month, I was discharged by Cowell, weighing 113 pounds. (I am six feet tall.) I had many surgeries, and would have many, many more—maybe close to two dozen in all. I lost count. I went to UCLA for the summer quarter as planned, but had to drop out for another colostomy and gut repairs. In yet another incident, a UCLA cop jacked up a car I was riding in. He thought my colostomy bag was a bag of weed after frisking me. Poor guy got quite a shock. They took me to the hospital.

My transfer to UCLA was only good for the summer quarter, so I had to go back to Cal when I had recovered again. But my attorneys warned me that I was under surveillance by the police, who were looking to put a bust on me, to assassinate my character this time around. So, I won an emergency transfer back to UCLA, which I'd really never wanted to go to, and there I got my degree in music and even won a fellowship in composition ten years after the shooting. The devotion to music was key to my survival.

I saw Deputy Lawrence Riche in court. To me he seemed like a PTSD sufferer, although that diagnosis didn't really exist until 1980. Nobody in their right mind would kill for no reason, so he had to have PTSD or something like it. He

looked like a pasty-faced young guy from Middle America, which he was. I don't know who or what he mowed down from his position as a helicopter gunner in Vietnam, but Sheriff Madigan said some of his guys equated Cal students with Viet Cong combatants. What? I was a kid reading Shakespeare, supposedly part of the cream of the coming generation, who had worked hard to earn a place at Cal. It was nothing but an atrocity to me.

My attorney's investigator found a guy in a crowd photo who had a camera capable of shooting movie footage. Then he found the guy and got to see what he took footage of. In fact, it was that footage that got them, the cops, to settle because it showed that the area where I got shot was calm and subdued—not the riotous hell the cops had portrayed under oath. But all the cops were acquitted of everything. How could I understand that? I just can't. It remains an undigested puzzle. I had over a dozen witnesses stating that my only "crime" was applauding. So my hands were definitely empty. No gun, no brick, no rock, nothing. But still, the lethal blast was loosed on me. It was almost a perfect center-of-mass hit, and Riche knew how to shoot a rifle. But shotguns tend to shoot a little low, another saving grace. He missed my heart, barely.

I have had hard times, obviously, and still do, as a result of this atrocity. I don't think that a person can recover from wounds of that magnitude inflicted under such circumstances. I can't seem to get over those ancient wounds to my body and soul. I am still troubled by how I treated my high school sweetheart, Amy Pieper. She was a big part of my recovery, but I took her for granted and didn't treat her as well as she deserved. I was pretty crazy, in spite of psychological help from student health [services]. Parts of my abdomen and back keep failing all my life. It has frankly been difficult to persevere at times, but that kid who flashed the peace sign after just being gunned down in cold blood may not have been entirely killed off after all. I am still working on myself as hard as I can. I think of Riche, I think of my ancestors who conquered and subjugated the native people as if they weren't human, and I am reminded that in the opinion of D. H. Lawrence, "The essential American soul is hard, isolate, stoic and a killer."

> ## "I had over a dozen witnesses stating that my only 'crime' was applauding."

Donovan Rundle's girlfriend, Amy Pieper.

RONDA RUNDLE

UC Berkeley undergraduate student

I was a history major at Cal in the spring of 1969. I was a very straight student. I was well-read on political issues and was a strong opponent of the Vietnam War, but I was not an activist. I think that we all felt pride in the fact that the Free Speech Movement had taken place at Berkeley, and it was one reason that I chose Cal. I was not drawn to the cultural aspects of the counterculture. My brother Don started at Cal in the spring of 1969. We saw each other a few times before May 15.

I was living in the dorms and would walk by what became People's Park often. I remember it as a muddy eyesore filled with junk, and I was shocked that the university would let it turn into such a junkyard.

I was generally aware that people had started to work on People's Park, but I didn't participate. I thought that they were improving the lot, but I wasn't interested enough to visit. It seemed that there were more community people involved than students, but that would make sense because community people would be more interested in beautification than students.

My memories of May 15 and the weeks after that are shadowy, with several extremely vivid images.

I remember the morning of May 15. Very early in the morning, maybe even before sunrise, I heard loud shouting in the neighborhood. There were waves of loud shouting. I remember a constant shout of "The pigs are coming." It was ominous, scary, and unsettling. I felt trepidation about what was going to happen. I understood that people would stand up for the park and that there could be a confrontation.

Late that afternoon I got a phone call in my dorm room from my father saying that Don had been shot and was in the hospital. I had not been aware of any violent activities that day. Dad told me that Don was being transported from Herrick Hospital to Cowell Memorial Hospital on campus. I walked to Cowell and waited there quite a while until I saw Don being wheeled down the hallway on a gurney. I took his hand. He lifted himself up slightly to acknowledge me. He was in great pain and you knew that it was serious. He was headed for surgery. My parents flew up from Los Angeles that night and we waited together for Don to emerge from the operating room. I know that I visited Don in the hospital often, and I believe that his girlfriend Amy was there as well.

My next strong memory is the day that he was discharged. It was a nightmare. He was emaciated, like a skeleton, and weak. I flew with him to Los Angeles. We stopped at his room on campus to pick things up, and nothing went smoothly. We ended up having to run to make the plane. I was very concerned about his condition and really thought that he should have had medical transport to Los Angeles. I've often thought that the trip may have contributed to his need for subsequent surgeries.

He has had a series of complications and setbacks, especially in the first years after the shooting. Amy Pieper was always with him then.

> **"I remember a constant shout of 'The pigs are coming.' It was ominous, scary, and unsettling. I felt trepidation about what was going to happen."**

She was his guardian angel and probably saved his life many times. She had an incredibly beautiful face and was unassuming and quiet. I don't know how their relationship ended, but thinking of her and how good she was sends chills down my spine. I adored her.

I graduated from Cal in 1971. What happened to my brother should never happen to anyone. He has shown unbelievable courage both with his physical struggles and his struggle to find meaning in what happened to him.

CAROLYN DEWALD
UC Berkeley graduate student in classics

I arrived in Berkeley in January 1969 for graduate work in the classics department. I was on the extreme end of naive. My recently married husband and I lived in a second-story apartment on Parker Street, just west of Telegraph Avenue.

I had hung out at People's Park a few times before May 15. It was a nice place; I thought it was great. People's Park lit up all the feelings we had, the frustration of the marches against the war that nobody paid attention to. It was fun to have.

On May 15, 1969, my then husband and I walked home, coming east up Parker. We were making lunch in our apartment when we heard noise. I went to the window and looked. An Alameda County deputy sheriff had raised his gun and was aiming west on Parker. Everybody except one man was running west away from him. Nobody was throwing rocks or anything else.

One student didn't run. He just stood there. He didn't raise his arm, he didn't throw anything. The sheriff shot him in the belly. His stomach exploded. There is more blood in the human abdomen than you would imagine. His guts were dangling outside of his body and the street was covered with his blood. It was an unspeakable act of violence. The bloodstains were on the street for at least a year.

My husband ducked and didn't see the shooting. He has not experienced the post-trauma stress that I have, the waking up in the night with the scene of Rundle's stomach exploding.

I testified in the civil trial of the young man, whose name was William Donovan Rundle, Jr. He told me that he had had many surgeries. He was emaciated and did not look like he was going to live very much longer. It was horrible.

LAURENCE D. KORN
eyewitness

Three Alameda County sheriffs walked from the intersection of Parker and Telegraph west on Parker until they were directly across Parker from the window we were looking through. A rock was thrown which landed about ten feet in front of the leading sheriff. He waited about fifteen seconds, lifted his shotgun, took careful aim for about three seconds, and fired two shots. We ran to the living room window and saw the victim limping to the house next door to us on Chilton Way. He was shot in one arm, the stomach, and buttock. An ambulance came in a few minutes and carried him away. He was unable to speak. The sheriff made no attempt to arrest him. He simply returned to Telegraph. (Written statement given to the police, May 26, 1969)

ALBERT F. MORENO
eyewitness

As the police approached, the crowd proceeded down Parker to about the corner of Chilton, when the gas machine ran out of gas. At this point about four to five individuals began clapping their hands, making fun of the officer with the machine. There were no objects thrown at the police, nor were there threats to do so, and the crowd did not advance back toward Telegraph. An officer then raised his shotgun, and with no warning and no apparent reason, shot twice in the crowd, felling the youth on the first shot. The youth collapsed at the corner of Parker and Chilton; as other individuals approached to aid him, the officer fired a second shot and then retreated to the corner of Telegraph and Parker.

WILLIAM NEEKS
eyewitness

On May 15 I witnessed a shooting at the corner of Chilton and Parker in Berkeley. A young man was shot by an Alameda [County sheriff's] deputy for no apparent reason. I viewed the incident through the picture window of my apartment on the corner of Chilton and Parker. I saw the policeman aim for about three seconds and then fire one shot at the victim standing at the corner, who was apparently not trying to escape. I believe that there was someone shot in the leg who had started to run and was just about five feet behind the victim. When the victim fell, clutching his stomach, someone appeared on

the scene, reached out to the victim, and disappeared. Someone else who had seen the shooting appeared apparently to help the victim. The policeman still had his shotgun aimed at the person who had come to help. He stretched his hands above his head. The policeman lowered his gun and then walked away. My roommate Jeff Knox then called the operator for an ambulance.

JEFFREY MATTHEW KNOX
eyewitness

Approximately twenty to thirty Alameda sheriff's deputies advanced up Parker Street toward Telegraph Avenue, the site of a burning City of Berkeley car, with shotguns. The time was about 1:30 p.m., May 15, 1969. They immediately opened fire upon their arrival at the intersection of Telegraph and Parker. There was no crowd visible from the porch of my apartment building. The shooting continued until 4:00 p.m. In that two-and-one-half-hour period the sheriffs, as far as I can tell, were shooting at individuals who came within range, which seemed to be one hundred yards. One officer seemed to be doing most of the shooting. At approximately 3:45 there was a lull in the shooting, which had, until then, been fairly constant. I looked out the kitchen window in time to see an Alameda County sheriff's deputy advance down Parker and take sight on a man standing in the street near a gutter at the corner of Chilton Way and Parker Street. The man saw the gun aimed at him and began to run north. The sheriff shot him twice. The first shot hit him in the stomach and sent him flying about six feet through the air. As he fell to the ground, a second shot seemed to hit him in the arm and another man in the leg. I immediately called the Berkeley Police to request an ambulance. When I looked back out the window, the man was being carried into a house on Chilton Way. The ambulance arrived a few moments later. The Alameda County sheriff who shot the man turned and walked back to the intersection, making no move to assist the victim.

TED VINCENT
UC Berkeley sociology instructor

I was standing at the filling station on the southwest corner of Parker and Telegraph watching a policeman on the northwest corner of Parker and Telegraph backing people away with a fog sprayer. A second policeman who was with the first policeman stopped in the middle of the street and with no apparent provocation raised his gun and fired two shots. I was approximately twenty to thirty-five feet away from the policeman, walking parallel to him. He now aimed at Vernon Forgue, a friend of mine, who was just behind a telephone pole. The policeman was aiming at Vernon's shoulders-to-head section. I went to the corner of Chilton. There was blood on the street. The people on the corner said someone had been shot with no provocation and had been taken inside a neighbor's house. I saw the victim being carried out of the house on a stretcher, flashing a victory symbol. I saw nothing thrown and no reason for the shooting.

VINCE MANING
undergraduate student at San Francisco State

I was alone standing behind an Alameda County sheriff on the northeast corner when he stepped off the curb, raised his shotgun (a 12-gauge pump-action). Approximately thirty people were standing on the sidewalk on the northwest corner of Chilton Way and Parker Street. They were simply watching, neither shouting, clapping, nor throwing any objects. The deputy sheriff fired once, chambered, and fired again. No order to disperse was given. The group seemed stunned, then approximately five moved to help the fellow who had been hit in the stomach and left arm. In the meantime, the Alameda deputy sheriff who had fired the shotgun went over back onto the sidewalk. Neither he nor any other deputies present moved to aid the victim. Student medics moved the victim from the sidewalk into the pink house on the northwest corner of Chilton and Parker.

STEFAN VETLUNG
Swedish tourist

I looked up the street and saw a police officer dressed in blue overalls aiming and firing at a man on the northeast corner of Chilton Way. He jumped, fell to the ground, and clutched his stomach screaming. Bystanders removed him to a house on Chilton Way (the second house down on the east side). The ambulance arrived shortly. The police gave no warning about the firing.

COLIN MCLEOD CAMPBELL
carpenter

I reached the first or second house next to the gas station on the corner of Parker and noticed a group of reporters. I turned and saw Alameda County Sheriff's Department deputies, in blue jumpsuits, walking down Parker. There were ten to fifteen people still in the intersection. The young man closest to the police stood facing the line of police. One of the deputies stopped within ten yards of him. The young man stood completely still, hands empty and at his sides for a few seconds. The officer raised his shotgun and aimed it directly at this man. The fellow seemed to be rooted to the spot; he didn't move. A second or two went by after the officer raised his gun. The cop fired at the young man. I could hardly believe my eyes. It was, I believe, a direct hit. The officer lowered his shotgun, turned around, and walked back toward the line of police, rather indifferently—matter-of-factly, it seemed to me.

CHRISTOPHER REAM
eyewitness

I peripherally saw one deputy turn and fire his gun in the direction of a young man who had been standing next to a car. He fell to the street and then rolled into the gutter. My first reaction was that he was "hitting the dirt," but when he remained motionless in the gutter, I realized that he had been shot. The deputy turned and fired twice directly (not in the air) at the fleeing crowd. The crowd then stopped and yelled at the deputy. Two rocks were thrown, both landing short. The same deputy fired twice more at the crowd. Another deputy said, "Did you see that? I guess you learned the lesson."

DORANNE JUNG
UC Berkeley undergraduate student

I was standing at the window of 2419 Parker Street in Berkeley, watching the intersection of Parker and Telegraph. I saw one policeman dressed in a blue jumpsuit step out of line, walk about ten yards down Parker. He seemed to be looking down the street. He toyed with his rifle for a while. Finally he raised it to aim carefully, but I couldn't see what he was aiming at. Then he shot after about ten seconds of aiming. People in the house shouted they had seen a boy shot.

MICHAEL SLOMICH
graduate student at San Francisco State

One policeman proceeded to walk into the middle of the intersection and aim his shotgun at a boy on foot who started to turn away upon seeing the policeman take aim. Before he could run away, the policeman fired and shot him in the side. The youth grabbed his stomach, writhed on the ground for a few moments, went into convulsions, and collapsed by the gutter in a pool of blood.

ERIC OTZEN
student at Merritt College

I saw the overturned car at Parker and Telegraph. I started talking to the attendants in the gas station. There were about one hundred to two hundred people around this intersection. Around twenty to thirty Alameda County sheriff's deputies moved into the intersection, all armed with shotguns. For a few minutes nothing happened. No one was told to leave. There was one young man standing somewhat isolated from the crowd. The man was about twenty feet from the rest of the people. Two seconds elapsed and the cop shot him in the stomach. The young man grabbed his abdomen and fell down and rolled three times into the curb. At this time, the other, shorter, policeman shot into the crowd. I saw someone fall down and grab his leg. I did not see the young man who was shot throw any rocks.

REESE ERLICH
suspended UC Berkeley undergraduate student and a reporter for Ramparts magazine

On May 15, my 1966 Ford Mustang was parked on Parker Street near the corner of Chilton Way. I returned in the afternoon to find my left-side window shattered. It had a hole the size of a golf ball. Witnesses in the area told me that it was the result of a police shotgun shot at a person.

In the report taken from your son, William Donovan Rundle, Jr., when he was admitted to the hospital on May 15, he described the uniform worn by the officer who allegedly shot him. The description was not that of the uniform worn by our department. For further information, we would refer you to the Berkeley Police Department, Berkeley, California. Very truly yours, Frank I. Madigan. (June 2, 1969)

Testimony of Lawrence Riche, deputy with the Alameda County Sheriff's Department in *United States v. Lawrence L. Riche* (1970)

Did you actually see anybody throw a rock at you?

No, sir. They were obscured. I saw the rock coming.

You saw some rocks coming. But you didn't see anyone throwing a rock?

No, sir.

Just raised your gun and fired?

Yes, sir.

And you were aiming in the direction of Chilton and Parker?

Yes, sir, it was in that direction.

And you say you hoped nobody would get shot.

Yes, sir.

But you fired your weapon in the direction of a group of people at the corner of Chilton and Parker, didn't you?

I fired at it.

What was your purpose in firing your shot there on the corner?

To disperse the crowd from which the rocks were coming, sir.

And again, you did not yell any warning before you fired the shot, did you?

No, sir.

If there were innocent bystanders there, what were they supposed to have done?

They should not have been there.

• • •

Lawrence Riche: So I walked over to the sidewalk. I looked on the sidewalk. I saw, I think, two people leaning over a male who was lying on the ground.

And then what did you do?

I yelled at them to move.

Did you see a [bloody] rag at that time?

No, they yelled, "He has been hit, he has been hit!" and then I saw the rag.

All right, and then what did you do?

Well, it had something red on it. It might have been blood, so I just let them take care of the man.

And when they told you that the man had been hit, you turned around and walked away, is that right?

Yes, sir.

Did you attempt to make any arrest?

No, sir, I did not.

The criminal jury acquitted Riche. Rundle prevailed in later civil litigation.

Other Shootings

There is no consensus on the number of people who were shot by police on May 15. It was almost certainly more than thirty.

DENNY SMITHSON
reporter for KPFA (broadcasting live)
They've got shotguns now and they're using them, shooting them. Christ. They're using guns now. They've all got shotguns now so they're using scatterguns against them. (May 15, 1969)

LOWELL JENSEN
district attorney for Alameda County
It was a terrible escalation, yes. It wasn't that anybody shot them to kill; they didn't set out to kill them. But they were thinking of crowd control. I didn't see any real difference between

List of Known Victims of Shootings

Published in *A People's Park Chronology,* by Gar Smith

Treated at Herrick Hospital:
 Marlin Ayotte, 27
 Michael Beavers, 19, chest
 Alan Blanchard
 Andrew Brandt, foot and thigh
 Clarence Edson, gunshot wound to the leg
 Richard Ehrenberger, leg
 Vincent Ferrari, right hand [according to one source; Ferrari himself reported having received "48 birdshot wounds in head, legs and arms"]
 Mark Greenburg, buckshot wounds in face, eye, and side
 Thomas Harris, 23, multiple gunshot wounds to arms and legs
 Ester Hepper, 47, facial wounds
 James Padgett, 20, buckshot wounds
 William D. Rundle, abdomen and hand
 Brennan Stiley, abdomen, chest, neck, and face
 Carl Utt, gunshot wounds
 Chris Venn, 22, one hundred pellets in back

Treated at Cowell Hospital:
 Mark Berry, pellet wounds
 Nancy Burns, pellets in hands and neck
 Clayton Crowell, pellets in arms
 Franklin Dunn, head and left arm
 Alan Francke (Cowell Hospital employee), hand
 Richard Graham, pellet wounds
 Robert Grudupt, pellets in back and neck
 John Christopher McCarthy, back
 Phillip Miller, pellets in leg
 Christopher Rouqier, pellets in face
 Thomas Rufa, pellets in hip and back of neck
 Tony Taladich, pellet wounds

Treated at Highland Hospital, in Oakland:
 Tom Wyatt, leg

In addition to the above, Tom Luddy, George Pauley, and Jim Carr, all from the Telegraph Repertory Cinema, were at least grazed by shotgun pellets.

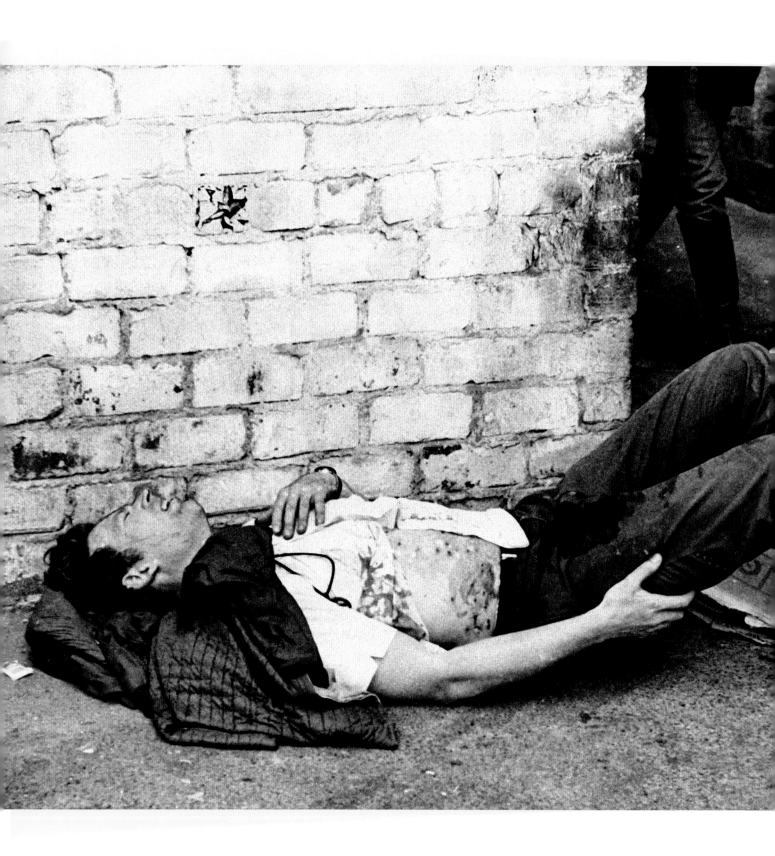

the threat of violence from that demonstration and what they had seen here in Oakland. (From "A Life Dedicated to the Administration of Justice and Legal Reform," interview conducted by Lisa Rubens and Marcia Jensen, 2005–2006, Regional Oral History Office, The Bancroft Library, University of California, Berkeley, 2009)

BERKELEY DAILY GAZETTE
All the officers were treated and released. Nine people were hospitalized at Herrick, three at Cowell, and two at Highland. (May 16, 1969)

ANDUS BRANDT
on hiatus from architecture school
I transferred to Cal from Colorado College in 1966 to study architecture. I dropped out in the spring of 1968. I worked with Volunteers in Service to America in Napa for a while and then returned to Berkeley. I had been a supporter of protests against the war in Vietnam but was not an activist or a leader.

Back in Berkeley, I lived at Cloyne Court. Friends there told me that people from the community had taken over a vacant lot and were making something beautiful. The day that I went to see it was the day that the university had the fence erected and began destroying the park. I went to the rally at Sproul Plaza and then walked with a crowd down Telegraph to Channing. I stayed on Channing west of Telegraph, in a parking lot on the south side of the street.

A group of Alameda County sheriff's deputies dressed in blue came around the corner from Telegraph. I didn't see anyone throw anything, I didn't throw anything, and I heard no warning from the deputies. I heard shots and assumed that the deputies had fired tear gas grenades. It wasn't until I tried to walk and couldn't that I looked at my ankle and saw that I had been shot. I grabbed and held onto a parking meter as the other students who had been standing around the parking lot fled to the dormitory on the north side of Channing. A couple of students saw me standing there and left the dorm to bring me inside.

There were others who were more seriously hurt than I was inside the dorm. The volunteer medics triaged us. Many people who had been shot were afraid to go to the hospital and were having friends remove birdshot from their bodies. People in the dorm called for ambulances for

several of us but were told that all ambulances were reserved for the police. After a couple of hours they loaded a few of us into several cars to go to the hospital. As we left Telegraph, a cop dropped a tear gas grenade into the car in front of me, which was taking a wounded person to the hospital.

At Highland Hospital, the police were checking everyone who was there seeking treatment and were trying to arrest some of them, but Movement lawyers stopped that. My ankle wound was caused by buckshot, which luckily had passed through my ankle between the bone and the tendon. I also had a wound on my thigh which the hospital didn't want to treat. I didn't want lead in my body and so insisted that they treat me. It too was a buckshot slug.

I was unable to walk for several weeks. When I could walk, I hitched to Colorado Springs. I

"If those crazy people don't know how to use those guns, they shouldn't have them."

didn't feel that Berkeley was safe. I was there for a while and then went to Philadelphia to the office of the Central Committee for Conscientious Objectors. I got a job at a coffee house in Urbana from them. In response to demonstrations at the University of Illinois in May 1970, the National Guard was called in. I looked down from the bell tower where I had made my room and saw the National Guard everywhere I looked. I realized that no place was safe and that things were crazy everywhere, so I decided to come back to Berkeley.

OAKLAND TRIBUNE

Michael Beavers, 19, a University of California student whose address is unknown, was in better than "satisfactory" condition yesterday, a spokesman at U.C.'s Cowell Hospital said. Beavers was shot in the chest. Robert Carter, of 1544 California St., San Francisco, is at San Francisco General Hospital. He received shotgun pellet wounds in the abdomen and suffered a ruptured spleen. (May 24, 1969)

FRESNO BEE

Yet another wounded nonparticipant is 57-year-old Ester Hepner, resident of the Berkeley Inn on Haste Street close to the contested people's park property. She is still in Herrick after undergoing surgery for damage to her mouth, upper lip, and left cheek, and treatment for a compound fracture of her nose. (June 8, 1969)

OPEN LETTER TO GOVERNOR REAGAN FROM PRIVATE BERT PINCOLINI, U.S. ARMY

I work in the emergency room of a large hospital here in Vietnam. Every day I am a witness to the same scene of torn and maimed young men arriving by helicopter for treatment. The everyday scene in this room is no different than the scene last week on the Berkeley campus. A man with a load of birdshot in his gut is not much better off than a man who walked into a booby trap. It is not so much the similar physical damage that creates the parallel, but the similar force of ignorance and blind pride that allow such horror to occur. This whole thing is so insane. I could spend a year in this hole, come home without a scratch, and then get shot by a cop as I walk down the street. (May 18, 1969)

HOWARD DRATCH
UC Berkeley graduate student in political theory

As things calmed down on Telegraph, I went back to campus, where things weren't calm. Police were shooting live ammunition, and I found bullets embedded in the sash of a window of the library. It might be that the police were shooting above our heads, but there was no mistaking the fact that live ammunition was being used.

CLARENCE EDSON
painting contractor from Fremont

If those crazy people don't know how to use those guns, they shouldn't have them. Tear gas was burning my eyes and I couldn't see to drive. I stopped and got out of my truck to wash my eyes clean. The next thing I know there was a burning pain in my right leg at the calf. (*Berkeley Barb*, May 30–June 5, 1969)

BERKELEY DAILY GAZETTE

After inspecting a twenty-three-unit apartment house at the corner of Milvia Street and Berkeley Way, [Clarence] Edson drove his truck to College Avenue, another job site, parked his truck, and walked down to a forty-nine-unit apartment house at 2520 Dwight Way. After learning another firm's carpenters had left the area because of tear gas wafting over the site area, he walked back to his truck to leave. Edson states:

> I had just turned left on Parker Street and was turning onto Regent Street—I double-parked my truck to go and get some water to relieve the tear gas pain. As I crossed onto the sidewalk looking for a faucet, I look to the left and then to the right, and on the right on the corner of Regent and Parker I noticed two policemen, gas masks on, and one of the policemen had either a

Alameda County Sheriff Frank Madigan accused the *San Francisco Chronicle* of doctoring this photo. The officer pictured was not charged, and the victim shot in the back was extradited to Texas for a draft violation.

rifle or a pistol aimed and shot me in the leg. The only thing I really noticed about their appearance was their blue helmets and gas masks—everything happened so fast. After the shooting, the officers just stood there and for two or three seconds I had to drag my leg over to my truck, and when I looked up again they were gone. In no way did they try to give me assistance or medical aid of any kind.

Edson estimates the officers were 125 feet away. He says he was not carrying or holding anything when he was shot. He was wearing a pair of slacks and a sport shirt. Doctors set a cast but left the bullet in his leg because they feared taking the bullet out might lead to an infection severe enough to require amputation. Although not knowing the exact caliber of the bullet, a doctor told Edson that it was not a bird-shot wound. Edson yesterday said on the basis of the x-rays, the bullet could be either .30 or .38 caliber. (May 29, 1969)

SAN FRANCISCO CHRONICLE
Houchins [Tom L. Houchins, field commander for the Alameda County Sheriff's Department] said he had investigated Edson's story and saw no reason to disbelieve it. (June 19, 1969)

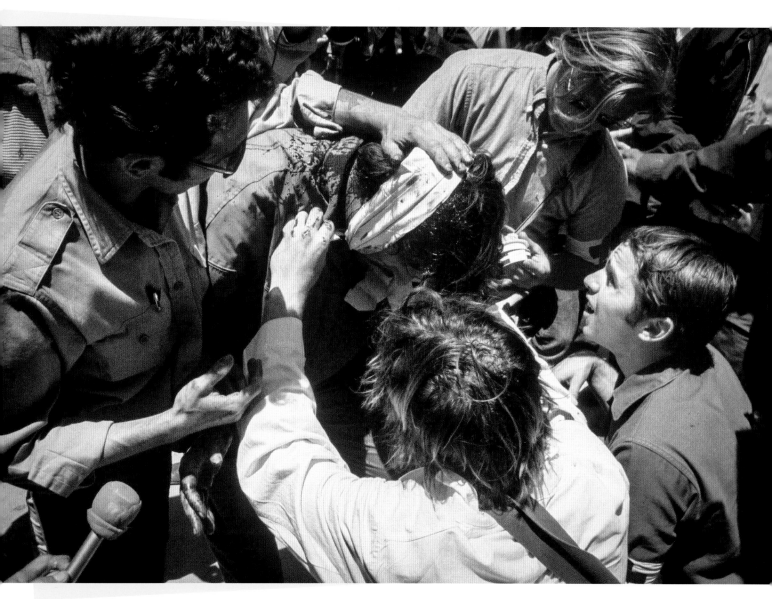

Berkeley Free Church medics provided first aid as best they could.

ROBERT BENYS
Clarence Edson's lawyer
Doctors told us that there is a possibility that if the bullet is removed the leg will be paralyzed from the wound down. The bullet fired by the cops was .38 caliber. (*Berkeley Barb*, May 30–June 5, 1969)

GAR SMITH
author
Sheriff Madigan charged that a photograph published in the *San Francisco Chronicle* and which appeared on the front page of the *New York Times* had been "doctored." The photo showed an Alameda [County] sheriff leveling his shotgun at the back of a fleeing demonstrator. The photographer, UC math student Emitt Wallace, denied any retouching of the negative and stated, along with another witness to the shooting, UC sociology major Mel Marrison, that from where they stood, there was no evidence of rock throwing. Chris Venn, a twenty-two-year-old part-time longshoreman, claimed to have been the individual shot by the deputy. "All I know is that I was about fifty feet down the street when something hit me. There was no warning. Nobody yelled for me to stop." (From *A People's Park Chronology*)

REVEREND PATRICK THOMPSON
Church of Tomorrow
A minister who came to Berkeley Wednesday May 14 to collect money for his burned-out church came within inches of losing his life the next day. Reverend Patrick Thompson of the Church of Tomorrow had a patch on the right side of his face. "The doctor said I was damn lucky. If I had been shot 3 inches lower I would be dead," the young minister said. He was walking up Parker near Dana Thursday afternoon. "All of a sudden I was knocked down. There was pain in my jaw. I managed to get up and go down to the Free Church for help." Later doctors took a steel pellet the size of a marble out of his cheek. (*Berkeley Barb,* May 23–29, 1969)

JACAEBER KASTOR
eighth-grader at Willard Junior High School
Daniel Peck was a friend in school. We all used to cut class pretty regularly and go to Telegraph to collect new concert posters and cards. He cut school and came back with little red holes on the side of his face and his chest—birdshot. He saw the nurse and then was taken to Herrick Hospital. He had gone to Telegraph with his Brownie camera. He raised it to take a photo of some cops. One of the cops raised his shotgun and aimed it at Dan. Dan thought that he was kidding but then realized he wasn't. He turned his face instinctively, and just in time. He told us that when he got the film developed it showed the cop aiming right at him.

ANONYMOUS WITNESS
One of my brothers came hobbling in with his left side looking like he had been used as a dart board. Dan Peck had been hobbling from station to station at the arm of a volunteer nurses auxiliary. (*Berkeley Barb,* May 23–29, 1969)

DARYL LEMBKE
reporter for the **Los Angeles Times**
A group of officers turned the corner and immediately fired several shots at us from about twenty yards away. Seventeen pellets hit Wegars [Don Wegars, a *San Francisco Chronicle* reporter] in the legs, shoulder, and face. We were engulfed by police tear gas. We were shot at while trying to escape from the gas. No one in the crowd was throwing anything. (*Los Angeles Times*, May 30, 1969)

WILLIAM B. JONES
UC Berkeley graduate student
I had just checked my mail in the classics department office, room 5303, Dwinelle Hall. I stopped at the foot of the steps. Somebody said, "They're shooting." I said, "That's ridiculous." At that moment I was hit with four pellets of birdshot—one in the lip, two in the chest, and one in the stomach. There was no indication from the police that I should not be where I was.

SOREN RASMUSSEN
UC Berkeley undergraduate student
Two Alameda [County] deputies came to the corner of Regent and Parker. They spotted this guy there; he was less than ten yards away from the police, and he was just standing. As far as I could see, he hadn't done anything. One of the deputies raised a shotgun to his eye. The victim

"I never dreamt that they were using guns, but the man next to me went backwards. After the kid was hit, he laid on the ground moaning for help. He was delirious. I couldn't get to him. It was war."

turned his back; he didn't fall but sort of lowered himself to the ground. The police didn't give any warning. After he fell to the ground, the cops went back to Telegraph by way of Parker. They never said anything to him at all. Two people went to his aid. They took him into a house on the west side of Regent between Derby and Parker.

RYDER MCCLURE
freelance photographer
I dove under a car when I saw that the gun pointed at me had narrow barrels. I never dreamt that they were using guns, but the man next to me went backwards. After the kid was hit, he laid on the ground moaning for help. He was delirious. I couldn't get to him. It was war. There is no other way to describe it.

THOMAS PARKINSON
UC Berkeley professor of English
This is a civic, state, and national problem as well as a campus problem. The use of live ammunition by a policeman in Berkeley is justified only when the life of a policeman or another citizen is in danger, or in the pursuit of a felon. This standard, this law, has not been followed. I think we need a break in the cycle of violence, some conciliation, mercy, decency, negotiation, compassion.

OWEN CHAMBERLAIN
UC Berkeley professor of physics and a Nobel Laureate
The park symbolizes the university using force contrary to the bulk of student opinion. We would have none of this trouble if the students thought the university had acted with any decency.

GILBERT SHANNON
factory worker
At approximately noon I arrived on Telegraph Avenue with my cousin Cathy Clark to show her around Berkeley, as she was visiting from out of state. I did not know anything was happening. When we got to Telegraph and Dwight, we discovered a crowd of students tipping over and burning a campus police car. One of the policemen turned toward the crowd on the southwest corner and shot a young man standing about thirty feet from him in the back. The policeman fired about three shots into the crowd there, hitting one man in the back of the head.

CATHY CLARK
visiting waitress
Suddenly one of the policemen raised his gun and shot a man across the street in the back. The police gave no orders nor said anything. The man fell on the street, screaming and writhing around. A couple of the policemen laughed. The police made no attempt to help the fallen man.

BARBARA DUDLEY
seamstress
I was standing on Telegraph Avenue at about 2:30 or 3:00. I heard the sound of shots, so I ran south on Telegraph. Everybody was really panicked and running. I saw a policeman wearing a helmet with a gun in his hand. He was shooting into the crowd. I saw a boy being dragged off Telegraph near Blake. His stomach was bloody. What really scared me was that the policemen didn't seem to be shooting at anybody in particular but at all of us.

POLICE SEIZE PARK; SHOOT AT LEAST 35

March Triggers Ave. Gassing; Bystanders, Students Wounded; Emergency, Curfew Enforced

The Daily Californian

Vol. 202, No. 34 The University of California, Berkeley, California Friday, May 16, 1969

By JOE PICHIRALLO

A peaceful noon rally and march to protest the University's seizure of People's Park erupted into a brutal day-long battle between police and demonstrators here yesterday.

Fifty-eight people were hospitalized and by the end of the day tear gas had penetrated the entire south campus area.

Police, openly brandishing shotguns, fired birdshot into surging crowds of demonstrators. The blood streaming down the faces of participants and observers was not the result of clubbings, but was caused by shot from police guns.

Late last night, Commanding General Glenn Ames, of the California National Guard, said he was calling up a "substantial number" of National Guardsmen, who would be moved into staging areas around Berkeley during the night "pre-pared to furnish whatever military support might be required."

Twenty-five people were arrested on charges ranging from misdemeanors for throwing rocks to a felony for possession of a concealed weapon.

One policeman was stabbed and three others received minor injuries from rocks and shattered glass. All were treated at Herrick Memorial Hospital and were eventually released in satisfactory condition.

At press time, local hospitals reported that 58 people were treated for injuries suffered in the riot. Of these, 12 were admitted to hospitals. About 30 people were wounded by bullets, of which four contained gunpowder, the rest birdshot.

By nightfall, approximately 500 police from nine different departments guarded the streets of Berkeley.

At the request of the Mayor and City Manager of Berkeley, Governor Ronald Reagan issued emergency regulations late yesterday which established a curfew over the entire city, including the University campus.

A helicopter circling over the city blared out the regulation that no person could loiter in or about the City of Berkeley between the hours of 10:00 p.m. and 6:00 a.m.

In addition Reagan's emergency regulations prohibit any "participation in a meeting, assembly or parade in or about Berkeley, including the campus." Any violation of these regulations will be considered a misdemeanor.

Rumors predicting the destruction of "People's Park" had become an almost daily occurrence around campus. However, Chancellor Roger W. Heyns issued a definitive statement on the park Wednesday, in which he announced his intention to construct a fence around the administration-proposed athletic field.

Thus the possibility of imminent destruction became a reality. A meeting was held in the park yesterday where a group of people decided not to defend the land with their bodies, primarily because that tactic had not worked in the past.

Instead they decided to treat the park as a "political candidate," to promote support in the entire Berkeley community through an intensive publicity campaign and wide-spread canvassing.

A grey darkness encompassed "People's Park" at 4:45 a.m. yesterday. Fifty people were sitting around camp fires discussing tactics, their voices punctuating the apparent stillness of the night.

Briskly, a new voice entered the park. "You are on university land." said Lieutenant Robert Ludden of the Berkeley Police Department. "If you don't disperse you will be arrested for trespassing."

(Continued on Page 3)

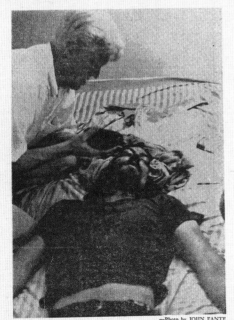

—Photo by JOHN FANTE

ALAN BLANCHARD . . . assistant manager at the Telegraph Repertory Theatre was shot with buckshot in the face and chest while watching the action yesterday from the roof of an apartment at 2410 Regent.

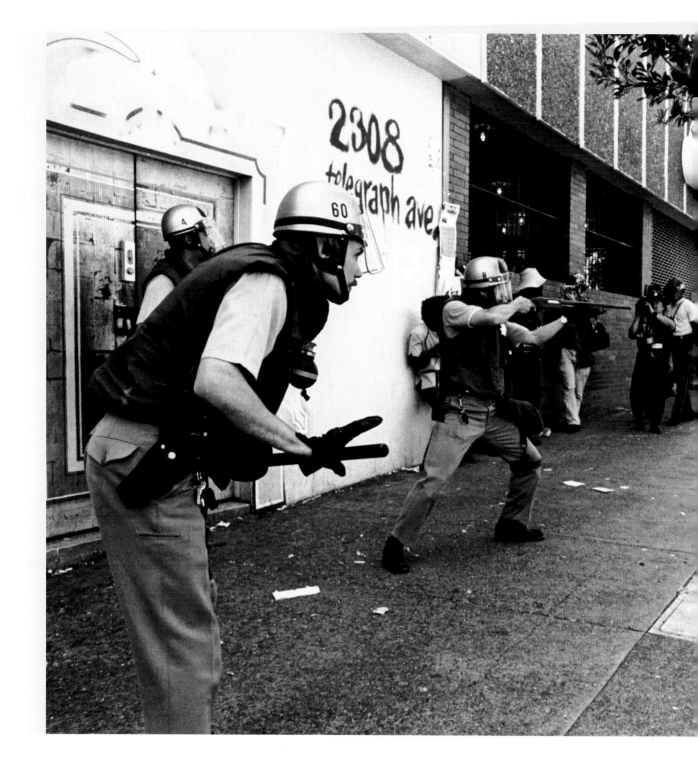

A police officer firing on Telegraph Avenue between Durant Street and Bancroft Way.

PINCHUS SHAPIRO
UC Berkeley undergraduate student
Some objects were thrown at the deputies at the intersection of Haste and Dana. One of the Alameda County deputies came back around the corner with a shotgun. He was aiming along the north sidewalk of Haste. Right after I heard the shot I saw a man run from the north sidewalk into the street, clutching his bottom and yelling.

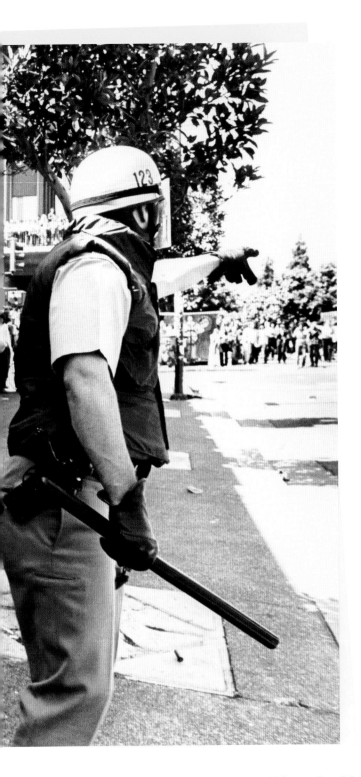

Telegraph Repertory Cinema. I saw about ten to fifteen sheriffs with shotguns in firing position. They started firing at the crowd on the sidewalks on both sides of Telegraph. We went down Telegraph but had to take cover lying on the ground behind a car.

CHARLIE PALMER
UC Berkeley undergraduate student and president of ASUC

I am appalled and angered by what I saw, and I am disillusioned by the governing processes of this university. Police fired arbitrarily and with very little reason.

TRUDY O'BRIEN
UC Berkeley undergraduate student

We were on the march and heard people shouting, "They're shooting! They're shooting!" It was hard to believe that they would use live ammunition against students. We saw a young man who was lying on Telegraph near Dwight. He had been shot and was bleeding profusely. We carried him to Barrows Hall on campus, where there were medics. We kept his bloody shirt and used it as a banner.

C. R. GLASSEY
teacher

My student was walking along the sidewalk of Regent Street when he noticed a man carrying a gun at the corner of Regent and Parker. The man with the gun stood for a few seconds looking at the quiet, almost deserted street, then slowly raised his gun and pointed it down the street. My student was frightened by this move, turned, and ran away. He heard a shot and a cry of pain. A few days later he returned to Regent Street and found that the victim of the shooting was [Clarence] Edson. My student remembered that the man with the gun was wearing a gas mask, a blue helmet, and a blue coverall of the Alameda County Sheriff's Department. (*Berkeley Daily Gazette,* May 29, 1969)

SETH ROSENFELD
journalist

The police crowd control was tragically flawed. The police should have been in top form, but they weren't. They were marauding the streets, shooting without consideration of innocent civilians

We moved peacefully south on Telegraph with the crowd. The police came down a side street and separated the crowd into two parts with tear gas. We were south of the police, and they pushed us farther south by the excessive use of tear gas. We went into a laundromat to escape the tear gas. But the tear gas was very thick in there, so we tried to get out. The police refused to let us out. When we were walking south we heard a shot fired. We saw a guy lying on top of the

in the line of fire. What they did was completely contrary to established policy. Through a combination of malice and incompetence they deviated seriously from standard procedures and endangered bystanders and innocent lives. Leaving the wounded in the streets was not an acceptable police practice either.

MARY PACIOS
peace and environmental activist
Returning home that night, we saw a note pinned to our door. It was from Charlie Devlin, a pacifist and dedicated environmental activist. Charlie quoted Golly Jipson: "This is not the vision I had." (From "Another Piece of Occupied Land: People's Park")

RICHARD EHRENBERGER
architect
On May 15 I was working on drawings at home on Claremont Avenue. I was exhausted and decided to go see a friend who lived on Regent Street. I drove my Porsche 356 and as I got close to Telegraph I heard commotion and smelled tear gas, which I had become familiar with when I lived on Haste. I parked in the Park and Shop parking lot. There was pandemonium on Telegraph, but just a block east it was peaceful. An older woman was watering her flowers, coeds were sitting on the sidewalk studying, and a student with a slide rule in his pocket (a telltale sign that he was an engineering student) was walking north toward campus. Seconds later I heard someone yell, "Watch out, he's going to shoot!" I looked and saw a Blue Meanie shooting south on Regent. I heard one or two shots and felt something hit my leg. I dove behind trees and worked my way back to Parker, where there was a Free Clinic group helping people who had been teargassed. They pointed to my feet. One of my tan shoes was tan and the other was bright red from bleeding.

I knew Mayor Wallace Johnson and drove to City Hall to see him. I was pissed. He wasn't there, and all the staff cared about was the fact that I was bleeding on the carpet. I then went to Herrick for emergency treatment. I was so angry at the police that I almost wished that I had a weapon. Driving home there were four or five police cars at the Smokehouse [restaurant] on Telegraph at Woolsey. I knew I had to

get straightened out and so I stopped to talk to them, one to one. That helped.

The next week I went to Kaiser [hospital] to have my wound, which they said was caused by buckshot, treated. A surgeon was cleaning up the infection around the wound when somebody mentioned that James Rector had died. The surgeon said, "That son of a bitch got what he deserved." I said, "That's it, stop." I walked out of the treatment.

I testified at a grand jury investigation of the police shootings. A painting contractor named Clarence Edson, who had been in Berkeley to pick up a ladder when he was shot, was there to testify too. He had been shot in the leg and I think that he was going to lose his leg.

EUGENE SCHOENFELD
physician and a columnist (writing as "Dr. Hippocrates") for the Berkeley Barb
Policemen who reacted like goons and mad dogs were "only following orders." But their orders came from goons who value property and budget more than human lives. Alan Francke works in the record room of Cowell Hospital and often brings me patients' charts. A shotgun blast tore through his left hand. Alan lost a third of his middle finger and two-thirds of his ring finger. The fifth finger of his left hand was connected only by shreds of tissue. If it is successfully fused to his hand again, the finger will always be stiff. (Berkeley Barb, May 23, 1969)

FRANK MADIGAN
Alameda County Sheriff
There are a lot of concerned citizens, but that's the way the ball game has to go. (Rat Subterranean News, May 13–19, 1969)

Sheriff Frank Madigan said that the police shootings had not been his idea and that events that day had been directed from "higher up." He declined to elaborate, but on the fateful day in Berkeley no one outranked Reagan's chief of staff. (From Berkeley at War, by W. J. Rorabaugh)

STEW ALBERT
Yippie and People's Park cofounder
All the hardline freaks are, as expected, set for war. The Park is their homeland and they are ready for its national defense. The Park is our revolutionary Capitol, the best guarantee that we

will stay in Berkeley. Thousands of us will resist. I hope we save the Park without confrontation. But if it goes down, we will try the war criminals in the street; and we'll do it in the sweet silent summer night when, self-assured, these enemies of something pleasant and good are fast asleep. (*Rat Subterranean News*, May 13–19, 1969)

JUDY GUMBO
Yippie and People's Park cofounder
I woke up one morning to find a bullet hole in a downstairs window of the Ashby house [where she and Stew and Tom Hayden lived].

DAILY CALIFORNIAN
Library spokesmen said yesterday that campus police had removed the slugs that caused six holes in the glass and frame of a library window last Thursday night. (May 20, 1969)

PHILLIP ST. JAMES
eyewitness, eighteen years old
At that instant as they emerged from the back-yard and continued west toward Shattuck Ave., a shotgun blast exploded and some of the kids were hit—all in the back. One was hit very badly. I still vividly recall the back of his white or light-colored shirt with a huge circle of bright red. It was blood! I couldn't believe this was happening! I wondered if I would be shot next. (From "No statute of limitations on murder or civil rights violation")

OPEN LETTER TO FRANK MADIGAN, ALAMEDA COUNTY SHERIFF, FROM SERGEANT C. D. GLENN, CHAIRMAN OF THE BERKELEY POLICE ASSOCIATION
The mob was beyond control and the decision was by your department to fire upon those engaged in the rioting. There is no question in the minds of our officers that your decision was not only justified under the circumstances but was directly responsible for the eventual dispersal of the rioters and the evacuation of injured police personnel without more serious injury or death. (*Instant News Service,* May 30, 1969)

DARYL LEMBKE
reporter for the **Los Angeles Times**
The area was like a battle zone. I had gone about 30 to 35 feet from the corner when something went off at my back. I turned around and saw a policeman in a jump suit with a shotgun pointed at me. I tried to flatten against a nearby building and then I felt something and looked down at my pants leg. It was bloody. (*Los Angeles Times*, May 30, 1969)

"Policemen who reacted like goons and mad dogs were 'only following orders.' But their orders came from goons who value property and budget more than human lives."

"We stood there like ducks in a shooting gallery and all we could do was hop and dance up and down and sideways to dodge the rocks and bricks and chunks of cement. The danger and the fear and the humiliation were so bad [that] for the first time in my life I really had the urge to kill."

VINCENT FERRARI
eyewitness, twenty-six years old

The police just blew their cool. A pepper gas bomb went right over my head. The people were extremely frightened. Some were yelling, "Guns, they have guns. Watch out." I ran up Telegraph Avenue to Blake Street and turned left. I was about 25 to 30 feet west of Telegraph Avenue. I slowed down and turned around. There was a policeman down on one knee in a military firing position, pointing a gun at me. I saw him aim at me. I turned and was shot. When he fired, there was no crowd. I had 48 birdshot wounds in my head, legs and arms. A motorist took me to Herrick. (*Los Angeles Times*, May 30, 1969)

BERKELEY DAILY GAZETTE

It was a reservist who received the most serious injuries. He was cornered alone near Cunha Pontiac on Telegraph Ave. by hundreds of screaming demonstrators who took his City car, set it afire, beat him to the ground, kicked, threw rocks and bricks at him, and knocked his head against the wall, according to witnesses as well as police. In desperation he drew his hand gun. The crowd surged back away from the prostrate man, and employees inside the Cunha building dragged him to safety. During the time the BPR [Berkeley Police Reserve] man had been felled, the police radio was filled with pleas from other field command officers for help. One said, "We have no recourse but to use our guns" without additional manpower.

An officer alone in his beat patrol car and without riot gear of any kind was sent into the fray to rescue and take the seriously injured BPR man to the nearest hospital. Every window in his patrol car was smashed out—bricks came hurling through the windows and he was surrounded by a yelling, angry mob shouting, "Kill the pig! Kill the pig!" "The sky was black with the things they were throwing at me," he said. "I just hunched down in my seat and went like hell right through that mob. I felt sorry about not being able to rescue—but in my estimate it was a case of me getting out of there alive," he said.

The "pepper-fogger" machine, however, refused to function properly and the men were surrounded with hundreds of demonstrators shouting, "Kill the pigs! Kill the pigs!" "We stood there like ducks in a shooting gallery and all we could do was hop and dance up and down and sideways to dodge the rocks and bricks and chunks of cement. The danger and the fear and the humiliation were so bad [that] for the first time in my life I really had the urge to kill." (May 29, 1969)

ANSWERS TO INTERROGATORIES TO PLAINTIFFS, SECOND SET, *RUNDLE ET AL. V. MADIGAN ET AL.*

The deputies who were employed in Berkeley on May 15, 1969, were, for the most part, by profession jailers or prison guards at Santa Rita and, in some instances, still on a probationary status.

ROBERT PECKHAM
judge with the United States District Court

Delegating authority to wield and discharge a firearm in the presence of people is a very serious matter, demanding a high degree of care. Failure to exercise such care would seem to be gross negligence. (Memorandum opinion in *Rundle et al. v. Madigan et al.,* filed November 20, 1972)

ANITA MEDAL
UC Berkeley graduate student

I was so angry after Bloody Thursday that I looked for Chancellor Heyns's phone number in the phone book and called him at home at about 2 a.m. I chewed him out. He heard me out without saying much.

SAN FRANCISCO CHRONICLE

Earlier, Berkeley police—after visiting all the hospital victims—said there was no evidence of anything other than birdshot wounds. (May 20, 1969)

OAKLAND TRIBUNE

Frank Madigan said Friday night his men had been issued only birdshot for their weapons. (May 21, 1969)

JONDAVID BACHRACH
UC Berkeley undergraduate student and ASUC senator

After May 15 I got a phone call from someone in the athletic department on behalf of Chancellor Heyns, who urged me to "stay tough, big tiger." That was one of the oddest moments of my time in Berkeley.

EDITORIAL
San Francisco Examiner

That parcel of land on the University of California campus in Berkeley is being accurately referred to as a "people's park." It is the property of the people of California.

The authorities of the university hold title to it in the name of the People of California. They must not surrender title to a band of shaggy nihilists who, in a public relations gimmick, seek to screen their revolutionary intent by planting shrubs. These people plant bombs, too.

The Berkeley marches are not the spontaneous protest of a neighborhood going up against an unpopular decision by local officials. They are as diagrammed in advance as any of Napoleon's battles.

The long-range goal of the mob's manipulators (and many of the manipulated) is to overthrow the United States government and American democracy. They would substitute for the endless repression of a Maoist ferment that in 20 years had made a shambles of ancient Chinese civilization.

They make no bones about their revolutionary claims. Why not take them at their word and act accordingly? The university must hold the line, using whatever measures are necessary in the defense of the public property. (May 20, 1969)

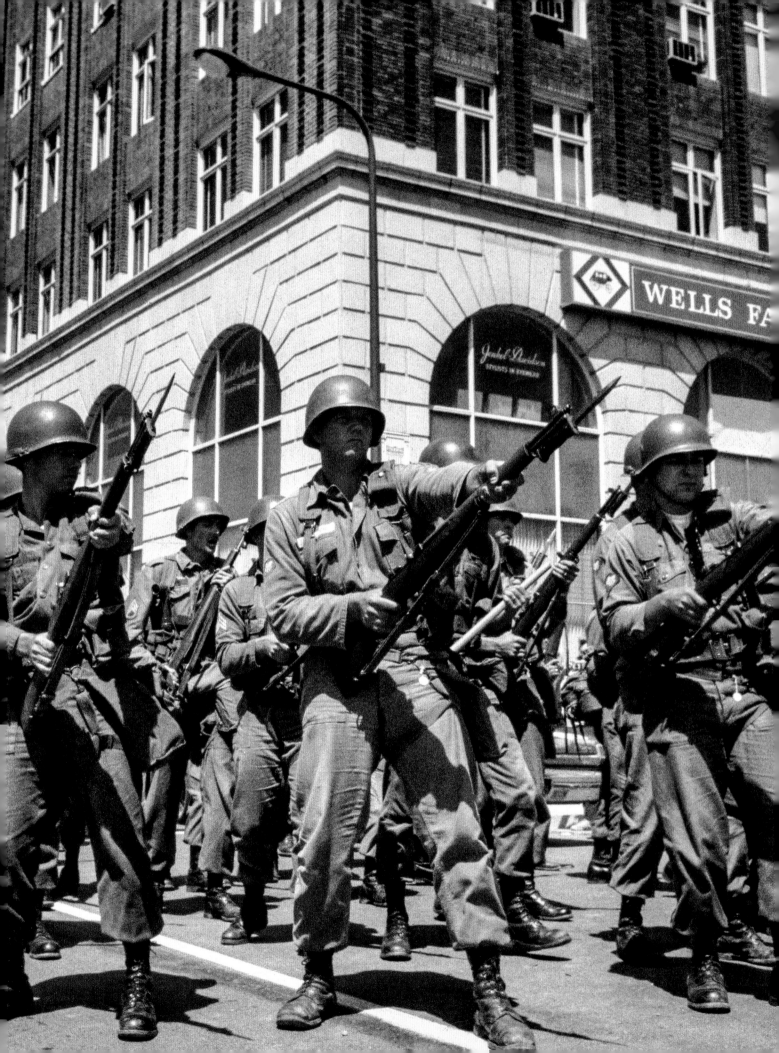

The Army Arrives

On February 5, 1969, during the Third World Liberation Front strike, Governor Reagan declared a state of extreme emergency in Berkeley, an order that had not yet been rescinded when violence erupted on May 15. Following Bloody Thursday, Reagan relied on the existing declaration to send three battalions of the 49th Infantry Brigade of the California Army National Guard into Berkeley on May 16. The Guard, which set up a command post at the Berkeley Hall of Justice, enforced a curfew as well as a ban on assembly:

> No person shall loiter in or about any public street or other public place in the City of Berkeley, including the campus of the University of California, between the hours of ten p.m. and six a.m. of the following day. No person shall conduct or participate in a meeting, assembly, or parade or use a sound or voice amplifier in or upon the public streets or other public place in the City of Berkeley, including the campus of the University of California.

A group of Guardsmen billeted at People's Park, with the majority bivouacking at the Berkeley Marina. The *Daily Californian* of May 26 contained a photograph of a National Guard armored personnel carrier at the Berkeley Marina. Seth Rosenfeld reported that four tanks were also positioned there, and Art Eckstein remembers several tanks parked near the Graduate Theological Union on the north side of campus. Many people remember tanks rumbling up University Avenue, but there is no contemporaneous documentation.

The Guard in Berkeley was led by Commanding General Glenn Ames, a veteran of the Pacific Theater during World War II and the Watts riots of 1965, during which thirty-four civilians were killed. The Guardsmen in Berkeley were a mixed bag. On the one hand, they were younger than their law enforcement counterparts, and many had joined the Guard to avoid serving in Vietnam. Park activists saw them as potential allies and at times sought solidarity with the Guardsmen. On the other hand, their bayonets were a clear and unambiguous intimidation, and they were far more disciplined in crowd control than their law enforcement brethren. Their behavior was as professional

and disciplined as the response of law enforcement on May 15 had been unprofessional and undisciplined. Part friend, part foe, more than two thousand National Guardsmen occupied Berkeley for several weeks. Concertina wire, military vehicles, and bayonets became fixtures in the South Campus area and downtown Berkeley.

The Case of Corporal
Michael Feliciano

The *Daily Californian* of May 21 reported that Corporal Michael L. Feliciano, age twenty-six, of Santa Rosa had told his fellow Guardsmen and commanding officer, "I can't stand this anymore." According to a *San Francisco Examiner* report, later that same day, he "suddenly threw his helmet to the ground, dropped his rifle, and cried: 'I can't stand it anymore.' As he was trying to remove his flak vest, he was restrained by military policemen, who took him to the Berkeley Police Station. A preliminary diagnosis there, according to [Bernard Nurre, captain of the National Guard], was one of 'suppressed aggression.' Feliciano was later removed by ambulance to the National Guard Armory in Petaluma to undergo more detailed examination."

The May 22 *Daily Californian* confirmed that Corporal Feliciano had been "rushed by ambulance to Petaluma where he is currently undergoing psychiatric examination." The alternative publication *Instant News Service* reported on May 21 that "Brother Guardsman Feliciano laid down his gun yesterday afternoon. He was busted, put in a jeep and handcuffed, and guarded by his peers at bayonet point before being taken away."

HOWARD DRATCH
UC Berkeley graduate student in political theory
I was sitting on the porch of the house where I lived with my ninety-five-year-old landlord, a man who had survived the 1906 San Francisco earthquake. A group of hippies walked by, followed by a group of Hare Krishnas. After them came the National Guard. My landlord asked me, "Do you understand what is happening?"

PAUL MORUZA
sixth-grader at Willard Junior High School
Having the National Guard occupying Berkeley was fascinating. I wasn't in the middle of the riots but would see them stationed all around my neighborhood. My family history was pro-military. I was not afraid of them at all.

GLENN AMES
commanding general of the California National Guard
As you know, we lost the services of fifteen of our young soldiers for a day and a half when they became the victims of a hallucinatory drug contained in cookies, fudge, and the like, given to them at one of our fixed outposts by some of the street people. (*Berkeley Daily Gazette,* May 21, 1969)

DAVID MCCULLOUGH
former UC Berkeley graduate student
Joel Geier, [a friend] with whom I also chatted, recalled that the Independent Socialist Club organized its female comrades and female supporters to fraternize with the troops, who were almost all draft dodgers and basically on our side. Flowers in the rifle muzzles and all that.

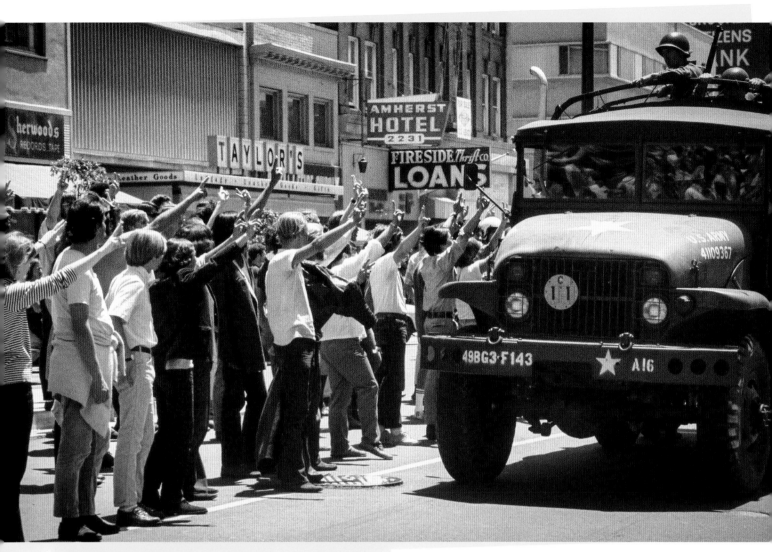

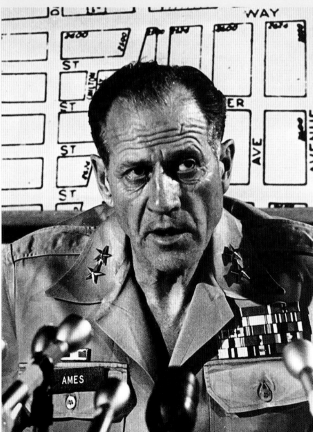

Above: National Guardsmen are greeted with peace signs as they arrive in Berkeley.

Left: General Glenn Ames, commander of the California National Guard.

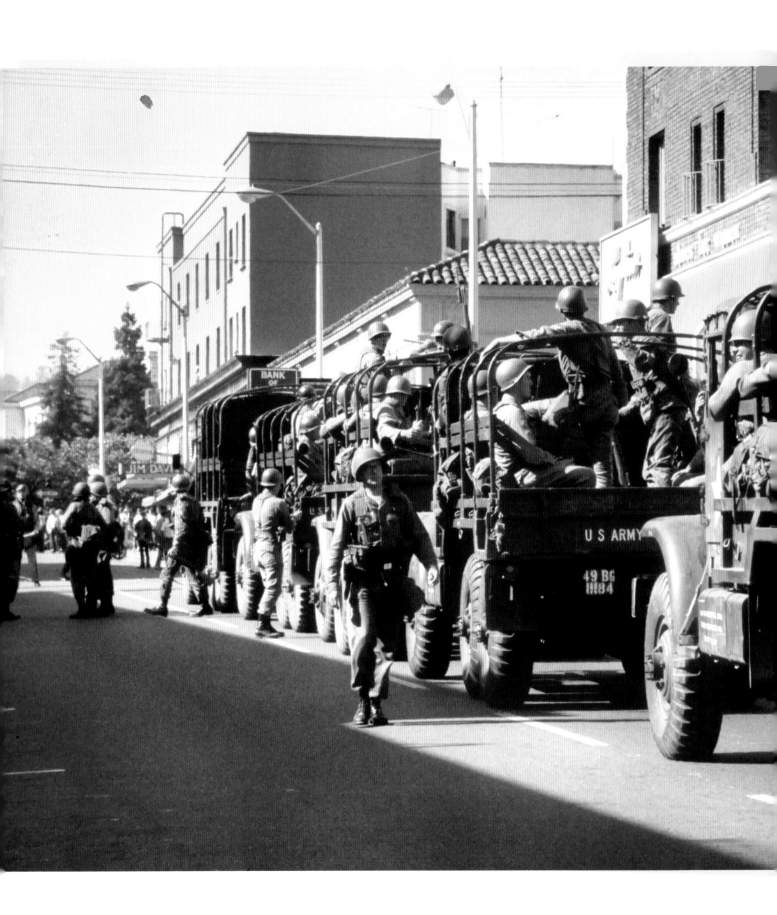

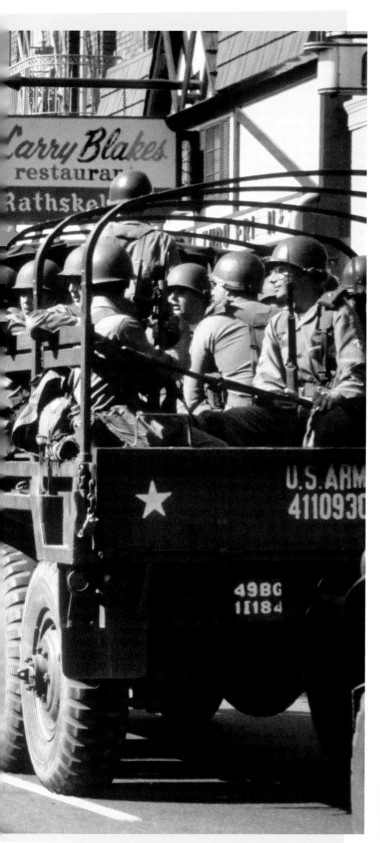

HENRY WEINSTEIN
UC Berkeley law student and a reporter for the Daily Californian

Having the National Guard occupying Berkeley was surreal. Not only were we occupied, but after James Rector, we knew that we could get shot. Our expectations of the consequences of protesting were different. It was a decidedly bad new normal. I started to get a glimmer of what it would be like to be a non-white person in America. Even in the bastion of liberalism this had happened. This happened in other places, not *here.* And it wasn't violent protestors who were shot, it was innocent bystanders.

OUTCRY!
leaflet produced by the Radical Student Union

To Guardsmen: Join us on Friday, Memorial Day, May 30, to form a massive contingent in the march of 50,000 to get back our park. The more Guardsmen from all over the state who join us, the better we can know our friends and isolate

Left: The National Guard arrives on Telegraph Avenue.
Below: The Guard on Shattuck Avenue. An older woman recoils.

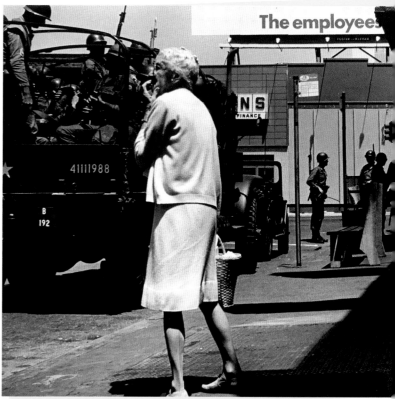

our enemies. You are not hired killers like the police. You are under orders to occupy our community against your will. You know we are not America's enemies. Don't let them turn you into pigs.

JERRY RUBIN
activist, organizer of the Vietnam Day Committee, and cofounder of the Yippies
People's Park became the base camp for the Occupational Forces in the war against the natives. Tents replaced our playground. Tanks and troop carriers ripped the trees and shrubs and flower beds. Crude Army boots destroyed the green grass. Beer cans and cigarette butts floated on the pond. (From _Do It!: Scenarios of Revolution_)

MARVIN GARSON
editor of the San Francisco Express Times
Now you know what a revolution feels like. Sunday in Berkeley—our maneuvers with the National Guard, the kite-flying, the frisbee playing, the block parties, the V signs everywhere, people happening to do the right thing in the right way at the right time—that high feeling is what it's like in every revolution. (Letter to the editor, _Daily Californian_, May 26, 1969)

DURWARD SKILES
UC Berkeley graduate student in physics
Especially in the first few days of their occupation, the National Guard was spread out everywhere, even near our apartment on Virginia west of Shattuck. They were intimidating with their heavy vehicles and bayonets and bandoliers filled with ammunition across their chests. They were everywhere on campus, an unbelievable situation. The faculty was split on the park, as they had been during the Free Speech Movement, but as a result of the faculty support of the students, Governor Reagan made sure that the faculty got no raises the next year.

UNSIGNED ARTICLE IN THE _BLACK PANTHER_
the official newspaper of the Black Panther Party
AN OPEN LETTER TO RONALD REAGAN: Ronald Reagan you're a FOOL, the people says you're a fool. You've got three to five thousand little fools running around Berkeley with guns even calling you a fool. Now how are you going to deal with that? There were many people who didn't believe me (and you still don't) when I said I held a Red Book [a collection of quotations from Chairman

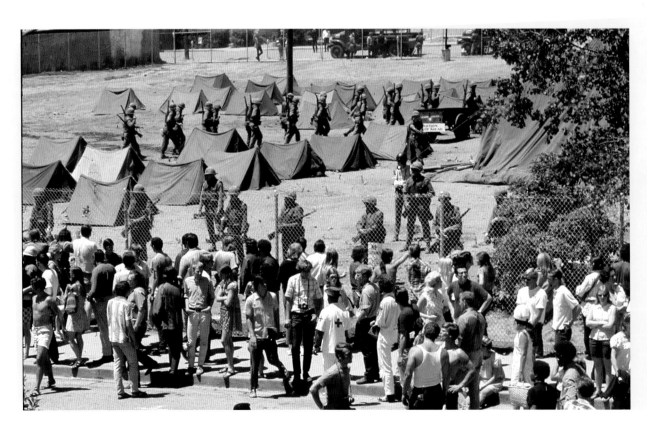

Top: An army armored personnel carrier at the Berkeley Marina.
Bottom: The National Guard was mostly encamped several miles from campus at the Berkeley Marina.
Left: Several hundred Guardsmen bivouacked in People's Park.

Mao Zedong] class with your National Guards. They told me seeing was believing. Now they believe[;] what about you, Reagan? Your own little punks are being haunted for knowledge from Chairman Mao Tse Tung's Red Book. (May 31, 1969)

DAILY CALIFORNIAN

STUDENT LEADERS ISSUE PARK SUPPORT STATEMENT. We, the undersigned students, feel that students and community needs would best be met through the spontaneous and continued development of that park area bordered by Dwight, Bowditch, and Haste. We feel that both the planning and the control of the park should lie not with just the University Administration, but primarily with those students and members of the community by whom the park was initially developed and creatively designed and whom the land is supposedly to benefit. [The titles of those who signed were listed as follows: a sorority president, a former editor of the *Daily Californian,* chairman of the Student Community Relations Board, chairman of the Rally and Games Council, president of the Campus Friends of the AFT, president of the [A]SUC, a student representative from the Student Affairs Committee, president of the Mortar Board honor society, head "pom-pom girl," former president of the Intrafraternity Council, senate chairman of ASUC, president of the Student Advisory Committee, president-elect of the Mortar Board honor society, president of Oski Dolls hostess organization, president of the Prytanean honor society, chairman of the Center for Educational Change, editor of the *Daily Californian,* editor of the *Blue and Gold* yearbook, chairman of the Orientation Board, president of the Senior Class, chairman of Senior Week, president of the Sophomore Class, chairman of Cal Campus ASUC Senate, Orientation Board, Poor People's Campaign Support Committee, chairman of the SUPERB Publications Board, chairman of Big Game Week, former chairman of the Rally and Games Committee [for the] ASUC Senate, [chairpersons of the ASUC for] the Women's Judicial Committee, Housing Board, SUPERB, and Executive Committee Intrafraternity Council, [and] chairman of High School Senior Day, and president of the Intrafraternity Council.] (May 20, 1969)

GREIL MARCUS
writer for **Rolling Stone** *magazine*
What I remember about People's Park was the violence. Just violence and more violence. That it wasn't worth fighting about, but we simply organized around the violence. I had National Guardsmen camped on my front lawn. That was interesting. (From *Conversations with Greil Marcus*)

INSTANT NEWS SERVICE
Fraternization between the people and the National Guard continued today, with many mellow scenes, but one Guardsman turned pig and bayonetted one of the people in the back, inside the Student Union. (May 20, 1969)

INSTANT NEWS SERVICE
Notice to National Guard: If you have anything you wish to say to other guardsmen or to the street people or to anyone else who reads this paper, call us and we'll print it. (May 22, 1969)

DREW KEMP
ninth-grader at Berkeley High School
While the older kids were engaged in serious radical politics at Berkeley High, us ninth-grade punks at West Campus were messing around with the National Guard occupation force who were camped out just down the road at the Berkeley Marina. Some of our hijinks included:

Selling any green crap that looked like weed to the Bakersfield farm boys up in the big city for the first time.

When they started asking for LSD, we quickly obliged by transforming aspirin tablets into Purple Haze with a little sandpaper and food coloring. It was like cutting a fat hog in the ass.

We would hot-wire the Santa Fe tracks across University Avenue by putting a penny across the rails a block away to drop the semaphores right in front of the convoy as it headed toward campus. They tumbled to that pretty quickly, so we got a little more devious by soldering a wire to two small magnets and placing it on the rail farther away in an inconspicuous spot, which took them a lot longer to find.

One night during martial law, we got a squad of soldiers to chase us down into

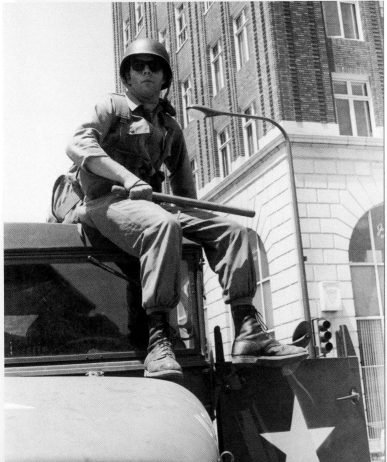

Above: The photograph here was taken in Berkeley in 1969, not Dresden in 1945.

Left: A Guardsman near the Wells Fargo building on Shattuck Avenue.

66**What I remember about People's Park was the violence.... I had National Guardsmen camped on my front lawn.**99

Codornices Creek in Live Oak Park. Our coconspirators let loose with a barrage of eggs from the trails on either side of the creek, catching them in a cross fire, in the dark, and disoriented as us little North Berkeley Viet Cong disappeared into the night.

When Reagan gave us lemons, we made lemonade.

INSTANT NEWS SERVICE
We sincerely hope that the guardsmen will remember their stay here. They are welcome back as brothers—we have seen enough of them as slaves. (May 25, 1969)

BOB AVAKIAN
activist and founder of the Revolutionary Union (RU)
We put out one leaflet to the National Guard itself, because a lot of the people in the National Guard were not really "gung-ho" types—quite a few of them were sympathetic to the struggle and some of them were even people who had been involved in the movement. (From *From Ike to Mao and Beyond*)

RUTH ROSEN
UC Berkeley graduate student in history
The city was occupied for a month. And what happened is [that] the worst aspects of the movement emerged. People did things that were totally counterproductive. There was a gendered quality to the street battles. It seemed as if some of the men were trying to earn their manhood, to earn what they didn't earn as veterans had.

SETH KATZMAN
dropout from San Jose State
Having the National Guard occupying Berkeley was creepy. They were stationed at the entrances to the city, checking identification.

DHYANI (JENNIFER) BERGER
UC Berkeley graduate student in biology
My boyfriend and I decided to go down to the Marina, where National Guardsmen camped. We wanted to confirm what was happening. We couldn't believe our eyes when we saw the military operation unfolding. I think I remember

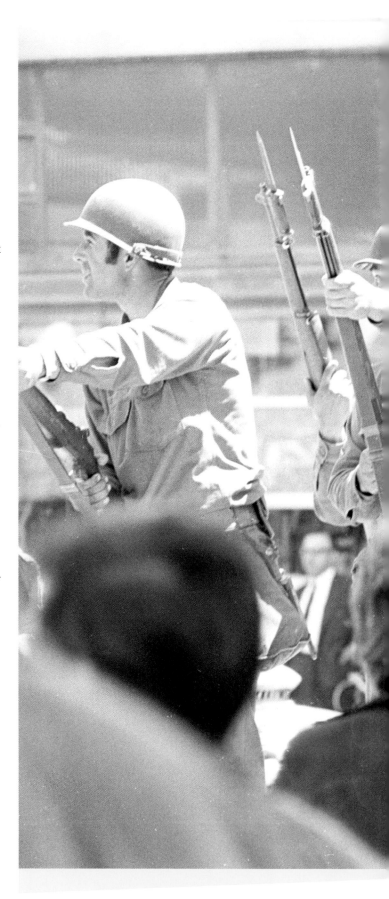

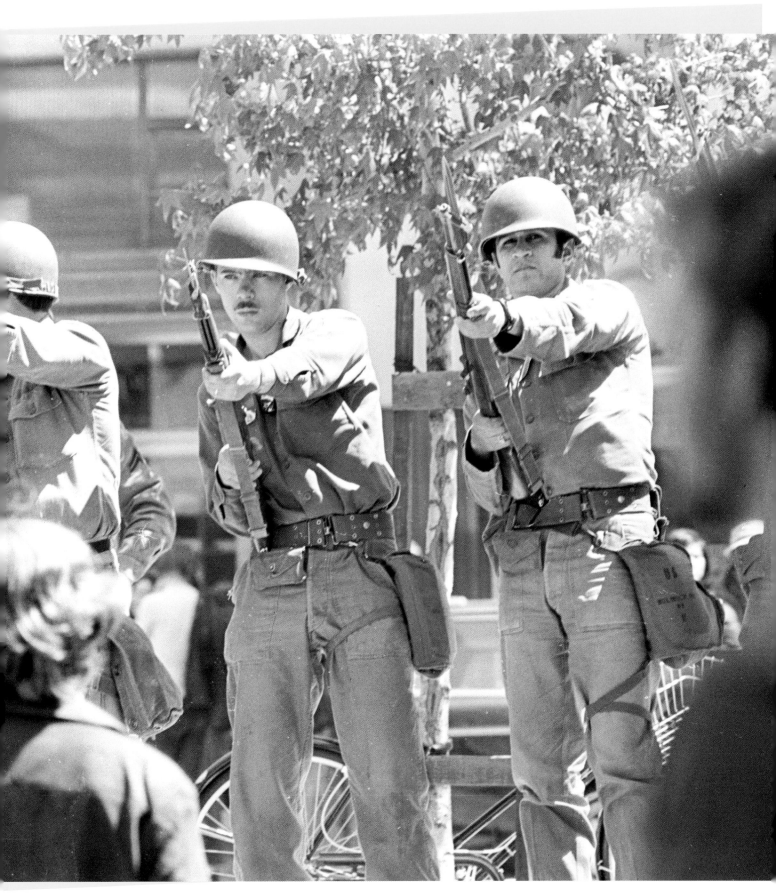

Many Guardsmen joined the National Guard to avoid duty in Vietnam, and some had sympathy for the protestors, but their bayonets threatened even greater violence.

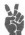 **INSTANT NEWS SERVICE**

1703 GROVE 841-6480

COURTESY: Good Times, Free University of Berkeley, Berkeley Graphic Arts

Vol. 1, No. 3 Tuesday, May 20, 1969

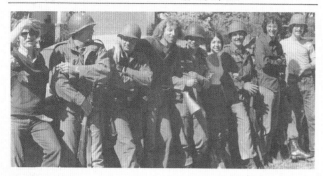

Yesterday morning at 11 am, UC professors held a peace vigil to protest police violence. The pigs broke up the vigil. Groups of people then congregated for a brief rally at the Campanile, then marched to the downtown business section. In the early afternoon, people gathered on Shattuck Avenue, clapping hands: "We want the PARK!" Traffic was rerouted, and pigs and guardsmen moved on the people.

At 3 pm the mayor of Berkeley, Wallace Johnson, held a press conference which was broadcast live over KPFA. Revolutionary press was not admitted to the conference. Johnson told the press that he will propose to the Berkeley City Council at its meeting on Tuesday morning that the City Manager be authorized "to explore with the UC Chancellor the possibility of the University leasing to the city property on Dwight Way just west of Telegraph Avenue for a 'neighborhood park.'" (The UC Chancellor, Roger Heyns, has been afraid to make any public statement of his own since Thursday.)

Yippie White Panther Stew Albert told KPFA that Johnson's suggestion was "ridiculous," and ignored the difference between doing it yourself and sucking the capitalist tit.

Fraternization between the people and the National Guard continued today, with many mellow scenes, but one Guardsman turned pig and bayonetted one of the people in the back, inside the Student Union. Today's pig is, of course, tomorrow's bacon.

MON., 11:45 PM. RECTOR IS DEAD. THE PIGS MURDERED HIM.

 INSTANT NEWS SERVICE

1703 GROVE, BERKELEY 841-6480

COURTESY: PEOPLE'S PRESS SYNDICATE

Vol. 1, No. 5 Page 1 Thursday, May 22, 1969

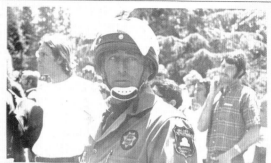

·PIGS IS PIGS, BUT GUARDSMEN IS SLAVES·
WHY ARE THERE STILL SLAVES?

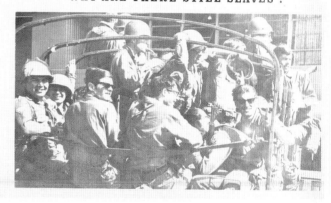

The photograph demonstrates the level of fraternization between some park supporters and some Guardsmen.

The Left sought to divide the Guardsmen from local law enforcement.

A lone Guardsman at the corner of Bowditch Street and Haste Street, the northeast corner of People's Park.

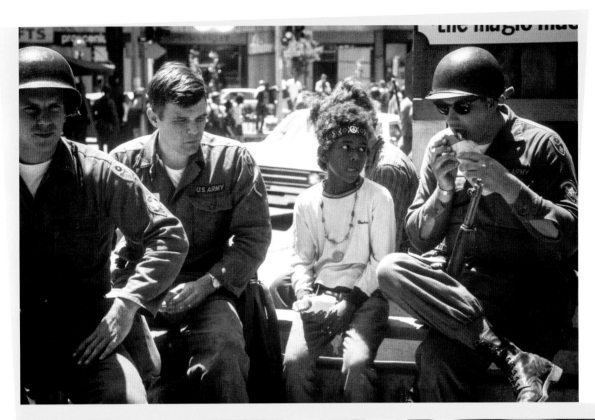

"I saw that huge military presence and thought to myself, 'This new world we made, this creativity, had to be crushed militarily?'"

seeing cannons and tanks with huge numbers of Guardsmen. I remember being totally shocked that it was as if we were at war.

DAVE SEABURY
eleventh-grader at Berkeley High School
I never felt afraid of the National Guard. I was afraid on Telegraph when the cops were shooting, but just having the National Guard around didn't scare me. They were everywhere. It was surreal and bizarre, that here we were in this amazing thing, but I never felt freaked out about it.

SHELDON WOLIN
UC Berkeley professor of political science
The events related here constitute the first application of systematic terror directed at an American campus by its own authorities.

CAROLYN DEWALD
UC Berkeley graduate student in classics
I called home and talked to my parents during the period of martial law. I told them to turn on their television and to tune in to one of the networks. I told them, "You see those coils of barbed wire? You see the house behind it? That's my house."

JANE SCHERR
partner of Max Scherr, publisher and editor of the Berkeley Barb
The National Guard was heavily concentrated in the South Campus area, starting a block north of my house. I saw that huge military presence and thought to myself, "This new world we made, this creativity, had to be crushed militarily?"

DOVE SHOLOM SCHERR
third-grader at Emerson School
I had grown up in a bubble where men all had beards and people wore hippie clothes. These soldiers with crew cuts and uniforms were so strange to me. I wasn't scared, but it was like they were from another world.

Young Guardsmen on Dwight Way at Telegraph Avenue.

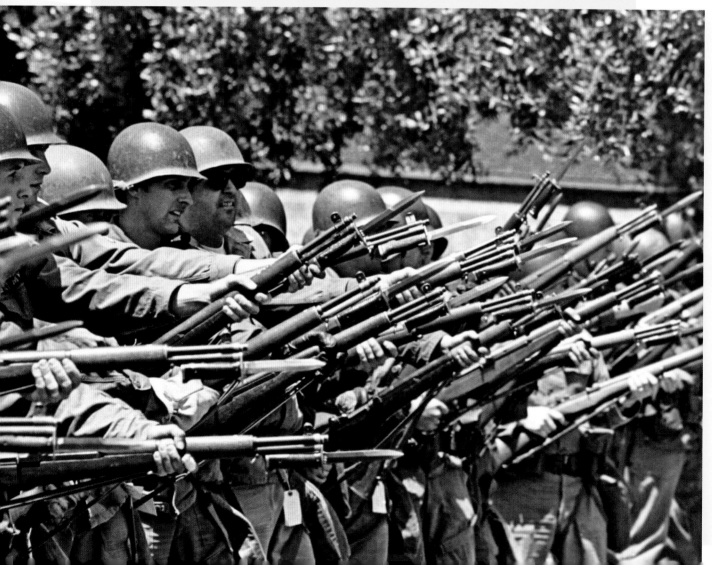

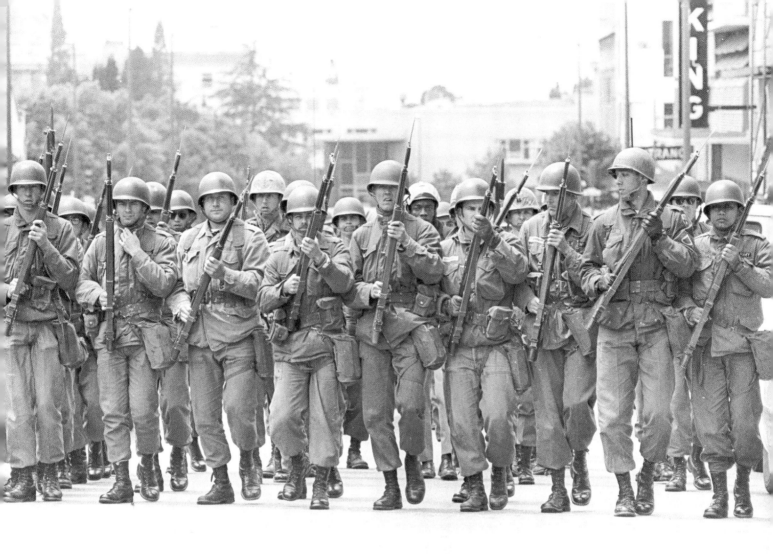

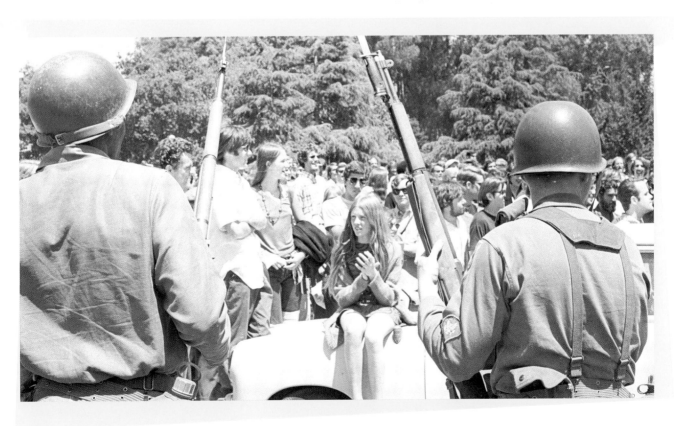

Above: There was little public support for the Guard occupation of Berkeley, but it did exist.

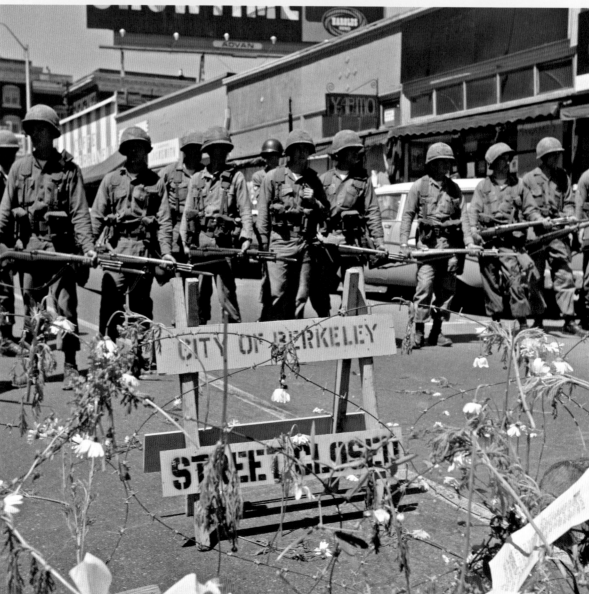

REESE ERLICH
suspended UC Berkeley undergraduate student and a reporter for **Ramparts** *magazine*

I was living in the Temescal District of Oakland. I got up every morning, took my gas mask kit, and hitched down Telegraph to Berkeley and the demonstration of the day. The military occupation of Berkeley seemed like the Nazi occupation of Europe or the Soviet seizure of Prague in 1968. It wasn't as bad, of course, but it was an occupation. One advantage that we had was that we knew the turf and they didn't. We knew shortcuts and escape routes from everywhere. The cops and National Guard had to spend a long time reading campus maps.

CAROL GORDON
UC Berkeley undergraduate student

The National Guardsmen who occupied Berkeley were young, and I couldn't understand how they could feel okay about being in Berkeley.

ANNA RABKIN
Holocaust survivor and housewife

Berkeley was under occupation. Armed soldiers patrolled from rooftops and street corners. Strict curfews were enforced. The ominous drone of helicopters overhead destroyed our peace. The hills were silent no longer; the sky filled with ghosts from my past. People's Park would become a symbol of grassroots resistance to establishment power. (From *From Kraków to Berkeley: Coming Out of Hiding—An Immigrant's Search for Identity and Belonging*)

NINA WAX
film editor for KQED television

I was working in San Francisco at KQED. Driving home across the Bay Bridge, I could see smoke lingering over Berkeley. I later learned that it was tear gas, not smoke. I was living on Hillegass. The National Guard and police were all over Berkeley and it was a very scary scene. I worked my way to Hillegass and went inside and to sleep. When I woke up the next morning there was a tank or other armored vehicle stationed outside my window. I never got used to having the National Guard occupying Berkeley.

PAUL VON BLUM
attorney and a UC Berkeley lecturer in rhetoric

I ignored the curfew and could because I was an attorney. I was stopped dozens of times, sometimes by National Guardsmen with rifle-fixed bayonets, and told that I couldn't drive. I showed them my bar card and said that I had clients in jail and every time was allowed to continue.

RICK FEINBERG
UC Berkeley undergraduate student

The occupation of Berkeley by the National Guard confirmed all of my worst instincts about what was happening in our country.

JOHN BISHOP
novelist and photographer

I had only begun to photograph seriously and felt no compunction to be out on the street, but during the two-week occupation I took pictures. Suddenly living under a military presence was

> **"The occupation of Berkeley by the National Guard confirmed all of my worst instincts about what was happening in our country."**

shocking, the threat of imminent physical harm palpable, the intent of the invaders unclear, and their actions apparently capricious. (From john-bishopexperience.com)

MICHAEL LERNER
UC Berkeley graduate student in philosophy and chapter president of Students for a Democratic Society (SDS)
The occupation by the National Guard escalated to what we had only read about. Public meetings were banned, but almost every day that restriction was violated. It was a transformative moment. At one point, a tear gas canister landed near me. I picked it up and threw it back toward the police, something that I could never imagine doing. I am a nonviolent person, but at that moment I was not.

CHARLES WOLLENBERG
professor at Laney College and a UC Berkeley graduate student in history
I was working full-time in Oakland teaching at Laney and so I missed many of the People's Park events. I was living on the north side and so was not as directly impacted by the National Guard as I would have been if I was living on the south side, but whenever I walked downtown or onto the campus to see what was going on I saw all of the National Guardsmen and knew that we were under military occupation. It did not seem to make sense at all given what had happened. It was not a logical response to what had happened on Telegraph. Governor Reagan was using this as a political issue, and Reagan's overreaction was being used by radicals as a political issue.

The National Guard as drawn by Dove Sholom Scherr, age eight.

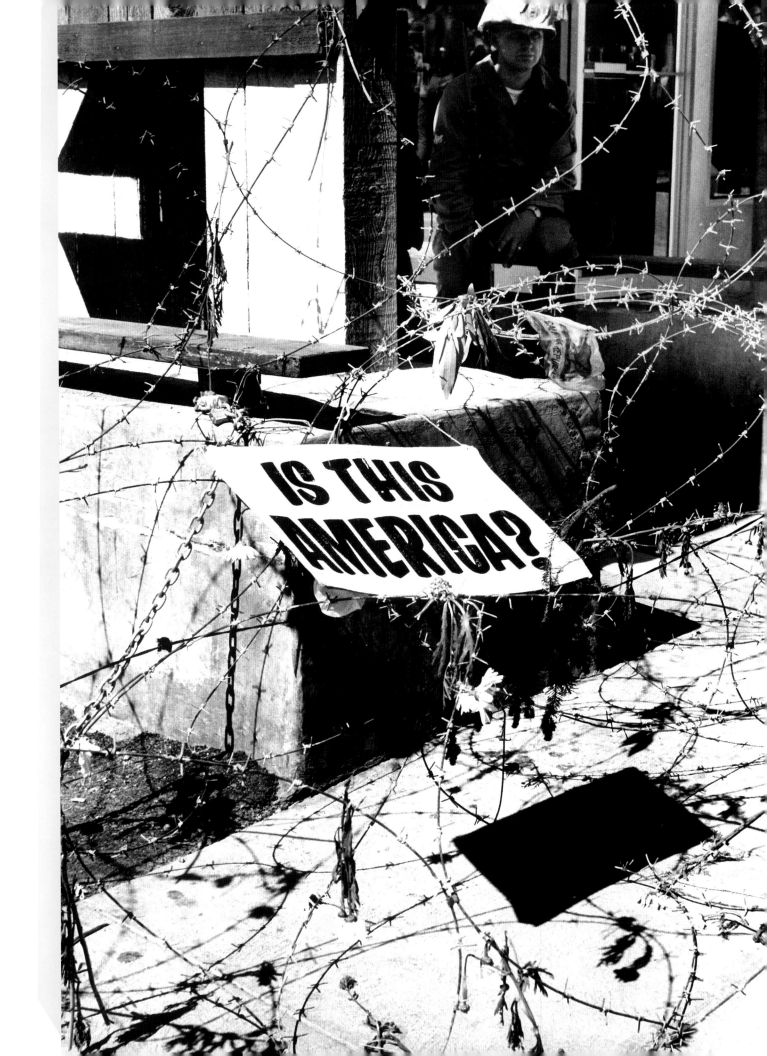

JACAEBER KASTOR
eighth-grader at Willard Junior High School
It was like birdwatching or trainspotting, looking at all the different outfits and trucks. There were soldiers on corners everywhere, especially in the South Campus area where I lived.

BERKELEY CITIZENS UNITED
a conservative political group
Dr. Richard Foster, Berkeley's Supt't of Schools, not only permitted but supported the ridiculous "sleep-in" held at BHS [Berkeley High School] by students protesting the presence of the National Guard. (BCU newsletter, June 1969)

INSTANT NEWS SERVICE
Students at Berkeley High will hold nightly sleep-ins at the school "until the massive and unnecessary armed force is removed from Berkeley." Supt. of Schools Richard Foster OK'ed it and said he would join except he's too old to sleep on concrete.

J. Feriam Danton, Jr., a spokesman for the group, said they were conducting a telephone campaign for support last night and expected good response.

A statement prepared by the group reads:

> Due to the presently existing circumstances in Berkeley, and in particular to the presence of excessive military

Berkeley High School Sleep-In

TO ALL BERKELEY HIGH STUDENTS: There will be a SLEEP-IN TONIGHT after school, beginning at 3:30 p.m., to demonstrate our concern over the safety of ourselves and others. We will refuse to leave the campus until the streets of Berkeley are safe. Due to the arrests, beatings and harassment of many Berkeley High School Students, we believe this action (i.e. the SLEEP-IN) to be both necessary and justified. OUR ACTION IS ENTIRELY LEGAL. It has the support and approval of Dr. [Richard] Foster, our Superintendent of Schools. You will NOT be subject to arrest if you participate. Bring a sleeping bag and cold food. Stay cool.

Please respect monitors wearing white arm bands, and organizers wearing white bands with blue stripes. We ask for your co-operation and support.

JOIN THE SLEEP-IN!!!

Right: Berkeley High School students face National Guardsmen at Sather Gate, on the UC Berkeley campus.

and police force, it is the sincere opinion of a large number of the students of BHS that the streets of this city are no longer safe, either from violence or unjustified and unjustifiable arrest.

Because of these dangers, already exemplified in numerous arrests, frequent acts of violence, and one tragic death, we feel that it is the duty of every citizen to take a positive stand.

One portion of this school's student body shall not walk the streets. However, we refuse, because of the lack of wise judgment of others, to jeopardize our own education.

As a result, tonight and subsequent nights, until the massive and unnecessary armed force is removed from Berkeley, a portion of the students of this school will not leave the campus.

The group said it "in no way" intends to disrupt the functions of the school or harass those students who do not agree with them. They said they would go to class, provide themselves with cold food, and sleep in sleeping bags on the school's Memorial Court. (May 26, 1969)

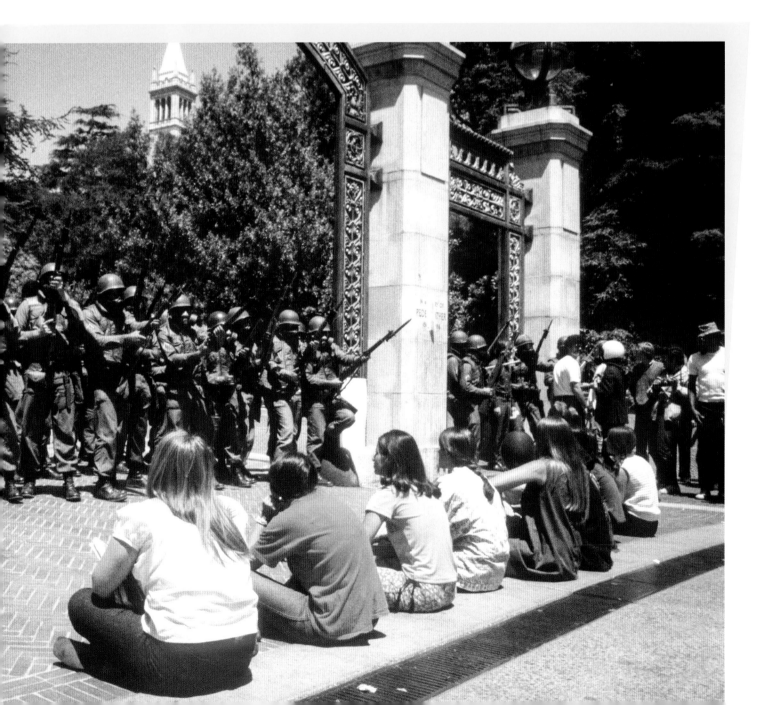

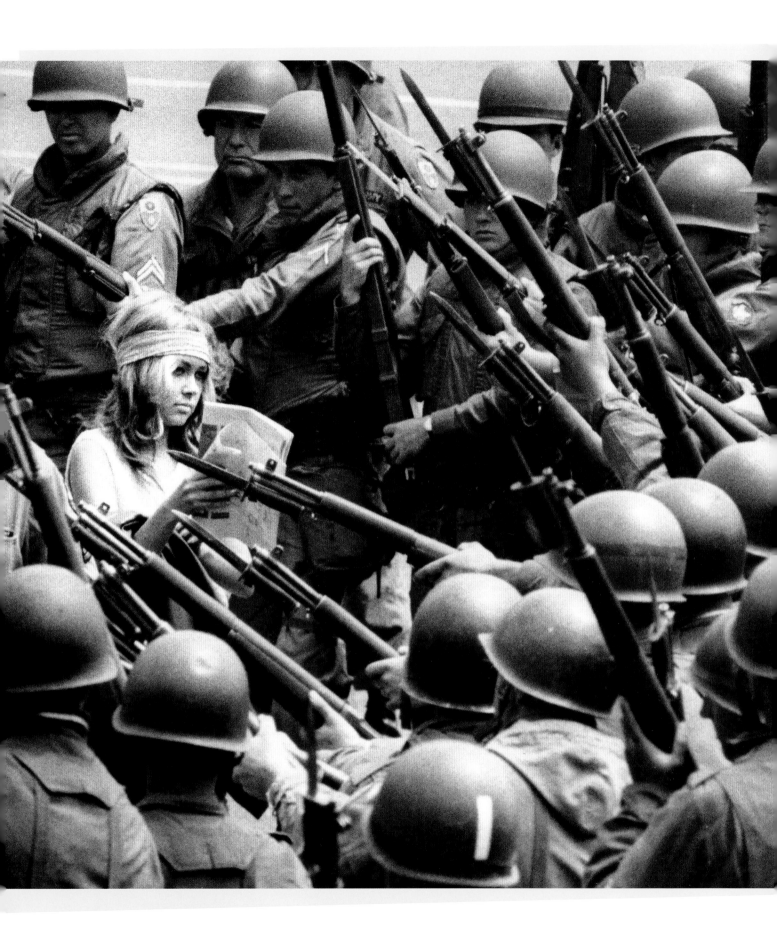

192 THE BATTLE FOR PEOPLE'S PARK, BERKELEY 1969

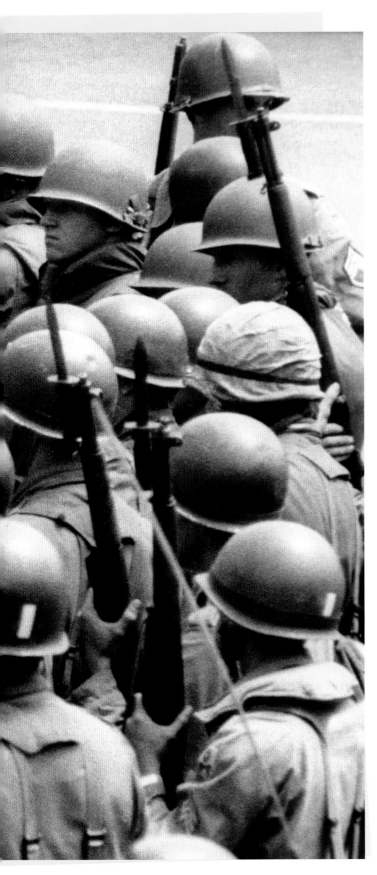

BERKELEY DAILY GAZETTE
About 40 Berkeley High School students continued a "sleep-in" at Berkeley High School last night, protesting the presence of "excessive military and police force" here. "Sleep-in" organizers said about 130 snoozed in the Berkeley High School Memorial Courtyard Monday night and they expect 200 to do so tonight. (May 28, 1969)

MEGAN (HESTERMAN) THYGESON
tenth-grader at Berkeley High School

I told my mother I was going to spend the night at school. It was Friday afternoon, the day after the People's Park march, when what was to have been a peaceful demonstration took a terrible turn. "We're gonna stay at school 'til the streets are safe." I explained there would be teachers and other adults on campus and reminded her that my older brother would be there. She agreed, and I headed to school with my sleeping bag, a peanut butter sandwich, a package of Fig Newtons, and a bag of walnuts.

Over two hundred students were gathered around our newly elected student body president [Steve Wasserman, the main organizer of the sleep-in]. He stood on the [Berkeley] Community Theater steps. He hollered into a bullhorn, "If our streets are not safe for us to come and go without threat, we'll stay at school until all restrictions are lifted." Other students took turns at the microphone, giving radical testimonials.

Monitors circulated, ensuring peaceful interaction. The school superintendent made an appearance in a gesture of solidarity. Parents arrived bearing steaming casseroles of rice and beans, noodles and chicken, tofu and vegetables for dinner. Platters of fruits, vegetables, cheeses, and nuts, boxes of Triscuits, Wheat Thins, and Cheez-Its, Sara Lee cakes in foil tins, and giant pink boxes of Dream Fluff doughnuts. After dinner, frisbees, music, dancing, and clouds of marijuana smoke rippled across the quad.

I still believe in the causes we fought for in the sixties, yet when I look back I see a vulnerable young girl who could have easily ended up in harm's way. Even with parents and teachers on campus, anything could have happened. For many of the kids sleeping at school, it was a chance for sexual exploration as well as political protest.

I only stayed for one night, but others slept in for a full week.

FIVE

Radical Reaction and Rightwing Response

In 1969, Berkeley had many radical groups. The far Left for the most part ignored People's Park until Bloody Thursday; the park was not an obvious example of class struggle and was not a gesture of resistance to the Vietnam War. With the May 15 shootings and beatings by the police and then the military occupation of Berkeley by the National Guard, however, several sectarian groups stepped into the fray. The issue of police and government oppression was one that fit their ideology. On Friday, May 16, a group called the Berkeley Coalition met at the Merritt College auditorium in Oakland, avoiding the Berkeley ban on assembly. Radio station KPFA recorded the meeting, from which the following four transcriptions are drawn.

The Spartacist League was a Trotskyist political group that became interested in People's Park only after Bloody Thursday.

RON YANK
UC Berkeley professor of rhetoric and a leader of Students for a Democratic Society (SDS)
Next week on Monday, if the power structure ruling class has not withdrawn troops and cops by twelve o'clock and not taken down that fence, we shut the U of C down. No strike, we just shut it down. Ten thousand of you had the guts to show that we weren't about to be intimidated. The worker-student alliance is going to be very, very dangerous. That line hasn't been settled yet. They want to smash us before we can form that alliance. I think People's Park is a good thing. I don't think it is a great thing. I don't think it is a solution. I don't think parks are a solution, but it's a good thing. They are using that as an excuse to smash the movement. I don't think we're going to get it through negotiations. I don't think we should be attacking the shoppers down on Shattuck; that's hurting the people we are trying to align with. The only way to fight back is through mass militant action.

JENNY GOLDMAN
activist
We go back to Shattuck tomorrow and stop people from shopping. The pigs like crowds. We need to diversify, to go into shops and see what's going on. We stay away from Telegraph—it's a trap. We stay away from the park; it's another trap.

BOB MANDEL
activist
If we continue to act militantly, we have a lever through which we might for the first time win today. The NLF [National Liberation Front] hasn't stopped fighting while they negotiate. At 11 everyone in this room assemble at Shattuck and Center and we peacefully take over downtown Berkeley. No normal business goes on in this city while there are troops and armed cops. They will have the choice of shooting up or tear-gassing every business in Berkeley. We hold that perimeter for an hour and a half or two hours. If cops are not there, we take the street, we block it, we have leaflets ready. Don't break windows. Don't loot. If the cops are there and hold the street, you stand in front of the stores.

MARIO SAVIO
Free Speech Movement leader
Which of the two is the better proposal? It is more cathartic and exciting to shut down Shattuck Avenue; also a wiser thing to do.

Those who favored taking the struggle to the business district on Shattuck prevailed, and demonstrations started there the next day. Those who had favored a worker-student alliance and wanted not to alienate Shattuck Avenue merchants and their employees joined forces with the Shattuck Avenue protestors.

In the coming days and weeks, many Left groups spoke up and produced flyers on People's Park.

LEAFLET PUBLISHED BY THE BAY AREA SPARTACIST LEAGUE
THE PARK AND THE REVOLUTION; GENERAL STRIKE AGAINST PIG TERROR. This education (of the public) alone does not justify the losses that our side has suffered. Revolutionists should not provoke the system into violent reactions and attacks on the people just for the sake of education. The most powerful response to the armed occupation of Berkeley would be a general strike....In the case of a general strike, the entire city and population are immediately affected, and it is much more clear to the soldiers that they are being sent against the people themselves. The power of the working people becomes very manifest, and along with this, their power to seize and reorganize society is clearly implied.

SPARTACIST-WEST

THE WORKING CLASS AND THE PARK: It was very apolitical and consistent with "hippie" thinking to fight the ruling class by simply planting flowers on a vacant lot. The problem is that as a revolutionary tactic it was a hopeless adventure. To win would mean bringing down the whole system right now. Working people should take the side of the students and park people in this issue, not because the park is a way to improve the workingman's condition, but because the students' and park peoples' enemy is the workers' enemy.

ANTI-IMPERIALIST COALITION

FASCISM IS HERE—SELF-DEFENSE NEEDED. The movement of the people has no choice but to defend itself against the murderous policies of the beast which calls itself a government of the people and against the wealthy interests behind this government. All who make sincere attempts to meet this new, clearly shown need of the people must be and will be supported by the movement of the people.

WHITE PANTHER PARTY

LET A HUNDRED FLOWERS BLOOM. The Heroic People of Telegraph will surely win their just struggle against the brutal and degenerate oppression imposed upon them by the Neo-Colonialist Berkeley City Council Fascist Ruling Clique and its Running Dog Lackies [sic] the Wicked Landlords. Progressive peoples from all walks of life resolutely support the firm demands for Local Salvation and Socialism on one street corner. It can be said with all certainty that the day is not far off when the People will rise up and claim the streets, parks and buildings as their own, forcing the occupying troops to flee for their lives.

STUDENTS FOR A DEMOCRATIC SOCIETY (SDS)

ATTACK THE REAL ENEMY! The decision for this repression was probably made on the national level and certainly has national implications. SDS believes many aspects of People's Park (the illusion of building islands of socialism in the U.S., building "parallel structures" or "liberated areas") are not progressive and don't build the fight against the real enemy. Building a special park for street people and students near the UC campus does not fight against the oppression and exploitation facing Third World and white working people every day. On Monday we should move in mass, militant action against the University or against City Hall.

INDEPENDENT SOCIALIST CLUB

Now we have to fight, we have to work, to build a movement which can take and hold not only that park but this city and this nation. That means struggling not for a compromise here or a concession there, but to destroy the power of the bankers, the landlords, and the industrialists who run America.

"Revolutionists should not provoke the system into violent reactions and attacks on the people just for the sake of education. The most powerful response to the armed occupation of Berkeley would be a general strike."

PETER CAMEJO
leader of the Berkeley chapter of the Socialist Workers Party (SWP)

At the time, I was firmly rooted within the more traditional socialist current and viewed the counterculture as diverting people from the real struggle at hand. [After Bloody Thursday,] Demonstrators leaderless. No transitional demands. We must avoid leadership of this situation. Also avoid demoralization of our own ranks. We did not want to alienate the people who had been behind this issue from the beginning. (From *North Star: A Memoir*)

OUTCRY!
leaflet produced by the Radical Student Union

We demand, and we will fight for:

- People's Park back to the People
- All troops out of Vietnam, the black ghettoes, and Berkeley
- Amnesty to all political prisoners
- Free Huey
- Bring back Eldridge
- Build parks everywhere
- All fences down
- The land belongs to the people
- All institutions to the people
- All wealth to the people.

INDEPENDENT SOCIALIST CLUB

The people may not win back the park—but then [Chancellor] Heyns (or his successor) will never get a soccer field either. A platoon of soldiers or a ring of cops cannot be maintained forever. Workers will not work there (the nephew of the president of the Alameda Central Labor Council was among those shot by the cops); students obviously will not play there; Berkeley mothers will not walk their children through a bitter travesty of a place for trees and grass. If the People's Park is suppressed, the land it was built upon will remain a wasteland, a symbol of the wreckage of Heyns's career, a monument to repression, a potential graveyard of the status quo. (Leaflet, May 23, 1969)

PROGRESSIVE LABOR PARTY

It is "private property" that prevents the young people of Berkeley from having a small plot of ground for a badly needed park. Private property and production organized for profit; profit and more profit, at no matter what cost, causes wars, racial division, inflation, poverty, loss of freedom, and police repression of all who would oppose them. (*Workers' Action* pamphlet)

BOB AVAKIAN
activist and founder of the Revolutionary Union (RU)

We in the RU decided that even though this wasn't the form of activity that we would have put our main energies into or focused our attention on, and we weren't the initiators of this by any means, once it became a much bigger issue it was important to relate to it. So we put out leaflets and tried to mobilize as many forces as we could to support this struggle. (From *From Ike to Mao and Beyond*)

REVOLUTIONARY UNION

WE WILL FIGHT FROM THIS GENERATION TO THE NEXT. Utopian? Sure. Doomed with fundamentally altering the system? Definitely. Should such projects be avoided? ABSOLUTELY NOT! For they meet *real needs* and they have genuinely arisen from the initiative of the people.

Last Thursday we were given a very practical demonstration of the truth that "all political power grows out of the barrel of a gun." We must fight back. We must refuse to be intimidated. We must be disciplined, and in an organized mass way resist the ban of rallies and meetings, the curfew and other fascist measures. If you don't have a gun, get one and learn to use it. (Undated leaflet)

INSTANT NEWS SERVICE

GUNS. Last Thursday, some people were saying, "We gotta buy guns." There is no reason to buy a gun. If you want a gun, enlist in the National Guard. (May 19, 1969)

EAST BAY RESISTANCE

There is no question that the death of James Rector is a tragedy. But it must be remembered that this tragedy is repeated many times each

"Would the powers that be denounce legitimate demands so readily if there were two hundred or three hundred beautiful young men standing silently with their own shotguns at the ready?"

day in Vietnam and the city ghettos. If we are to remain an effective political movement, we must keep our own local troubles in this perspective. One man was killed in the fighting in Berkeley last week; over 500 were killed in the battle for one hill in Vietnam.

COMMUNIST PARTY OF NORTHERN CALIFORNIA

The People's Park is the symbol of community and student resistance to monopoly's "civilization." It has likewise become the test for the Regents and the City officials to fulfill their plans. But let there be no illusions. The People's Park became an excuse for a new level of repression against the Movement. This government, State and Federal, is losing touch with reality. Unable to even grapple with, much less solve, a general social crisis of the System, they now attempt general armed violence against the People.

"WHAT NOW? CALL TO ARMS"
pamphlet written by "Sneed Hearn"

When you had the now infamous march on People's Park, what would have been the effect and consternation in the policeman's heart when he saw thousands of people raising their voices and hundreds of silent ones with them, holding close to their bodies weapons more substantial than rocks and bottles? The time's short. The weapons will not always be available. What will you do then? Will pitchforks and clubs stand up against some wild-eyed policemen with shotguns in their hands, even if they are "only loaded with salt"?

Would the powers that be denounce legitimate demands so readily if there were two hundred or three hundred beautiful young men standing silently with their own shotguns at the ready? Would the clubs that fit so readily into the hands of chronically sick policemen who consider them the vital extension on their bodies fall as fast and hard on the skulls of those who dare to use the word "pig" if, two feet away, a young man silently watched with his own vital extension held calmly in his hand?

Our founding fathers armed their men pitifully, but in Lexington, when a small group of ill-clad and poorly armed men stood to defend their women and children with few possessions, did the powers that then were rush in wildly clubbing and shooting? No they didn't, and you know damn well why. The only reason that the fighting did start then was because some wild-eyed defender of the state let fire one bullet. That one bullet marked the start of a dream which has become a nightmare. I doubt strongly whether it could happen again. If it did, perhaps the struggle would save us—before God tires of the shit that flies and destroys us before we get to do it ourselves.

Do it, you fools, before it's too late. Sell your damned *Berkeley Barb*s and buy a piece and learn how to use it. Gather together and learn how to defend yourselves and others. Then just silently stand with your brothers and perhaps we'll "travel to the beat of a different drum" and be saved. Do you think that the National Guard will stop you? I don't. I think that half of them would lay down their arms and go home, or even keep their arms and walk over to join you. Give them the choice—and make your own while you can.

"No one should be so naïve as to think that all of this repression was brought about because of someone trespassing on a piece of land."

THE BLACK PANTHER
official newspaper of the Black Panther Party

It's a hard question. Mickey Mouse Ronald Reagan and his running dogs have declared war on the hippies, yippies, and white mother country radicals. The City of Berkeley is under martial law. Pigs by the thousands patrol the community. National Guardsmen come to town by the truck loads. The CHP were patrolling the skies in their helicopters. All of the activity was supposedly brought about because of a small plot of land that was of no use to anyone until a group of young progressive people started to plant flowers.

As a result, people have been shot, maced, gassed, beaten and arrested. People living in the surrounding community have been shot down from their rooftops for just observing the actions of the pigs. One elderly man has been permanently blinded by these trigger happy, war hungry pigs. Early Sunday morning four car loads of Berkeley pigs came down in front of Panther National Headquarters to announce that under martial law no public address systems are allowed. The Black Panther Party was blowing Malcolm [X] over the sound system. Up the street a long fire truck stood by to block off the streets.

No one should be so naïve as to think that all of this repression was brought about because of someone trespassing on a piece of land. As this article was being written, news came that one of the persons shot by the pigs died of shotgun wounds. The pig power structures of California are trying to set examples for the pigs of the nation and make examples out of the people who want the people's park.

The oppressed people of the world are waiting for revolution to occur within the mother country. The Black Panther Party is making the revolution. The redguard is trying to follow the correct example, and the brown community is moving. We see that the white mother country radical is willing to lay down a life. We ask, is he willing to pick up the gun?

It is well known that one doesn't fight fire with fire. However, wars are won with guns, among other things. Power never takes a back step to anything but power. There are more people than there are pigs, and all power belongs to the people. Period! (May 25, 1969)

LEON WOFSY
UC Berkeley professor of molecular and cell biology

Actually, there's one thing which I didn't mention at all because it came later, but I think a large part of my connection both with faculty and with students also revolved around the encounter that I had with Reagan. It was during People's Park. What happened was that the People's Park situation was very ominous after Rector was killed.

Well, at that point I was not involved in the People's Park thing. I wasn't opposed to it, but somehow I wasn't caught up in the wave of counterculture that developed in the late sixties, early seventies. But what was happening, of course, was the campus was getting more and more tense. Reagan had called out the National Guard, Rector had been killed, and we were very, very close to the situation which a year later became Kent State. So under the circumstances, a number of us initiated—a few faculty got together and decided to go up to Sacramento, not in a public

demonstration of any kind, and not to see Reagan, but to try to talk to Republican and Democratic legislators to see if we could possibly bring some sense into the situation and try to cool it off.

And we were doing very well, meeting with them, getting a very good response because everybody at that point was anxious for things not to go any further in terms of violence. Reagan had heard we were there, and we got a message that the governor wanted to see us. It was his request, not ours. And we went in, and we got into an anteroom, an auditorium outside his office, and it was loaded with television cameras from all over the world, the usual big press conference thing.

We had chosen Owen Chamberlain as our spokesperson, but he never got one sentence out before Reagan began shaking his finger, with the cameras rolling, and saying, "It's you people, the faculty, who are responsible for everything that happened. You told your students they can violate the law. In general, you supported civil disobedience, and that's what's led to this. So it's your responsibility."

Anyway, I was sitting in the back, sort of a hangover of my old concerns not to be up front in this situation. What was happening was very alarming because quite clearly our whole effort was going to simply lead to a report in the press the next day of how Reagan had told off the eggheads from the Berkeley faculty. So I interrupted him. I said, "That's a fine political speech, but we came here to try to see if we could do something to cool off the violence."

He and I went back and forth at it a while. He asked who I was. I said, "Would you let me finish?" And he said, "No, tell me who you are." Then he said he knew who I was, and he wouldn't believe anything I said, and it became, you know—and I went on to say that you can't run a campus this way, under bayonet, any more here than you can in Prague.

And then everybody else spoke up. It really turned into a very important back-and-forth discussion, the like of which hadn't taken place before, and it got a lot of publicity. Owen Chamberlain walked out at the statehouse. He was already a Nobel Prize winner, and Reagan treated him like something the cat dragged in. (From the Bancroft Library Regional Oral History Office, interview by Lisa Rubens, 1999)

GOVERNOR RONALD REAGAN
This violence was precipitated. I would like to propose that the issue is that on the campuses you who are adults, you who are entrusted with these young people, have a responsibility to make it plain to them from the very beginning that you yourselves do not tolerate the kind of conduct that has led to the burnings of Wheeler Hall, that has led to two murders on the campus. Listen, you [Professor Wofsky], are a liar. (Response to a question posed by UC Berkeley professor Leon Wofksy during a press conference in Sacramento, May 21, 1969)

"It's you people, the faculty, who are responsible for everything that happened. You told your students they can violate the law. In general, you supported civil disobedience, and that's what's led to this. So it's your responsibility."

At the opposite end of the political spectrum, the far Right didn't need the riot of May 15 to know that the people of Berkeley were up to no good. Ever since the anti-HUAC demonstrations that involved many Cal students in San Francisco in 1960, the right wing had demonized Berkeley. The Right had long seen the university's professors and students as communists intent on taking over the university as a staging ground for revolutionary operations. It was through this lens that they saw People's Park.

JOHN R. COYNE, JR.
journalist
Let there be no doubt about it. There is a war, and the New Leftists at Berkeley, having won the souls of many of their peers, are now attempting to seize territory. The People's Park, however, was official. The New Leftists and the street people, no longer content with unofficial occupation, decided officially to annex a chunk of university territory, and by so doing to legitimize their culture and make it a recognized force in the community. (From "Positively the Last Word on the People's Park," *National Review,* October 7, 1969)

MIKE CULBERT
editor of the **Berkeley Daily Gazette**
Berkeley is the dry run for revolution in this country. And we mean socialist revolution. (March 24, 1969)

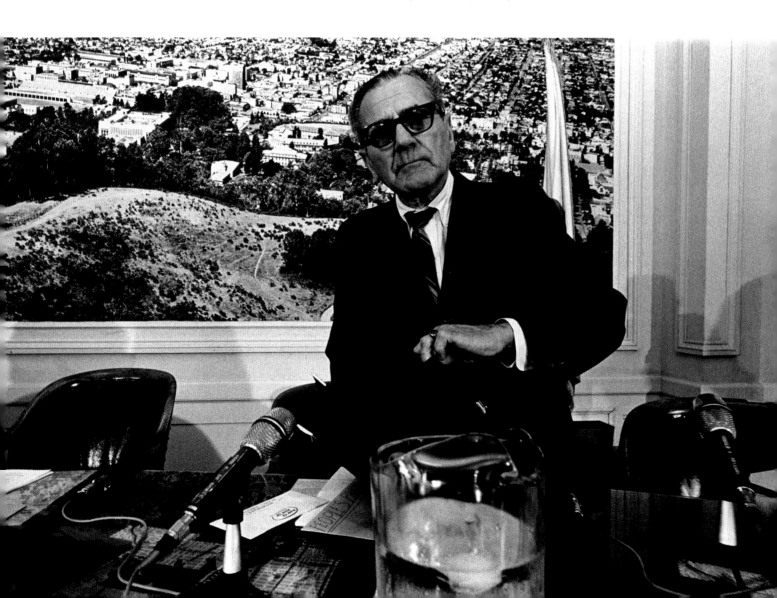

John K. DeBonis,
chairman of the Berkeley City Council

John DeBonis served on the Berkeley City Council from 1963 until 1971. He ran for mayor and lost in 1971. He was a blunt, outspoken conservative. He had a certain charm, and there were those on Telegraph Avenue who affectionately greeted him as "Johnnie." Following are some quotations from DeBonis published in 1971 by the Socialst Workers Campaign Committee.

All I can say is that this is a beautiful sight. If these radicals want to fight with powder puffs, fight them with powder puffs, if they want to fight with clubs, fight them with clubs, if they want to fight with guns, fight them with guns; they've got to be curtailed[;] this is a radical and an international conspiracy; this is a revolution but they're not going to win. (May 15)

We're in a revolution. Believe me, we're in it! The question is who is going to win it. And I'm trying to have the good people in this country win this revolution, and not turn it into anarchy. (May 20)

I think we must show force. They've invaded Berkeley, they're trying to take over Berkeley, and who are we to tell the Governor or the United States Army that we don't want bullets? (May 20)

I don't understand what there is to negotiate about. The property is privately owned by the University of California. The park people have no right to it. There is no reason that everyone has to negotiate on a bunch of squatters taking over private property. There's nothing to negotiate. (May 24)

It's a gypsy land, it's a hobo jungle. Eating their Mulligan Stew tonight out of a big ash can! Do you want that in your neighborhood? I'm talking about the hippy Disneyland up there. (May 27)

What we're doing here by even suggesting that there be a park there is nothing more than more appeasing and yielding to pressure. (May 27)

If it takes a confrontation to clean this city up, let's have this confrontation once and for all and for good. (June 3)

It's filthy, the City of Berkeley. It's going to be Berkeley with a jungle, with a hobo jungle, with a gypsy paradise. We've got to bring this city back to where it used to be. A beautiful image, clean, not a dirty pig sty. (June 3)

The reason we are having these confrontations is because we have been using clean, white kid gloves. We have appeased them. We have vacillated. We have just not made them live up to the rules and regulations of society. (June 3)

Left: John DeBonis of the Berkeley City Council was brash, blunt, and deeply conservative.

Berkeley Barb

VOL. 8, NO. 22, ISSUE 198, MAY 30-JUNE 5, 1969
2042 UNIVERSITY AVE., BERKELEY, CA. 94704, 849-1040

PUBLISHED WEEKLY 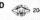 204

15ᶜ BAY AREA

25ᶜ ELSEWHERE

HOW TO WIN A WAR

FREEDOM'S FINEST HOUR
adapted from the award winning documentary film
Narrated by RONALD REAGAN

DEDICATED
by the PEOPLE OF
BERKELEY, Calif.
In MEMORY of
JAMES RECTOR

Negotiations

Between late April and late May there were a number of meetings between university officials and park supporters about the park. These meetings were often referred to as negotiations—but only after Bloody Thursday—and they were not what is traditionally understood as negotiations, with the exchange of proposals and mutual, incremental compromise. Here is what happened:

The first meeting was on April 29 between Vice Chancellor Cheit and Wendy Schlesinger, a park cofounder. Later that day, Cheit met with Chancellor Heyns. In effect, the outcome of those meetings was that the university determined, only a week into the park's life, that it would reclaim the land and fence the park in.

Over the next weeks, there were a number of meetings, all of which must be evaluated in the context of the decision that Chancellor Heyns had made on April 29: to occupy and fence in the park. Park activists who attended at least one meeting included Wendy Schlesinger, Michael Delacour, Paul Glusman, Art Goldberg, Jon Read, Doug Bogen, Bill Miller, Jim Hawley, and JoAnn Lennon. Also present at some point in the month were representatives of the Telegraph Avenue Concerns Committee, Carl Wirth (director of the Berkeley Parks and Recreation Department), Jim Egenberg (from the Berkeley Planning Department), Rene Jope (president of the Berkeley Chamber of Commerce), Fred Cody (founder and owner of Cody's Books on Telegraph Avenue), Sim Van der Ryn (UC Berkeley professor of architecture), Charlie Palmer (ASUC president), Jondavid Bachrach (ASUC senator), and attorney Joe Grodin.

One of the obstacles to negotiations was the organizational structure—or lack of structure—of the park activists. There was no centralized leadership of the park movement for any purpose, and no consent by those who built and enjoyed the park to be bound by decisions of anyone. The park's highly decentralized character was not easily understood by the university. Many leaders of the Free Speech Movement had worked with SNCC (the Student Nonviolent Coordinating Committee) in the South and had learned the tactics of confrontation, believing that the purpose of nonviolent direct action was to create the conditions under which negotiations become possible. On this point, the People's Park movement parted company with their Free Speech elders. For the park activists, negotiations were neither the means nor the end.

The university eventually gave the park activists an ultimatum to form a negotiating committee authorized to speak on behalf of the park supporters. The deadline was met. On May 14, they elected an eleven-member negotiating committee.

The park activists were problematic, but the university negotiators did not come to the table with clean hands either. As willing as the university administrators might have been to make concessions, they were under intense pressure from Governor Reagan not to, and Reagan's dismissal of Clark Kerr two years earlier left no doubt as to his readiness to dispense with university administrators who did not comply with his wishes.

Reagan's position on negotiations was crystal clear: "Negotiate? What is to negotiate? On that issue don't you simply explain to these students that the university has a piece of property that it bought for future construction of the campus and it is now going ahead with the plan? What do you mean negotiate?" He had long demonized Berkeley, and two years into office he was not about to change.

It is easy to see why the negotiations never got serious. Governor Reagan would not authorize any concessions by university officials, while the entire ethos of the park movement strained against the notion of concession and compromise. Park activists resisted any leadership model in which a few could speak for the many. University efforts at workarounds relying on student government leaders and professors whose leadership was not recognized by park activists were destined to—and did—fail.

WENDY SCHLESINGER
feminist, eco-activist, and People's Park cofounder
Heyns concluded by telling us we would have three weeks, or until May 27, to elect representatives for the People's Park contingent who could definitively speak and act for the Park people, so he could have someone to negotiate with. (From *The Whole World's Watching*)

SIM VAN DER RYN
UC Berkeley professor of architecture
A key factor leading to the park crisis was the Chancellor's demand for a committee which could not be produced instantly by the Park people. The university's exclusive reliance on old forms of hierarchal organization [included] the use of closed planning processes that do not involve consumers in significant decisions. (From "Building a People's Park," *Design for Life*)

ROGER HEYNS
chancellor of the University of California
Certainly one of the problems was that there wasn't any representative mechanism. It was often very difficult to identify somebody with some kind of representational authority. It was a motley committee, including a kid who was about twelve years old, maybe older, maybe fifteen or sixteen. He was not a student. He was not in any school. He was just a street kid, and he'd been elected by the people to show up. It was ludicrous. It was absolutely wild. It shows you the total absurdity of the situation.*

————————

* The young man that Heyns dismissed as "just a street kid" was Doug Bogen, a student at Berkeley High School's McKinley Continuation School.

The park supporters' negotiating committee issued periodic reports on the process of negotiations.

NEGOTIATION REPORT

We have completed three negotiating sessions with the University and City. Our team consists of Doug Bogen, Art Goldberg, Jacquie Rosenbaum, and John Reid from the Park Negotiating Committee, Charles Palmer from the ASUC, and Joe Groden as our legal counsel. Their team consists of Chancellor Heyns and Vice-Chancellor Cheit from the University; Mayor Johnson, City Manager Hanley, and Councilman Wilmot Sweeney, from the City; and Renee Jopee from the Citizens Committee to Restore Civic Activity.

The people are with us. In by far the largest election in campus history 85% of the 14,969 students voted to support our demand to return control and design of the park to its users and to take the fence down. Many more thousands have voted with us in the street.

OUR DEMANDS

1. The Park must be community controlled.
2. The Park must allow spontaneous design by user construction.
3. The fence must come down.
4. The troops must be removed.
5. The prisoners must be released and charges dropped.
6. The State of Emergency must be lifted.
7. The University must pay financial reparations for the injured and for the damage done to the Park.

We initially offered Heyns three alternatives to implement the demands:
1. The University could sell or give us the land.
2. The University could lease the land to a non-profit community corporation (as the city of Richmond does for one of its parks).
3. The University can let the community control and develop the park under the sponsorship of the College of Environmental Design.

THEIR RESPONSE

In public statements Heyns has appeared to move far towards an accomodation. His original soccer-field-cum-fence position has been replaced by the claim he would now allow a park with some degree of community control and design by users. BUT IN NEGOTIATIONS HEYNS HAS MOVED AWAY FROM ANY REASONABLE SETTLEMENT.

In Wednesday's negotiations Heyns' position was that the University under any settlement would keep control over the land; this would include the Chancellor's unilateral and arbitrary power to set time, place, and manner rules. He specifically stated he would forbid political rallies, be-ins, love-ins, and rock concerts in the park. In addition he would not allow spontaneous design by user-construction.

Following the mass demonstration on Thursday, Friday's negotiation session looked much more hopeful. Heyns agreed that if the University leased the land to the City, the land would no longer be subject to University time, place, and manner regulations but would be subject only to the normal City park regulations.

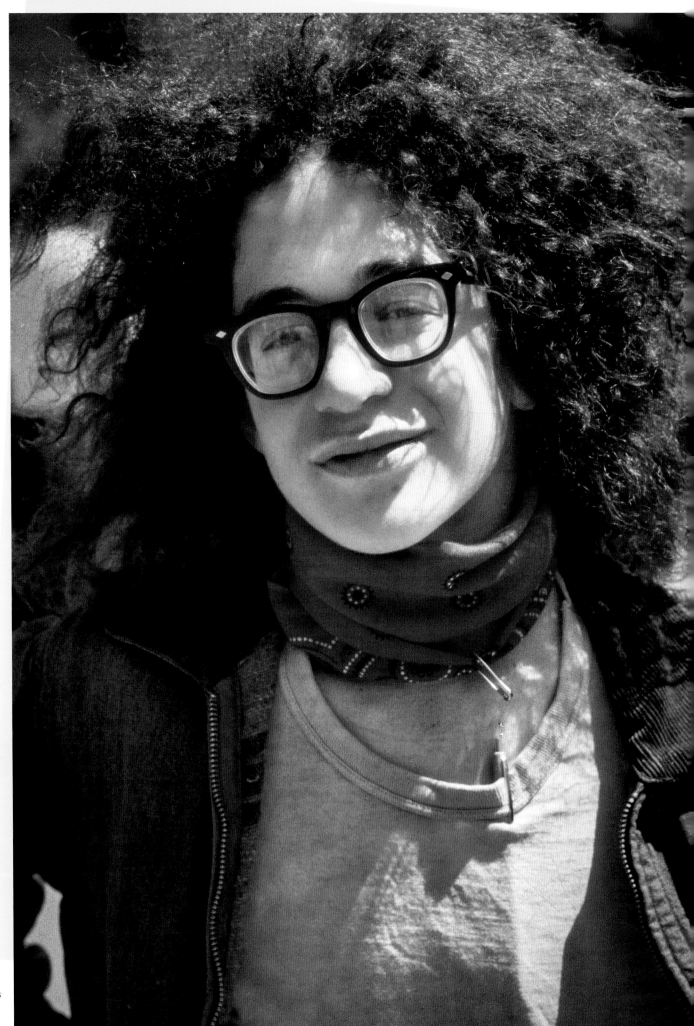

Doug Bogen, student at Berkeley High School's McKinley Continuation School

I came to Berkeley as a fifteen-year-old runaway, more or less, in fall of 1968, and didn't really leave until 1993. I knew only one person: Lenny Heller, who wrote for the *Express Times*. I had met him that September when he had come to cover the International Assembly of Revolutionary Student Movements at Columbia. He was like, "Sure, you should come out to Berkeley; we have plenty of room." People were like that, then. And he was very gracious when I turned up— totally unexpectedly, I'm sure—at his apartment on Alcatraz Avenue. Not long after, we moved to a house on Shattuck, about half a block from the Black Panther Party headquarters.

I was flat broke at the time, so Lenny passed his "pay"—free copies of the newspaper—on to me. I supported myself for months by selling them in and around the Caffe Med for a day or two each week—fifteen cents, but here's a quarter and keep the change. This was plenty; a full chicken dinner at the Med was just $1.29.

In the late spring of 1968 I had moved in with my brother (who was in [the] City College [of New York]) and his girlfriend on 125th Street, just off St. Nicholas Avenue, and right down the block from the Apollo. I spent a good deal of the summer hanging out at the SDS [Students for a Democratic Society] "liberation school" at Columbia University—I can still remember Mark Rudd [SDS leader at Columbia University] explaining to me what "teleological" meant. Somehow I found myself in charge of the mimeograph machine and must have run hundreds of thousands of leaflets over the summer.

It's worth mentioning that both the Columbia shutdown and People's Park were prompted by university takeovers of community land. And both were the logical inheritors not only of campus events like the Free Speech Movement but of community actions like the Embarcadero Freeway revolt [a protest in the early sixties to prevent new highway construction in San Francisco] just a few years earlier.

I guess I knew pretty much everybody who was involved in People's Park, and mostly pretty well.

I knew Mike Delacour quite well and spent a lot of time hanging out at [the] Red Square [dress shop]. One day he asked me to take a walk around the sea of mud that later became the park, and described his plan for how he'd try to get Telegraph Avenue merchants to chip in for sod and such. Mike had a vision in his head for just how effective it could be as a community organizing tool. Looking back it's really quite remarkable that he could see it so clearly. I didn't think it had a prayer of succeeding; just as some months later I thought the name "People's Park" would never stick.

Bill Miller owned The Store [a head shop], which was originally next to Yarmo's [a dress shop] on Telegraph and was our main hangout. When it moved into the old Moe's [Books] site I did a lot of work helping to fit it out, and wound up spending a lot of time running the place. There was a large and loose family with Bill, his wife Liz Griffith, and a house they rented up on Frat Row. Curtis Rosa moved in at some point, and he helped ride herd on various kids who were always around. Liz would take a crew of us on camping trips to the Russian River in the summer. I don't know if she was working at the time, but she was a social worker of some sort. When I got arrested for being a runaway in 1969, she organized my becoming a ward of the state in care of Charles and Diane Perkel, who we knew from Moe's, and who were one of the few married couples I knew.

Left: Doug Bogen.

Jon Read I got to know better a couple of years later. He was leading a community effort to build a safe playground at the Le Conte [Elementary] School, so I pitched in. He taught me a lesson I'll never forget. I was cutting some lumber with a power saw, which is to say that I was well on my way to destroying the saw. He told me to listen to the saw, and it would tell me when I was using it properly. Made no sense to me at the time, but over the years I've seen how it applies to most kinds of work: it lets you know if you're doing it right or wrong.

I knew Super Joel very well. I was a little older than the Red Rockets kids* and he was a little wild, even for me, but Joel knew a lot of people, and we all got to know each other. I also knew, but wasn't especially close with, people like Stew Albert and Frank Bardacke, who spent less time around Telegraph Avenue. The thing that stands out in my memory about Frank was how effective he was at being the voice of reason.

I spent tons of time in the park from day one, and helping out on projects during the week. The story I think everybody remembers is from the first day: Jon Read up on a tractor plowing up the mud, and the millions of rocks that people somehow cleared by hand. A little bit of sod went down that day, and then every week a new patch would be added.

Usually there was a big community turn-out on Sundays, so I'd take that day off to just get stoned and hang out. I recall one time that [Black Panther leader] Bobby Seale turned up; he told a long story about Huey Newton and his car, the Gray Roach. The clock from my history class turned up too, way up high in the little clump of trees in the middle of the park. No idea how it got there, but it wasn't much of a trek—my school was the McKinley Continuation High School, just a bit farther down on Haste.

It had once been a large, formal place but was mostly closed down when the main high school campus was built. In the rest of California, continuation schools were where they sent the all-but-dropouts and hard cases, but in Berkeley, it got some of the best students and

teachers and advisers. I enrolled because they had a no-questions policy; if you were a kid who wanted to go to school, they overlooked details like missing parents. It's probably the reason I wasn't shipped home when I was finally arrested for being a runaway.

On May 15, two scenes stand out: listening to Mike Delacour at Sproul Plaza and running back down to Haste with my gang to see if we could get the fire hydrant opened. I don't know why, but it seemed like a good idea at the time. The rest of the day is a blur—less because of time, I think, than because this kind of confrontation recurred so many times in Berkeley.

It was standard Berkeley rioting: getting chased by the police, getting tear-gassed, running up to grab tear gas canisters and throw them back, pitching in to throw whatever was at hand into the street to try to slow down the police cars. For me and my buddies, it wasn't ever about random destruction of property. Rather, the police were trying to hurt us, or arrest us, and we were trying to stop them. We wanted to be in the street, not destroy it.

I was out in the demonstrations every day with my buddies. A march is kind of a herd movement, especially when it's trying to avoid police lines. We knew the campus and surrounding streets quite well, so we'd try to get the crowd to move along a good path. The movement into Lower Sproul Plaza on May 20 didn't look good from the get-go. We tried to get the crowd to stay out and route around, but they all went in and wound up getting trapped and tear-gassed. It was pretty easy to see what was coming.

I think that Paul Glusman's article for the *Express Times* summed the Memorial Day march up best: something to the effect that a small number of people marched to take back the park, and another thirty thousand marched to stop them.

My friends and I had gotten hold of a few pounds of weed; we rolled up hundreds of joints the night before and passed them around as we marched up University Avenue. The city was on high alert, of course, and the route was laid out in advance. I recall that as we made the turn toward the park from Shattuck Avenue a sheriff's deputy briefly pointed a shotgun at us, which scared the bejesus out of me. When we reached the park we would have been delighted to join in tearing down the fence; but as Paul noted, the vast majority of marchers were having none of it.

* The Red Rockets were a loosely knit group of young teenagers who spent their days on Telegraph Avenue between Haste and Dwight. Some were runaways, some had families in Berkeley, and some were in between.

Something that was obvious, and which I think Mike Delacour might have pointed out at the time, was that the City and university had in a way fenced themselves in: the park and the fence were the focal point of every community action for years after that.

I was on the negotiating committee that got elected on May 14. As I recall, we were chosen by assent ("Hey, how about the kid?") at a meeting in the park. I don't remember who initiated the actual negotiations, but there was no expectation whatsoever they would achieve anything.

[The meetings] were held in a back room of the Crocker Bank, I think on Bancroft and Shattuck, at the invitation of Rene Jope, the manager. In Berkeley terms, he was kind of the Fred Cody of the banking world and very well might have put meetings together himself. Besides us, Berkeley mayor Wallace Johnson was there, along with Chancellor Roger Heyns and a couple of others.

The only moment I remember distinctly occurred one day when I had come a bit early. I happened to have a bag of marshmallows, and I set one down at each place. Eventually Heyns ate his; I turned to one of the negotiators and whispered, but loud enough for the room to hear, "Do you think he knows there's LSD on it?" Now, this was actually a thing in those days, so Heyns reacted as expected—I think the word "blanched" was invented to cover these situations—and we all had a good laugh.

To me, viewing the past in terms of success or failure is like panning *La Bohème* because Mimi dies. No single step along the way determined the final outcome and, as with the evolution of Berkeley itself, there were always many unconnected forces pulling in different directions. I particularly reject the notion that the park, or the larger Berkeley community, somehow sowed the seeds of their own destruction.

On the contrary, I think that the rest of the country slowly but surely began to catch up with us. Over time, People's Park wasn't the only park designed to meet the needs of the community, rather than city planners, and Berkeley wasn't the only place where people who were different could finally breathe.

"The negotiations had no chance of succeeding. Governor Reagan didn't want an agreement. We didn't either. We were not reasonable. We were revolutionaries."

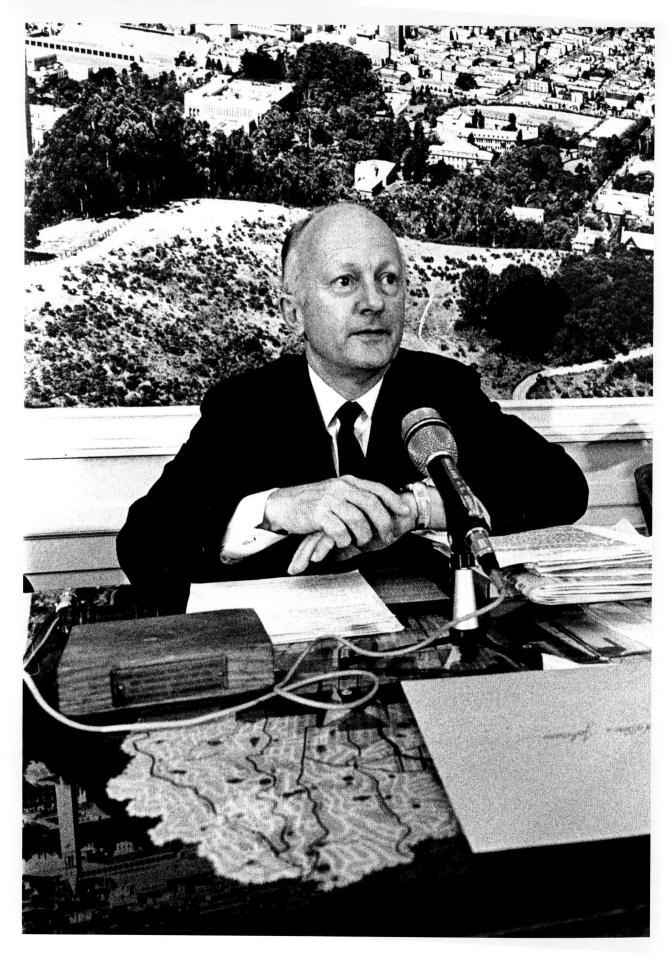

Wallace Johnson, mayor of Berkeley from 1963 to 1971.

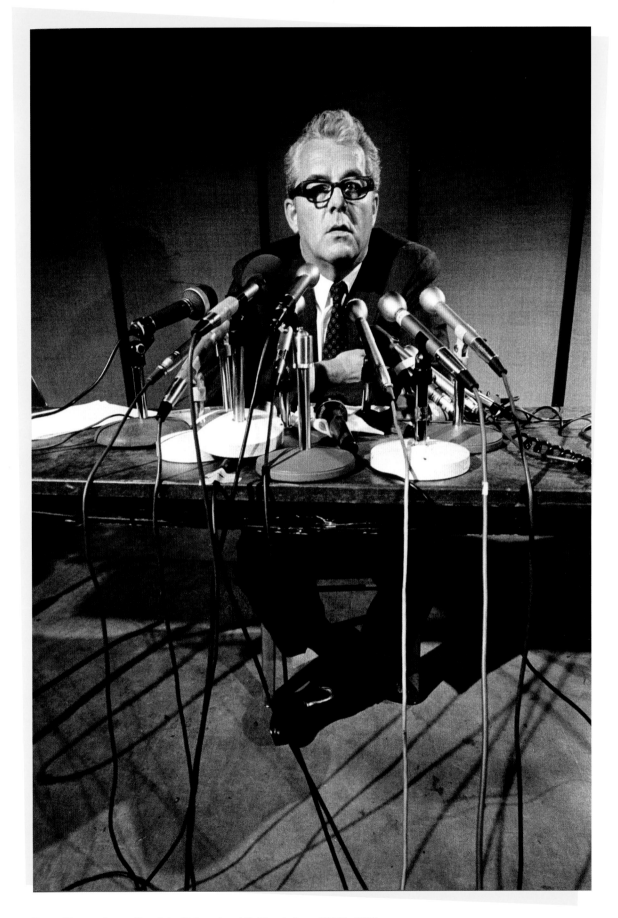

Roger Heyns, chancellor of the University of California from 1965 to 1971.

CRAIG PYES
UC Berkeley undergraduate student
The negotiations had no chance of succeeding. Governor Reagan didn't want an agreement. We didn't either. We were not reasonable. We were revolutionaries.

PAUL GLUSMAN
student activist
In the words of our great leader and teacher Jerry Rubin, "They can't coopt us because we want everything." (*Good Times,* May 14, 1969)

JOE GRODIN
attorney and a professor at the University of California's Hastings School of Law
I knew [ASUC president] Charlie Palmer and had represented him and ASUC about allocation of funds to ASUC by the university. He asked me to represent ASUC on the People's Park negotiating committee. I was conflicted about People's Park because it seemed to me that the founders had no endgame and no real theory except Frank Bardacke's stretch theory about use. Budd Cheit represented the university in the negotiations; I had dealt with him in the past and found him to be somebody you could work with. One of the representatives of the park people was a fourteen-year-old who seemed astonished to be in the room. He brought presents to the meetings, first popcorn and then pot, which I ruled out. The park supporters were anarchists and oppositional and thought it would be funny to send the kid. These were not conventional negotiations built on giving and taking, and, as I already said, I didn't see any endgame or exit strategy from the park supporters. They were smart and polite and earnest, but they had no interest in negotiating protocols, tactics, or strategies. We held one preparation meeting at our house. My neighbor said to me, "I think you have the great unwashed of Berkeley in your house."

ART GOLDBERG
UC Berkeley graduate and Free Speech Movement leader
The negotiations are not going well. There has been a shift in the position of the administration.

It seemed for a while as though they were anxious to have the thing settled, but that feeling ended Sunday night. We haven't won. They haven't agreed to spontaneous development and design or to community control of the park. We don't care what legal structures are necessary, as long as these essential conditions are met. (*Daily Californian,* May 27, 1969)

ROGER HEYNS
chancellor of the University of California
There will be no negotiations in regard to the land known as People's Park. (*Daily Californian,* May 19, 1969)

CHARLES SELLERS
UC Berkeley professor of history
Heyns's comments are precisely that kind of intransigence that has caused blood to flow in the streets of Berkeley.

CHARLIE PALMER
UC Berkeley undergraduate student and president of ASUC
Heyns doesn't have any real commitment. And he's not an open man; he didn't really level with us or trust us when we tried to work with or negotiate with him.

BUDD CHEIT
executive vice chancellor of the University of California
I can't possibly guarantee anything I may have to offer. We are powerless here; the regents will eventually make all final decisions.

JONDAVID BACHRACH
UC Berkeley undergraduate student and ASUC senator
I remember meeting with Chancellor Heyns at the chancellor's residence once. I don't know if it was before or after this meeting, but at one point I lowered the university flag on campus and flew the Jolly Roger flag in honor of Chancellor Roger Heyns. He showed me his rose garden at the house. He had stunning roses, including a gray one from which I took a cutting for my Regent Street porch garden.

Jondavid Bachrach, a senator for the Associated Students of the University of California in 1969.

"These were not conventional negotiations built on giving and taking.... [The park supporters] were smart and polite and earnest, but they had no interest in negotiating protocols, tactics, or strategies."

Charlie Palmer,
president of
the Associated
Students of the
University of
California in
1969.

The university eventually agreed to let the park remain a park, but Heyns insisted that the university at least maintain control over design and construction, a stipulation that led Charlie Palmer, the liberal-not-radical president of the student body, to a modest rant:

CHARLIE PALMER
UC Berkeley undergraduate student and president of ASUC
What is offered by the Chancellor is not participation. He and his people will decide. Let no one be misled. The Chancellor offers a hoax. (*Daily Californian*, May 19, 1969)

On May 15, before the battle erupted on Telegraph, the faculty of the College of Environmental Design passed a resolution asking Chancellor Heyns to designate People's Park as the Environmental Field Station, under sponsorship of the College. The resolution fully supported the spontaneous development of the park as "appropriate and good." Park negotiator Art Goldberg said that this was an idea that they could support.

The Department of Landscape Architecture submitted a more detailed proposal that included leasing the park to a nonprofit organization. This effort to impose mainstream organizational hierarchy on the movement was championed by William Wheaton, dean of the College of Environmental Design and an international authority on housing and urban development policy. He floated the concept of a People's Park Corporation and suggested that architect and park cofounder Jon Read serve as president of the corporation.

The board would consist of five members of the People's Park negotiating committee, the president of ASUC, and five other residents and civic leaders. The names attached to the draft articles of incorporation were John Algeo, Donald Appleyard, Michael Delacour, Sandra du Fosse, John McEthaney, Scott Newhall, Charlie Palmer, Jon Read, Peter Sanborn, Elizabeth Temko, and Sim Van der Ryn.

Jon Read went to Michael Delacour with the idea of a corporation headed by Read. Delacour remembers dismissing it: "Jon, this is bullshit. We risked our lives for that park and no one in this room has. If you walk down to the park and say you're president, no one's going to listen to you anymore."

When university negotiators failed with their efforts to work around the park activists, they got caught making promises they couldn't keep.

On May 7 or 8, Vice Chancellor Cheit met with ASUC senator Jondavid Bachrach. Cheit affirmed the assurance of prior warning before the university took action on the park.

BUDD CHEIT
executive vice chancellor of the University of California
There will be no surveyors, fences, or bulldozers on premises without notice well in advance. When we move on the land, it won't be in the middle of the night.

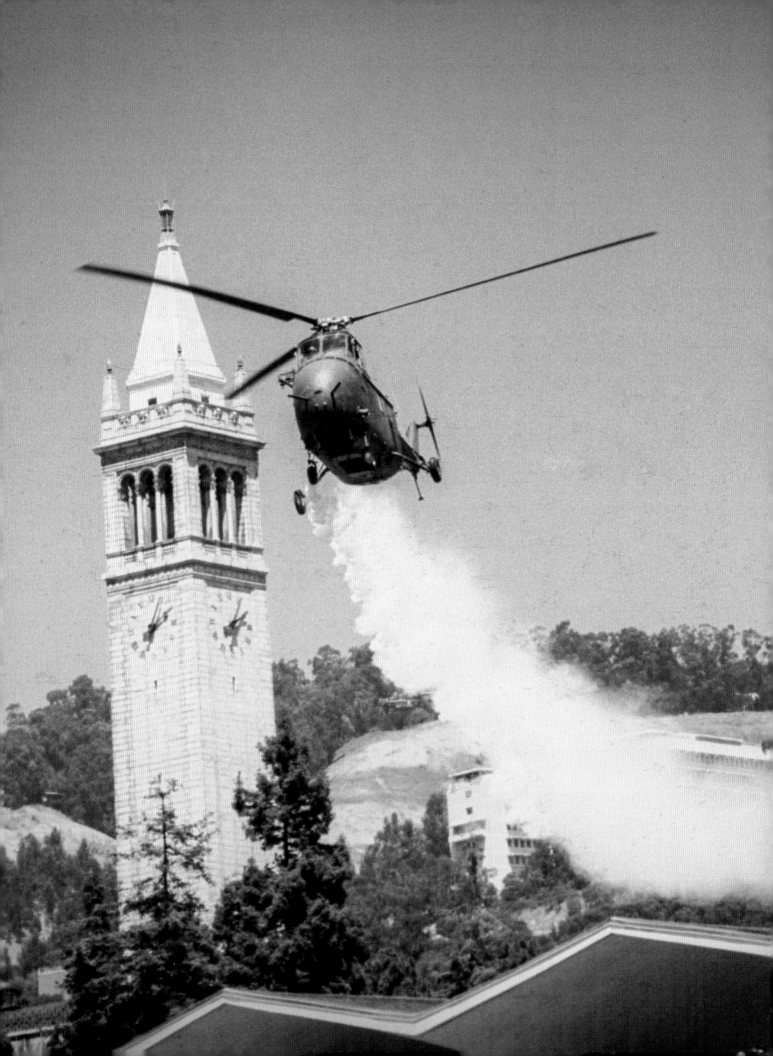

Terror from Above

The events of May 20, 1969, are remembered with subjective, alternative, self-serving, and contradictory versions of the same incident from the perspectives of the National Guard, the Berkeley Police, Governor Reagan, protestors, and onlookers.

It is agreed that at some point a police officer with a bullhorn said to hundreds of people who had gathered in UC Berkeley's Sproul Plaza after a faculty vigil for James Rector, "Chemical agents are about to be dropped. I request that you leave the area." All protestors spoke of having been allowed to enter the plaza but not allowed by the police and National Guard to leave it. The Guard and police deny this. The police spoke of a riot on the verge of deadly. All protestors, and television film from KPIX, show nothing approaching a riot.

What is agreed upon: a National Guard Sikorsky H-19 Chickasaw multipurpose helicopter used by the United States Army and the United States Air Force dispersed tear gas over the Cal campus, including Sproul Plaza. But what gas was dispersed? A National Guard information officer first said that it was chloroacetophenone (CN), or conventional tear gas, with a white coloring agent added for "psychological effect" (*San Francisco Chronicle,* May 21, 1969). The next day, however, he said that, in fact, it was diluted chlorobenzylidenemalononitrile (CS) (*San Francisco Chronicle,* May 23, 1969). Exposure to CS gas causes a burning sensation and tearing of the eyes such that the victims often cannot keep their eyes open, combined with a burning irritation of the nose, mouth, and throat mucous membranes, causing intense coughing, mucous nasal discharge, disorientation, and difficulty breathing. It is especially nasty stuff. Wind carried the gas as far north as Oxford Elementary School, as far south as Tunnel Road, and east up into Strawberry Canyon.

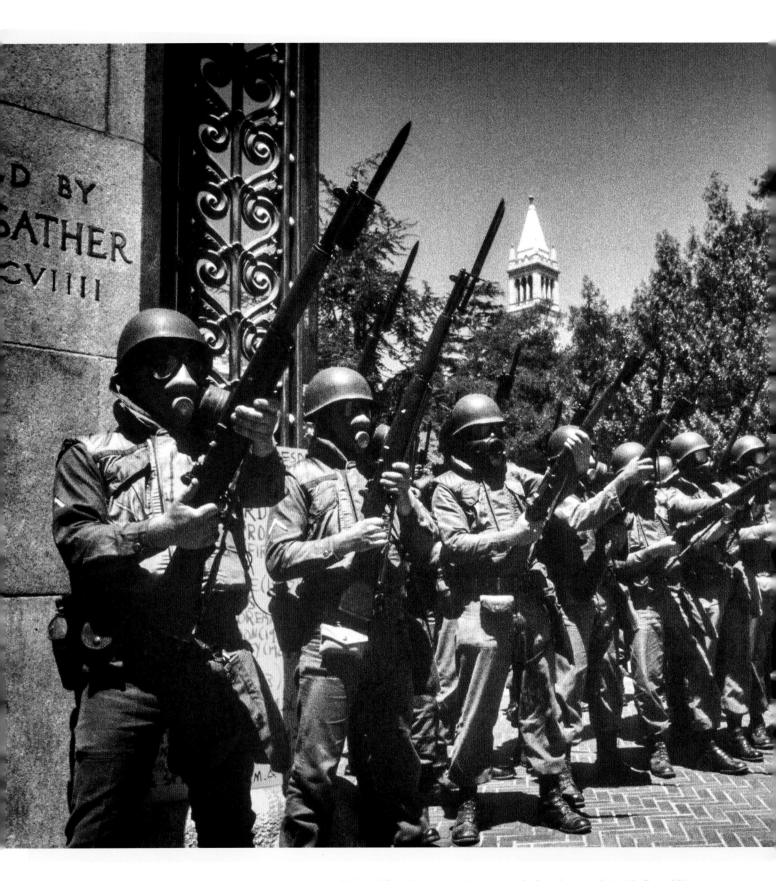

National Guardsmen wearing gas masks keeping people inside Sproul Plaza
before the National Guard helicopter disperses CS tear gas over the campus.

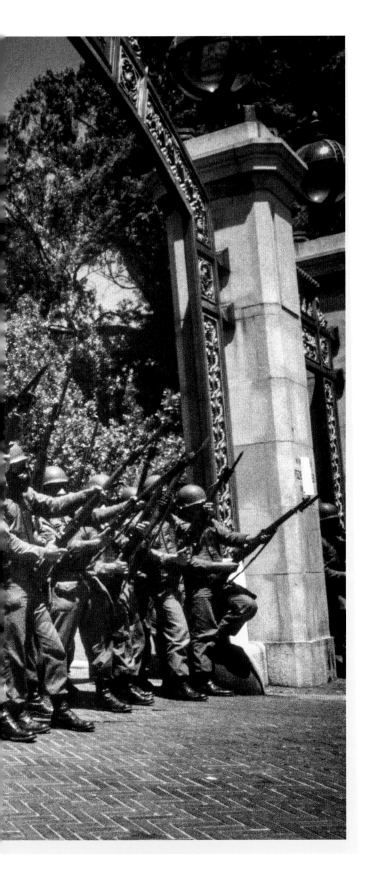

San Francisco Chronicle

Downtown Berkeley is now a proven battleground on which volleys of gunfire have been numerous and occasionally deadly, and the city has experienced a kind of total war in which an aerial gas attack overspread the target area to invade classrooms, private homes, and a hospital....

The citizens have been sickened by displays of force far in excess of provocation, necessity, or justification. The peace-keeping agencies, it appears, grossly over-reacted to a situation that was undoubtedly troublesome but—up to the time of those displays at least—not one requiring fusillades of bullets and a rain of gas from the skies....

Sheriff Madigan's implications that his deputies were using nothing more dangerous than birdshot was gruesomely refuted by the post-mortem discovery of buckshot pellets in the heart of young James Rector. So was the repeated assertion of police that the fatal wounds were incurred in a fall from a rooftop.

Again, the assurance that armed peace offers were opening fire only when in danger of life or injury was completely discredited by the published photograph of a deputy sheriff carefully drawing a bead on the back of a fleeing and unarmed man.

No wonder, then, that the use of a helicopter to drop gas on an assembly of students—a piece of arrant recklessness at that time and place—should have generated widely credited reports that something far more deadly than tear gas had been brought into play.

The responsible authorities, civil and military, from Sheriff Madigan to the governor's office and back again, have introduced a kind of storm-trooper philosophy into the Berkeley confrontation. Let them de-escalate their zapping tactics promptly. At best, they have been guilty of incredibly bad judgment. (May 22, 1969)

ALAN CRANSTON

United States senator from California

The duty of law enforcement officials dealing with campus disorders and student unrest is to arrest demonstrators, not to maim and kill them with shotguns. [Spraying tear gas from a helicopter was] an unconscionable tactic. It is not plain to all who is making decisions about gas-spraying helicopters, about weapons like shotguns, about ammunition like buckshot. (*Sacramento Bee*, May 24, 1969)

WALLACE JOHNSON
mayor of Berkeley
An extremely unfortunate thing and it will not be repeated. (*San Francisco Chronicle*, May 22, 1969)

It was a mistake to use a helicopter to spray gas on the campus like a crop-dusting operation. A friend had his wife and infant daughter at a swimming pool in Strawberry Canyon and that stuff drifted up there and nearly caused a panic. (*Los Angeles Times,* May 30, 1969)

THOMAS HOUCHINS
field commander for the Alameda County Sheriff's Department
The gas was not dispersed in the manner in which they said they would. We were told the gas could be dropped immediately over the target area. I assumed this was how it would be done. I don't know who is to blame—someone must know. But it wasn't dropped in the manner it was intended.

GLENN AMES
commanding general of the California National Guard
Delivery of chemical agents from a helicopter is not a very precise form of delivery, but is intended to cover a large area with a large volume of gas on a quick basis.

RONALD REAGAN
governor of California
All warnings failed. There was every indication that an imminent assault was at hand. The field commander made a battlefield decision and called for a helicopter to make a tear gas drop. The mob was told this had been done. Some left, but most remained.

There's no question but that innocent people suffered the distress that goes with tear gas. But there is no question, also, that tales exaggerated this episode beyond any resemblance to the facts.

There can be no question that the alternative to the tear gas was hand-to-hand combat between the mob and the Guardsmen, and this could have provided real tragedy. (Address to the Commonwealth Club, San Francisco, June 13, 1969)

"Delivery of chemical agents from a helicopter is not a very precise form of delivery, but is intended to cover a large area with a large volume of gas on a quick basis."

I can look at the tactical decision that was made and wonder about it, wonder what concern prompted the spraying. Whether that was a tactical mistake or not, once the dogs of war are unleashed, you must expect that things will happen and people, being human, will make mistakes on both sides. (*Oakland Tribune*, May 22, 1969)

BRUCE R. BAKER
chief of the Berkeley Police Department
I am sincerely sorry if you were made uncomfortable or were inconvenienced by the use of a chemical agent. However, experience has shown that this is the most humane way to control crowds of rioting persons. (Letter to concerned citizen Charles Wells, Marin Avenue, Berkeley, June 6, 1969)

BERNICE DECKER
representative from the Berkeley Planning Department
What's going to happen to us? How can you govern a city when this kind of thing goes on? (*Los Angeles Times,* May 30, 1969)

Right: People rubbing their eyes after being exposed to CS tear gas.

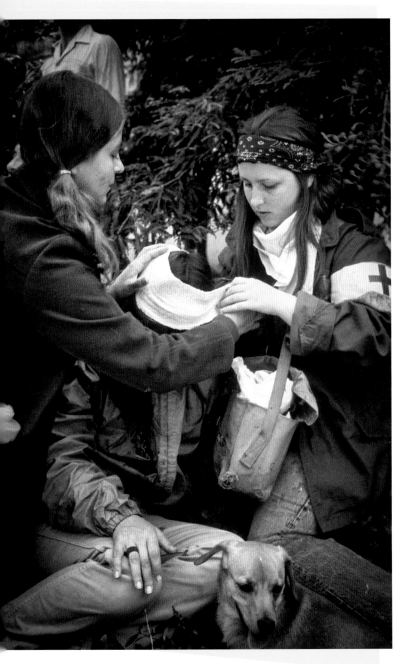

Volunteer medics treating an injured person.

DAILY CALIFORNIAN

The helicopter that sprayed CS tear gas over the Berkeley campus was using techniques developed by the Stanford Research Institute (SRI), according to an investigation by the *Stanford Daily.* One of the ongoing SRI contracts involves a study of "explosive dissemination" of hydrophobic CS powder. According to an SRI researcher who did not wish to be named, this contract is designed to develop techniques for spreading CS tear gas on swamps and brush-land in Vietnam. (May 23, 1969)

RUTH ROSEN
UC Berkeley graduate student in history

I was riding my bike when I heard the helicopter, flying over Cowell Hospital. The gas was pouring down on everything below. A friend, a big guy, picked me up off my bike and threw me into a bush to escape the gas. It was traumatic. To this day I think I have PTSD, triggered by hearing a helicopter.

JANET GRODIN
Berkeley resident and wife of attorney Joe Grodin

Our youngest daughter, Lisa, came running into the house from school. "Mommy, Mommy, we've been gassed." The school had released the children and sent them running home. We live very near the Claremont Hotel, which shows how far the gas carried. I was working downstairs and felt my throat constrict. I thought that I was getting sick.

ANITA MEDAL
UC Berkeley graduate student

I was furious after the gassing. I led a mothers', parents', and concerned citizens' march down Shattuck Avenue protesting the gassing. There might have been a thousand of us.

JONDAVID BACHRACH
UC Berkeley undergraduate student and ASUC senator

I thought that the May 20 helicopter gassing was outrageous and inhumane. At the same time, I think that being gassed became a badge of honor, and there may have been some exaggeration in the reports of how far the gas drifted.

STEPHEN SHAMES
UC Berkeley undergraduate student and photographer

I carried a gas mask with me most days, and did on May 20, when the National Guard helicopter gassed Berkeley. It was horrible, a scene out of a war zone.

JENTRI ANDERS
UC Berkeley graduate student in anthropology

A friend said, "Check it out. The cops are letting people in but they aren't letting people out." I saw that this was true. There were people on the plaza trying to come toward us through the line and being stopped, but everyone heading toward the plaza was being let through. As we remained in our spot and watched, it became clear to us that this was some kind of plan. They were making the crowd bigger than it would have been by blocking all escape routes from the plaza. I saw the spray starting to come out. I screamed, "Look out! Gas!" [My friend] John grabbed me and led me into the building behind Sproul Hall, the business building. I had time to look back and see cops beating people as they tried to break through the line. (From *Berkeley Backlog*)

SETH ROSENFELD
journalist

For more than half an hour, the soldiers let people enter but not leave the plaza, capturing hundreds of people who milled about in passive confusion. (From *Subversives*)

"A REPORT ON THE 'PEOPLE'S PARK' INCIDENT"

According to the reports of all actual witnesses, no demonstration or threats were actually occurring in the plaza at the time....They found to their great dismay that Alameda [County] sheriff's deputies had just discharged two or more canisters of tear gas in the shower room. (Report prepared for the UC Academic Senate, May 26, 1969, by Frederick Berry, UC Berkeley associate professor of geology; Thomas Brooks, UC Berkeley assistant professor of English; and Eugene Commins, UC Berkeley associate professor of physics)

CRAIG PYES
UC Berkeley undergraduate student

When I saw the helicopter coming, I could only think, "Oh my God—look at this!" My main reaction was to the technology; the police had escalated in their use of tear gas from grenades to the pepper-foggers, and now had gone to a helicopter. I and others had gotten almost immune to the tear gas. You washed it off and went on with your day.

WILLIAM COLEMAN
UC Berkeley graduate student in criminology

The Guards blocked the gate; then cops blocked from Sproul Hall to the gate, and they were blocking the Bancroft exit. There was an announcement from the Student Union balcony to disperse in five minutes because chemical agents would be dropped. I went into the lower plaza and tried to exit by the north end

"I carried a gas mask with me most days, and did on May 20, when the National Guard helicopter gassed Berkeley. It was horrible, a scene out of a war zone."

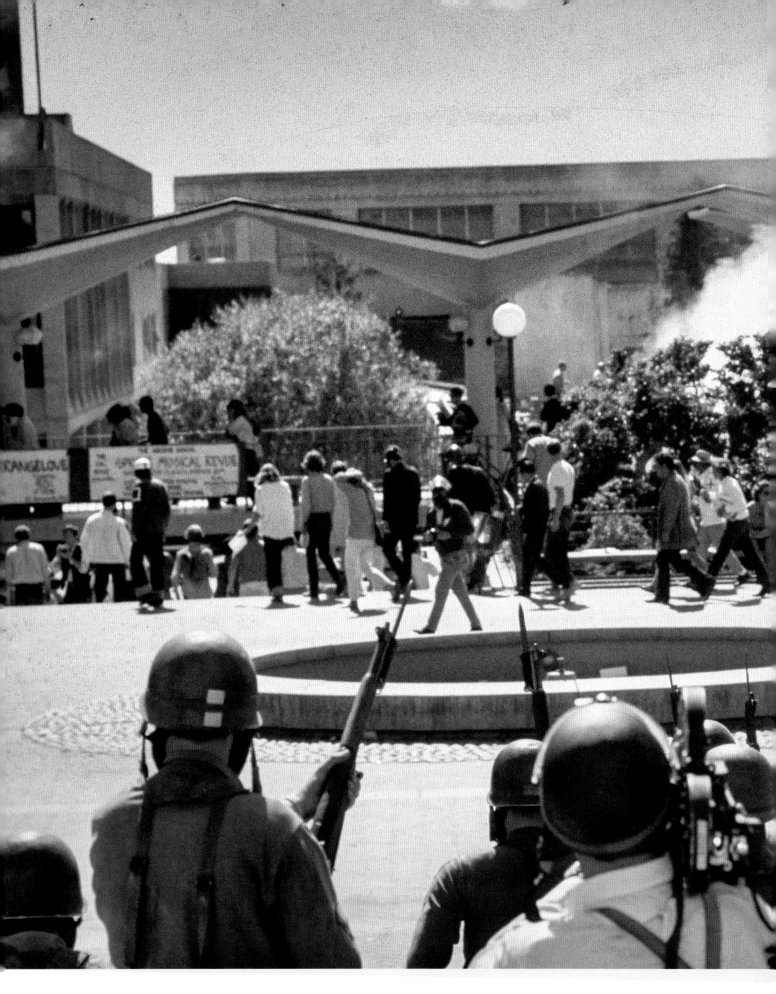

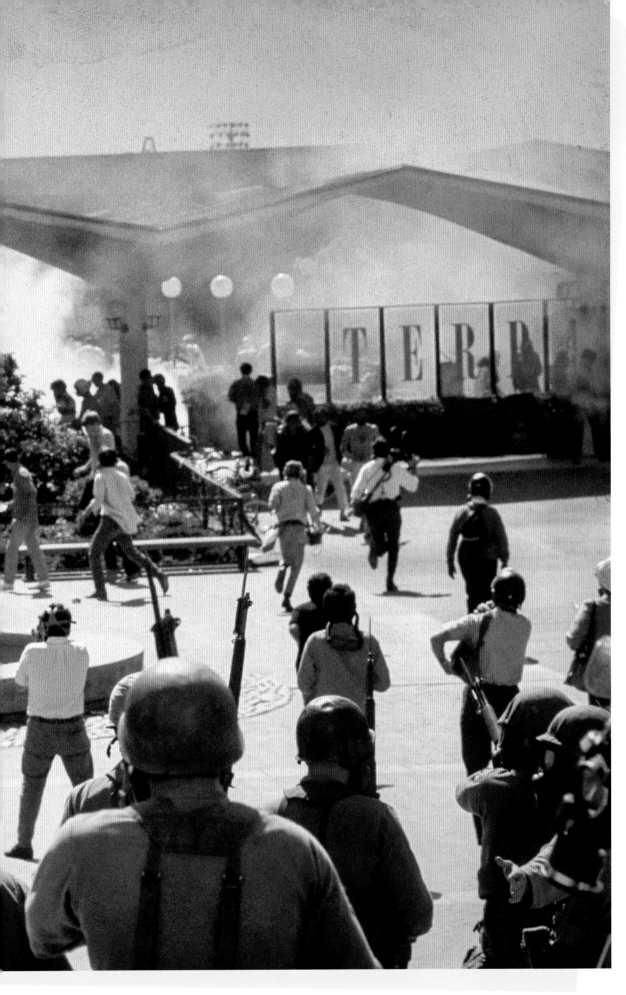

Tear gas lingers over Sproul Plaza as National Guardsmen, in the foreground of the photograph, are stationed to keep people from leaving the plaza.

of Zellerbach. Troops moved in and blocked the exit. Many people had been able to leave before troops blocked exits. I asked the troops to let me through and they refused. Within three minutes of the warning the helicopter came and dropped the gas. When the gas came there was a panic, screaming, choking. I was in the middle of this, blinded for at least five minutes, choking, coughing, and mouth, nose, and skin burning. Prior to the gassing there were absolutely no threats to the troops. People were asking to be able to leave the plaza. Even during the gassing people were not allowed to leave the area.

W. R. JOHNSON
UC Berkeley professor of classics
Governor Reagan explained to the public at large that this action was necessary because the students refused to disperse when ordered to do so. The fact is that the students and other members of the university community were encircled by members of the law enforcement agencies and prevented from dispersing. If you were not gassed yourself, remember that many others were, including the sick at Cowell Hospital and the many children who were playing at Strawberry Canyon.

CHARLIE PALMER
UC Berkeley undergraduate student and president of ASUC
I had gotten a phone call from Jesse Unruh, speaker of the California Assembly. He wanted to tour Berkeley and so I led him on a tour that took us to Sproul Plaza as the tear-gas-dispersing helicopter flew over. I vividly remember Speaker Unruh in his neon blue suit getting a taste of the state reaction to protest in Berkeley. The gassing was odd because nothing was happening on Sproul Plaza before the helicopter gassing, and it certainly was not a pitched battle.

DHYANI (JENNIFER) BERGER
UC Berkeley graduate student in biology
I remember tear gas coming into the laboratory via the air conditioning system.

EDITORIAL
Daily Californian
Heyns had a full hour last night on KQED [television] to speak out, and he refrained from even modest criticism....Reagan, Madigan, Johnson, Hanley—this despicable crew, the scum of public life, must be removed. Roger Heyns must also be removed. The bloody lot of them must go. The police must go. (May 23, 1969)

JOHN SEABURY
ninth-grader at Berkeley High School, West Campus
I do remember the day of the infamous helicopter flyover at Sproul Plaza, when they dumped CS gas on the crowd. My brother Dave was in the middle of it, and my dad [UC Berkeley political science professor Paul Seabury] got gassed because his office window was open. But I was home with a cold that day. We lived at least three

❝As the tear gas drifted in through an open window, he closed the window and said to the class, 'What's going on outside is ephemeral. What we are doing here is eternal.'❞

miles from campus, but I got teared up and so did my cat. The next day at school, I and a few friends got called to the principal's office. There was a Berkeley cop there who showed us surveillance photos from Sproul the day before. He wanted us to identify any West Campus students in the photos. We pretended that we didn't recognize anyone. The principal knew better but kept it to himself. I guess he didn't like the cops hassling his boys.

ART ECKSTEIN
UC Berkeley graduate student in history
When the helicopter dispersed the gas on Sproul Plaza, I was in class in Dwinelle Hall with Paul Alexander, a Jewish refugee from Nazi Germany, who was one of the world's leading Byzantinists.

He was against the war and would picket in Marin County wearing a three-piece suit. As the tear gas drifted in through an open window, he closed the window and said to the class, "What's going on outside is ephemeral. What we are doing here is eternal."

ROBERT TRACY
UC Berkeley professor of English
I don't remember being affected by the tear gas on May 20, but my daughter was at Le Conte School. My wife Rebecca joined a group of Berkeley mothers who went to Sacramento to protest the indiscriminate use of gas in a way that affected school children. The reaction in Sacramento ranged from indifferent to hostile. Many said that they didn't believe the mothers, that only rebellious students had been gassed.

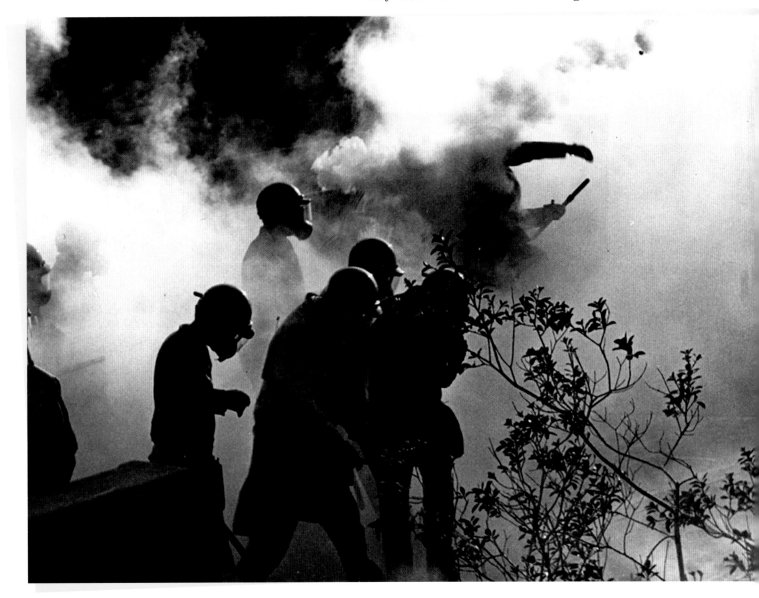

HENRY WEINSTEIN
UC Berkeley law student and a reporter for the Daily Californian

On May 20 I was inside when the helicopter dispersing gas passed over the campus. When reporting for the *Daily Cal* I had been carrying a gas mask for a while. I put it on and went out to see what was going on. The whole week was chaos. One day that week I was walking down Telegraph with Gerry Lubenow, then the San Francisco bureau chief for *Newsweek*. We saw a Tactical Squad officer stop a young teenage boy. He pointed to a tear gas canister lying on the ground and he asked the boy to please bring it over to him. The boy did so, and the cop promptly arrested him for possessing an explosive device. I was in court during People's Park and saw a young teenage boy in court who had been arrested for running a red light on his bike as he tried to escape tear gas. Such was the state of justice in Berkeley in 1969.

DURWARD SKILES
UC Berkeley graduate student in physics

I only remember a slight exposure to gas on May 20, but my wife was working in the electrical engineering and computer science department in Cory Hall on the northeast corner of campus. She and colleagues were on the roof watching what was going on below on campus when the helicopter made its approach on the campus from the northeast. She and her colleagues got significant doses of the gas.

TRUDY O'BRIEN
UC Berkeley undergraduate student

We were on campus when the helicopter came. It was amazing to see the helicopter, but where we were didn't really get hit hard. It didn't seem that the dispersal by the helicopter was very effective; it dissipated. What was really exciting was how photographs of the helicopter gassing Berkeley made it to newspapers all over the world, including the Eastern Bloc countries.

CHUCK MCALLISTER
Medical Committee for Human Rights

I've seen young people hit with canisters of gas, their heads split open. We'd patch them up, being gassed at the same time. Private ambulances,

regular city-run ambulances, were being gassed so badly that the men finally had to put on their own respirators. (Press conference broadcast on KPFA radio, May 21, 1969)

WILMONT SWEENEY
vice mayor of Berkeley

I have often seen the use of tear gas without any prior warning in the area. I think we know that this has occurred. At Sproul Plaza, people were actually blocked in and then gassed. This must not go. This isn't supposed to apply here. The same thing goes for indiscriminate beatings. You're only supposed to use enough force that is reasonably necessary. You don't beat people for punishment. (Press conference broadcast on KPFA radio, May 21, 1969)

THOMAS BODENHEIMER
Medical Committee for Human Rights

Law enforcement here is using chemical warfare to control the situation. There is no clear-cut distinction between lethal and nonlethal weapons. Riot-control chemicals can and have killed people. They were using CS gas driving down Bancroft before this took place. (Press conference broadcast on KPFA radio, May 21, 1969)

THOMAS PARKINSON
UC Berkeley professor of English

On Tuesday, May 20, 1969, Berkeley, a city in the United States, a university town with many suburban dwellers as well as the faculty, staff, and students of the university, was attacked from the air by toxic gas from a helicopter. It was the first city within the continental United States to be assaulted by a helicopter flown by a member of the National Guard and under the orders of an elected official, the sheriff of the county. The gas was sprayed into an area where seven hundred people were confined by the National Guard in close formation....The gas spread through the campus and into the university hospital, forcing the physicians to order the evacuation of some bed patients and to place one man in an iron lung in order to save his life. It spread to a school yard where a group of eight-year-old children were playing at their recess, and several of those children were burned by it. (From *Protect the Earth*)

"My kids ran home from school, vomiting and teary-eyed from the poison gas that had wafted into their school."

STEW ALBERT

Yippie and People's Park cofounder

The people were ordered to leave the Plaza and then blocked by bayonets and mercilessly gassed. The hangmens [*sic*] claustrophobia of ghetto death gripped at our consciousness. The pigs could have methodically killed us. I had the feeling that we were actors in a dress rehearsal for genocide. (*Berkeley Barb*, May 25–31, 1969)

HENRY BRUYN

director of Student Health Services at Cowell Hospital

Gas flew into the hospital causing irritation to staff and patients. One student had to be put into a respirator to ease breathing. (*Daily Californian*, May 21, 1969)

STEVE LADD

UC Berkeley undergraduate student

It was insane. Spraying gas all over Berkeley from a helicopter—are you kidding me? The gas was blowing east up the hill to Cowell Hospital. I was astonished that they would do that.

MIRIAM KASIN

eyewitness

The mucous membranes inside my nose and mouth were so inflamed that I could not eat. My mother took me to an emergency room, which was packed with people injured by the CS gas. Every chair was taken, and people huddled against the walls. The doctor who saw me was furious that the government would do this to its own peacefully protesting citizens. He could not do anything to treat my symptoms, so I was unable to ingest anything except to drink clear soup for a week.

SIM VAN DER RYN

UC Berkeley professor of architecture

My kids ran home from school, vomiting and teary-eyed from the poison gas that had wafted into their school. (From "People's Park: An Experiment in Collaborative Design," in *Design for Life*)

THOMAS BODENHEIMER

Medical Committee for Human Rights

A green canister labeled U.S. No. 6 Blister Gas was found on May 20. We shudder to think of what methods of counterinsurgency may be used next. (From *A People's Park Chronology*, by Gar Smith)

GLENN AMES

commanding general of the California National Guard

An inescapable by-product of combating terrorists, anarchists, and hardcore militants on the streets and on the campus. (*San Francisco Chronicle*, May 22, 1969)

DAVE SEABURY

eleventh-grader at Berkeley High School

My friends and I were at Lower Sproul Plaza. We saw the helicopter coming over Barrows Hall spewing gas. We started to run as fast as we could out of the north corner of Lower Sproul to the Life Sciences Building. My eyes were burning, so I washed them with water from a sprinkler. The problem is that with CS gas, water doubles or triples the intensity of the gas. I was totally fucked up, writhing on the ground,

The Daily Californian

Vol. 202, No. 37 Wednesday, May 21, 1969

The University of California, Berkeley, California

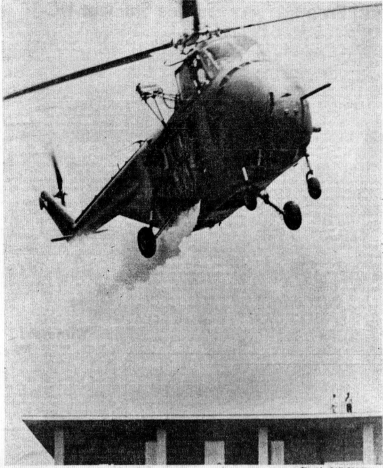

AN ARMY HELICOPTER . . . swooped down through Lower Sproul Plaza emitting tear gas along the way. Dr. Henry Bruyn, director of student health services said gas which floated east from the Plaza caused "great discomfort" to some patients at Cowell and one patient was put in a tank-type respirator for a time.

—Photo by PAT CROWLEY

South Campus Area Cleared by Police as Memorial March Halted

By JERRY POPKIN

Police and National Guardsmen, aided by a gas-spewing helicopter, cleared the south campus area of people during a two-hour tear-gas attack after over 3000 students, faculty and University employees staged a march in honor of James Rector, who died Monday of gunshot wounds suffered in last Thursday's riot.

Demonstration organizers announced they would not try to march from the campus to Berkeley today. Instead, they urged supporters to gather along Shattuck Avenue to contact people in the community.

The olive-drab helicopter, used here for the first time yesterday, circled the Sproul Plaza area just after 2 p.m. yesterday warning students below that gas would be dropped. Three minutes later, the copter began spraying pepper gas.

Demonstrators Vow to Return Despite 85 Arrests

The aerial attack was supplemented by police and guardsmen on the ground, who fired gas canisters and grenades at students retreating from the campus. The parking lot at the corner of Bancroft and Dana was particularly heavily gassed.

Police continued to use gas near the campus for an hour and a half. Dr. Henry Bruyn, director of Cowell Health Services, reported that gas flew into the hospital causing "irritation to staff and patients." One student had to be put into a respirator to ease breathing, but Bruyn said he "wouldn't consider the incident serious."

The tear-gas attack followed a march around the campus by more than 3000 people in honor of James Rector. The marchers, many wearing black armbands as a sign of mourning, gathered in the Sproul Plaza area between 11 a.m. and noon, where faculty and University

(Continued on Page 17)

Many Groups Protest; Heyns Resignation Urged

By CLAUDIA COHRT

Waves of community and campus-wide protest, emanating from the use of armed forces and the resulting death of James Rector, culminated yesterday in a resolution passed by a group of faculty members urging the resignation of Chancellor Roger Heyns.

In addition the faculty members voted to form a committee to investigate the use of armed weapons and unnecessary force, and to further declare that until the State of Emergency is ended "we are unable to perform our educational duties and encourage

fellow faculty members, students and other members of the community not to participate in University activities while their personal safety is threatened."

Another resolution passed by the faculty members called for "immediate negotiations between the People's Park Negotiating Committee and the University Administration to find a reasonable solution, such as that proposed by the College of Environmental Design; and that during these negotiations the Park be open for public use."

The resolution asking for

Heyns' resignation was passed with a vote of 131 to 26 with 16 abstentions in the emergency meeting of 230 faculty members. The meeting was called by the Berkeley Faculty Union (AFT 1474) when the chairman of the Academic Senate allegedly refused to call an emergency meeting of the Senate yesterday.

The Heyns resolution, which was drawn up by Herbert Phillips, professor of anthropology,

and Jack Potter, associate professor of anthropology, reads: "Our censure of Chancellor Heyns, the Board of Regents, Governor Reagan, Mayor Wallace Johnson, and City Manager William Hanley for their use of improper and unjustified armed force against the University community and the citizens of Berkeley. The responsibility for the use of dangerous gas, the shooting of students and citizens, and the chain of events

which resulted in the death of James Rector, rest with them. We further declare that we no longer have confidence in Chancellor Heyns and demand his resignation."

It was clarified by a member of the College of Environmental Design that their plan does not propose that the College maintain control over the paark; rather, the plan advocates the forma-

(Continued on page 5)

Faculty Members Won't Teach

The undersigned faculty members, including Nobel prize winners, have signed the following statement indicating their unwillingness to work as long as Berkeley is occupied by police and armed forces. They have urged other faculty members to join them at 9 a.m. today in the Senate Chambers to sign the statement.

Because of the occupation of Berkeley by police and armed forces, because of the loss of life and the threat of further deaths, because we and our students are being gassed; we professors at Berkeley, declare our unwillingness to teach on this campus until peace has been achieved by the removal of police and troops. Signed by Roger Y. Stanyer, bacteriology; Thomas Parkinson, English; Frank Pitelka, chairman, zoology; Owen Chamberlain, physics; Elizabeth L. Scott, statistics.

A faculty vigil will be held at 11 a.m. while students will meet at noon for a rally on Sproul

steps, move to the Campanile and then break into 10 to 15 groups to march through various buildings. The plan is not to disrupt but "to educate those few who are still doing 'business as usual'." Plans include "Creativity" for demonstrations at Sproul, Moses and King Halls and the Chancellor's house at 3 p.m.

At the UC San Diego, 800 students voted to strike until National Guardsmen are withdrawn from Berkeley. Picket lines went up this morning and an official school wide convocation is held at noon today.

At the Santa Cruz campus, 600-700 students voted to try to organize a University wide demonstration against the state of affairs here. On Monday, students at Santa Cruz barricaded the administration building in protest.

At the University of Wisconsin in Madison, the Committee Against Legal Repression has called for a demonstration today in support of the students here.

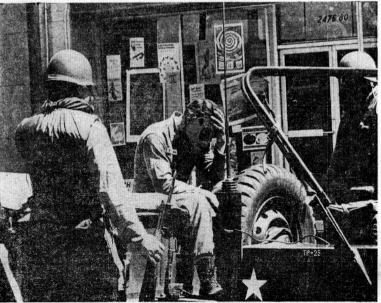

CORPORAL FELICIANO . . . the first Guardsman to lay down his helmet and arms, waits to be taken away after being "apprehended" by fellow National Guardsmen.

—Photo by JOHANNES BESSERAT

vomiting. Somebody pulled me into the building, where I calmed down. I didn't talk about this with my parents because I was afraid that I'd get in trouble. My father was Paul Seabury, a very conservative professor of political science. His office was on the upper floors of Barrows Hall, and gas came through his open windows.

GLEN ANGELL
recent UC Berkeley graduate student
I came to Berkeley in 1965 to attend law school. I hated it and dropped out after two months. I switched my major to art history and got my master's degree in 1968. For my first few years in Berkeley, I was studious and didn't get involved in politics. Then I met Liane Chu, and she and her friends at the Med slowly radicalized me. In 1969 I was working as a carpenter on the boat of an economics professor down at the [Berkeley] Marina. The National Guard was bivouacked at the Marina, and on May 20 I saw Guardsmen in silver Tyvek jumpsuits getting a helicopter ready for takeoff. I called KQED and told them that we were about to come under attack.

CAROLYN DEWALD
UC Berkeley graduate student in classics
I was taking a final exam in Dwinelle Hall when the helicopter flew over. Tear gas filtered into the classroom and filled the room. The professor released us from the exam. My eyes were compromised by the gas for a while.

GEORGE CSICSERY
UC Berkeley undergraduate student
I had a job in the French department and was in Dwinelle Hall when the helicopter gassed the crowd. I saw people running in all directions.

PETER HABERFELD
attorney with the National Lawyers Guild
I was representing a protestor at an arraignment in municipal court on May 20. Looking out the window, we saw the helicopter that had dispersed the tear gas at Sproul Hall. I immediately made a motion to dismiss the charges on the grounds that we were now living under martial law and the civilian court had no jurisdiction. The motion was denied.

PAUL VON BLUM
attorney and a UC Berkeley lecturer in rhetoric
I was in Sproul Plaza when the helicopter gassed us. I was a direct victim of the gas. I felt nauseous for a couple of days after.

HOWARD DRATCH
UC Berkeley graduate student in political theory
When I got out of my exam on May 20, I went outside and saw the gassing. When the helicopter dropped gas, I saw it as militaristic overkill. I was amazed at the escalation by the National Guard. We said to ourselves, "Is that all they have? Just this one more thing?"

CHARLES WOLLENBERG
professor at Laney College and a UC Berkeley graduate student in history
I was at work at Laney on May 20, but my nephew was in the first or second grade at Oxford School, which is one mile north of the north end of campus. He and his class all suffered in their classroom at Oxford from the tear gas sprayed at Sproul.

THE "PEOPLE'S PARK": A REPORT ON A CONFRONTATION AT BERKELEY, CALIFORNIA
Police reported that the balcony of the Associated Students building was loaded with rocks and chunks of cement. As the Guardsmen were moving in, another barrage of rock throwing took place in Sproul Plaza. The crowd was left an access to retreat out of the northeast corner of the Plaza and the west side of the Plaza. A group of 600–700 dissidents were closing on the troops and three chairs were thrown from an upper story into the troop formation. (California Governor's Office, July 1, 1969)

LOS ANGELES TIMES
The helicopter gassing was ordered by Brig. Gen. Bernard Nurre, 55, commanding general of the National Guard's 49th Brigade, because, he said, guardsmen were being threatened by furniture thrown from windows of campus buildings. "This was a decision he [the general] felt was necessary

Left: Front page of the *Daily Californian*, May 21, 1969.

because his troops were being hurt and were in danger of being more seriously hurt," said a National Guard spokesman. "This way people got their eyes burned a little, but no one got seriously injured." (May 30, 1969)

ELIZABETH WHITAKER
substitute teacher
Third-graders were wondering when the gas was going to come down on them or if they were going to be shot. (*Los Angeles Times,* May 30, 1969)

REESE ERLICH
suspended UC Berkeley undergraduate student and a reporter for **Ramparts** *magazine*
I was in Sproul Plaza when the helicopter dispersed gas, but I had the gas mask that I had bought at an army surplus store and carried with me. I put it on and the gas didn't bother me. I kept the gas mask for years, and eventually gave it to a South Korean student in the 1990s so he could use it during antigovernment demonstrations in Seoul. The helicopter spraying gas drove people out of Sproul Plaza and had been a military victory, but it was a political disaster for the Guard.

LEE FREMSTAD
staff writer for McClatchy newspapers
At 1:35 a guard force of at least 200 men blocked passage through Sather Gate. A similar force blocked the southern exit from the plaza on Bancroft Way. By 1:45 both the upper and lower plaza were quiet. This reporter sat at a lower plaza picnic table eating lunch. There were perhaps 700 to 1,000. As Gen. Nurre put it, the strategy was "to seal off the campus so they couldn't get out." It worked well. (*Sacramento Bee,* June 8, 1969)

SAN FRANCISCO CHRONICLE
Wind picked up the stinging, powdery vapor and carried it hundreds of yards away. It blanketed residential homes, entered university classrooms and offices, and caused a minor crisis when it seeped into the rooms of the university hospital.

The gas attack—which came with little warning—caught many unaware. Students who had not heard the order to leave the plaza—or who had not been able to find an exit in the tight perimeter of Guardsmen—reeled panic-stricken and vomiting through the fog.

Unaware of the impending attack, students munched sandwiches outside the Terrace restaurant and watched the movements. Other students filed in and out of the Student Union building. Some who were carrying books crossed the plaza on their way to class. It was impossible to determine who had participated in the earlier demonstration and who had not.

The Guardsmen tightened the perimeter, leaving one breach in the line at the southwest corner near Eshleman Hall.

Doctors who witnessed its effects said yesterday that CS is a dangerous chemical agent that can prove harmful—and sometimes even fatal—to persons with serious respiratory conditions. (May 22, 1969)

CAROL GORDON
UC Berkeley undergraduate student
After the "fall" of the park, everything unfolded very quickly. It was a very frightening and confusing time. As I look back at it now, I only have snapshots in my mind of that whole experience. I was shocked that the university would allow students to be tear-gassed. The "People's Park" was such a harmless and innocent thing. Why were they getting so angry? I didn't understand the hatred that the administration and politicians had for students. It was very confusing. It made me very sad, and I was disappointed in a university that I loved so much and from which I was about to graduate.

Operation Snatch

In addition to the helicopter assault, May 20 saw ninety-one arrests and numerous beatings by police.

DIANE SUE THOMPSON
secondary-school teacher

On Tuesday, May 20, I was walking up Durant Avenue. On the north side of the street on my way home from school, a young man ran around from the northeast corner of Telegraph Avenue and Durant—east on the north side of Durant—and then swerved to the south side of the street. The car followed him across the street, and a policeman jumped out of the car, chased the boy a few steps, caught him, and started hitting him in the lower back area with a club. The two other officers riding in this car jumped out and beat this boy. About twelve other officers joined these officers. They all beat this boy, even after he was down on the ground writhing and screaming as I left.

MICHAEL BORTIN
UC Berkeley undergraduate student

I was throwing a frisbee with several friends in front of my house on Fulton Street. At one point, the frisbee unintentionally went into a [random] car window. I requested that the frisbee be returned. Ray Komer tapped once on the rear door of the car with his walking stick while demanding the frisbee's return. I saw four Berkeley policemen run toward Ray. He turned with the walking stick held in both hands to shield his head from one of the policeman's swinging billy clubs. The billy club hit the stick, and then Ray was struck with the club several times. One cop grabbed his hair, another held a club across his neck, and another bent his fingers and arms back. A fourth officer struck a bystander who was attempting to take pictures of the incident.

JAMES DARCEY
UC Berkeley undergraduate student

In attempting to hit Ray [Komer] with his billy club, the officer's club struck the stick. Immediately, at least two other policemen were upon him. He was completely defenseless. They dragged him from the street and pushed him up against a car parked in a driveway. For about a minute the three policemen roughed him up. One held his hair from the back while another had a billy club against his throat. The third one was roughing him up. They dragged him down Channing Street.

JON ANDREWS
tax consultant

I witnessed one arrest in particular. About five feet from the corner [a young woman] turned and threw a paper sack. From the way that it sailed, I know that there was nothing heavy in it, but she was in a highly emotional state. Two policemen took hold of her by each arm and proceeded to walk her back toward Hink's Department Store. Two more police came from the north corner, and the four police escorted her back to the corner.

NANCY BLUM
teacher and tutor

Steven Wilmoth, an associate professor of sculpture, was walking ahead of us on the other side of the street. He reached the police line just as it formed. He came to about four feet from the last point on the line. Steve has long hair and was wearing a purple shirt. After he had walked several steps, a policeman, badge number 75, left the line and ran behind it to grab him and force him up against a wall and leaned in his face and talked very close to him.

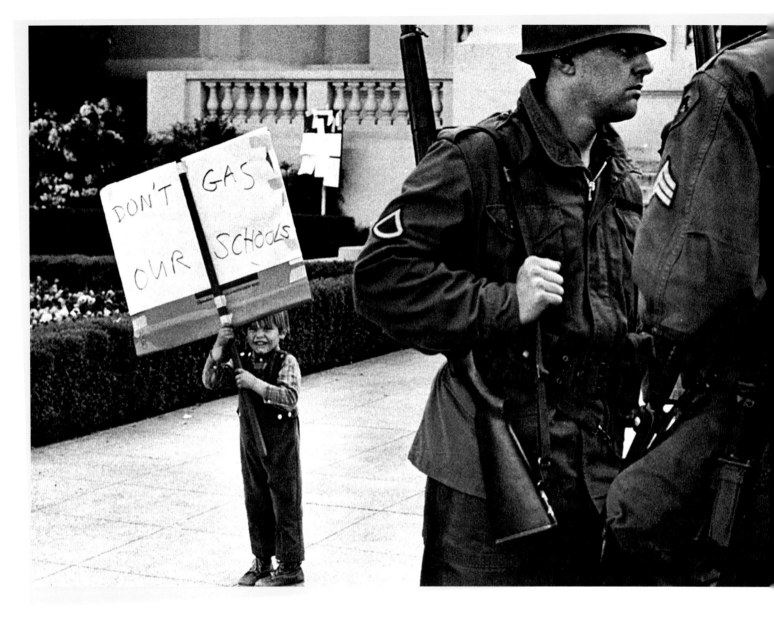

ROBERTO BEREYDIVEN
UC Berkeley teaching assistant
One of the policemen caught one of our group from behind in a chokehold. The policeman roughly dragged the young man into one of the store doorways. Because it seemed clear that the police were now arresting people at random, I hurried to remain out of their range.

ROZ LEISER
UC Berkeley undergraduate student
I was sitting on my front lawn at 2421 Durant. A boy was walking west on Durant. He had reached the area in front of the bookstore. Two Alameda County sheriffs, dressed in blue uniforms and blue helmets, were walking west from the Telegraph and Durant intersection. When they got behind the boy they either nudged or looked at each other and each grabbed one of his arms. The sheriff closest to me stuck his club into the boy's stomach. He looked terribly surprised. They took him back to the intersection.

ROSALYN ROLON
UC Berkeley undergraduate student

There were about five hippie-type boys of about college age walking west on the south side of Durant. Four Berkeley police jumped out of the car and grabbed the boy who was the nearest. They started clubbing him around the shoulders. I ran out and was yelling "stop it." His friends were yelling "stop it" also. The police[man] stopped—he was smiling and had his club up, and said, "You kids better run, because if we don't you're going to...," and he pointed in the direction of Dana Street, where there were quite a few Alameda [County] sheriffs in blue uniforms. They put the boy who had been clubbed into the car and drove off.

WILLIAM CHESTER
UC Berkeley undergraduate student

In the afternoon after the aerial gassing, I was standing on the stairs at the southeast corner of the ASUC building on Sproul. A man was talking to the National Guard troops. He was talking quietly. One question I heard him ask gently: "What are you doing here?" He was being very polite with them. The Guard had set up a line, bayonets toward the university, and behind the line on the street were trucks and jeeps. Through this line came two CHP [California Highway Patrol officers], who walked toward the center of Sproul Plaza. They turned back and went toward this man. One of the CHP grabbed the man with his left arm around the man's neck in a headlock. The CHP began punching the man

in his midsection, quite hard. The man made no resistance. The other CHP grabbed the man by his left arm. They led him through the Guard line and slammed him against the truck. I began yelling at the CHP, "You can't do that, pigs!" They threw one of the little spherical gas canisters at me. It exploded at my feet.

WILLIAM EDWARD MACK
UC Berkeley undergraduate student

I was walking on Shattuck toward the university and stopped to observe the long line of National Guard trucks parked on Shattuck. The four police walked up to the group around me and told us to move on, and all of us began to comply at a normal walking pace. One of the policemen grabbed a young man in a bear hug. The other three officers jogged up and assisted in dragging the young man into a doorway of a store. Once in the doorway, an officer pressed his billy club into the Adam's apple of the young man. The young man had appeared not to provoke the officers in any manner; however, his hair was longer than most people in the area and he wore a leather vest which said on the back "Power to the People."

STEVEN WEAVER
UC Berkeley undergraduate student

I was at Swensen's ice cream parlor on the first block of Durant. A young man was walking along. One policeman was chasing him with three policemen behind. Three Highway Patrol

> ❝The young man had appeared not to provoke the officers in any manner; however, his hair was longer than most people in the area and he wore a leather vest which said on the back 'Power to the People.'❞

cars pulled up. A policeman chased him across the street and knocked him down and gave him fierce blows with a two-foot club in the middle of the back and roughed him up considerably. He seemed to be unconscious because his legs hung so limp. They slammed him against a car for four or five minutes. The police closed off traffic and pulled up a paddy wagon. It was quite brutal, and they certainly could have facilitated the arrest with much less brutality.

JAMES DANSE
UC Berkeley undergraduate student
I was in the barbershop on the north side of Durant between Telegraph and Bowditch. Byron Holmes was on the sidewalk and took a picture of an arrest being made. Two Alameda County sheriffs came up and grabbed him under the arms, one on each side. They took him briskly across the street to where their car was parked. They leaned him facedown on the car with his hands behind his back. They kept him in that position for about five minutes. They appeared to be putting handcuffs on him.

LINDA MEESE VAUGHN
UC Berkeley undergraduate student
There was a police car and they had a young man there. I heard another young man say, "You can't do this; I live here." The police then turned and moved toward him and he kept yelling that. They ran him up against a brick building and beat him down with their wooden sticks. It looked like there were so many police because there were all those great big blue bodies and one little brown one collapsing in the center. They had him on the ground. They brought the man toward me and the wagon. As they went by, I said, "Are you all right?" He said, "No!"

KATE MCVAUGH
Danza Squire, Marcus Hesterman, Kathleen Wasser, and Candy Freeland, fifteen- and sixteen-year-olds from Berkeley High School, head up to the chancellor's house to join in a peaceful protest against the occupation of Berkeley and the People's Park situation. They are some of the first to arrive. The National Guard are already staged in front of the chancellor's residence, equipped in full riot gear: bayonets, gas masks, and helmets. There are a lot of them. Soon many more Cal students and others begin to gather on the lawn in front of the house. Many hold signs and chant. As the crowd grows, the four BHS students at the front begin to feel the bumps and jostling, and the tension increases. The National Guardsmen are given orders to form a solid line, don their gas masks, hold their bayonets at the ready.

The Berkeley High kids are well-versed in protests. They have participated in them since seventh grade. They know the risk of being on the front line. There is always someone in the very back who decides to throw a brick, or a bottle or a rock. And then the folks in the front get clobbered, and tear gas is thrown, and mayhem takes over. And there goes the peaceful protest. One of the BHS kids looks around at the growing tension and has an idea. "Let's start singing patriotic songs." The friends agree. The choice for the first is "The Star-Spangled Banner," followed by "My Country 'Tis of Thee," "America the Beautiful," "This Land Is Your Land," and others.

Soon, the entire group of protestors are singing along. The BHS students have another idea: "Let's sit down." And then the whole crowd sits down. The National Guard guys start to relax. First one takes off his gas mask and helmet and backs away. Then another, and another. Their

"It looked like there were so many police because there were all those great big blue bodies and one little brown one collapsing in the center."

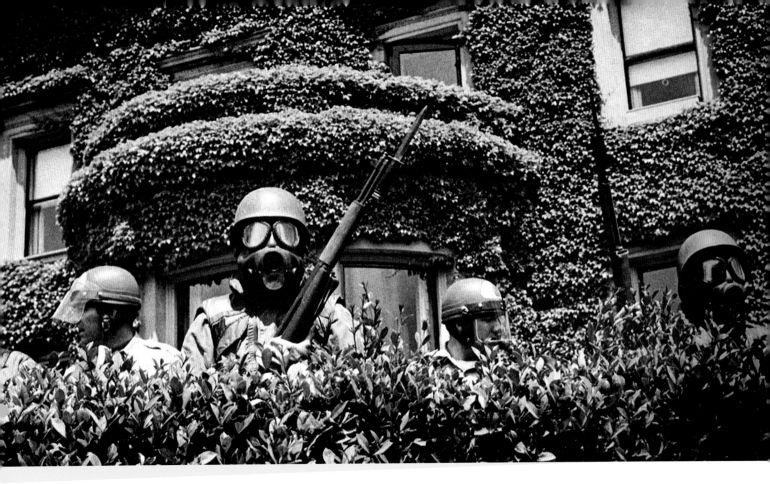

lines loosen up. A mellow mood envelops the crowd. After a few more songs, the protest crowd begins to dissipate; everyone in a good mood.

The BHS students are elated. They actually prevented heads from being cracked, tear gas from being thrown, and arrests from being made. Only those four knew that they were the ones who had done it; and that was enough.

AUGUST MAGGY

reporter for the Berkeley Daily Gazette

Walking south along the west side of Shattuck Avenue near Kittredge Street, at 3 p.m. yesterday, I was halted by a National Guardsman who snatched away my army-type helmet, which was held in my right hand.

He said the helmet looked like army property and took it to a field commander at the scene who agreed with him.

The commander ordered my helmet put in a Guardsman's truck. I purchased the helmet and liner six days ago for three dollars at Globe Sales Company, 1156 East 12th Street, Oakland. The store deals in army surplus material. When I asked for the return of my property and displayed my press pass issued by the City of Berkeley, Guardsmen told me to leave. As they backed me around the corner on Kittredge, two or three Berkeley policemen rushed over and waved billy clubs in my face.

I again stated I would want to know where I may regain my helmet and again showed my press card. I was shoved once and then twice hard in the stomach. As I doubled over, I was clubbed across my right arm and leg and collapsed to the sidewalk. The policemen and Guardsmen left me there.

As I groaned and laid upon the sidewalk, my glasses fifteen feet from me, I heard a passerby remark, "Well, if they would mind their own business, this wouldn't happen."

Two street medics who witnessed the incident comforted me and inspected for signs of broken bones. I entered Herrick Hospital's emergency quarters early last night, and doctors indicated no broken or fractured bones were visible in x-rays.

I now sport, however, a swollen and bruised right arm and small bruises on the right leg and stomach.

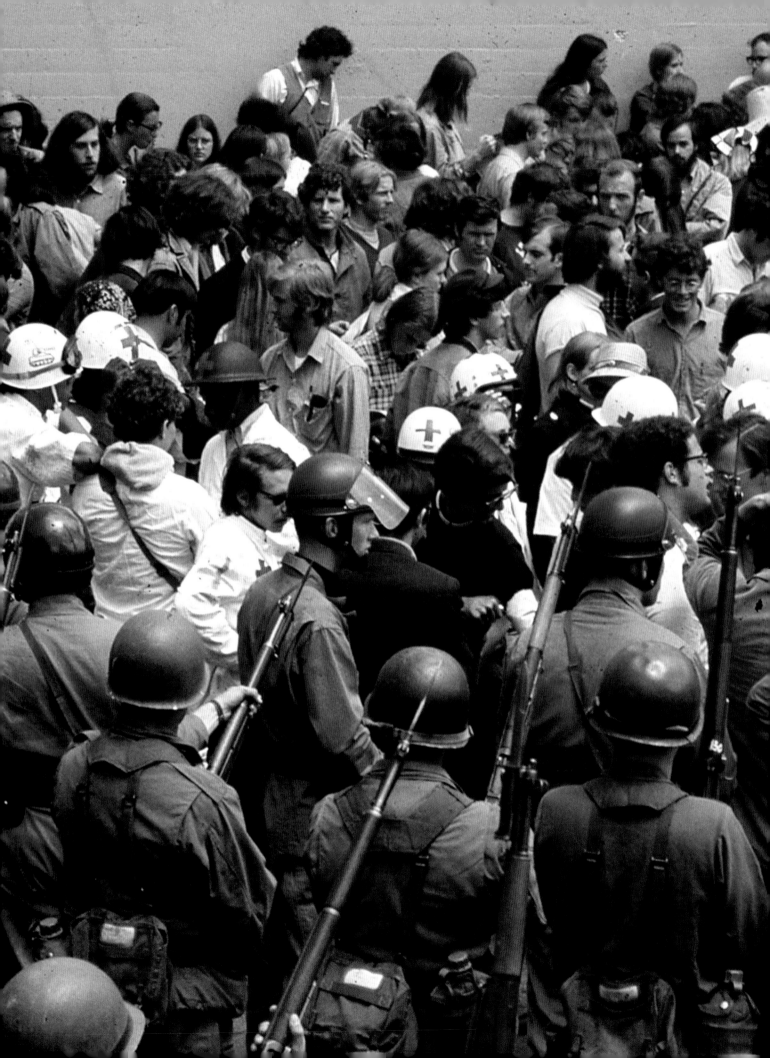

Boxed and Beaten

Operation Box

On Thursday, May 22, a faculty-led march of about one thousand protestors was dispersed on campus. Marchers then turned to the Shattuck Avenue business district, which since May 15 had often been the focus of protests. The choice of Shattuck as *locus bellum* was not unlike a secondary boycott: put pressure on business to put pressure on the City to put pressure on Governor Reagan to withdraw the National Guard.

During the lunch hour, Guardsmen began driving people into the Bank of America's parking lot. A total of almost five hundred people, including shoppers and ordinary citizens on their lunch hours, were then arrested and jailed. There was almost no violence on the part of either demonstrators or the Guard.

The Guard action was identified in Operation Cable Splicer records as "Operation Box." The arrests were well-orchestrated but legally flawed. Charges from all 482 arrests were dismissed.

MICHAEL DELACOUR
boilermaker and People's Park cofounder

There were strategy meetings almost every night. Some were at a commune on Warring [Street], and some were at the house where I had lived with Bill Miller, also on Warring. At one meeting I advocated directing demonstrations at People's Park. Others argued that we should move the center of action downtown to Shattuck, with the thought that merchants would not like the disruption to their business and would put pressure on the City to get rid of the National Guard. The group decided to move the demonstrations downtown, which was the right decision.

DENNY SMITHSON
reporter for KPFA (broadcasting live)

People are not being allowed to get out of this box. (May 22, 1969)

HARLAN KESSEL
salesman for the University of California Press

I was just out to eat lunch. All I'm doing is having lunch. The cop said, "I will get you out of here." Fifty or seventy-five people were herded in here. Mrs. Mary Schwab, a sixty-five-year-old woman, was out for lunch too. There are hundreds of people in there who don't know why they're there. I was herded into an unlawful assembly and then was arrested. (KPFA radio, May 22, 1969)

DAVE SEABURY
eleventh-grader at Berkeley High School

My friends and I were on Shattuck watching the demonstrations, not in school. As we stood there, we were pushed into a parking lot by National Guardsmen with drawn bayonets. An announcement was made saying that we were going to be transported by bus to Santa Rita [Jail]. Outside the line of National Guardsmen, I saw Clifford Wong, the principal at Berkeley High. I shouted to him, "Mr. Wong, it's Dave Seabury." He asked what we had been doing, and we said that we had just been getting lunch. He got a group of us released, but not all of us. Some of my friends ended up at Santa Rita, and from their stories I know they had a rough time. Mr. Wong told us to go home and not to Telegraph. We of course went to Telegraph. I didn't tell my parents about this, but Mr. Wong was friends with my mother and so I got busted.

CRAIG PYES
UC Berkeley undergraduate student

On May 22, I was near the front of the group on Shattuck Avenue. As the herding began, I got poked by a cop with a baton. I read what was going on—I could see that we were being encircled. I got out of the area as quickly as I could and avoided arrest, but I had several friends who were arrested and taken to Santa Rita.

TRUDY O'BRIEN
UC Berkeley undergraduate student

My husband [Brian O'Brien, a UC Berkeley graduate student in microbiology] and I were on a motorcycle trying to see what was going on. Trying to cross Shattuck we were told to get off the motorcycle and we were herded toward the Bank of America parking lot. The Guardsmen said nothing; they just herded us. We were taken to Santa Rita despite the fact that we had four children at home waiting for us. I didn't get to make a phone call until after midnight to tell our babysitter what was going on. The charges against us were not dismissed when most of the other charges were. Our lawyer, Penny Cooper, was told by the prosecutor that Ed Meese was mad about a speech that Brian had given in front of City Hall a few days earlier and wanted to keep the charges against us alive. In the end, the charges were dropped.

NACIO JAN BROWN
photographer

I photographed People's Park in 1969 with press credentials for the Associated Press. A few days before May 22, I was standing on the corner of Channing Way and Telegraph at about 2:15 and a couple of cops told me to move. I walked about fifty feet down the street, but in the doorway of Fraser's two or three of them grabbed me, slammed me up and over a patrol car, and went through my pockets. I told them I had my [Berkeley Police Department–issued] press pass in my front pocket, and one of them answered me, "We don't want to see nuthin', motherfucker." Bob Klein, the AP bureau chief, was nearby. He came over, vouched for me, and the policeman released me. I think that eighty-five people were arrested that day.

On May 22, I was on Channing taking photos. A cop grabbed me and slammed me down. I said, "I'm press. I have credentials." He said, "I

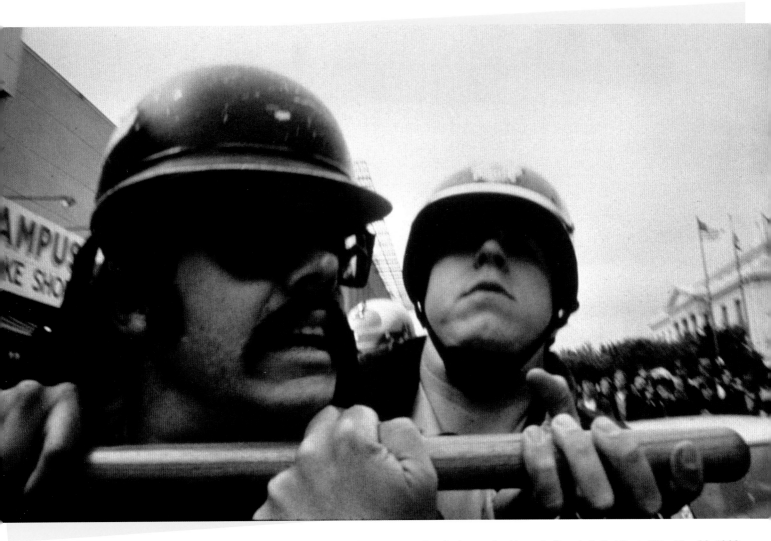

Photographer Nacio Jan Brown being arrested and taken to the Alameda County Jail at Santa Rita, May 22, 1969.

"A cop grabbed me and slammed me down. I said, 'I'm press. I have credentials.' He said, 'I don't care what you have, motherfucker, you're going to jail.'"

 # INSTANT NEWS SERVICE

1703 GROVE, BERKELEY 841-6480

COURTESY: PEOPLE'S PRESS SYNDICATE

Vol. 1, No. 6 Page 1 Friday, May 23, 1969

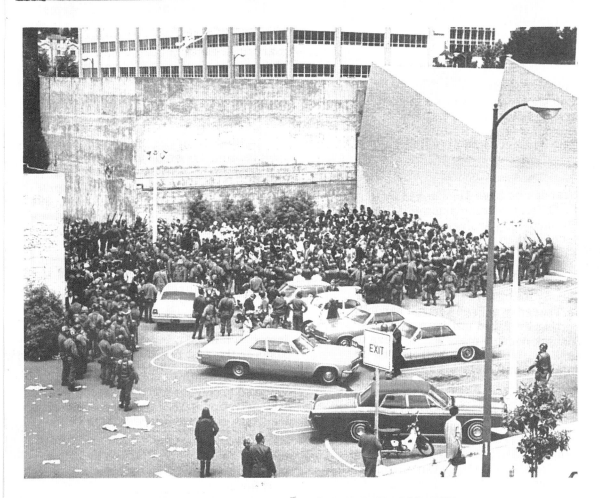

"THE POLICE ISN'T HERE TO CREATE DISORDER.
THE POLICE IS HERE TO PRESERVE DISORDER."

RICHARD J. DALEY

PIGS BUST 482 IN SPRING ROUNDUP

Score a point for the pigs. 482 of us were caught off guard yesterday by a mass bust. Most of the arrested were charged with blocking traffic and failure to disperse. Bail has apparently been set at $800 per person.

At Santa Rita our women were forced to lie face down on bare concrete while awaiting the pigs' pleasure. The second week has begun.

The *Instant News Service* of May 23 led with this photograph of hundreds of people boxed into the Bank of America parking lot by National Guardsmen and local law enforcement.

"This is the kind of thing we condemned in Hungary and Czechoslovakia."

don't care what you have, motherfucker, you're going to jail." I was walked to the Civic Center and loaded onto a bus. When the bus was full, we were taken to Santa Rita. Denny Smithson was broadcasting live on KPFA. He reported that I had been arrested. My sister heard the report, went to the bank for money, and bailed me out at about three in the morning. Charges were dropped.

CHARLIE PALMER
UC Berkeley undergraduate student and president of ASUC

I ran away from the National Guard trap on Shattuck. My brother was caught up in it. I will give them credit—it was well-executed even if it did sweep up many nonparticipants.

SETH ROSENFELD
journalist

The police action on May 22 was known as "Operation Box." On a random basis, almost five hundred people on Shattuck were herded together and targeted for arrest. A few people talked their way out of the "box," but for the most part if you were in the box you were going to be arrested and taken to Santa Rita. It was executed peacefully and in keeping with plans for dealing with massive civil unrest, but it resulted in many complete innocents being arrested because they were at the wrong place at the wrong time. It also resulted in no convictions.

JIM CHANIN
UC Berkeley undergraduate student

I saw the police sweep starting on Shattuck. I had been arrested once already and didn't want to get arrested again. I got in my car and started picking up friends. We turned at one point into a line of National Guardsmen with bayonets fixed. I wasn't going to stop. I drove up to them and the line parted.

JOHN BURTON
California state assemblyman

This is the kind of thing we condemned in Hungary and Czechoslovakia.

DAVE MINKUS
UC Berkeley graduate student in sociology

I was in a health food store on Shattuck on May 22. A National Guardsman took me out and placed me with the hundreds of people being arrested. I was in Santa Rita for a night. I saw all the abuse, the lying on the gravel, the tying someone to a signpost and hitting the post until their ears bled, and more.

JONDAVID BACHRACH
UC Berkeley undergraduate student and ASUC senator

I was not caught up in the police sweep on Shattuck on May 22 and was never Santa Ritacized. Right about that time, though, I was stopped by a policeman because I was wearing a used U.S. Navy shirt that I had bought at the Salvation Army store in Oakland. He told me, "You can't wear that. You are impersonating a member of

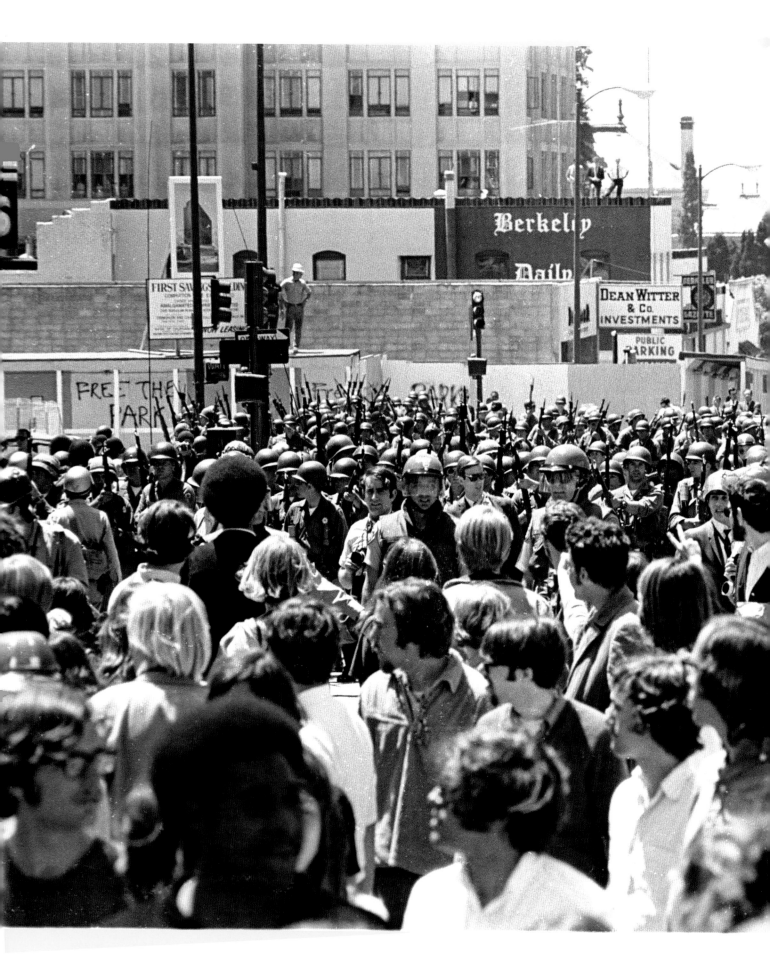

246 THE BATTLE FOR PEOPLE'S PARK, BERKELEY 1969

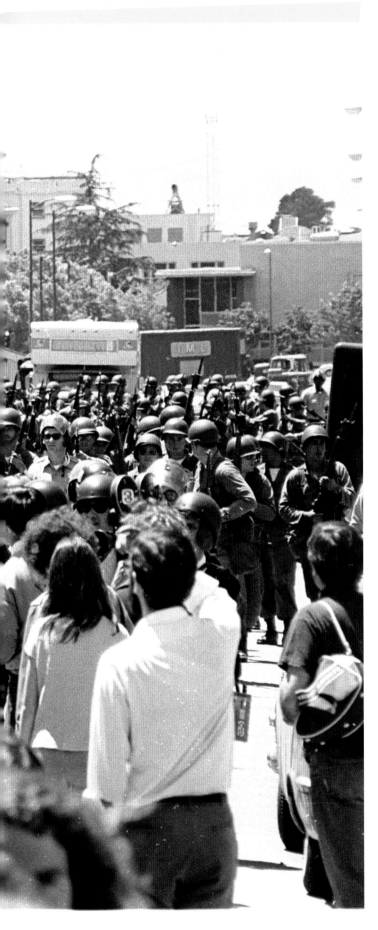

the navy. I served in the navy and I resent you wearing the shirt." I said, "That is about the dumbest thing I have ever heard anyone say." He asked me to turn around, handcuffed me, and took me to the Berkeley jail. Needless to say, the charges against me were dropped. His badge was number 151.

WAYNE COLLINS
UC Berkeley graduate and casual stevedore worker
I was on Shattuck when I saw the sweep of people into a parking lot start. I stepped inside a café and avoided arrest, although people outside the café were arrested.

ART GOLDBERG
UC Berkeley graduate and Free Speech Movement leader
I was part of an eight-to-ten-person ad hoc steering committee that met each evening to plan the next day's activities. We each took turns to be the official leader of the day. Frank Bardacke told me that it was my turn, but I declined. I was waiting for my State Bar moral turpitude hearing and did not want to get arrested. I regret that now, but I know why I did it. I avoided getting arrested on Shattuck as they herded people into a parking lot.

EDWIN HOROWITZ
UC Berkeley professor of biology and physics
On Thursday evening, May 22, I drove down Telegraph to do my laundry, as is my custom, in the laundromat between Parker Street and Dwight Way on Telegraph Avenue in Berkeley. Just after crossing the Haste Street–Telegraph Avenue intersection, I saw and heard an officer in the front seat of a police car of the Alameda County Sheriff's Office speak roughly to a young couple walking hand in hand in the same direction as myself, ordering them to move along more quickly. As the officer's urging seemed to me to constitute unnecessary harassment of the young couple, I stopped a moment to glare at him and was quickly told, "Get moving, buster." I replied, "I'm not used to being spoken to in that tone." The officer at the wheel nodded to the two officers in the back seat of the car, and all three quickly donned their helmets and opened their car doors. I immediately raised both hands, palms forward, above my head, and said in some fear, "Arrest

me if you like. I surrender." The men seized my arms, but to my surprise—never before having experienced arrest—they did not simply "take me into custody" but dragged me quickly toward the other side of the street, twisting my arms and, as my balance became insecure, pushing me this way and that. Officers of the Berkeley Police Department came to meet us from the other side of the street and began hitting me all about, forcing me down toward the ground. In terror I cried out—I write it to my shame, but I confess I feared for my life!—"But I'm a professor, gentlemen; really, officers, I'm a professor." The pummeling only became more brutal, whispered curses alternating with shouts aloud such as, "Want to fight, do you?" "Kick, will you?" and remarks in a similar vein, such as might lead unobservant passersby to think that it was I that was provoking the struggle. I found myself forced lower and lower, and finally thrown heavily down, thinking, half-dreamily, "Good God, they want to kill me! Is this really happening to me?" Finally they stopped and I began to feel a great pain in my chest. I was made to lie on the sidewalk alongside the car for perhaps ten or fifteen minutes. After a while I was told to get up and into the police car.

JOHN STALLAR
UC Berkeley undergraduate student
I picked up a postage-due letter at the main Berkeley post office. I stood at the corner of Addison and Shattuck, one block north of University, and saw a lot of people coming south on Shattuck. I walked in the same direction as they were walking. When I saw the policemen or National Guardsmen blocking Shattuck I tried to separate myself from the crowd and was prevented from doing so. I was herded into the parking lot, arrested, and sent to Santa Rita.

ROBERT FEINSTEIN
on leave from Columbia Law School
I went to a camera store to check on some film I had left there and then went to the health food store. When I came back out on Shattuck, the march was breaking up. I went over to a Berkeley sergeant and asked if I could go home. He replied that no one was to pass. Within a minute the Guard started closing in on the people within the area and herded everyone to the Bank of America parking lot. A few hours later I was arrested and taken to Santa Rita.

MICHAEL PERLMAN
UC Berkeley graduate student in agricultural economics
I was standing on the east side of Oxford Street, on the west lawn of the campus. A young man took one or two steps off the curb and spoke to a young lady whose car had stopped. She was alone and beckoned him to come over. I saw four Highway Patrolmen running from the south toward the young man. The first officer to reach the young man hit him across the upper back with a club, causing him to fall on his elbows. While curled up, another officer grabbed the boy's hair and pulled while another beat him on the back with a club. Without first allowing the young man to stand, the officers picked him up by his hair and clothes and dragged him across the street.

"Good God, they want to kill me! Is this really happening to me?"

SIDNEY DONG
UC Berkeley graduate student
I was standing on the west lawn of the campus facing Oxford and Center. A pedestrian tripped over the rear wheel of a motorcycle moving about five miles per hour. One of the policemen hit him with his billy club on his back. He got up and made his way to the lawn. One of the three officers caught up with him and clubbed him again. The fellow attempted to protect himself by wrapping his arms around his head. Then two of the policemen lifted the fellow and took him off while the third stood guard.

DAVID JAMIESON
UC Berkeley undergraduate student
I was with the demonstration at Shattuck and Center and heard no orders to disperse. The leaders of the demonstration told everyone to disperse, but by that time all exits were blocked off by either National Guard or Berkeley police. Everyone was forced into the Bank of America parking lot on Center Street. Finally at 5:30 I was arrested and put on a bus and taken to Santa Rita. Upon arriving at Santa Rita, we saw other arrestees lying facedown on the asphalt. We were forced to run to where they were lying and lie facedown. We remained in this position for two hours, only being allowed to move our heads. Failure to comply with these orders resulted in physical punishment. The policeman who fingerprinted me threatened to break my hand and my foot unless I did everything he told me.

MIKE SCHEWICH
employee of Joe's Ranch Burgers
I was standing in front of See's Candy Store on Telegraph below Bancroft. There was a Berkeley police car stopped near See's Candy. A young man was photographing the police car. The policeman jumped out and apprehended the photographer. The photographer started to move away. The policeman tackled him, grabbing him around the waist. The policeman and photographer fell down. Three other policemen from the same car got out and one grabbed the photographer's leg and twisted it; the other two were holding him. The photographer started yelling, "Don't break my camera." He screamed in anguish. One of them was jabbing his club in the photographer's ribs. They put the photographer in the back seat of their police car and drove away.

HANK SIMPSON
UC Berkeley undergraduate student
I was standing on the east side of Telegraph on my way home from making an application for a football scholarship for next year. A young man was taking pictures of a Berkeley police car and its occupants. One of the police got out of the BPD car and started walking toward the young man with the camera, who started to move away. The policeman grabbed him around the waist, dragged him south down the street. The CHP officers got out of their cars to help the Berkeley police officer. About four CHPs and the Berkeley policeman grabbed the victim and pressed him down on the sidewalk and handcuffed his hands behind his back. They lifted him up and led him to the BPD car.

GARY HANKS
student at Merritt College
I and six friends were shopping at Goodson's Health Food Store at 2165 Shattuck. The woman who was working in the store told the police that we were her customers and that we were peaceful and the police said we could leave. We left and were herded into the Bank of America parking lot on Center Street and arrested.

BELLE PERITZ
co-owner of Goodson's Health Food Store
I witnessed in my store the arrests by two members of the Berkeley Police Department of about thirty persons, most of whom were making purchases in my store.

DIANNE PETRICH
UC Berkeley undergraduate student
I joined the march on Shattuck near University. It became obvious that it was going to be a mass bust, and so I started to move east on Center Street when an announcement was made to disperse. I went up Center, but the National Guard had the street blocked off west of Oxford. They weren't allowing people to get through. There were police behind the Guard. I turned around and looked for any other way out, and I went west back to Shattuck, but that

was blocked. I wandered around to see if there was any way to get out, but there wasn't. All the units forced everyone into the Bank of America parking lot. I waited in the parking lot for about half an hour or forty-five minutes [and then] an officer told me I was under arrest. I was searched before getting on the bus.

LESLIE BERGMAN
UC Berkeley undergraduate student

I was at the window of my apartment at 2715 Channing Way. A young man was leaning on the open driver's door of the Chevy with his arms crossed, talking peacefully to several policemen. All of a sudden the young man was thrown to the ground. I saw the young man on the ground being shaken by the shoulders. One of the officers picked the young man up by his hair and dragged him by the hair to the police car about seven feet away.

TERRY STEPHEN DORAN
teacher at Berkeley High School, East Campus

A microphone on a car with Berkeley police in it gave an order to disperse. Myself and many others tried to disperse. I walked in every direction possible to try and disperse, but there were either policemen or National Guardsmen blocking every exit of that area. The Berkeley police entered the building I was in and said for everyone to leave the building. At this point they herded us west about ten yards on Center below Shattuck. I assumed we were being allowed to disperse. The police abruptly stopped us. They slowly herded us into the Bank of America parking lot. Three hours later I was taken outside of the crowd and told I was being arrested for failure to disperse and blocking a thoroughfare.

FRANK MARTIN
stock investor

I was shopping at University and Shattuck. I was directed by a Berkeley police officer to proceed south on Shattuck. I was crowded into the corner of the Bank of America parking lot on Center. At that time I was told by a Berkeley police officer that I was being arrested for unlawful assembly and failure to disperse.

MARK MUSICANT
UC Berkeley undergraduate student

There were about twenty of us standing and watching the ranks of National Guard when two Highway Patrolmen came by and in a friendly manner asked us to move. We were then walked up past National Guardsmen on Shattuck, and I realized it was a trap. When we arrived at the parking lot we were faced with two hundred National Guardsmen, bayonets pointed, who ushered us into the group of those previously arrested en masse. I was taken and told my rights and the charges and ushered onto a bus and driven to Santa Rita.

BARRY MOYER
UC Berkeley graduate student in mathematics

I was inside the health food store on Shattuck Avenue south of Center Street. Three or four National Guardsmen reached the store from the street, and one or more grabbed me from behind by the jacket and pulled me out of the store and pushed me up against the window. They held me against the window and called some Berkeley police. One of them grabbed me from behind and put some bruises on my arm. Some people asked the officer why I was being arrested. The officer said the National Guard didn't like my jacket. We were put on the bus to Santa Rita. We got to Santa Rita and saw all the people lying on their faces. They made us lie down with our hands at our sides.

CHRISTOPHER HENRY ROMBARDO
UC Berkeley undergraduate student

I withdrew money from the American Savings and Loan Association office on Center and Shattuck. I came out and walked up the north side of Center Street to Oxford, where a line of Guardsmen and policemen were blocking the sidewalks and Center Street itself. A Guardsman told me I couldn't go through to go to campus. I explained I wasn't part of the demonstration. He said to move down Center Street. I asked a lone-standing officer how I could leave the area. His response was to go over to the parking lot and that I could get out there. Bayonetted Guardsmen and assorted police closed off the lot and I was arrested.

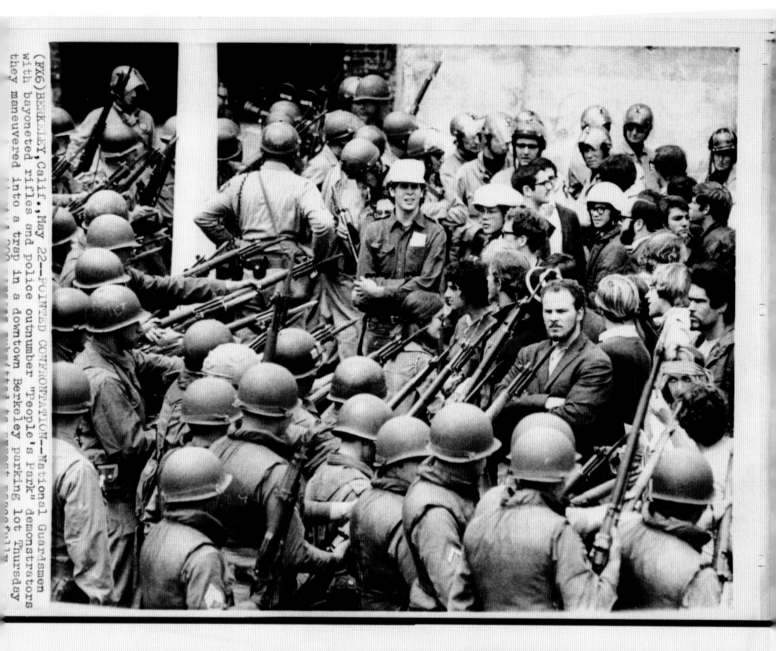

(FX6)BERKELEY,Calif.,May 22—POINTED CONFRONTATION—National Guardsmen with bayoneted rifles and police outnumber "People's Park" demonstrators they maneuvered into a trap in a downtown Berkeley parking lot Thursday [...]

JOHN ROSOVE
UC Berkeley undergraduate student
I was in the parking lot at Center Street and Shattuck Avenue. I heard no warning from the police to disperse. The majority of the people crowded there were unable to hear the announcement because the megaphone the police were using was at a very low volume.

DAVE VALORY
UC Berkeley graduate student in anthropology
At around 2 p.m. there was a serpentine march around Sproul Plaza. A CHP sergeant struck a man with a heavy club across the back very, very hard and knocked him to the ground. He was kicked out of the way, and the CHP went in. The man who was struck was just walking west and had nothing to do with the march.

ROBIN MATT
UC Berkeley undergraduate student
I went east on Center Street from Shattuck to Oxford Street. I was confronted by a line of Highway Patrol closing off the street. I could not get through the line. A line of National Guard were sealing off the intersection of Shattuck and Allston. I and a friend entered the Central Valley Bank and asked to be let out the side entrance to Allston Way. They refused and we went back onto Shattuck. We were herded into the parking lot on Center, surrounded by National Guard, and arrested.

CHRISTINE EGAN
secretary for UC Berkeley's sociology department
I left the Berkeley Fabric Center and was attempting to return to work, but the way east was blocked by the National Guard. A girl who told the police "You disgust me" was pulled by the arms out of her car. One officer opened the car door as the girl began to scream. The girl was not fighting the policemen but was somewhat limp as the officers pulled her toward a paddy wagon.

TOM HELBIG
UC Berkeley undergraduate student
I was in the Wells Fargo Bank to get a statement on my account. The Berkeley Police came in and made everybody with long hair leave. The police asked the tellers if the people still there had accounts at the bank, and if the tellers said yes, the police forced them to show some proof. A man who was trying to cash a check was grabbed by the arm and shoved toward the door.

NORRIS DELANO LARGE
stringed instrument repairman
I was in [the San Francisco Bay Area] to donate a kidney to my brother. I was attempting to avoid the large gathering of people at Shattuck and Center. I was aware that the gathering was not legal, and I didn't wish to be arrested or injured during my recovery from the kidney removal. There was no way to get off Center Street. I was herded onto a parking lot and was eventually arrested.

Every criminal charge filed on May 22 on Shattuck Avenue was ultimately dismissed.

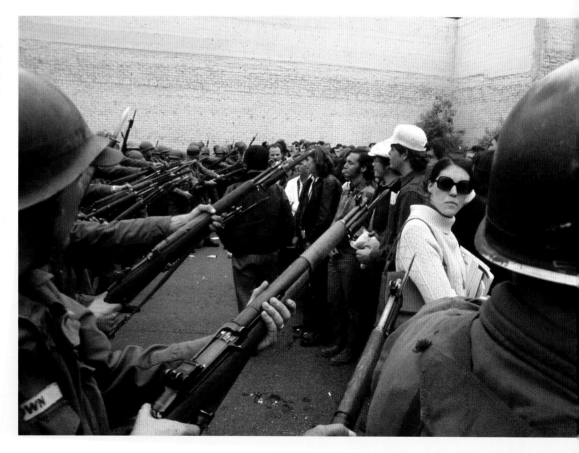

GREGORY GOOD

UC Berkeley undergraduate student

I told a police officer that I had heard an order to disperse and was attempting to do so. The end of Center Street was blocked by policemen. I tried to explain my position to the policeman, but he raised his club in a threatening fashion as I stepped toward him. I continued up Center, trying to get to Oxford Hall, where I live. I was herded with the rest of the people into the Bank of America parking lot.

BILL PATTEN

former manager of the Ski Hut

I entered Goodson's Health Food Store, fleeing from mass arrest. In Goodson's I bought and ate my lunch. As I was eating my lunch, I noticed National Guardsmen moving north. I hoped to leave the store after they passed, getting behind them. In about five minutes two Berkeley policemen entered the store and said we were all under arrest. Mr. Goodson said, "These are my customers."

JOHN DAVID HEM, JR.

UC Berkeley undergraduate student

I arrived at Shattuck and Cedar by car about fifteen minutes before the main body of demonstrators arrived at Cedar. After the main body arrived, we walked to Center. At Shattuck and Center we crossed the street. We proceeded to Shattuck and Center and a parking lot where approximately twenty medics congregated. The police lines closed in around us and finally I knew that I was going to be arrested.

TERRY MARKARIAN

stained-glass craftsman

I was shopping in the health food store on Shattuck near Center. Three National Guardsmen were stationed at the door, preventing our exit. Several minutes later a Berkeley police officer entered and informed us that we were all under arrest. He ushered us past a line of National Guardsmen into a parking lot behind the Bank of America, where we joined four hundred other arrestees.

LYNDA KOOLISH

UC Berkeley undergraduate student

I parked my car at Bancroft and Shattuck and proceeded up Shattuck in a medic's uniform. I approached the outskirts of the crowd in order to be available in case of injury. Many National Guardsmen and police formed a ring around the crowd. The Guard and police directed the crowd toward a specific location, and I assumed that they were giving directions for the crowd to disperse. I followed the directions and found myself in the parking lot of the Bank of America. The Guard had formed a ring around the crowd. I never heard an order to disperse, but had there been an order, there was absolutely no way to disperse because we were surrounded by National Guard and police who refused to allow anyone to disperse in any direction. I had no idea that I was under arrest. It wasn't until almost an hour later that we were informed by the police that we were under arrest. After all the girls had been booked, we were herded into a tunnel-like construction, which was very damp and cold. We were taken to Santa Rita.

MARY SUE ODEGARD

secretary

I was walking down Shattuck with my friend Lucretia Beltrone. At the island corner I looked at the men being arrested and I noticed my husband. I ran over to him to find out why he was being arrested. He was as perplexed as I. As I started to question him, Berkeley Police Officer #12 threatened and finally arrested me for interfering with an arrest. I saw Lucretia being escorted to the paddy wagon by another police officer.

WILLIAM MENKING

UC Berkeley undergraduate student

I had an appointment with an architect at the corner of Shattuck and Center. I was waiting to cross Shattuck with Richard Bulger, who also had an appointment with the architect. The police surrounded us from behind and said, "You people, march across the street with us." I told them, "I have an appointment at the office. Can I go there?" They just said, "Please keep walking up the street." They herded us into the parking lot and made the arrest there.

JOHN SULLIVAN
UC Berkeley undergraduate student

I walked to Center and saw a lot of Guardsmen about one and a half blocks west on Center. At this point, we thought that it might be a trap. We saw some people getting away by climbing over the wall of the eating area of Kentucky Beef. We looked down Shattuck to the north, which was blocked off by police, and we looked south on Shattuck, which was blocked off by Guardsmen with drawn bayonets. We found an open door in an office building. We walked to the back of the store, hoping to get out that way. I stayed inside the building about forty-five minutes, and I went back out the back when I saw that the Guard had gone.

DAVID KARP
UC Berkeley undergraduate student

When I saw the police starting to close in, I went into a dress store on Shattuck. We were followed into the store by two Berkeley police and were told to leave. Upon leaving, the National Guard was moving south on Shattuck. The Guard pushed the crowd into a small area. The Guard moved in with fixed bayonets and backed us against the back walls of the lot. The mood of the crowd was still pretty cheerful as we waited around. Around 3:15 the paddy wagons came in from an alley and the Berkeley Police Department started to arrest people.

PAUL DRESHER
UC Berkeley undergraduate student

I was walking down Shattuck to Fidelity Savings at 2323 Shattuck Avenue, where I have a savings account. I attempted to walk toward Bancroft, but all the streets were blocked by National Guard. All exits were blocked and the crowd was milling around Shattuck and Center. I asked an officer how to get out and he directed me up Center, which was also blocked by Guardsmen who would not let me through. The crowd was pushed by Guardsmen into the Bank of America parking lot on Center. I was arrested at about 3:30.

WILLIAM ESCAMILLA
UC Berkeley undergraduate student

I was walking with my friends on Shattuck Avenue when I was trapped after being prevented from dispersing. I tried to disperse in two ways: one, by going inside the Wells Fargo building at the corner of Center and Shattuck, and then—after being swept out of the building by police—two, trying to go west on Center Street, [but] prevented from doing so by newly formed lines of police. Eventually we were herded into the parking lot, arrested, and taken to Santa Rita.

DAVID RAVITCH
UC Berkeley undergraduate student

A young man with fairly long hair was standing in the crosswalk at the corner, a foot or so from the curb. Two policemen walking up the sidewalk saw him yelling and went to get him. He didn't see them until they were a few feet away from him, at which time he tried to run away. He fell over a motorcycle. When he fell to the ground, the policemen converged on him, one of them striking with his club. They picked him up. One of the policemen was holding him by the hair. The two policemen were on each side of him; they took him through the National Guard line.

KAREN COOK MCNALLY
UC Berkeley undergraduate student

I was with two other students. We decided to go shopping, since this was a "shop-in." About twenty of us went into Goodson's Health Food Store. Almost everyone was purchasing things and eating them. We were talking with the proprietor. We were standing in the alcove between the shop door and the street when about ten National Guardsmen came to the door and grabbed one of our group. He was taken away to the north. About three or four Berkeley police in khaki uniforms entered the store from the front and said, "Everybody go out back." The proprietor said, "Officer, these people have caused no trouble whatsoever; they have been here making purchases." The officer listened, hesitated for a moment, and said, "Okay, out the front door." We went out but were forced to go to the parking lot on Center by the officers.

Santa Rita

The almost five hundred protestors and bystanders who were arrested in Operation Box on Shattuck Avenue were transported to Santa Rita Jail in Dublin, thirty miles east of Berkeley. They were housed in World War II–era barracks-style buildings.

The Operation Box arrestees, especially the men, were subjected to extraordinary physical and emotional abuse by jailers from the Alameda County Sheriff's Department. From the record, it appears that abuse was the rule, not the exception. Even the district attorney and Sheriff Frank Madigan recognized this.

Among those arrested was a reporter from the *San Francisco Chronicle,* Tim Findley. His story about the abuse at Santa Rita was on the front page of the May 24 *Chronicle.* He wrote in graphic terms about the physical and verbal abuse by guards. He suggested a class bias: "The most threatening of the guards were about the same age—mid 20s—as most of the arrested demonstrators. Repeated references to the Army and to the draft seemed to indicate the young guards had a lesson they were itching to teach their radical contemporaries. There seemed to be a special interest among the youngest of them in proving their authority."

The *Berkeley Barb* wrote about the Santa Rita experience in its May 30– June 5 issue, not mincing words in the headline "INSIDE SNAKE PIT."

Also arrested was Jesse P. Ritter, Jr., a reporter for *Life* magazine. The entire country was able to read about the abuse at Santa Rita in the August 15, 1969, issue of *Life,* in an article entitled "Nightmare for the Innocent in a California Jail":

> Aboard were students with books and notepads who had been on their way to and from classes at the university. There was a U.S. mailman (with long hair), still carrying his bag of mail....
>
> We were marched into the compound and ordered to lie prone in rows. Those who looked around or stumbled or didn't move fast enough were prodded and hit with clubs. Frequently men were dragged out of the marching lines and forced to kneel while being struck....From time to time we were forced to close up ranks by crawling across the asphalt, which was covered with sharp gravel. Those accused of speaking or looking around or moving slightly were dragged out and forced to kneel with their hands behind them in a separate group. Some remained kneeling for hours....
>
> It was cold when the sun went down, and men around me were shivering....We then lay back down on our faces....
>
> [A guard] assaulted one of us—a very young boy with long hair— by slugging him with his fist and then grabbing the boy's hair and slamming his face into the wall....
>
> One boy was forced to lean his head on a post while the guards beat on the post. His nose began bleeding. Guards would prod him, pull him off the post and strike him....

We marched at double-time, forced to yell, "WE LOVE THE BLUE MEANIES!" The guards were proud of this idea....

At a press conference, Alameda County Sheriff Frank Madigan admitted there had been "irregularities"....Many of the deputies assigned there, he said, are young Vietnam war veterans and "they have a feeling that these people should be treated like Vietcong."

LOWELL JENSEN
district attorney for Alameda County
Well, it sort of got into another area, because there was a mass arrest made there that the National Guard got involved in. They made an arrest of a couple hundred people, and that turned out not to be a good idea, because they took them all out to Santa Rita, and one of the people they arrested was a *Chronicle* reporter, I think. He went in to see if he'd get arrested, and he was; then he wrote all these stories about mistreatment of people in Santa Rita. So the fallout was that the way it was handled was bad—badly done by the sheriff. There were a couple of people who were deputy sheriffs who used force on some of the people who had been arrested. (From the Bancroft Library Regional Oral History Office, interview by Lisa Rubens and Marcia Jensen, 2005–2006)

FRANK MADIGAN
Alameda County Sheriff
We have a bunch of young deputies back from Viet Nam who tend to treat prisoners like Viet Cong. (From "A Night at Santa Rita," by Robert Scheer, *Ramparts*, August 1969)

PAUL VON BLUM
attorney and a UC Berkeley lecturer in rhetoric
By the time of People's Park there was a fully mobilized legal defense team, which I was part of. I was one of the first lawyers to arrive at Santa Rita after the arrests started. I stayed there all day and night, trying to get people released on their own recognizance. I saw hundreds of protestors forced to lie facedown on the gravel. I saw two or three Alameda County sheriffs hit people who were lying down on the side of their head with their blackjacks. The sheriffs were just plain nasty. If prisoners even moved, a deputy would kick them in the back or legs.

PETER HABERFELD
attorney with the National Lawyers Guild
During People's Park, I was out at the county jail in Santa Rita almost every day after May 15 trying to find out who had been arrested. There was no other way to find out; the police station in Berkeley wouldn't give out any information. Using Santa Rita for pretrial detention was not ordinary.

I was at Santa Rita on May 22 with someone who was trying to find his brother. We were

"We marched at double-time, forced to yell, 'WE LOVE THE BLUE MEANIES!'"

talking with an Officer Jenson, who said that the person in question was not there. I had learned that the person was in fact in custody at Santa Rita but that at the moment was appearing in justice court nearby. I said, "That's not quite correct; he is—," and that was as far as I got. Officer Jenson jumped over the counter, grabbed me, ripped my shirt, and said, "That's enough out of you!" I was arrested and charged with violation of California Penal Code Section 148, obstructing a law enforcement officer from performing his lawful duties.

I was placed in the maximum-security unit in a cell with Hells Angels. I refused bail. The next day, I was taken to the justice court in Pleasanton. The justice court denied my motion for release on my own recognizance. My attorney immediately went to Judge Lionel Wilson in the Superior Court, filed a writ, and got me released on my own recognizance. The charges against me were dismissed in return for my waiving my right to civil litigation against the county.

OAKLAND TRIBUNE

Peter Haberfeld, attorney for some of the 500 persons arrested in the latest Berkeley disturbances, found himself behind bars Thursday night after he went to the Santa Rita Rehabilitation Center to check on his clients. Officers at the jail said he asked for information "piecemeal" rather than providing a list of names as officers asked, and continually interfered in other conversations during the hectic two hours all were being booked. Haberfeld, 27, was booked on charges of trespass and interfering with an officer. (May 23, 1969)

PAUL GLUSMAN
student activist

When we got to Santa Rita, we were welcomed by perhaps ten deputies, one of whom pointed a shotgun at us. We were ordered to lie on our stomachs, face against the asphalt, hands at our sides, legs outstretched. We could not talk, smoke, or chew gum. The deputies constantly made remarks about how they should shoot us all. Several people were hit because they moved or chewed gum. All of the time we were subjected to loud and abusive threats by the deputies to kill us and beat the shit out of us. (*Daily Californian*, May 26, 1969)

GARY HANKS
student at Merritt College

At Santa Rita I observed Joel Tornabene leaning at an extreme angle against a pillar with his head against the pillar and his hands near his head in an obviously very uncomfortable position. A policeman was shouting at him, poking him with a stick in the legs and feet (the back of his ankles).

GREGORY GOOD
UC Berkeley undergraduate student

At Santa Rita, a young man named Schaupp closed one of the barracks windows because it was cold. He was beaten. We were taken into another barracks in the same compound to be booked. We were lined up and searched. Schaupp was thrown against a cement wall by Deputy [Lawrence] Riche.

EDMUND BURR NASH
UC Berkeley undergraduate student

I was lying facedown in a prone position on the surface with loose gravel outside the booking office at Santa Rita. Shortly after I arrived, the prisoner on my left joined a group of prisoners who were allowed to go to the bathroom. I heard shouts from guards and the prisoner's screams of a hysterical nature. He did not return when the group returned. He returned half an hour to forty-five minutes later, breathing heavily. An hour later a guard called for the person with a medical problem. The prisoner on my left rose and said, "Yes, that's me. I'm the one who got the shit beat out of me."

LYNDA KOOLISH
UC Berkeley undergraduate student

After all the girls had been booked, we were taken to Santa Rita. At midnight we were given a sandwich and milk. The mayonnaise on the sandwich was rancid, causing me to vomit for over an hour. We were stripped and searched before we entered the room. I asked the matron if she would close the door while I was being stripped, but she refused.

DERRICK VON SCHLEGELL
UC Berkeley undergraduate student

I arrived at Santa Rita about 5 or 6 p.m. on May 22. About 5 a.m. I was with six other men to

be booked. A pig came around to my right and began yelling. He hit me with his stick on my stomach and on the side of my knee, while yelling in my ear, "You've got lice in your hair. God, you stink!" That pig moved to my left side and one of his buddies moved to the right and began yelling the same sort of thing. I kept saying, "I don't understand. What are you doing?" The pig on the left hit me twice very hard on my belly with his sticks. And the pig on my right began hitting me with his fists. I started to gasp and they began yelling again, "What's the matter, you short of breath, you piece of shit? Can't you take it?"

We were taken to breakfast. Someone said, "There's Super Joel [Tornabene]." There were three or four Alameda County pigs taking turns hitting that side of the pillar opposite Joel's forehead with their nightsticks. They did it to various other people who wouldn't eat their breakfast.

KAREN COOK MCNALLY
UC Berkeley undergraduate student
At Santa Rita I didn't want to give contact information for my mother because she was critically ill with cancer. They took me down the hall, unlocked a door, and told me to go in there. I was locked in a cell all by myself. It had windows open, no blankets; it was very cold.

JOHN FRANKLIN HEATH
student at Merritt College
At Santa Rita, we were ordered to lie down on our stomachs, hands to our sides, and feet spread three to four inches apart, and we were kept there for approximately four hours. The surface of the compound was conglomerate concrete with the gravel protruding, and there was loose gravel. Anyone who moved was hit with a billy club. People were picked at random and placed in the front and were ordered to sit on their knees, hands by their sides, and made to look at the sun but not close their eyes.

INSTANT NEWS SERVICE
The Santa Rita scene was a Marine Corps boot camp. The guards told us they wanted to kill us, continually threatened to break limbs and faces. Called us creeps, assholes, and stupid fools. The whole scene was threats supported by half a dozen real beatings and scores of bruises, kicks, and minor beatings. (May 24, 1969)

ROBERT FEINSTEIN
on leave from Columbia Law School
We were told to move single file into the courtyard. A man five or six ahead of me in line was clubbed in the back and kicked to the ground. We were told to lie on our stomachs with arms at our sides and our face facing left. We were told not to move a muscle. After about an hour of this, the guards inquired who wanted to go to the bathroom. I raised my hand but my turn never came up. The guards ordered us to crawl on our knees and fill the spaces of eight people who were called away. I was called inside for booking. During the search I was picked up by the back of the trousers and kicked in the ankle. I was printed and booked. I was taken to Barracks B. Throughout the night, guards came in and made threats to take people outside and beat them. At approximately 1:30 I was called and released on bail. My friends told me they had been waiting at the jail since 10:00 a.m.

DAN PETRICH
UC Berkeley undergraduate student
When I got off the bus they took my camera. We were herded into a compound and told to lie on our stomachs with our legs uncrossed and our hands at our side. I was in this position for between two and three hours. The guards forced a guy in a red jacket to stand up. The guards called people "queers," "hippies," "traitors," "rats." "Creeps" seemed to be a favorite expression. We were told that any cameras which might be found on us at this time would be smashed, as well as our heads. I was hit on the ankle for moving my head to rearrange with my teeth a handkerchief that was under my head. I was hit again on the ankle, and I believe it was for shifting my head. While we were eating breakfast, a guy wasn't eating and the guard leaned him up against a pole, spread-eagle, and kicked the backs of his legs and hit them with a club, and one of the guards went around to the other side of the pole and started banging it very hard with his club, just opposite where the prisoner's head was. His name was "Super Joel."

TERRY STEPHEN DORAN
teacher at Berkeley High School, East Campus
When we got to the compound I saw people already lying in straight rows, flat on their

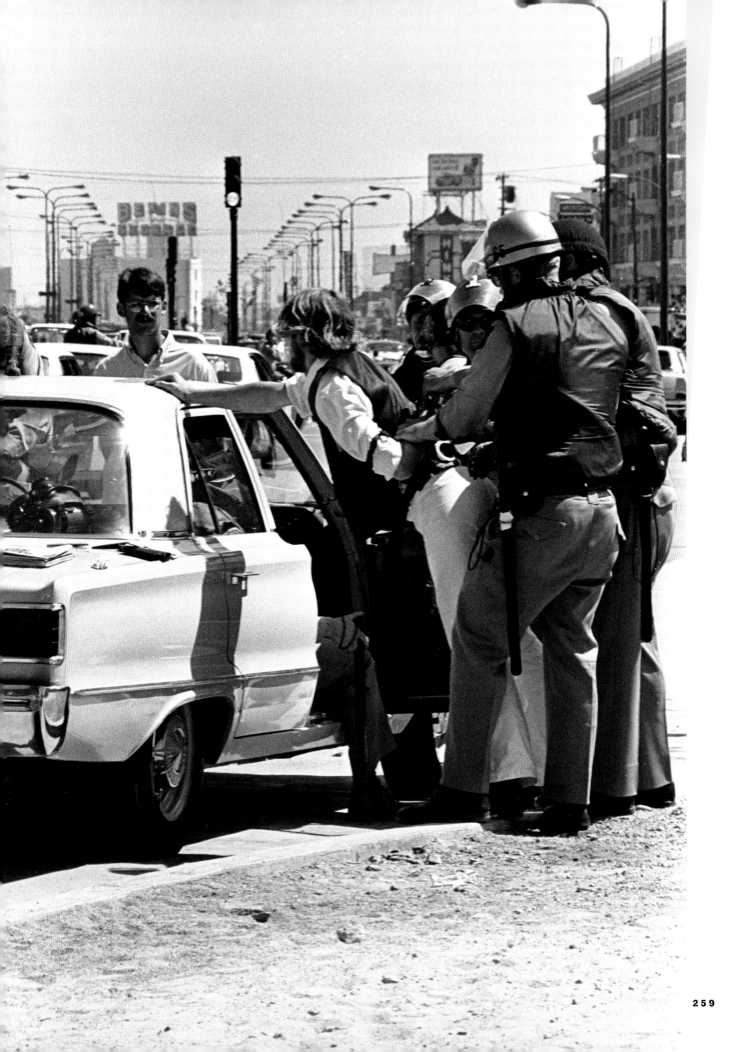

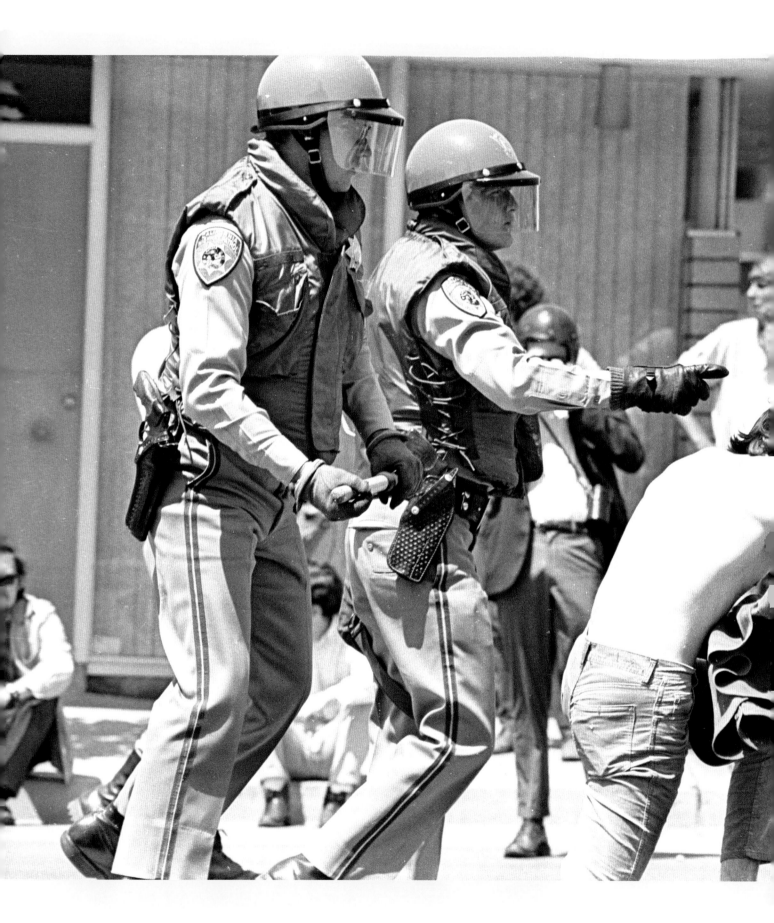

bellies, legs straight out, arms at their sides, their faces all facing the left. They told us to do the same thing, constantly reminding us that if we didn't move fast enough they would split our heads open. One man was hit with a club by a guard, and the guard said for him to move faster. He made some verbal protests about the guard for hitting him. Two other guards grabbed him roughly from behind. They pushed him around and at least three guards at one time or another were hitting him in his arms and his back and his legs. He was then forced to stand upright on his knees, not his feet, for an hour. At about 10 p.m. we were allowed to go inside. I was never allowed to eat or drink.

FRANK MARTIN
stock investor
At Santa Rita we were lined up side by side and told to lie facedown with our arms at our sides, our legs uncrossed, and with our heads facing to the right so that our left cheek was resting directly on an asphalt parade ground covered with a fine layer of grit and gravel. We were told to urinate in our pants. I was searched. During the search procedure, I did not spread my legs fast enough to please the officer searching me and so he repeatedly kicked my ankles.

JOHN ROSOVE
UC Berkeley undergraduate student
Upon arrival at Santa Rita, I was placed face-down on a gravel-cement courtyard until 8:30, when we were allowed to sit up. From 9:30 to 3:30 a.m. the guards constantly threatened and harassed us. During breakfast, Super Joel refused to eat. The guards ordered him to a wooden post, where they made him stand five feet from the post. He was ordered to lean with his head against the post and hands behind his back. They took their clubs and banged them against the post next to his head.

JOE GRODIN
attorney and a professor at the University of California's Hastings School of Law
I heard reports of abuse of prisoners. Jim Brosnahan from Morrison-Foerster and I worked with a group all night, and we got an injunction. In my confirmation hearings before the Commission on Judicial Appointments, a "law and order" committee brought this up against me.

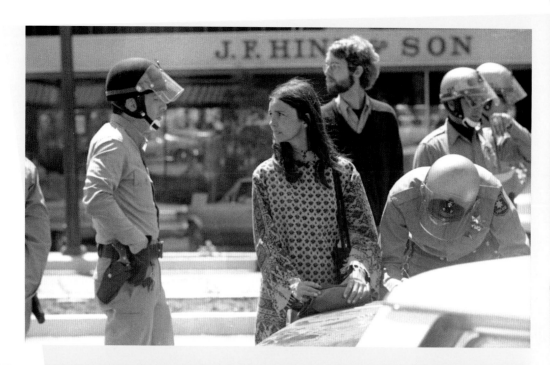

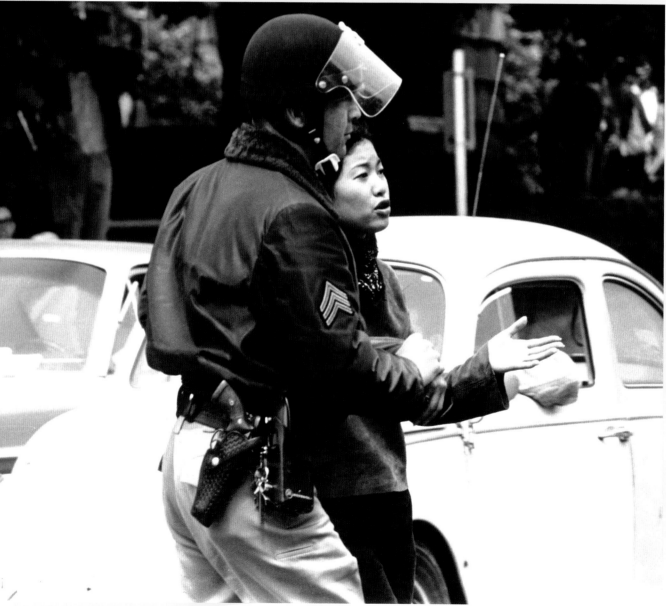

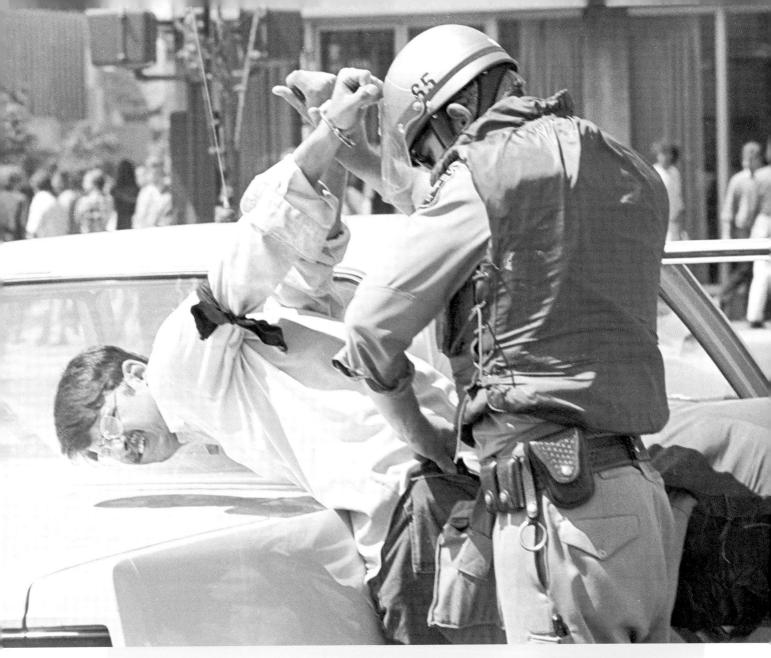

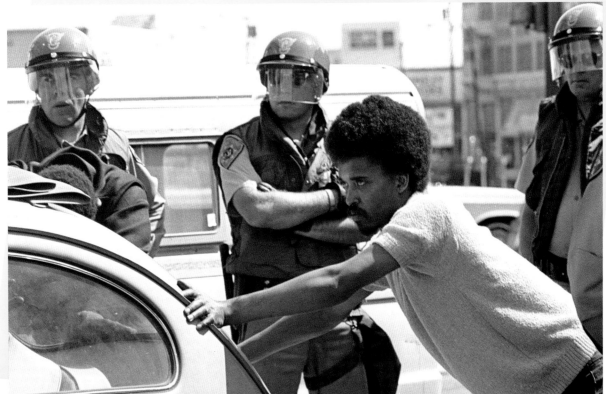

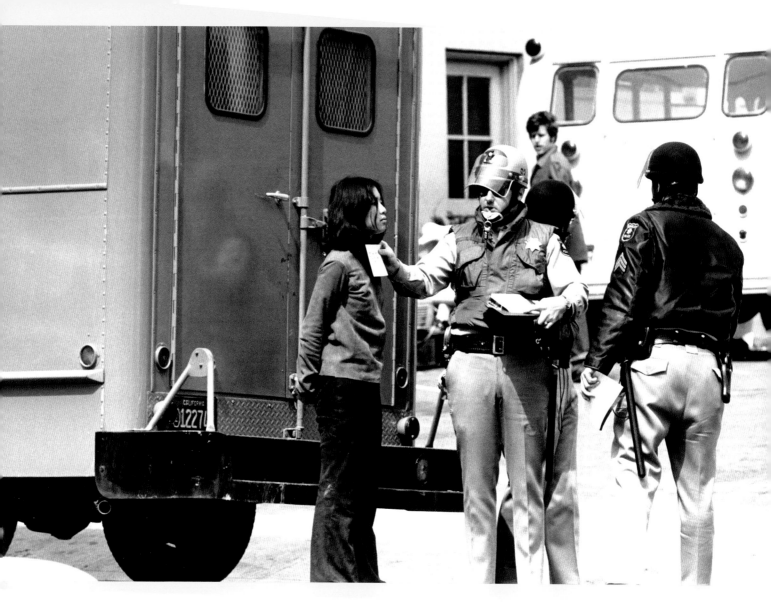

JOSEPH P. BORT
Alameda County Supervisor
It is my conclusion that in some cases there was some mishandling of the situation. I don't care to get into specifics. (*San Francisco Examiner*, May 28, 1969)

DAILY CALIFORNIAN
RESTRAINING ORDER ISSUED AGAINST SHERIFFS. Sheriff Frank Madigan and the Alameda County Sheriff's Department were named in a temporary restraining order issued by U.S. District Court Judge Robert Peckham Saturday as a result of alleged physical and verbal abuse of prisoners at the Santa Rita Rehabilitation Center. Attorneys filed 13 affidavits alleging torture and verbal abuse at the county jail near Pleasanton Thursday. The Order restrains Madigan and the Sheriff's Department from:

- Assaulting the plaintiffs with clubs or in any manner whatsoever;
- Depriving plaintiffs of right to counsel either by intimidation of plaintiffs or their attorneys;
- Intimidating plaintiffs by threats that defendants will take such action; [and]
- Threatening physical injury to plaintiffs. (May 26, 1969)

Criminal charges were eventually filed against a number of deputies for their actions at Santa Rita on the night of May 22. All were acquitted. These events served as a stark contrast to the relative discipline exercised by the National Guard.

"A Night at Santa Rita," by Robert Scheer

Originally published in *Ramparts* magazine, August 1969

"We have a bunch of young deputies back from Viet Nam who tend to treat prisoners like Viet Cong."

–Alameda County Sheriff Madigan

The National Guard had simply closed off a large area of downtown Berkeley, arresting shoppers and protestors alike. I had a valid press pass, given to me that day by the Berkeley Police, but with my long hair and all, Sergeant #1 would not let me leave the ring. Angry, I sat down with those caught, chatting for hours, surrounded by bayonets. A cop pulled me out and said I was arrested. I showed him my press card. Terribly impressed, he used it to get my name and address and sent me on to fingerprinting and the sheriff's bus. Like the others, I expected to be bailed out after a few hours' booking at Santa Rita (the county prison farm), and then be home for a late dinner. Like the others, I was to be in a state of literal terror for the next sixteen hours.

The one-inch slit in the window of the Alameda County Sheriff's bus didn't let us see much of Santa Rita Rehabilitation Center, only a lot of wire and low white barracks—somebody referred to it jokingly as a cross between a concentration camp and a chicken farm. The bus stopped at the gates and two guards with shotguns jumped on. "All right, you creeps, move your asses out of here. The last guy out gets his head cracked open." People who live in college towns spend their lives seeing old gangster movies, and it was difficult at first to realize that that corn and violence had suddenly become the real world. We stumbled out of the bus and through a gauntlet of club-swinging deputy sheriffs. The guy in front faltered and they hit him on the head—it does sound like a "crack." He said something like "Take it easy," and they moved in on him. The rest of us made it through the gate and were greeted by the sight of two hundred arrestees lying prone on a concrete yard—heads turned sideways, hands straight back at their sides, legs pulled close together. Two hundred bodies perfectly tense and quiet, but the guards walking between the rows of bodies gave proof of life as they whacked and poked the men with their clubs. These guards were the same deputies who had done all the shooting in Berkeley the week before—the "Blue Meanies" (in America it's always comic-book death: macabre, unreal and later funny). It was getting dark and cold; the countryside was moorish and vacant; we could hear no cars moving on Highway 50 below; and the place was flooded with guards—enough to turn any organized resistance into a bloodbath.

The concrete was gravelly and it dug into your cheek. The wind blew some of the smaller bits into your eyes, which had to be open to catch sight of the guard about to whack your limbs for having moved or shivered in the bitter cold. After thirty minutes you could turn your head to rest on the other cheek. We lay there from 6:00 p.m. to 8:30 p.m. The fellow who was beaten as we came off the bus was forced to take a different position—resting on his knees, arms hanging at his sides, while three guards systematically beat him for several minutes—one guard for the stomach, one for the back, and one who specialized on the head. (When he got out later a doctor reported that he pissed blood and that his body was a mass of bruises.) The rest of us just lay there—no one said anything, no one protested. Perhaps some tried to, but the minute their hands moved they became the center of other guards' attention. "If you don't like it, do something and we'll bust you on a felony for assaulting an officer—you'll never get out." That's the threat that finally keeps you in line.

While my body had suddenly become very important because it was vulnerable to pain, my mind floated elsewhere, giddy and irrelevant. All this time I thought of [prominent liberal newspaper columnists] James Reston and Max Lerner and the other good, rational men. I began to compose an open letter to Reston. "Dear Scotty," it went, "This letter concerns your column holding

the New Left responsible for the increase of violence in American society. You condemned the New Left for its distrust of the legal system. Remember? It's the column that had the cute line about the New Left kids being neo-Nazi crybabies who won't pay their dues. Well, before I get into those arguments, Scotty, why don't you try paying some dues? 'Lie down on this concrete floor, motherfucker, hands back, legs together,' as the guards here say. 'Come on, creep faggot, get your ass down there, cheek to the stone, keep your hands out—what are you doing, masturbating? Move your head and I crack it open...At Santa Rita we shoot to kill.' Sorry, Scotty, have to run now. There's this guard talking to me."

The guard is, like most all the other guards, a stocky, nasty redneck (except that he's enamel white—not enough sun in Northern California). Like most of the younger ones, he was let out of the Marines six months early to enter this profession. He seems to have only two comments to make about life. One is, "We shoot to kill in Santa Rita," and the other is, "Creep, I split heads." He has been commenting on life for two hours, and now his club is two inches from my nose. Do I want to go wee-wee? It's a good thing, a favor, a release. My head won't be cracked, nor will I be shot—on the contrary, five of us are getting to go to the bathroom. One cannot simply walk in and piss in the latrine, for there seems to be an elaborate and well-established ritual which the fat, middle-aged latrine guard is bent on following. It requires that one first sit in line, three feet from the latrine, and observe a good two minutes of silent reflection. Then the fat guard has us all jump to and line up on three sides of the small box to piss on signal and, unavoidably, on each other.

At 8:34 p.m. we are given a minute's exercise running in place. Soon we are allowed to sit, hands clasped, no talking—nirvana. At 10:00 p.m. they run us, shivering, into a barracks—eight to a double bunk—and it is rumored that a doctor has blocked the guards' fervent and often expressed wish that we freeze to death out in the compound.

During all this, they are calling out names for booking. Booking is blessed, because until one is booked he cannot be bailed. I am not booked until early the next morning. We are kept in the barracks from 10:00 p.m. to 4:30 a.m. Three lawyers arrive and there are wild cheers from inmates. The guards snarl but hold their clubs.

Kids are afraid to talk too freely to the lawyers with the guards watching.

One lawyer talks too much to an inmate and is himself made an inmate (charged with interfering...etc.). The other lawyers leave and the guards snap back to viciousness, making up for the twenty minutes they've lost. The guards don't want to see any closed eyes—no sleeping. If eyes close, you get a rap on your bunk or self. "Yes, sir," you say. If not, then outside to be beaten and lie face down in the cold. The ACLU green card had said, "You have the right to call counsel." Later another kid asks whether we will get to call a lawyer. "You say something, creep? Come here, creep." He too is hauled out and hit. Fuck the ACLU green card. Survive. You forget your rights and concentrate on the main problem, keeping your eyes open—10:00 p.m. to 4:30 a.m.—and pray for booking. Most are already called and we get desperate as our numbers decline. Finally our turn comes—five names called—up against the fence—nasty redheaded pig makes us trot, whacking the last guy.

The booking hut is all efficiency—lots of deputy sheriffs, five typewriters going, fingerprinting and searching. You start by sitting on the floor, once again hands clasped in front, eyes riveted ahead "or we'll rip them out and paste them up there." Scrape along on ass, still sitting, from stop to stop—first stop is for searching again. "Stand up, hands against wall, feet back. No, creep. Like this." One's head is then thumped hard against the wall, legs kicked back, pig hand searching entire body. The mind is by now too tired for outrage. Back down on the floor, we scrape along on our bottoms to the next station, then up again, heels together at attention, answering questions for the deputy who is typing: "Marital state?" "Married, sir." "Legally?" "Yes, sir." "Bullshit, don't lie to me or you're dead. Children?" "One, sir." "Legitimate?" "Yes, sir." "Yeah. Ever work?" "Yes, sir." "You got a job, hippie?" "Yes, sir. Editor, sir." "Where?" "*Ramparts* magazine, sir."

All activity in the booking hut stops suddenly as the assembled deputies are duly informed that the editor of *Ramparts* magazine is indeed in their company. They all seem reasonably impressed and one jabs me quite hard in the back with his club. A deputy hustles me over to the sanctuary of his ink pad. It is important that my fingerprints "get to Washington quickly," he tells another pig. Then it's back on the floor, eyes

straight ahead, to be given a bologna sandwich and a small container of milk—the first food or drink we've had in fifteen hours. Because I am the editor of *Ramparts* I get to "clean every fuckin' piece of paper off the floor of the hut" before eating my bologna sandwich.

With booking finished, we're off to compound C and sleep, only to be awakened forty-five minutes later. It's breakfast time: line up at bunks, eyes ahead, "Move your asses, creeps[;] run to the mess hall or heads get split." It's Wheat Chex and watery milk and keep elbows off the table, for any elbows on the table get cracked. "Hey, you fuckin' hippie queer, don't you understand English? Get up against the wall." Whack—the poor bastard didn't get to eat his Wheat Chex.

We then stand up and one of the medical volunteers from the Free Church, dressed in a white smock with a huge red cross on his chest, is thought by one of the guards to have smiled, ever so slightly. "Did you smile?" "No, sir." "Aren't you happy here?" The kid has by now had it—seventeen hours is too much. He refuses to answer and is thrown against the wall and beaten. The rest of us are by now on our knees, eyes ahead, crawling to the door. "Crawl, motherfucker, crawl, creep. Keep that ugly fuckin' head of yours absolutely straight or it's split open." After breakfast we get to crawl through the mess hall door and then double-time back to compound C.

It's already daylight and AM radio is piped through the intercom, with the morning d.j. bullshit and news particularly obscene in our situation: "...an orderly, peaceful arrest of 480 went off without a hitch, with those arrested now in Santa Rita. The bail has been set at $800 and the police are to be congratulated on their efficiency and the lack of unpleasant incidents in the arrest. Chancellor Heyns was pleased that violence had been avoided..." The medical kid is back in our compound. Soon the guards find another excuse to haul him outside and resume the beating.

There is one very scared kid in our compound who actually was shopping in one of the downtown stores when the roundup began and didn't even know about the demonstration. He is the only one who cracks, silently hysterical and shaking whenever a guard comes near. I now tell

him bail should come any minute. It doesn't for three more hours. Never allowed our phone call, we've worked out a system of getting word out by compiling a list of names and phone numbers on the outside. Whoever's bailed out should take the list, but the first guy is too scared of the guards' threats and eager to get out. He forgets the list, but the next kid insists on being able to take it and gets off with it.

I hear my name and am in a group of ten trotting through fences, with a Central European guard (I swear)—metal-frame glasses and accent—barking at us that if he had his way he wouldn't let us go. When we come back after conviction we'll really get it. Then stop, hold attention for five minutes, then run. We see normal prisoners for the first time and they are bewildered by the charade. As we trot around, the guards shout, "Who do you love?" No answer. "Say the Blue Meanies!" No answer. "Halt. Let's get it straight, creeps. If you want to get out, you'll answer. We can keep you here all week." Trot again. "Who do you love?" A couple reply, "The Blue Meanies." Most of us finally manage to draw the line and chant, "Fuck the Blue Meanies." The guards are pissed but realize that it's too close to the end to push it.

Suddenly I'm in a car back to Berkeley and for about three hours I frantically try to raise bail money for others and tell people what has happened. Then the entire experience fades out. To begin with, nobody really believes you. Even hard-bitten Berkeley radicals still hold some illusions about American life, about legal limits and public opinion. I began to consider the possibility that this was all some paranoid fantasy. The terror had worked back there because we were cut off and they had total power to define reality. Once we were outside, the guards no longer existed; they were nowhere to be seen in that Chinese restaurant or coffee shop where I was boring people with yesterday's war story.

Perhaps I wouldn't have written up the "incident," but it turned out that Tim Findley, a reporter for the *San Francisco Chronicle,* had also been arrested, and his eyewitness report, printed in that paper the next day, made it somehow all right to remember.

It had been real—it was in the papers.

The Memorial Day March

On Friday, May 30, between twenty thousand and thirty thousand people marched from the People's Park Annex—at Hearst and Grove (now Martin Luther King Jr. Way)—to People's Park. The Annex was a nascent spin-off of the original People's Park and it exists today as Ohlone Park.

The stated goal of the march was to force removal of the cyclone fence around People's Park. Just as there had been a change in the leadership of the park activists after May 15 with an infusion of sectarian Left groups, there was a second shift for the May 30 march. Fred and Pat Cody of Cody's Books, Roy Kepler of Kepler's Books in Menlo Park, and local Quaker leaders feared a repeat of Bloody Thursday and so stepped in, training more than seven hundred march marshals to keep the peace.

Peter Bergel coordinated the training. He had taught a course titled "Non-Violence and Social Change" at the Free University of Berkeley, and his lessons included a series of Peace Games—intense role-playing exercises that would split participants into attackers and defenders. Around seven hundred people went through the peace training at Le Conte Elementary School the night before the march. On the day of the march, marshals greeted cars as they drove into Berkeley, establishing a peaceful tone for the day. The Berkeley Friends Church distributed thirty thousand cut daisies. Marshals were spread throughout the march, nipping any potential problems in the bud.

The San Francisco Mime Troupe's Gorilla Band was near the front of the march.

A delegation of Hells Angels on motorcycles led the march. The San Francisco Mime Troupe's Gorilla Band played. It was a beautiful Berkeley day. The peace was kept in the largest march and demonstration in Berkeley's history, and at a time when the city was under military occupation.

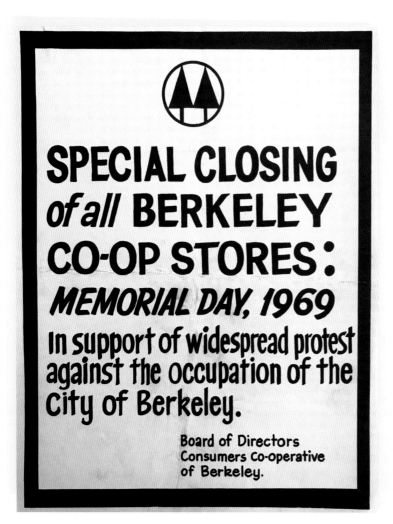

SPECIAL CLOSING of all BERKELEY CO-OP STORES: MEMORIAL DAY, 1969 In support of widespread protest against the occupation of the City of Berkeley.

Board of Directors
Consumers Co-operative
of Berkeley.

MARCH IN BERKELEY MEMORIAL DAY

DEMAND THAT THE FENCE BE TORN DOWN!

On Friday, May 30, Memorial Day, come to Berkeley to join the mass protest against the killing, blinding, beating and jailing of our brothers and sisters. Join the march to demand amnesty and the immediate end of bayonet and shotgun rule.

Berkeley has undergone ten days of siege by 2,700 National Guardsmen and thousands of police. All political and constitutional rights have been suspended by Reagan's fiat. A reign of terror, with heavily armed police teargassing and breaking into homes, schools and dormitories has hit the university community.

IT IS OUR CONSTITUTIONAL RIGHT TO HAVE THIS MARCH.
WE INTEND TO BE PEACEFUL.

We will assemble, we will be students, street people, faculty, trade unionists, black and brown workers, housewives, priests, off duty guardsmen, etc.........demanding that OUR RIGHT OF PEACEFUL ASSEMBLY BE RESPECTED. (route & location to be announced)

DEFEND PEOPLE'S PARK IT'S YOURS

For Information:
Peoples Park Committee 549 0563
Main Coordination and Information...626 8222
Free Church, (Medical/Bail)........549 0649
Community/Labor Support............848 9334
Speakers Bureau....................549 0563
Campus & High Schools..............626 4577

PEOPLE'S PARK
MARCH COMMITTEE
LABOR DONATED

"We intend the march to be peaceful and we will not initiate violence; instead we intend it to be a weekend of festivity."

JOIN THE STRUGGLE FOR THE PEOPLE'S PARK
COME TO BERKELEY FRIDAY MAY 30, MEMORIAL DAY
WE WILL MARCH TO OUR PARK --TO THE PEOPLE'S PARK
WE WILL DEMAND THAT THE FENCE COME DOWN

We built a Park. Heyns, Reagan, and Madigan put up a fence. The Park was beautiful and free so they killed to destroy it.

Private property in America is a God and the pigs are its armed priests. The University was satisfied with a swamp; the people of Berkeley built a beautiful park. Helicopters, bayonets, and shotguns were brought in to tear up the grass and rebuild Heyns' private swamp.

We are fighting to return our park to the control of the people in the community, the people who built it. Reagan and Madigan fear people who fight back. The black movement, the student movement, the anti-war movement have begun to ressurect the great American tradition of fighting back. Our fight is spreading and we will continue it.

COME TO THE MARCH

The people of Berkeley are outraged and demand an end to the incredible terrorism of the reckless professional politicians who control state and police power. We are marching to demand:

1. The fence must come down.
2. The police must be disarmed.
3. The national guard must go home.
4. All charges against demonstrators must be dropped.
5. Reparations must be paid to the injured.
6. The police criminals and their generals must be brought to justice.

Another articulation of the demand that the fence around People's Park come down.

DAILY CALIFORNIAN
If the fence is still up by Friday, park supporters intend to surround the park and "fence in the fence" by building a park around the present one, similar to the "park" created Tuesday on Telegraph and Haste Streets. (May 29, 1969)

INSTANT NEWS SERVICE
Join the struggle for the People's Park. Come to Berkeley Friday May 30, Memorial Day. We will march to our park—to the People's Park. We will demand that the fence come down. (May 28, 1969)

WENDY SCHLESINGER
feminist, eco-activist, and People's Park cofounder
We intend the march to be peaceful and we will not initiate violence; instead we intend it to be a weekend of festivity. We hope to create an atmosphere where people will be able to experience the beautiful feeling of community that we felt when we were creating the park. (*Daily Californian*, May 29, 1969)

 # INSTANT NEWS SERVICE

1703 GROVE, BERKELEY 841-648C

COURTESY: PEOPLE'S PRESS SYNDICATE

| Vol. 1, No. 11 | Page 1 | Wednesday, May 28, 1969 |

JOIN THE STRUGGLE FOR THE PEOPLE'S PARK

COME TO BERKELEY FRIDAY MAY 30, MEMORIAL DAY

WE WILL MARCH TO OUR PARK --TO THE PEOPLE'S PARK

WE WILL DEMAND THAT THE FENCE COME DOWN

· STAGING AREA — PEOPLE'S PARK ANNEX — HEARST AND GRANT ·

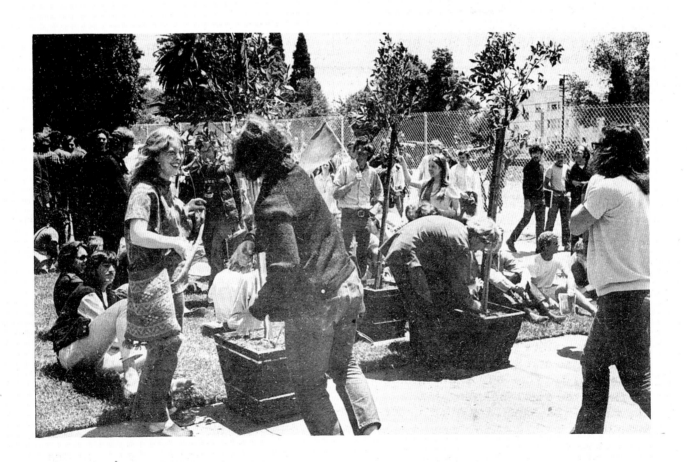

—HASTE STREET ANNEX—

CHARLIE PALMER

UC Berkeley undergraduate student and president of ASUC

If the leaders refuse to respond, then people will look elsewhere to get things done. (*San Francisco Chronicle*, May 29, 1969)

We are not asking anyone who is attacked or beaten by the cops to lie down and accept it. If a person is attacked it will be his decision of how he chooses to defend himself. (*Daily Californian*, May 29, 1969)

DAILY CALIFORNIAN

The half-page-size photograph of wire cutters which appeared on page 13 of Wednesday's *Daily Californian* was an advertisement paid for by a supporter of People's Park. (May 29, 1969)

BERKELEY BARB

The park negotiating committee does not advocate taking the fence down Friday. Nevertheless there are persistent rumors of small groups who plan raids on the fence. (May 30–June 5, 1969)

MICHAEL DELACOUR

boilermaker and People's Park cofounder

If the pigs stop the march, we will build parks in the streets and hold a three-day Park-In. The march will have the same militant spirit as all our street tactics for the last two weeks, with snake dances, whistles, drums and kites. The theme for the weekend is Sleep with a Stranger. Everybody gets a blister this weekend. (*Berkeley Barb,* May 30–June 5, 1969)

FRANK BARDACKE

UC Berkeley graduate student and People's Park cofounder

We're not organizing a riot. We're not calling for a riot. (*San Francisco Chronicle,* May 24, 1969)

There is no violence hinted for next Friday. ("The Big Four State Their Cases," KPFA radio, May 26, 1969)

GEORGE DEUKMEJIAN

State Senate Majority Leader

We're very, very concerned there could be further violence or bloodshed.

KLAUS DEHLINGER

radiologist at Herrick Hospital

I do not feel the police should use any sort of equipment that will kill people unless there is a commensurate danger to police. There was no attempt to kill the police that day [May 15]. (*San Francisco Chronicle*, May 30, 1969)

FRANK MADIGAN

Alameda County Sheriff

Shotguns will be used again under the same circumstances. (*San Francisco Chronicle*, May 30, 1969)

BERKELEY DAILY GAZETTE

Berkeley Police Chief Bruce Baker and Berkeley City Manager William Hanley said last night they have "no knowledge" of alleged 30 mm machine guns in Berkeley. (May 30, 1969)

"We're not organizing a riot. We're not calling for a riot."

Several days before the march, park supporters made an improvised park across Haste Street from the fenced-in original People's Park.

OAKLAND TRIBUNE

An ominous note was sounded by a member of the People's Park Negotiating Committee yesterday when it was declared, "The fence will come down on Friday." (May 28, 1969)

BILL MILLER
Telegraph Avenue merchant and People's Park cofounder

We intend to be peaceful and to follow the line of the march laid out by Chief of Police Baker. But some people will stop at the park and will try to build a park around the park. We plan to surround the National Guard with a sea of Green. (*San Francisco Chronicle*, May 31, 1969)

THOMAS HOUCHINS
field commander for the Alameda County Sheriff's Department

The Alameda County Sheriff's Office said Thursday if it is faced with further disturbances at UC Berkeley, it will use shotguns and "we might use buckshot." (*Los Angeles Times*, May 30, 1969)

INSTANT NEWS SERVICE

Bring only defensive weapons to the march. The Alameda pigs' trigger finger is just itching; to them Berkeley is a Memorial Day shooting gallery. Don't be a pigeon. Your three best weapons are: 1. Your cool; don't panic, don't run. 2. A wet cloth inside a plastic baggie [to protect you] against gas. 3. A camera; take pictures of everything. (May 30, 1969)

SAN FRANCISCO CHRONICLE

Chancellor Heyns was firm about that issue. Asked if there was a chance the fence would be removed this weekend, he said flatly, "no." (May 31, 1969)

NORMAN GOERLICH
fundraiser for the American Friends Service Committee

At the planning meetings, we were trying to teach people to be monitors and squelch any uprisings or problems surrounding people. I went down to my little old ladies in San Jose and they gave me $3,000 for the [thirty thousand] daisies. It was quite an accomplishment, what happened that time. And it was peaceful.

CHARLES SCHULTZ
UC Berkeley professor of physics

I arrived in Berkeley in 1960. I did my undergraduate and graduate work in physics at MIT and then was an assistant professor at Stanford for four years. I was a typical academic research type. When the Free Speech Movement happened, I figured that's what liberals do. My younger brother died in 1966, and that drove me to ask what was the meaning of life. The answer was politics and opposition to the Vietnam War. During the Sproul Hall sit-in protesting the university's treatment of Eldridge Cleaver, I volunteered to be a monitor with the permission of my dean. When the police swept the building, they arrested me too. I said I was a faculty member keeping the peace, but they didn't care. I got out the next day and went to the Moses Hall sit-in. I admonished the students to be peaceful and not vandalize the offices. They ignored me, and that was a lesson learned. I called Chancellor Heyns asking him to help expunge my arrest at Sproul Hall. He didn't help. He said, "Well, Schultz, I think you're learning how to behave." That completely radicalized me.

During one of the big People's Park demonstrations in Sproul Plaza, I stood on top of the steps at Sproul Hall to keep the peace. When the sweep by the police started, we talked with them, telling them calmly and politely that we were there to keep the peace. They accepted us. It was a sweet moment.

On the Memorial Day march, I was a monitor. I had some Quaker training. I marched and kept an eye out for trouble. I'd check in at stops along the march about how things were going.

STEVE LADD
UC Berkeley undergraduate student

It was a beautiful day and there was music blasting out of windows along Dwight. Boy, did we feel the power of mass opposition. Peter Bergel had trained hundreds of marshals. The idea was to talk with people, to address them as individuals, especially if they were carrying rocks or slingshots or rebar. That broke the crowd mentality and reminded people who they were. There was very little violence.

MICHAEL DOYLE

author

[Peter] Bergel and bookseller Fred Cody appropriated a grade school and began summoning all the nonviolence trainers they could think of. Roy [Kepler] and other Peace Games veterans that night ran a quick session in nonviolence. Hundreds attended. (From *Radical Chapters*)

FRED CODY

co-owner of Cody's Books

People coming into Berkeley for the march were to be contacted as soon as they entered the city. For that purpose it was proposed to set cars at the main entry points off the freeway and at other places in Berkeley. These welcoming stations, marked as prominently as possible, were to distribute material from the Peace Brigade to all who were arriving. (Quoted by Joseph Lyford in *The Berkeley Archipelago*)

"PERSPECTIVES ON BERKELEY"

The technique settled upon was to have unidentified monitors throughout the demonstration. They were to be alert to provocative action as quickly as possible and expected to act immediately. Great quantities of handbills and other literature were run off to establish the peaceful nature of the walk and the moral victory to be won by projecting love instead of hate. The nonviolence graduates and others were fully expecting to have to step between bayonets and clenched fists. (From *Newsletter of the American Friends Service Committee,* Summer 1969)

PETER BERGEL

peace activist

We salted ourselves through the entire march… and managed to head off any violence. It was a magnificent success. (Quoted by Michael Doyle in *Radical Chapters*)

TELEGRAM FROM EUGENE MCCARTHY, DEMOCRATIC UNITED STATES SENATOR FROM MINNESOTA, TO PRESIDENT NIXON

Dear President Nixon: It is my opinion that the recent actions of the local police and National Guard troops in Berkeley, California, go far beyond anything necessary or acceptable. You will recall that President Eisenhower in 1957 federalized the Arkansas National Guard in order to

> **"The nonviolence graduates and others were fully expecting to have to step between bayonets and clenched fists."**

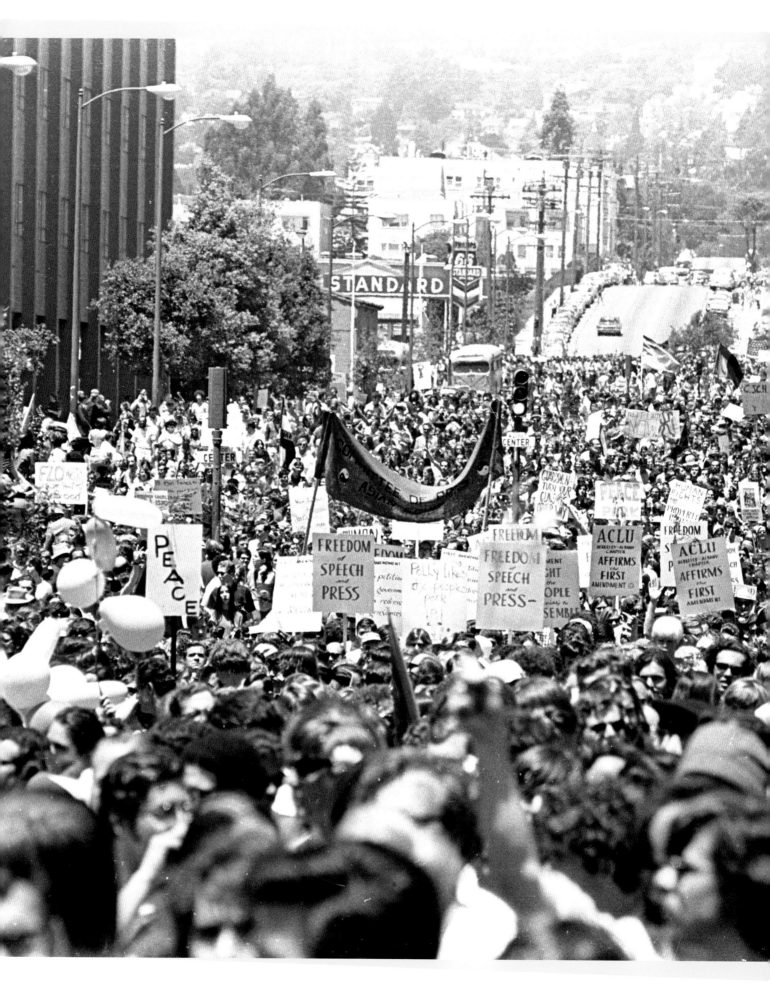

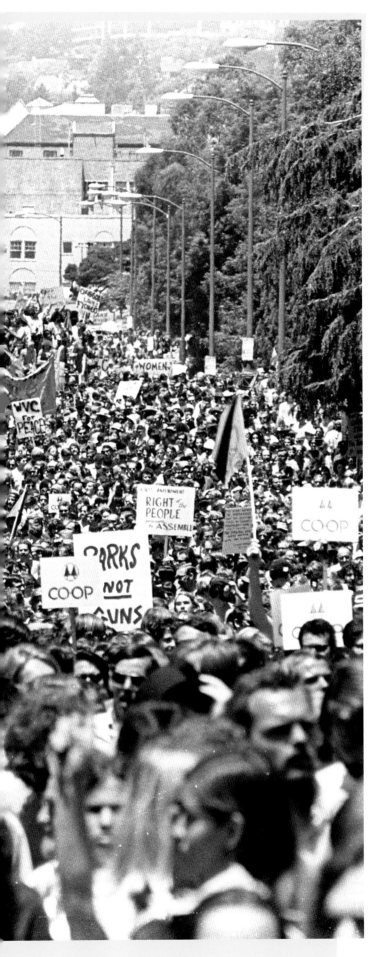

protect the individual rights of students in that state. To guard against reoccurrence of what has happened on the Berkeley campus in recent days, I urge you to give consideration to the same action in California, so that students and citizens there will be protected from additional abuse and aggressive violence. (May 29, 1969)

RANDY KEHLER
staff member of the War Resisters League
I attended a meeting about nonviolence shortly before the Memorial Day march. I remember Roy Kepler, Fred Cody, Ira Sandperl, and David Harris in the meeting. Roy led the meeting, emphasizing that with trained peacekeepers we could try to keep the march nonviolent. The decision was made then to train peacekeepers for the march. I did not take part in that training.

MITCHELL GOODMAN
antidraft activist
With the park, Berkeley may at this moment be the most important single place in the United States. Let's call ourselves Park People, which is to say, all people. (KPFA radio, May 28, 1969)

PAT CODY
co-owner of Cody's Books
People were very emotional, very close to each other, always very close to tears or laughter. It was hot, and at times the streets were so packed that it was impossible to keep moving. Residents along the march route got garden hoses and sprayed us, and everyone raised their arms and opened their mouths. (Quoted by Seth Rosenfeld in *Subversives*)

MANDY CARTER
staff member of the War Resisters League
I was first exposed to the ideas of pacifism and nonviolent resistance by Jack Hickey, a Quaker who was my social studies teacher at the Schenectady Children's Home. I went to a Quaker camp in the Pocono Mountains, where I learned about the American Friends Service Committee. I came to San Francisco in the summer of 1967 and through the Haight-Ashbury Switchboard I met Vincent O'Connor from the Catholic Peace

Marchers came east on Hearst Avenue and then turned south on Oxford Street, shown here.

Fellowship. He introduced me to Joan Baez and her Institute for the Study of Non-Violence in Carmel Valley. I got arrested with Joan at the Stop the Draft Week demonstration in Oakland in 1967, and through that met the War Resisters League, where I got a job.

In San Francisco we were aware of People's Park. It was unbelievable that Governor Reagan had sent the National Guard in to occupy Berkeley—extraordinary, unusual. When the call for the Memorial Day march went out with the rallying cry of "Take the fence down—by any means necessary," Roy Kepler told us, "If ever there was a time for a nonviolent intervention it is now." Roy was a World War II draft resister, owned Kepler's Books and Magazines in Menlo Park, and was a lynchpin of the nonviolent movement in the Bay Area. Roy asked for staff volunteers to go to Berkeley to form a human barrier between the National Guard with their bayonets raised and the demonstrators.

About ten of us got to Berkeley early in the morning on May 30. They told us they thought it was not a good idea and that it was risky. Early in the morning we talked with the National Guardsmen, telling them who we were, what we believed in, and that even though we were making a human barrier we were fully in support of the park. When the thousands of marchers arrived, we were pressed against the National Guard. I have never been more scared in my life. In the end there was no violence. The ten of us can't claim responsibility for that, but we were part of a larger effort to promote nonviolence.

Afterward I read that some of the radicals said that they would have taken the park that day if not for the damned pacifists.

BERKELEY DAILY GAZETTE

The "peace power people," who attended an all-night seminar at Le Conte School Thursday night and Friday morning, went generally unnoticed in the crowd but were highly effective in many incidents in preventing trouble. (May 31, 1969)

LEAFLET DISTRIBUTED BY PEACE ACTIVISTS PRIOR TO THE MAY 30 MARCH

We can't beat the cops at the violence game. We can't let them define the terms of this struggle. Instead, let's get ourselves together with Peace Power. Let's not give the police any excuse to do their thing. They can't chase someone who won't run. They can't bully someone who isn't afraid. People's lives depend on how WE act. Don't follow the leader—be one.

BERKELEY DAILY GAZETTE

Groups of marchers assailed the barbed wire and the chain link fence surrounding the "People's Park" only with flowers, leaflets, placards and pieces of paper. They occasionally sent volleys of flowers over the fence into the "park" site itself. (May 31, 1969)

DAVE MINKUS
UC Berkeley graduate student in sociology

It was a beautiful sunny day with blue skies. What I remember the most is taunting the National Guard by singing Johnny Taylor's "Who's Making Love to Your Old Lady?"

> ## "We can't beat the cops at the violence game. We can't let them define the terms of this struggle."

Police estimated the number of marchers at between twenty and thirty thousand, making it the largest march in Berkeley history.

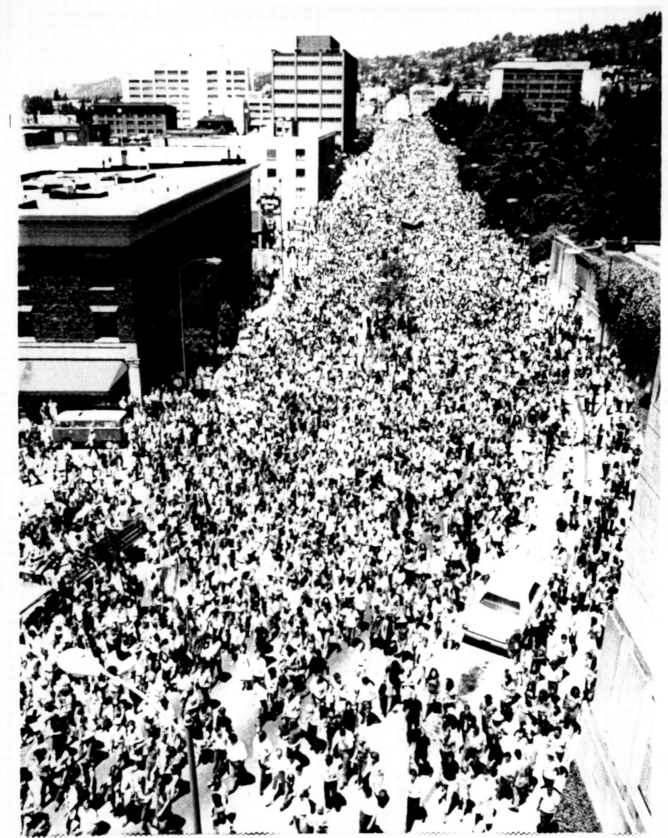

(FX3)BERKELEY,Calif.,May 30--THOUSANDS IN PROTEST PARADE--Thousands
march along Oxford Avenue in downtown Berkeley Memorial Day to protest
closing of a "People's Park" by University of California officials.
On the right is entrance to the university. More than 2,000 National
Guardsmen and police were on hand, but there was no trouble. On May
15 a bloody riot in Berkeley prompted the governor to bring in the
National Guard.(See Story)(APWIREPHOTO)(ott61600stf) 1969

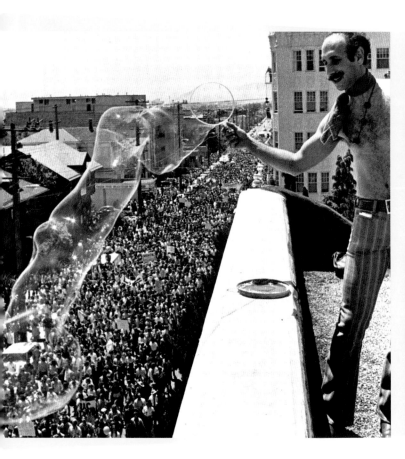

Some marchers carried sod along the route of the march, stopping occasionally to create short-lived, instant "parks."

BRUCE DODD
architect

My wife Joan and I married and moved to Berkeley in 1958. In September 1968, Berkeley adopted a voluntary two-way busing program interchanging white and black students. We had young children and were thrilled that we were living in a place that was clearly moving into the future. Perhaps we were innocent liberals, but Berkeley was an exciting place and there was change in the air. People who didn't care for the change moved to Orinda, making room for others who wanted to live in a lively place with principles.

In the summer of 1961, I worked for the City of Berkeley, surveying houses in the South Campus area as part of the City's proposed urban renewal project. I was to look for signs of blight, especially in properties owned by the university. Blight would be an excuse that the university used to demolish the homes in the block that became People's Park.

We were disgusted by Governor Reagan and his firing of Clark Kerr. When People's Park blew up, it seemed to us that both Governor Reagan and the leaders of the park movement needed to have things escalate for their own political purposes. As citizens of Berkeley, we felt a need

to de-escalate the conflict. Enough of helicopters and gas and telling our kids to come straight home from school and not to stop to play. We wanted our liberal, orderly, peaceful Berkeley back.

The night before the Memorial Day march, we went to a meeting with City Councilwoman Carol

"**We wanted our liberal, orderly, peaceful Berkeley back.**"

Sibley. We knew nothing about demonstrations, so she explained how to avoid trouble and how to avoid getting trapped.

It was a large and tremendous march. It was a hot day, and people along the march route threw water for marchers to cool off with. Our friend made brownies and offered them to the National Guard, but they declined. We had daisies and wove them into the fence around People's Park on Dwight. We thought that the march affirmed that the people of Berkeley wanted things to calm down and for Berkeley to go back to being a quiet town.

SAN DIEGO FREE PRESS

Brothers and sisters were there from all over the U.S. and abroad. San Diego was well represented with people from San Diego State, Mesa College and UCSD. People gathered under placards representing the places they were from to show their solidarity with Berkeley: Stanford, all UC branches, American Federation of Teachers, AFL-CIO locals, university librarians. The San Francisco Mime Troupe Gorilla Band was there, bedecked in leaves and branches. They executed some snappy maneuvers and featured a groovy drummer. Everyone carried signs demanding that People's Park be returned to the people.

People surged into the street and waited for the parade to get under way. Some speakers had been scheduled to rally the crowd, but the sound system was poor and most people couldn't hear them. They didn't need to anyway—the spirit was already there. The people didn't need any message from on high in order to get together and do what they had come to do. It was a long wait and people got impatient, but finally the parade started.

All kinds of people were there: students, workers, young, old, black, white and all shades in between. Infants in strollers, old gents with canes, people in wheelchairs and on crutches—all marched for People's Park.

All along the route people flashed "V" signs from windows and cheered the marchers. Many provided water from garden hoses or from paper cups. Some old people set up a stand and were dispensing Kool-Aid and punch. Parent groups set up little stands with signs like "Parents to Prevent Thirst." The community was with the marchers. The community was behind the marchers. The community was indistinguishable from the marchers.

It was a strange parade in many ways. In bygone days, we were accustomed to seeing the people line the sidewalks while various military units, officials, prancing ponies, perfectionist bands never missing a beat or losing a step, veterans with their bellies hanging out of World War II uniforms, did their thing. But the People's Parade for People's Park was a different kind of Memorial Day parade. The people were in the streets and the military lined the sidewalk. (June 6–12, 1969)

JEFF CRUMP
tenth-grader at McKinley High School
Because I was convinced that the National Guard would open fire on the demonstration, I stayed home, falling into a protective shell where I remained for many years.

WES "SCOOP" NISKER
reporter and newscaster for KSAN radio
On the day of the big march, a KSAN d.j. named Tony Pigg urged Berkeley listeners to open their windows and aim their radios out the windows as he played a set of songs that fit the march. All along the march route we had a rock-and-roll soundtrack thanks to KSAN and Pigg.

"But the People's Parade for People's Park was a different kind of Memorial Day parade. The people were in the streets and the military lined the sidewalk."

TONY PIGG
KSAN radio disc jockey
When I moved from KYA to KSAN, I changed my radio name from Tony Bigg to Tony Pigg. Neil Young was once on my show and I told him my name. He said, "Pigg—far out."

I was into what was happening culturally, not politically. I was over in Berkeley once during the National Guard occupation. I was driving a VW bug with a fellow d.j. in the car, and we encountered armed National Guardsmen everywhere we went. His fear was palpable, but I was not afraid. It changed my opinion of him.

I don't remember where I got the idea for asking listeners in Berkeley to put their radios on their windowsills pointing out to the street. I don't have a set list of what I played that day, but it would have included "Street Fighting Man" by the Rolling Stones ("'Cause summer's here and the time is right for fighting in the street, boy"), "For What It's Worth" by the Buffalo Springfield, and "Get Together" by the Youngbloods. I was just fooling around, playing a game.

HENRY WEINSTEIN
UC Berkeley law student and a reporter for the Daily Californian
It was a big, peaceful march. What I remember the best is the music—people along the march route had their windows open with radios blasting out the windows, tuned to KSAN. The two songs I remember the best were "Get Together" by the Youngbloods and "People Got to Be Free" by the Rascals.

DURWARD SKILES
UC Berkeley graduate student in physics
I came to Cal in 1963 and stayed until 1969. I was on the Ex Comm [Executive Committee] of the Free Speech Movement, representing a libertarian group that a friend and I created, although I don't think that either one of us was truly a libertarian. I was arrested in Sproul Hall, first for illegal assembly and then, when I asked what the charges against me were, for resisting arrest. I proudly wore a SACK HUAC button.

By the time of People's Park I had taken up photography. The physics department had a darkroom in LeConte Hall, which was a big benefit. During People's Park I was more of an observer making photographs than a participant. By the time of Bloody Thursday, I was noticing

a lot of new faces in the demonstrations, people without Berkeley roots and who had no dog in the park fight. In fact, I think that they could not have cared less about the park, it was the confrontation that attracted them. They were among the more militant protestors on marches and demonstrations. By the time I left Berkeley in 1969 I was ready to leave. Outsiders with their propensity for violence were just too much of a presence for me.

ANNA RABKIN
Holocaust survivor and housewife
I wanted to go on the march, but the scene at People's Park with the booted, helmeted, and baton-wielding men in uniform summoned too many specters from my childhood. I would have to find some other way to help. (From *From Kraków to Berkeley: Coming Out of Hiding—An Immigrant's Search for Identity and Belonging*)

GEORGE CSICSERY
UC Berkeley undergraduate student
I did not take part in the Memorial Day march because there was a North Vietnamese or Viet Cong flag at the head of the march. I was also annoyed that Tom Hayden and other people who had not been involved in the park were now grandstanding and hijacking the issue.

WAYNE COLLINS
UC Berkeley graduate and casual stevedore worker
I was on the march and it was pretty impressive. Paul Schrade from the United Auto Workers was there and wanted to speak in support of the park, but the leaders wouldn't let him speak because he was so recently arrived. I think that this was a big mistake.

SAN FRANCISCO CHRONICLE
Barbed wire barricades that were set up to keep the parade along its scheduled march were laced with daisies and other blossoms. The Guardsmen were relaxed and nonchalant, and the deputies stationed on rooftops with shotguns and rifles found nothing to shoot at. (May 31, 1969)

Right, top: Police and intelligence agency operatives kept tabs on the march. Right, bottom: Flowers left by marchers on concertina wire on Telegraph Avenue just north of Dwight Way.

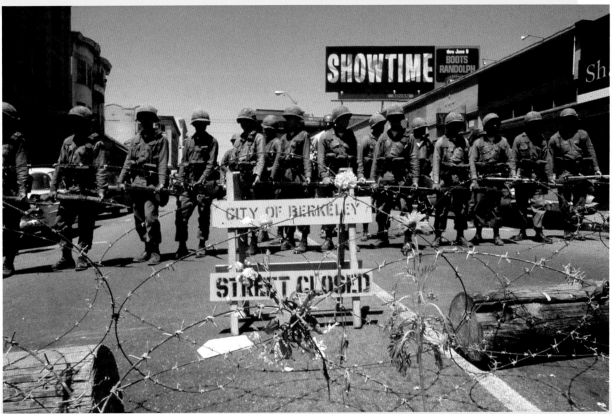

Above: Park supporters along the march route showed their support for People's Park and other progressive causes, such as peace and feminism.

Right: The march attracted thousands of non-radical, non-hippie Berkeleyans, including these housewives and mothers.

"We marched, but a mass march like that was acknowledging the reality that we had lost the park."

REVEREND RICHARD YORK
Berkeley Free Church
Our leader, Jesus, the Prophet who resisted the Establishment, march here beside us. (*San Francisco Chronicle*, May 31, 1969)

JUDY GUMBO
Yippie and People's Park cofounder
I was in the "this is defeat" faction, the "this is not good faction." We marched, but a mass march like that was acknowledging the reality that we had lost the park.

FRANK BARDACKE
UC Berkeley graduate student and People's Park cofounder

TOM HAYDEN
activist and cofounder of Students for a Democratic Society (SDS)
We are not implying that the march should have been turned into an insurrection, only that it fell far short of the kind of confrontation which was needed. We should have surrounded the fence (like the Pentagon and Chicago Hilton were confronted), angrily exposing to everyone that only raw outside military force stood between us and our park. (*Berkeley Tribe*, August 22–29, 1969)

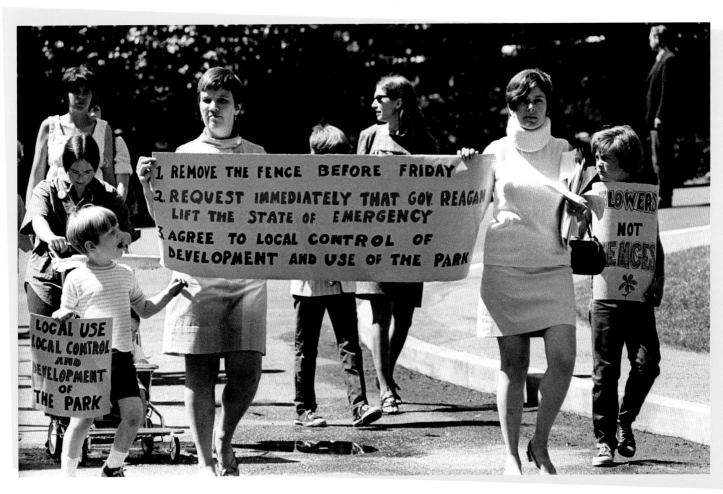

Right: A contingent of motorcycles helped lead the march.

Below: Marchers with American flags followed by a flatbed truck at the head of the march.

Far right, bottom: Quaker activists who worked to keep the march peaceful handed out thirty thousand daisies, including the two on this policeman's helmet.

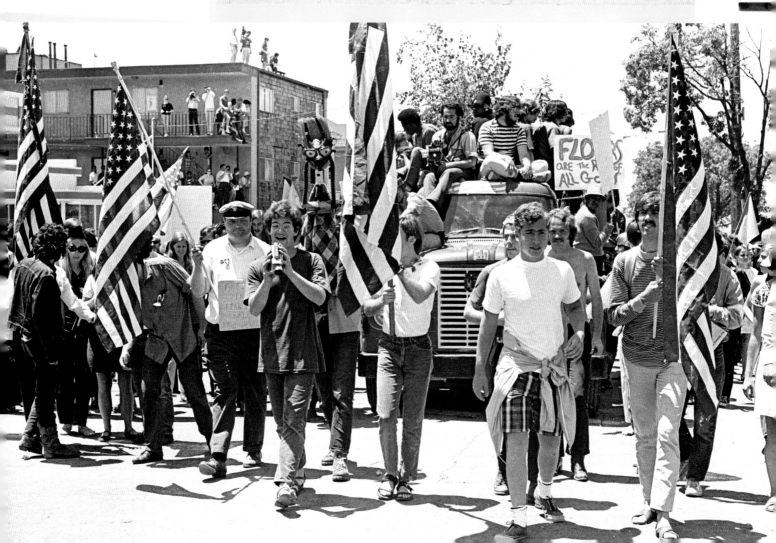

DHYANI (JENNIFER) BERGER
UC Berkeley graduate student in biology

One of the start-off places for the march was where an alternative park was being planted....I think that was happening at other places in Berkeley...on the vacant strips of land over newly built underground BART. My boyfriend lived close to one of these gardens near Grant Street, so we joined the crowd there. The atmosphere was one of defiance. People were determined to keep the spirit of People's Park alive by planting alternative parks. There were speeches expressing disgust with the heavy-handed approach of the university and determined not to give up. Besides a sense of defiance, the message going around was to avoid aggression, to walk in peace, focusing on the positive vision that People's Park had embodied. We confronted the National Guard with flowers. Permission had been given for the march, but we had to follow a specific route. As we walked past side streets we would see Guardsmen blocking the way out. There was a feeling that at all costs we should prevent confrontation. I think we sang a lot. I can remember walking along waving bright yellow flowers and passing by many Guardsmen with flowers dangling from their bayonets. Some smiled. When we reached the park fence it was time for picnic, smoke, and dance. Some people had bought rolls of sod so it was comfortable to sit on the pavement outside the fence. I don't remember how long I stayed there.

BARBARA RHINE
UC Berkeley law student

I marched on May 30. By then I was working on building the People's Park Annex at Hearst and Grove [now Martin Luther King Jr. Way]. The march was huge; it was hard not to feel victorious, even though it changed nothing.

Dove Sholom Scherr (with the guitar) and her younger sister Apollinaire (back to the camera) riding on a flatbed truck outfitted with grass and shrubs.

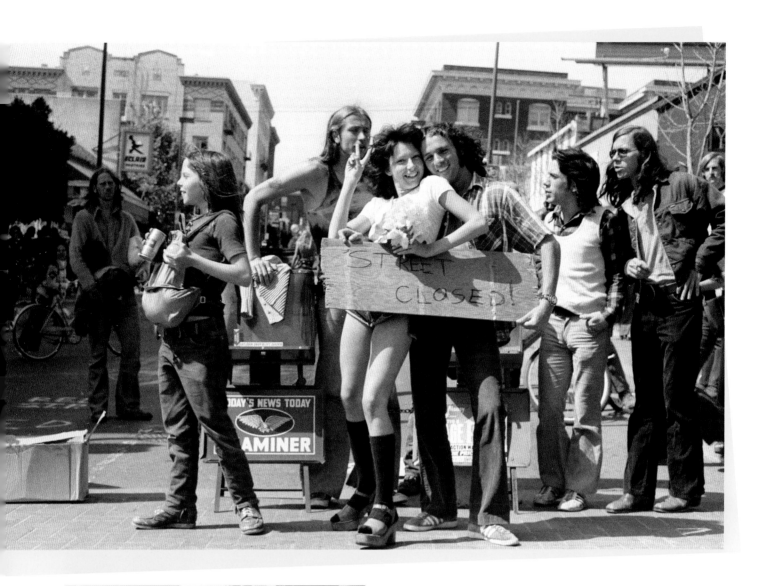

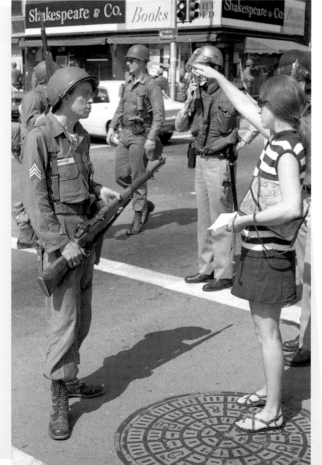

Left: A very young-looking Guardsman in conversation with a woman at the corner of Dwight Way and Telegraph Avenue.

"The march was huge; it was hard not to feel victorious, even though it changed nothing."

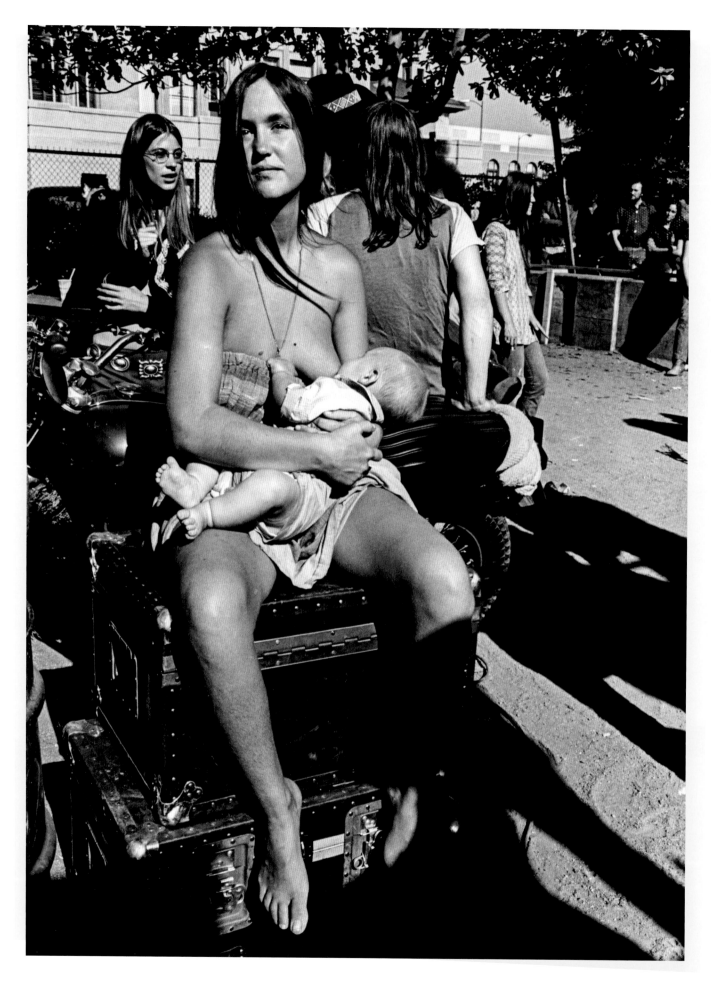

CHARLIE PALMER
UC Berkeley undergraduate student and president of ASUC

I think that everybody felt good about the size of the Memorial Day march and the fact that it stayed peaceful. There were marshals, and they helped. Tom Hayden was riding a motorcycle, stopping and checking on marshals along the parade route. Some of the park leadership may have been trying to drive the message of the march in a different direction, but it was about a park. It had been a violent year, and here so many of us came together in a nonviolent march. "We've done it!" was the feeling that I saw; we had come together in something positive. It was a huge relief.

Later in 1969 I was elected president of the National Student Association. Through the NSA, I was friends with a student body leader from the East Coast who knew John Ehrlichman, assistant to President Nixon for Domestic Affairs. My friend told me that Ehrlichman had reached out to him to say that the White House was concerned about the lack of discipline in the Alameda County Sheriff's Department and would be in Berkeley to monitor the sheriffs. As I marched, I saw sheriff snipers on rooftops. Next to each sniper was a man in a white shirt and tie.

STEW ALBERT
Yippie and People's Park cofounder

The great march was a mixed bag of beauty, defeat, triumph and foolishness. Ronald Reagan was unable to scare us off the street. There was something great about being in the street with 35,000 good people, to smoke some grass and forget about the shotguns and helicopters, to dance to the groovy sounds and to realize Eldridge [Cleaver] was right when he said there were "more people than pigs." But somewhere in the front of the march people forgot what it was all about. They gave flowers to the pigs and chanted, "We love the Blue Meanies." I can hardly believe it but it sounded like a lot of people were trying hard to really mean it. The sadists who murdered James Rector were now okay because they took our flowers and forced their lips into a smile. (*Berkeley Barb,* June 6-12, 1969)

MICHAEL DELACOUR
boilermaker and People's Park cofounder

We lost control of the march. The Quakers took it over. (Quoted by Joseph Lyford in *The Berkeley Archipelago*)

DAN SIEGEL
UC Berkeley law student and incoming president of ASUC

For me it was a big disappointment because the march didn't address the park issue. At least the march got the National Guard out of town.

HUBERT LINDSEY
street preacher

The purpose of the demonstration was to conceal the radicals' guilt of murder, bloodshed, and rioting. Along this peaceful demonstration march, I preached to the various crowds. I told them I had predicted bloodshed and death, that the radicals knew full well they were not building a park but a battleground. (From *Bless Your Dirty Heart*)

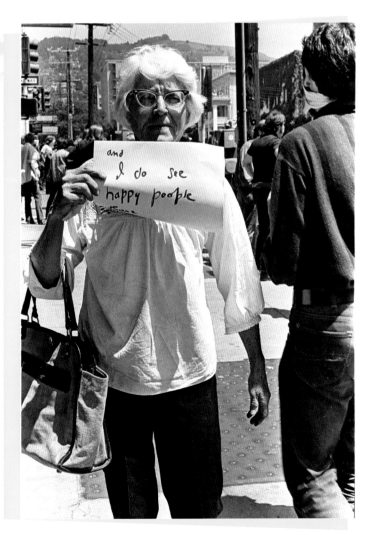

JIM CHANIN
UC Berkeley undergraduate student

I thought that the march was great. I was coming to believe that factionalism was not good, that we have to support good ideas no matter whose idea they were. I didn't care for gratuitous violence, but I thought that when somebody's got something good going, we should support it. That's the way it was with the march.

PAUL VON BLUM
attorney and a UC Berkeley lecturer in rhetoric

I was on the march. It was very large and peaceful. It left no doubt but that we had a lot of support. It didn't do anything about the park, but was a powerful moment. There was no moral epiphany by Governor Reagan or the university leadership, but that is not surprising because it is extremely rare that someone in power has a moral epiphany.

RICK FEINBERG
UC Berkeley undergraduate student

It was successful as a large march, but it was not successful in stopping the university from occupying the park.

RON DELLUMS
member of the Berkeley City Council

Today is a beautiful day. Berkeley is telling the world that this is our response to tyranny, violence and fascism. We are telling America that Berkeley will not be a Nazi Germany. (*San Francisco Chronicle*, May 31, 1969)

ROBERT SCHEER
editor of Ramparts magazine

They let you parade around like in a circus and it gives you an illusion of power. It's a shuck. (*San Francisco Chronicle,* May 31, 1969)

ART GOLDBERG
UC Berkeley graduate and a Free Speech Movement leader

I had mixed feelings about the Memorial Day march. It was impressive, but I thought that we should have torn down the fence. That wasn't where most of the marchers were at, though, and I knew that it would have been a minority of the marchers who would have taken part in an action. It was a great march, but I felt in my heart that we were near the end of things.

CHARLES WOLLENBERG
professor at Laney College and a UC Berkeley graduate student in history

I missed most of the People's Park events because I was teaching at Laney College, but I went on the Memorial Day march. It seemed that every aspect of the 1960s could be found in the South Campus area and South Berkeley—hippies, radicals, street people, communes, collectives, antiwar activists, and the Black Panthers. There was a pitched civil war between the antiestablishment and the establishment—the university, the City, the County, and Governor Reagan—for years, with Telegraph Avenue as the battlefield, the disputed territory. The march was the final chapter in that convergence of the sixties in Berkeley. Every aspect of Berkeley was there except for the Panthers. The march was symbolic—sod rolled out on the street—and had a counterculture tone. It was peaceful, much to the consternation of Governor Reagan and probably some of the more extreme radicals. In the five years since the Free Speech Movement, activists became more desperate as efforts to end the war failed, and the influence of the counterculture grew tremendously.

There was a hippie flavor to the march, with daisies in the guns of the National Guardsmen. It was a sad commentary on the counterculture theme of "do your own thing," with "your thing" being the moral equivalent of "my thing." The center of the march should have been the supremacy of human beings over property.

At the same time, the SDS [Students for a Democratic Society] was splitting into two factions. People's Park was another nail in the coffin of the New Left, which was open, hopeful, joyous, nonviolent, and had a loving orientation. In its place came fear and the politics of despair. In a way, the series of events at People's Park made extremists on the Left more plausible.

FRANK BARDACKE
UC Berkeley graduate student and People's Park cofounder

I was excited by the crowd. I remember radios tuned to Tony Pigg's show on KSAN blasting "For

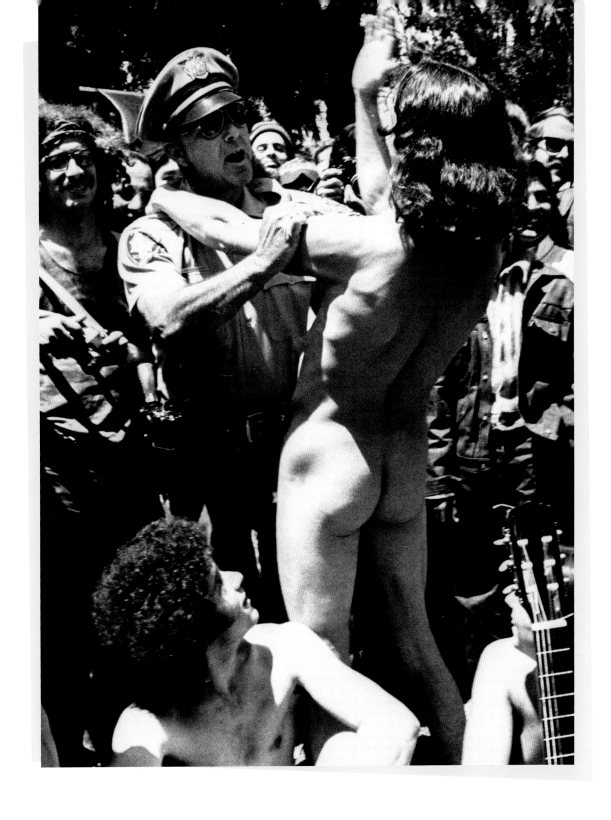

"They let you parade around like in a circus and it gives you an illusion of power. It's a shuck."

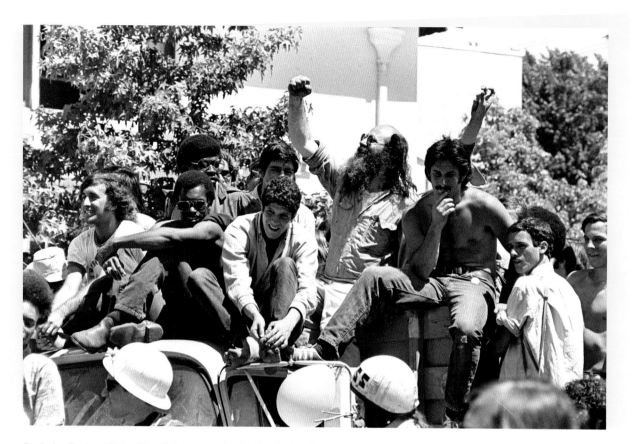

Berkeley Barb publisher Max Scherr pumping his fist during the Memorial Day march.

What It's Worth" by the Buffalo Springfield. But we fucked up. It was wonderful, fine, but the park was still there. It was the right thing to do, but it didn't get the park back.

CRAIG PYES
UC Berkeley undergraduate student
I marched in the Memorial Day march. The helicopter gassing had united the community. While the community may not have been on the side of the radicals, they didn't want their children gassed. It united the community against the occupying forces. Frank Bardacke gave a powerful speech against violence, saying that we would "take the street with kazoos."

HOWARD DRATCH
UC Berkeley graduate student in political theory
I saw the Memorial Day march as an act of deflation and loss—the bad guys had won. [At the same time,] the march was a celebration. My feelings were simple—the bad guys had won.

MICHAEL LERNER
UC Berkeley graduate student in philosophy and chapter president of Students for a Democratic Society (SDS)
I was very disappointed with the Memorial Day march. It was just a march, nothing else, and there was no articulation of ideas beyond People's Park. Opposing suppression was more important than the values articulated. The government had switched our attention. Instead of a radical discourse on private property and democracy and money, we were talking about our right to demonstrate. I longed for the idealism of the students in Paris who revolted in 1968, with their slogan of "Power to the Imagination."

John Lennon and Yoko Ono on KSAN

WES "SCOOP" NISKER
reporter and newscaster for KSAN radio

KSAN was the drumbeat of the counterculture. I had just gotten the job as news director. I changed the format from a shtick with ironic one-liners to sound and voice collages. They were the essence of what the news was. Because we were KSAN, it was possible to get the John and Yoko interview. After the interview, I got calls from the Red Tribe [a radical Berkeley collective]. They were pissed off because they thought that I'd been too light on John, that I should have gotten him to advocate more confrontational tactics. I was invited to a political consciousness–raising meeting where people were critical of Lennon, and of me as well for not trying to convince him of the need for confrontation.

SCOOP: There's a big march tomorrow on Memorial Day and we wish you could be here.

JOHN: Well, we send you our spirit. We will be there in spirit, you know, and good luck to the march and let's hope it just doesn't end up in another riot, you know, because I think marches are just tending to end up in riots and...but what we're sayin' is that there are many ways of protesting or celebrating, and maybe bed-ins is one of them or maybe it will inspire people to have other ideas, you know.

SCOOP: How else are we going to get our park back? How do you propose we get our park back?

JOHN: If Gandhi can get rid of the fascist British, you can get your park back. You must have experienced it, that violence begets violence, you know. I mean, the people have been trying to get things militantly for thousands of years, you know, and it never works. Take France, Russia, Britain, Ireland. All the places that have revolution through violence, all they got was another establishment doing exactly the same as the other one. What we've got to change is their heads, and San Francisco is one of the major centers for that, and it's a pity that "make love, not war" has become, turned out to be, a trendy cliché and the people don't believe it, you know, and if they can't wait a year or two and they think they're going to get it back, but they won't get it. It will take just as long to do it non-violently, and if they're that impatient, you know, as Yoko just said to someone here, you don't get a child and then stretch it into an adult, you've got to wait for it to grow, and peace is something like that and change is like that, and you won't get it by trying that and you won't get it by trying to push the barriers. You know, shaking fists at a building doesn't make the building fall down. If you smash the building down you've got to build it up again.

Wes "Scoop" Nisker, the KSAN reporter and news director who interviewed John Lennon and Yoko Ono about People's Park.

BERKELEY LIBERATION PROGRAM

THE PEOPLE OF BERKELEY PASSIONATELY DESIRE HUMAN SOLIDARITY, CULTURAL FREEDOM AND PEACE.

Berkeley is becoming a revolutionary example throughout the world. We are now under severe attack by the demons of despair, ugliness and fascism. We are being strangled by reactionary powers from Washington to Sacramento.

Our survival depends on our ability to overcome past inadequacies and to expand the revolution. We have not done enough to build a movement that is both personally humane and politically radical.

The people of Berkeley must increase their combativeness; develop, tighten, and toughen their organizations; and transcend their middle-class, ego-centered life styles. We shall resist our oppressors by establishing a zone of struggle and liberation, and of necessity shall defend it. We shall create a genuine community and control it to serve our material and spiritual needs. We shall develop new forms of democratic participation and new, more humane styles of work and play. In solidarity with other revolutionary centers and movements, our Berkeley will permanently challenge the present system and act as one of many training grounds for the liberation of the planet.

1 WE WILL MAKE TELEGRAPH AVENUE AND THE SOUTH CAMPUS A STRATEGIC FREE TERRITORY FOR REVOLUTION.

2 WE WILL CREATE OUR REVOLUTIONARY CULTURE EVERYWHERE.

3 WE WILL TURN THE SCHOOLS INTO TRAINING GROUNDS FOR LIBERATION.

4 WE WILL DESTROY THE UNIVERSITY UNLESS IT SERVES THE PEOPLE.

5 WE WILL STRUGGLE FOR THE FULL LIBERATION OF WOMEN AS A NECESSARY PART OF THE REVOLUTIONARY PROCESS.

6 WE WILL TAKE COMMUNAL RESPONSIBILITY FOR BASIC HUMAN NEEDS.

7 WE WILL PROTECT AND EXPAND OUR DRUG CULTURE.

8 WE WILL BREAK THE POWER OF THE LANDLORDS AND PROVIDE BEAUTIFUL HOUSING FOR EVERYONE.

9 WE WILL TAX THE CORPORATIONS, NOT THE WORKING PEOPLE.

10 WE WILL DEFEND OURSELVES AGAINST LAW AND ORDER.

11 WE WILL CREATE A SOULFUL SOCIALISM IN BERKELEY.

12 WE WILL CREATE A PEOPLE'S GOVERNMENT.

13 WE WILL UNITE WITH OTHER MOVEMENTS THROUGHOUT THE WORLD TO DESTROY THIS MOTHERFUCKING RACISTCAPITALISTIMPERIALIST SYSTEM.

WE CALL FOR SISTERS AND BROTHERS TO FORM LIBERATION COMMITTEES TO CARRY OUT THE BERKELEY STRUGGLE.

Sisters and Brothers,
Unite for Survival,
Resist and Create,
Fight for a Revolutionary Berkeley,
With your Friends, your Dope, your Guns,
Form Liberation Committees,
Carry Out the Program,
Choose the Action and Do It,
Set Examples and Spread the Word:

POWER TO THE IMAGINATION ALL POWER TO THE PEOPLE

The Berkeley Liberation Program

The thirteen-point Berkeley Liberation Program first appeared on page 16 of the *Berkeley Barb* in its issue of May 30–June 5, 1969. Within a few days it was reproduced as a full-size poster and a colorful leaflet. The program states that it was "written by several Berkeley Liberation Committees." In fact, Tom Hayden was its driving force.

On March 20, 1969, Hayden and seven others had been indicted by a federal grand jury and charged with various federal crimes stemming from anti–Vietnam War protests during the tumultuous Democratic National Convention in Chicago in 1968. The trial began on September 24, 1969. Hayden had spent most of the summer living in Berkeley preparing for the trial and had been around for the building of People's Park and the subsequent police actions.

Despite his standing as a Movement "heavy," Hayden did not assume a leadership role in People's Park. His only documented speech, at Sproul Plaza, was a modest call for unity: "We must unify ourselves now as a matter of necessity. This little community of Berkeley must be unified, must be invincible, must be strong, must find solidarity, must struggle, must have a program, and must be the rock on which this attempt to impose fascism is shattered."

JUDY GUMBO

Yippie and People's Park cofounder

Tom [Hayden] called together a group of twenty of his closest friends, including Stew [Albert] and me. Tom beckoned; we responded. We met at an art deco hotel in Oakland and put together what we titled the Berkeley Liberation Program. Modeled on the Black Panther Party ten-point platform and program, Tom's goal was to set out a political vision for Berkeley and the world. This vision, like the *Port Huron Statement* [put forth by SDS in 1962 to establish, in part, the guiding principles of the New Left], would be democratic, participatory, and ultimately socialist. (Remarks given at the memorial for Tom Hayden, held at the Mechanics' Institute, San Francisco, February 9, 2017)

THE BERKELEY LIBERATION PROGRAM

The people of Berkeley passionately desire human solidarity, cultural freedom and peace.

Berkeley is becoming a revolutionary example throughout the world. We are now under severe attack by the demons of despair, ugliness and fascism. We are being strangled by reactionary powers from Washington to Sacramento.

Our survival depends on our ability to overcome past inadequacies and to expand the revolution. We have not done enough to build a movement that is both personally humane and politically radical.

The people of Berkeley must increase their combativeness; develop, tighten, and toughen their organizations; and transcend their middle-class, ego-centered life styles. We shall resist our oppressors by establishing a zone of struggle and liberation, and if necessary shall defend it. We shall create a genuine community and control it to serve our material and spiritual needs. We shall develop new forms of democratic participation and new, more humane styles of work and play. In solidarity with other revolutionary centers and movements, our Berkeley will permanently challenge the present system and act as one of many training grounds for the liberation of the planet.

1. WE WILL MAKE TELEGRAPH AVENUE AND THE SOUTH CAMPUS A STRATEGIC FREE TERRITORY FOR REVOLUTION.

Historically this area is the home of political radicalism and cultural revolution. We will resist plans to destroy the South Campus through University-business expansion and pig assaults. We will create malls, parks, cafes and places for music and wandering. Young people leaving their parents will be welcome with full status as members of our community. Businesses on the Avenue should serve the humanist revolution by contributing their profits to the community. We will establish cooperative stores of our own, and combine them within an Avenue cooperative.

> **"Berkeley is becoming a revolutionary example throughout the world. We are now under severe attack by the demons of despair, ugliness and fascism."**

Right: Tom Hayden, principal author of the Berkeley Liberation Program and a founder of Students for a Democratic Society.

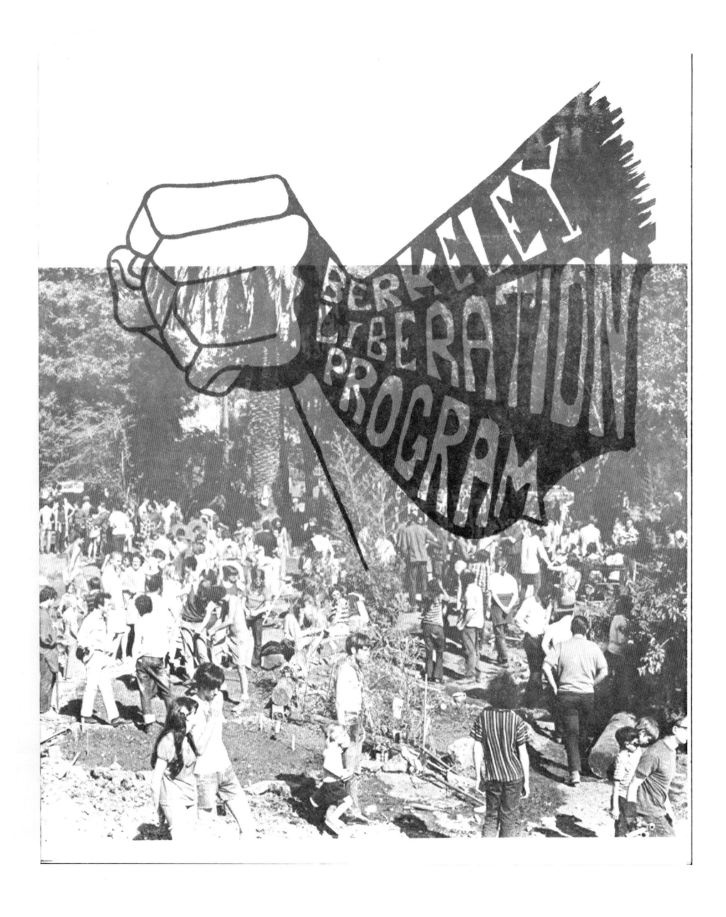

2. WE WILL CREATE OUR REVOLUTIONARY CULTURE EVERYWHERE.

Everyone should be able to express and develop himself through art—work, dance, sculpture, gardening and all means open to the imagination. Materials will be made available to all people. We will defy all puritanical restraints on culture and sex. We shall have media—newspapers, posters and leaflets, radio, TV, films and sky-writing to express our revolutionary community. We will stop the defiling of the earth; our relation to nature will be guided by reason and beauty rather than profit. The civilization of concrete and plastic will be broken and natural things respected. We shall set up urban and rural communes where people can meet for expression and communication. Many Berkeley streets bear little traffic and can be grassed over and turned into people's parks. Parking meters will be abolished and we will close areas of downtown and South Campus to automotive traffic. We shall celebrate the holidays of liberation with fierce dancing.

3. WE WILL TURN THE SCHOOLS INTO TRAINING GROUNDS FOR LIBERATION.

Beneath the progressive facade of Berkeley's schools, students continue to be regimented into accepting the existing system. The widely-celebrated integration of the schools is nothing in itself, and only perpetuates many illusions of white liberalism. The basic issue is creating an educational system in which students have real power and which prepares the young to participate in a revolutionary world. Students must destroy the senile dictatorship of adult teachers and bureaucrats. Grading, tests, tracking, demotions, detentions and expulsions must be abolished. Pigs and narcs have no place in a people's school. We will eliminate the brain-washing, fingernail-cutting mass production of junior cogs for tight-ass America's old age home war machine. Students will establish independent educational forms to create revolutionary consciousness while continuing to struggle for change in the schools.

4. WE WILL DESTROY THE UNIVERSITY UNLESS IT SERVES THE PEOPLE.

The University of California is not only the major oppressive institution in Berkeley but a major brain center for world domination. UC attempts to kill radical politics and culture in Berkeley while it trains robots for corporations and mental soldiers to crush opposition from Delano to Vietnam.

Students should not recognize the false authority of the regents, administration and faculty. All students have the right to learn what they want, from whom they want, and in the manner they decide; and the right to take political action without academic penalty. We will build a movement to make the University relevant to the Third World, workers, women and young people searching for human values and vocations. Our battles will be conducted in the classrooms and the streets.

We will shatter the myth that UC is a sacred intellectual institution with a special right to exist. We will change this deadly Machine which steals our land and rapes our minds, or we will stop its functioning. Education can only begin when we're willing to close the University for what we believe.

5. WE WILL STRUGGLE FOR THE FULL LIBERATION OF WOMEN AS A NECESSARY PART OF THE REVOLUTIONARY PROCESS.

While the material oppression of women varies in different classes, male supremacy pervades all social classes. We will resist this ideology and practice which oppresses all women. As we struggle to liberate ourselves, many of the problems of inequality, authoritarianism and male chauvinism in the Berkeley movement will be overcome.

We will create an unfettered identity for women. We will abolish the stifling masculine and feminine roles that this society forces on us all. Women will no longer be defined in terms of others than themselves—by their relationships to men and children. Likewise, men will not be defined by their jobs or their distorted role as provider. We seek to develop whole human beings and to bring together the most free and beautiful aspects of women and men.

We will end the economic oppression of women: job discrimination, the manipulation of women as consumers, and media exploitation of women as sexual objects.

We demand the full control of our own bodies and towards that end will establish free birth control and abortion clinics. We will choose our own sexual partners; we will eliminate the demeaning bustling scene in Berkeley which

let a hundred flowers bloom
—mao mao

THE PEOPLE OF BERKELEY PASSIONATELY DESIRE HUMAN SOLIDARITY, CULTURAL FREEDOM AND PEACE.

Berkeley is becoming a revolutionary example throughout the world. We are now under severe attack by the demons of despair, ugliness and fascism. We are being strangled by reactionary powers from Washington to Sacramento.

Our survival depends on our ability to overcome past inadequacies and to expand the revolution. We have not done enough to build a movement that is both personally humane and politically radical.

The people of Berkeley must increase their combativeness: develop, tighten, and toughen their organizations; and transcend their middle-class, ego-centered life styles. We shall resist our oppressors by establishing a zone of struggle and liberation, and of necessity shall defend it. We shall create a genuine community and control it to serve our material and spiritual needs. We shall develop new forms of democratic participation and new, more humane styles of work and play. In solidarity with other revolutionary centers and movements, our Berkeley will permanently challenge the present system and act as one of many training grounds for the liberation of the planet.

1 WE WILL MAKE TELEGRAPH AVENUE AND THE SOUTH CAMPUS A STRATEGIC FREE TERRITORY FOR REVOLUTION.

Historically this area is the home of political radicalism and cultural revolution. We will resist plans to destroy the South Campus through University-business expansion and pig assaults. We will create malls, parks, cafes and places for music and wandering. Young people leaving their parents will be welcome with full status as members of our community. Businesses on the Avenue should serve the humanist revolution by contributing their profits to the community. We will establish cooperative stores of our own, and combine them within an Avenue cooperative.

2 WE WILL CREATE OUR REVOLUTIONARY CULTURE EVERYWHERE.

Everyone should be able to express and develop himself through art—work, dance, sculpture, gardening and all means open to the imagination. Materials will be made available to all people. We will defy all puritanical restraints on culture and sex. We shall have media—newspapers, posters and leaflets, radio, TV, films and skywriting—to express our revolutionary community. We will stop the defiling of the earth; our relation to nature will be guided by reason and beauty rather than profit. The civilization of concrete and plastic will be broken and natural things respected. We shall set up urban and rural communes where people can meet for expression and communication. Many Berkeley streets bear little traffic and can be grassed over and turned into people's parks. Parking meters will be abolished and we will close areas of downtown and South Campus to automotive traffic. We shall celebrate the holidays of liberation with fierce dancing.

3 WE WILL TURN THE SCHOOLS INTO TRAINING GROUNDS FOR LIBERATION.

Beneath the progressive facade of Berkeley's schools, students continue to be regimented into accepting the existing system. The widely-celebrated integration of the schools is nothing in itself, and only perpetuates many illusions of white liberalism. The basic issue is creating an educational system in which students have real power and which prepares the young to participate in a revolutionary world. Students must destroy the senile dictatorship of adult teachers and bureaucrats. Grading, tests, tracking, demotions, detentions and expulsions must be abolished. Pigs and narcs have no place in a people's school. We will eliminate the brainwashing, fingernail-cutting mass production of junior cogs for tight-ass America's old age war machine. Students will establish independent educational forms to create revolutionary consciousness while continuing to struggle for change in the schools.

4 WE WILL DESTROY THE UNIVERSITY UNLESS IT SERVES THE PEOPLE.

The University of California is not only the major oppressive institution in Berkeley, but a major brain center for world domination. UC attempts to kill radical politics and culture in Berkeley while it trains robots for corporations and mental soldiers to crush opposition from Delano to Vietnam.

Students should not recognize the false authority of the regents, administration and faculty. All students have the right to learn what they want, from whom they want, and in the manner they decide; and the right to take political action without academic penalty. We will build a movement to make the University relevant to the Third World, workers, women and young people searching for human values and vocations. Our battles will be conducted in the classrooms and the streets.

We will shatter the myth that UC is a sacred intellectual institution with a special right to exist. We will change this deadly Machine which steals our land and rapes our minds, or we will stop its functioning. Education can only begin when we're willing to close the University for what we believe.

song of the earth spirit
origin legend

It is lovely indeed, it is lovely indeed,
I, I am the spirit within the earth.
The feet of the earth are my feet
The legs of the earth are my legs
The bodily strength of the earth is
 my bodily strength
The thoughts of the earth are
 my thoughts
The voice of the earth is my voice
The feather of the earth is my feather
All that belongs to the earth
 belongs to me
All that surrounds the earth
 surrounds me
I, I am the sacred words of the earth
It is lovely indeed, It is lovely indeed.

—navajo

5 WE WILL STRUGGLE FOR THE FULL LIBERATION OF WOMEN AS A NECESSARY PART OF THE REVOLUTIONARY PROCESS.

While the material oppression of women varies in different classes, male supremacy pervades all social classes. We will resist this ideology and practice which oppresses all women. As we struggle to liberate ourselves, many of the problems of inequality, authoritarianism and male chauvinism in the Berkeley movement will be overcome.

We will create an unfettered identity for women. We will abolish the stifling masculine and feminine roles that this society forces on us all. Women will no longer be defined in terms of others than themselves—by their relationships to men and children. Likewise, men will not be defined by their jobs or their distorted role as provider. We seek to develop whole human beings and to bring together the most free and beautiful aspects of women and men.

We will end the economic oppression of women: job discrimination, the manipulation of women as consumers, and media exploitation of women as sexual objects.

We demand the full control of our own bodies and towards that end will establish free birth control and abortion clinics. We will choose our own sexual partners; we will eliminate the demeaning hustling scene in Berkeley which results from male chauvinism and false competition among men and among women. We will not tolerate harrassment in the parks, streets, and public places of Berkeley.

We will resist all false concepts of chivalry and protectiveness. We will develop self-reliance and the skills of self defense. We will establish female communes so that women who so choose can have this free space to develop themselves as human beings. We will end all forms of male supremacy by ANY MEANS NECESSARY!

6 WE WILL TAKE COMMUNAL RESPONSIBILITY FOR BASIC HUMAN NEEDS.

High-quality medical and dental care, including laboratory tests, hospitalization, surgery and medicines will be made freely available. Child-care collectives staffed by both men and women, and centers for the care of strung-out souls, the old and the infirm will be established. Free legal services will be expanded. Survival needs such as crash pads, free transportation, switchboards, free phones, and free food will be met.

7 WE WILL PROTECT AND EXPAND OUR DRUG CULTURE.

We relate to the liberating potential of drugs for both the mind and the body politic. Drugs inspire us to new possibilities in life which can only be realized in revolutionary action. We intend to establish a drug distribution center and a marijuana cooperative. We recognize the right of people to use those drugs which are known from experience to be harmful. However, as a loving community we shall establish drug information centers and free clinics. We will resist the enforcement of all drug laws in our community. We will protect people from narcs and burn artists. All drug busts will be defined as political and we will develop all necessary defense for those arrested.

8 WE WILL BREAK THE POWER OF THE LANDLORDS AND PROVIDE BEAUTIFUL HOUSING FOR EVERYONE.

Through rent strikes, direct seizures of property and other resistance campaigns, the large landlords, banks and developers who are gouging higher rents and spreading ugliness will be driven out. We shall force them to transfer housing control to the community, making decent housing available according to people's needs. Coordinated housing councils will be formed on a neighborhood basis to take responsibility for rents and building conditions. The housing councils will work with architects to plan for a beautiful community. Space will be opened up and living communes and revolutionary families will be encouraged.

results from male chauvinism and false competition among men and among women. We will not tolerate harassment in the parks, streets, and public places of Berkeley.

We will resist all false concepts of chivalry and protectiveness. We will develop self-reliance and the skills of self-defense. We will establish female communes so that women who so choose can have this free space to develop themselves as human beings.

We will end all forms of male supremacy by ANY MEANS NECESSARY!

6. WE WILL TAKE COMMUNAL RESPONSIBILITY FOR BASIC HUMAN NEEDS. High-quality medical and dental care, including laboratory tests, hospitalization, surgery and medicines will be made freely available. Child-care collectives staffed by both men and women, and centers for the care of strung-out souls, the old and the infirm will be established. Free legal services will be expanded. Survival needs such as

> **"We will abolish the stifling masculine and feminine roles that this society forces on us all."**

9 **WE WILL TAX THE CORPORATIONS, NOT THE WORKING PEOPLE.**

The people cannot tolerate escalating taxes which are wasted in policing the world while businessmen are permitted to expand their profits in the midst of desperate social need. Berkeley cannot be changed without confronting the industries, banks, insurance companies, railroads and shipping interests dominating the Bay Area. In particular, University of California expansion which drives up taxes should be stopped and small homeowners should no longer pay property taxes. We will demand a direct contribution from business, including Berkeley's biggest business—the University, to the community until a nationwide assault on big business is successful.

10 **WE WILL DEFEND OURSELVES AGAINST LAW AND ORDER.**

America's rulers, faced with the erosion of their authority in Berkeley, begin to take on the grotesque qualities of a dictatorship based on pure police power. We shall abolish the tyrannical police forces not chosen by the people. States of emergency, martial law, conspiracy charges and all legalistic measures used to crush our movement will be resisted by any means necessary—from courtroom to armed struggle. The people of Berkeley must arm themselves and learn the basic skills and tactics of self defense and street fighting. All oppressed people in jail are political prisoners and must be set free. We shall make Berkeley a sanctuary for rebels, outcasts and revolutionary fugitives. We shall attempt to bring the real criminals to trial; where this is impossible we shall implement revolutionary justice.

11 **WE WILL CREATE A SOULFUL SOCIALISM IN BERKELEY.**

The revolution is about our lives. We will fight against the dominating Berkeley life style of affluence, selfishness, and social apathy—and also against the self-indulgent individualism which masquerades as "doing your own thing." We will find ways of taking care of each other as comrades. We will experiment with new ways of living together such as communal families in which problems of income, child care, and housekeeping are mutually shared. Within the Berkeley movement we will seek alternatives to the stifling elitism, egoism, and sectarianism which rightly turns people away and creates organizational weakness. We have had enough of supposed vanguards seeking to manipulate mass movements. We need vanguards of a new type—people who lead by virtue of their moral and political example; who seek to release and organize energy instead of channeling or curbing it; who seek power not for themselves but for the people as a whole. We firmly believe in organization which brings out the leadership and creativeness existing in everyone.

12 **WE WILL CREATE A PEOPLE'S GOVERNMENT.**

We will not recognize the authority of the bureaucratic and unrepresentative local government. We will ignore elections involving trivial issues and personalities. We propose a referendum to dissolve the present government, replacing it with one based on the tradition of direct participation of the people. People in motion around their own needs will become a decentralized government of neighborhood councils, workers councils, student unions, and different sub-cultures. Self-management in schools, factories, and neighborhoods will become commonplace. Locally chosen "people's mediators" will aid those desiring to settle disputes without referring to the illegitimate system of power.

13 **WE WILL UNITE WITH OTHER MOVEMENTS THROUGHOUT THE WORLD TO DESTROY THIS MOTHERFUCKING RACISTCAPITALISTIMPERIALIST SYSTEM.**

Berkeley cannot be free until America is free. We will make the American revolution with the mass participation of all the oppressed and exploited people. We will actively support the 10-point program of the Black Panther Party in the black colony; all revolutionary organizing attempts among workers, women, students and youth; all Third World liberation movements. We will create an International Liberation School in Berkeley as a training center for revolutionaries.

WE CALL FOR SISTERS AND BROTHERS TO FORM LIBERATION COMMITTEES TO CARRY OUT THE BERKELEY STRUGGLE.

These committees should be small democratic working groups of people able to trust each other. We should continually resist the monster system; our emphasis should be on direct action, organizing the community, and forming a network of new groups. Together as a Berkeley Liberation Movement, the liberation committees will build people's power and a new life.

Sisters and Brothers,
Unite for Survival,
Resist and Create,
Fight for a Revolutionary Berkeley,
With your Friends, your Dope, your Guns,
Form Liberation Committees,
Carry Out the Program,
Choose the Action and Do It,
Set Examples and Spread the Word:

POWER TO THE IMAGINATION
ALL POWER TO THE PEOPLE

FOR MORE INFORMATION CALL 549 - 3618 or 653 - 5642 or 549 - 2804

crash pads, free transportation, switchboards, free phones, and free food will be met.

7. WE WILL PROTECT AND EXPAND OUR DRUG CULTURE.

We relate to the liberating potential of drugs for both the mind and the body politic. Drugs inspire us to new possibilities in life which can only be realized in revolutionary action. We intend to establish a drug distribution center and a marijuana cooperative. As a loving community we shall establish drug information centers and free clinics. We will resist the enforcement of all drug laws in our community. We will protect people from narcs and burn artists. All drug busts will be defined as political and we will develop all necessary defense for those arrested.

8. WE WILL BREAK THE POWER OF THE LANDLORDS AND PROVIDE BEAUTIFUL HOUSING FOR EVERYONE.

Through rent strikes, direct seizures of property and other resistance campaigns, the large landlords, banks and developers who are gouging higher rents and spreading ugliness will be driven out. We shall force them to transfer housing control to the community, making decent housing available according to people's needs. Coordinated housing councils will be formed on a neighborhood basis to take responsibility for rents and building conditions. The housing councils—in work with architects to plan for a beautiful community space—will be opened up[,] and living communes and revolutionary families will be encouraged.

9. WE WILL TAX THE CORPORATIONS, NOT THE WORKING PEOPLE.

The people cannot tolerate escalating taxes which are wasted in policing the world while businessmen are permitted to expand their profits in the midst of desperate social need. Berkeley cannot be changed without confronting the industries, banks, insurance companies, railroads and shipping interests dominating the Bay Area. In particular, University of California expansion which drives up taxes should be stopped and small homeowners should no longer pay property taxes. We will demand a direct contribution from business, including Berkeley's

"We shall resist our oppressors by establishing a zone of struggle and liberation, and of necessity shall defend it."

BERKELEY LIBERATION PROGRAM

1 WE WILL MAKE TELEGRAPH AVENUE AND THE SOUTH CAMPUS A STRATEGIC FREE TERRITORY FOR REVOLUTION.

7 WE WILL PROTECT AND EXPAND OUR DRUG CULTURE.

2 WE WILL CREATE OUR REVOLUTIONARY CULTURE EVERYWHERE.

8 WE WILL BREAK THE POWER OF THE LANDLORDS AND PROVIDE BEAUTIFUL HOUSING FOR EVERYONE.

3 WE WILL TURN THE SCHOOLS INTO TRAINING GROUNDS FOR LIBERATION.

4 WE WILL DESTROY THE UNIVERSITY UNLESS IT SERVES THE PEOPLE.

9 WE WILL TAX THE CORPORATIONS, NOT THE WORKING PEOPLE.

5 WE WILL STRUGGLE FOR THE FULL LIBERATION OF WOMEN AS A NECESSARY PART OF THE REVOLUTIONARY PROCESS.

10 WE WILL DEFEND OURSELVES AGAINST LAW AND ORDER.

11 WE WILL CREATE A SOULFUL SOCIALISM IN BERKELEY.

6 WE WILL TAKE COMMUNAL RESPONSIBILITY FOR BASIC HUMAN NEEDS.

12 WE WILL CREATE A PEOPLE'S GOVERNMENT.

13 WE WILL UNITE WITH OTHER MOVEMENTS THROUGHOUT THE WORLD TO DESTROY THIS MOTHERFUCKING RACISTCAPITALISTIMPERIALIST SYSTEM.

WE CALL FOR SISTERS AND BROTHERS TO FORM LIBERATION COMMITTEES TO CARRY OUT THE BERKELEY STRUGGLE.

Sisters and Brothers,
Unite for Survival,
Resist and Create,
Fight for a Revolutionary Berkeley,
With your Friends, your Dope, your Guns,
Form Liberation Committees,
Carry Out the Program,
Choose the Action and Do It,
Set Examples and Spread the Word:

POWER TO THE IMAGINATION
ALL POWER TO THE PEOPLE

THE PEOPLE OF BERKELEY PASSIONATELY DESIRE HUMAN SOLIDARITY, CULTURAL FREEDOM AND PEACE.

Berkeley is becoming a revolutionary example throughout the world. We are now under severe attack by the demons of despair, ugliness and fascism. We are being strangled by reactionary powers from Washington to Sacramento.

Our survival depends on our ability to overcome past inadequacies and to expand the revolution. We have not done enough to build a movement that is both personally humane and politically radical.

The people of Berkeley must increase their combativeness; develop, tighten, and toughen their organizations; and transcend their middle-class, ego-centered life styles. We shall resist our oppressors by establishing a zone of struggle and liberation, and of necessity shall defend it. We shall create a genuine community and control it to serve our material and spiritual needs. We shall develop new forms of democratic participation and new, more humane styles of work and play. In solidarity with other revolutionary centers and movements, our Berkeley will permanently challenge the present system and act as one of many training grounds for the liberation of the planet.

1 WE WILL MAKE TELEGRAPH AVENUE AND THE SOUTH CAMPUS A STRATEGIC FREE TERRITORY FOR REVOLUTION.

Historically this area is the home of political radicalism and cultural revolution. We will resist plans to destroy the South Campus through University-business expansion and pig assaults. We will create malls, parks, cafes and places for music and wandering. Young people leaving their parents will be welcome with full status as members of our community. Businesses on the Avenue should serve the humanist revolution by contributing their profits to the community. We will establish cooperative stores of our own, and combine them within an Avenue cooperative.

2 WE WILL CREATE OUR REVOLUTIONARY CULTURE EVERYWHERE.

Everyone should be able to express and develop himself through art—work, dance, sculpture, gardening and all means open to the imagination. Materials will be made available to all people. We will defy all puritanical restraints on culture and sex. We shall have media—newspapers, posters and leaflets, radio, TV, films and skywriting—to express our revolutionary community. We will stop the defiling of the earth; our relation to nature will be guided by reason and beauty rather than profit. The civilization of concrete and plastic will be broken and natural things respected. We will set up urban and rural communes where people can meet for expression and communication. Many Berkeley streets bear little traffic and can be grassed over and turned into people's parks. Parking meters will be abolished and we will close areas of downtown and South Campus to automotive traffic. We shall celebrate the holidays of liberation with fierce dancing.

3 WE WILL TURN THE SCHOOLS INTO TRAINING GROUNDS FOR LIBERATION.

Beneath the progressive facade of Berkeley's schools, students continue to be regimented into accepting the existing system. The widely-celebrated integration of the schools is nothing in itself, and only perpetuates many illusions of white liberalism. The basic issue is creating an educational system in which students have real power and which prepares the young to participate in a revolutionary world. Students must destroy the senile dictatorship of adult teachers and bureaucrats. Grading, tests, tracking, demotions, detentions and expulsions must be abolished. Pigs and narcs have no place in a people's school. We will eliminate the brainwashing, fingernail-cutting mass production of junior cogs for tight-ass America's old age home war machine. Students will establish independent educational forms to create revolutionary consciousness while continuing to struggle for change in the schools.

4 WE WILL DESTROY THE UNIVERSITY UNLESS IT SERVES THE PEOPLE.

The University of California is not only the major oppressive institution in Berkeley, but a major brain center for world domination. UC attempts to kill radical politics and culture in Berkeley while it trains robots for corporations and mental soldiers to crush opposition from Delano to Vietnam.

Students should not recognize the false authority of the regents, administration and faculty. All students have the right to learn what they want, from whom they want, and in the manner they decide; and the right to take political action without academic penalty. We will build a movement to make the University relevant to the Third World, workers, women and young people searching for human values and vocations. Our battles will be conducted in the classrooms and the streets.

We will shatter the myth that UC is a sacred intellectual institution with a special right to exist. We will change this deadly Machine which steals our land and rapes our minds, or we will stop its functioning. Education can only begin when we're willing to close the University for what we believe.

5 WE WILL STRUGGLE FOR THE FULL LIBERATION OF WOMEN AS A NECESSARY PART OF THE REVOLUTIONARY PROCESS.

While the material oppression of women varies in different classes, male supremacy pervades all social classes. We will resist this ideology and practice which oppresses all women. As we struggle to liberate ourselves, many of the problems of inequality, authoritarianism and male chauvinism in the Berkeley movement will be overcome.

We will create an unfettered identity for women. We will abolish the stifling masculine and feminine roles that this society forces on us all. Women will no longer be defined in terms of others than themselves—by their relationships to men and children. Likewise, men will not be defined by their jobs or their distorted role as provider. We seek to develop whole human beings and to bring together the most free and beautiful aspects of women and men.

We will end the economic oppression of women: job discrimination, the manipulation of women as consumers, and media exploitation of women as sexual objects.

We demand the full control of our own bodies and towards that end will establish free birth control and abortion clinics. We will choose our own sexual partners; we will eliminate the demeaning hustling scene in Berkeley which results from male chauvinism and false competition among men and among women. We will not tolerate harrassment in the parks, streets, and public places of Berkeley.

We will resist all false concepts of chivalry and protectiveness. We will develop self-reliance and the skills of self defense. We will establish female communes so that women who so choose can have this free space to develop themselves as human beings. We will end all forms of male supremacy by ANY MEANS NECESSARY!

6 WE WILL TAKE COMMUNAL RESPONSIBILITY FOR BASIC HUMAN NEEDS.

High-quality medical and dental care, including laboratory tests, hospitalization, surgery and medicines will be made freely available. Child-care collectives staffed by both men and women, and centers for the care of strung-out souls, the old and the infirm will be established. Free legal services will be expanded. Survival needs such as crash pads, free transportation, switchboards, free phones, and free food will be met.

7 WE WILL PROTECT AND EXPAND OUR DRUG CULTURE.

Drugs are an integral part of our culture. We intend to establish drug distribution centers and marijuana cooperatives. We will continue to use drugs to inspire us to new visions of life knowing that these visions can only be realized through revolutionary action. We will discourage the use of drugs as an escape from involvement in struggle. Likewise we will fight against the use of such hard drugs as heroin and speed as harmful to both the individual and the community. Toward this end we will establish drug information centers and free clinics. While we attempt to learn and teach each other about drugs we will resist the enforcement of all drug laws in our community and develop all necessary defense for those arrested. We define all drug busts as political and will protect people from narcs as well as burn artists. We want a world where it is not a bummer to come down.

8 WE WILL BREAK THE POWER OF THE LANDLORDS AND PROVIDE BEAUTIFUL HOUSING FOR EVERYONE.

Through rent strikes, direct seizures of property and other resistance campaigns, the large landlords, banks and developers who are gouging higher rents and spreading ugliness will be driven out. We shall force them to transfer housing control to the community, making decent housing available according to people's needs. Coordinated housing councils will be formed on a neighborhood basis to take responsibility for rents and building conditions. The housing councils will work with architects to plan for a beautiful community. Space will be opened up and living communes and revolutionary families will be encouraged.

9 WE WILL TAX THE CORPORATIONS, NOT THE WORKING PEOPLE.

The people cannot tolerate escalating taxes which are wasted in policing the world while businessmen are permitted to expand their profits in the midst of desperate social need. Berkeley cannot be changed without confronting the industries, banks, insurance companies, railroads and shipping interests dominating the Bay Area. In particular, University of California expansion which drives up taxes should be stopped and small homeowners should no longer pay property taxes. We will demand a direct contribution from business, including Berkeley's biggest business—the University, to the community until a nationwide assault on big business is successful.

10 WE WILL DEFEND OURSELVES AGAINST LAW AND ORDER.

America's rulers, faced with the erosion of their authority in Berkeley, begin to take on the grotesque qualities of a dictatorship based on pure police power. We shall abolish the tyrannical police forces not chosen by the people. States of emergency, martial law, conspiracy charges and all legalistic measures used to crush our movement will be resisted by any means necessary—from courtroom to armed struggle. The people of Berkeley must arm themselves and learn the basic skills and tactics of self defense and street fighting. All oppressed people in jail are political prisoners and must be set free. We shall make Berkeley a sanctuary for rebels, outcasts and revolutionary fugitives. We shall attempt to bring the real criminals to trial; where this is impossible we shall implement revolutionary justice.

11 WE WILL CREATE A SOULFUL SOCIALISM IN BERKELEY.

The revolution is about our lives. We will fight against the dominating Berkeley life style of affluence, selfishness, and social apathy—and also against the self-indulgent individualism which masquerades as "doing your own thing." We will find ways of taking care of each other as comrades. We will experiment with new ways of living together such as communal families in which problems of income, child care, and housekeeping are mutually shared. Within the Berkeley movement we will seek alternatives to the stifling elitism, egoism, and sectarianism which rightly turns people away and creates organizational weakness. We have had enough of supposed vanguards seeking to manipulate mass movements. We need vanguards of a new type—people who lead by virtue of their moral and political example; who seek to release and organize energy instead of channeling or curbing it; who seek power not for themselves but for the people as a whole. We firmly believe in organization which brings out the leadership and creativeness existing in everyone.

12 WE WILL CREATE A PEOPLE'S GOVERNMENT.

We will not recognize the authority of the bureaucratic and unrepresentative local government. We will ignore elections involving trivial issues and personalities. We propose a referendum to dissolve the present government, replacing it with one based on the tradition of direct participation of the people. People in motion around their own needs will become a decentralized government of neighborhood councils, workers councils, student unions, and different sub-cultures. Self-management in schools, factories, and neighborhoods will become commonplace. Locally chosen "people's mediators" will aid those desiring to settle disputes without referring to the illegitimate system of power.

13 WE WILL UNITE WITH OTHER MOVEMENTS THROUGHOUT THE WORLD TO DESTROY THIS MOTHERFUCKING RACISTCAPITALISTIMPERIALIST SYSTEM.

Berkeley cannot be free until America is free. We will make the American revolution with the mass participation of all the oppressed and exploited people. We will actively support the 10-point program of the Black Panther Party in the black colony; all revolutionary organizing attempts among workers, women, students and youth; all Third World liberation movements. We will create an International Liberation School in Berkeley as a training center for revolutionaries.

WE CALL FOR SISTERS AND BROTHERS TO FORM LIBERATION COMMITTEES TO CARRY OUT THE BERKELEY STRUGGLE.

These committees should be small democratic working groups of people able to trust each other. We should continually resist the monster system; our emphasis should be on direct action, organizing the community, and forming a network of new groups. Together as a Berkeley Liberation Movement, the liberation committees will build people's power and a new life.

Sisters and Brothers,
Unite for Survival,
Resist and Create,
Fight for a Revolutionary Berkeley,
With your Friends, your Dope, your Guns,
Form Liberation Committees,
Carry Out the Program,
Choose the Action and Do It,
Set Examples and Spread the Word:

POWER TO THE IMAGINATION
ALL POWER TO THE PEOPLE

FOR MORE INFORMATION CALL 549 - 3618 or 653 - 5642 or 549 - 2804

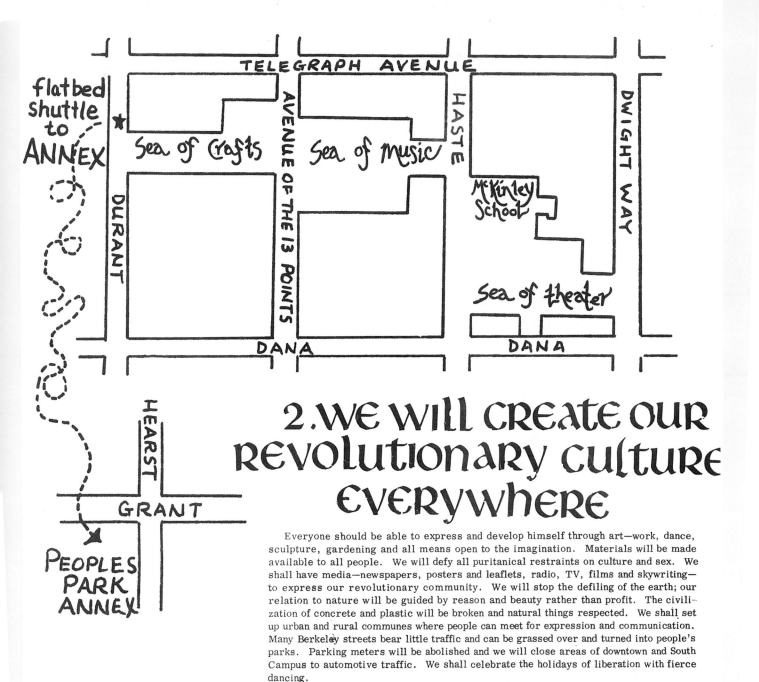

2. WE WILL CREATE OUR REVOLUTIONARY CULTURE EVERYWHERE

Everyone should be able to express and develop himself through art—work, dance, sculpture, gardening and all means open to the imagination. Materials will be made available to all people. We will defy all puritanical restraints on culture and sex. We shall have media—newspapers, posters and leaflets, radio, TV, films and skywriting—to express our revolutionary community. We will stop the defiling of the earth; our relation to nature will be guided by reason and beauty rather than profit. The civilization of concrete and plastic will be broken and natural things respected. We shall set up urban and rural communes where people can meet for expression and communication. Many Berkeley streets bear little traffic and can be grassed over and turned into people's parks. Parking meters will be abolished and we will close areas of downtown and South Campus to automotive traffic. We shall celebrate the holidays of liberation with fierce dancing.

BERKELEY LIBERATION PROGRAM

POWER
to the
imagination

all power
to the people

biggest business—the University—to the community until a nationwide assault on big business is successful.

10. WE WILL DEFEND OURSELVES AGAINST LAW AND ORDER.

America's rulers, faced with the erosion of their authority in Berkeley, begin to take on the grotesque qualities of a dictatorship based on pure police power. We shall abolish the tyrannical police forces not chosen by the people. States of emergency, martial law, conspiracy charges and all legalistic measures used to crush our movement will be resisted by any means necessary—from courtroom to armed struggle. The people of Berkeley must arm themselves and learn the basic skills and tactics of self-defense and street fighting. All oppressed people in jail are political prisoners and must be set free. We shall make Berkeley a sanctuary for rebels, outcasts and revolutionary fugitives. We shall attempt to bring the real criminals to trial; where this is impossible we shall implement revolutionary justice.

11. WE WILL CREATE A SOULFUL SOCIALISM IN BERKELEY.

The revolution is about our lives. We will fight against the dominating Berkeley lifestyle of affluence, selfishness, and social apathy—and also against the self-indulgent individualism which masquerades as doing your own thing. We will find ways of taking care of each other as comrades. We will experiment with new ways of living together such as communal families in which problems of income, child care, and housekeeping are mutually shared. Within the Berkeley movement we will seek alternatives to the stifling elitism, egoism, and sectarianism which rightly turns people away and creates organizational weakness. We have had enough of supposed vanguards seeking to manipulate mass movements. We need vanguards of a new type—people who lead by virtue of their moral and political example; who seek to release and organize energy instead of channeling or curbing it; who seek power not for themselves but for the people as a whole. We firmly believe in organization which brings out the leadership and creativeness existing in everyone.

12. WE WILL CREATE A PEOPLE'S GOVERNMENT.

We will not recognize the authority of the bureaucratic and unrepresentative local government. We will ignore elections involving trivial issues and personalities. We propose a referendum to dissolve the present government, replacing it with one based on the tradition of direct participation of the people. People in motion around their own needs will become a decentralized government of neighborhood councils, workers councils, student unions, and different sub-cultures. Self-management in schools, factories, and neighborhoods will become commonplace. Locally chosen people's mediators will aid those desiring to settle disputes without referring to the illegitimate system of power.

13. WE WILL UNITE WITH OTHER MOVEMENTS THROUGHOUT THE WORLD TO DESTORY THIS MOTHERFUCKING RACISTCAPITALIST-IMPERIALIST SYSTEM.

Berkeley cannot be free until America is free. We will make the American revolution with the mass participation of all the oppressed and exploited people. We will actively support the 10-point program of the Black Panther Party in the black colony; all revolutionary organizing attempts among workers, women, students and youth; all Third World liberation movements. We will create an International Liberation School in Berkeley as a training center for revolutionaries.

WE CALL FOR SISTERS AND BROTHERS TO FORM LIBERATION COMMITTEES TO CARRY OUT THE BERKELEY STRUGGLE.

These committees should be small democratic working groups of people able to trust each other. We should continually resist the monster system; our emphasis should be on direct action, organizing the community, and forming a network of new groups. Together as a Berkeley Liberation Movement, the liberation committees will build people's power and a new life.

POWER TO THE IMAGINATION
ALL POWER TO THE PEOPLE
(*Berkeley Barb,* May 30–June 5, 1969)

Hayden's work on the Berkeley Liberation Program invites a comparison with the *Port Huron Statement,* the 1962 political manifesto of the Students for a Democratic Society, written largely by Hayden, who had visited Berkeley in 1960 and been inspired by SLATE. The Berkeley Liberation Program includes an allusion to the French student and worker uprising of 1968, in which "Power to the Imagination, All Power to the People," the slogan coined by the Situationists, was alluding to the "All Power to the Soviets" slogan of Russia's October Revolution. The Berkeley Liberation Program's use of the term "strategic free zone" foreshadows the work of George Katsiaficas and the theory of temporary autonomous zones and liberated zones.

ART ECKSTEIN
UC Berkeley graduate student in history
Hayden's Berkeley Liberation Program was not written in language that fit Berkeley. Ironically, the one point of the program that has come to fruition is point 7—"We will protect and expand our drug culture." It is the least New Left and the most informed by the counterculture of all the points.

The program served one purpose well—as antithesis or foil for Governor Reagan and his ongoing demonization of Berkeley and Berkeley radicals.

THE "PEOPLE'S PARK": A REPORT ON A CONFRONTATION AT BERKELEY, CALIFORNIA
Before dismissing this hazy mixture of Marxism and vulgarity as the prattling of a few anonymous "revolutionaries," it should be remembered that it was just this sort of anonymous declaration that launched the "People's Park" controversy. (California Governor's Office, July 1, 1969)

The Berkeley Liberation Program did not take hold in Berkeley. In general, the New Left was splintering, as seen by the schism within SDS at its June 1969 convention and, closer to home, in the rift between the *Berkeley Barb* and the *Berkeley Tribe.* Berkeley radicals had always favored action over words, and the Berkeley Liberation Program did not change that.

"Berkeley cannot be free until America is free."

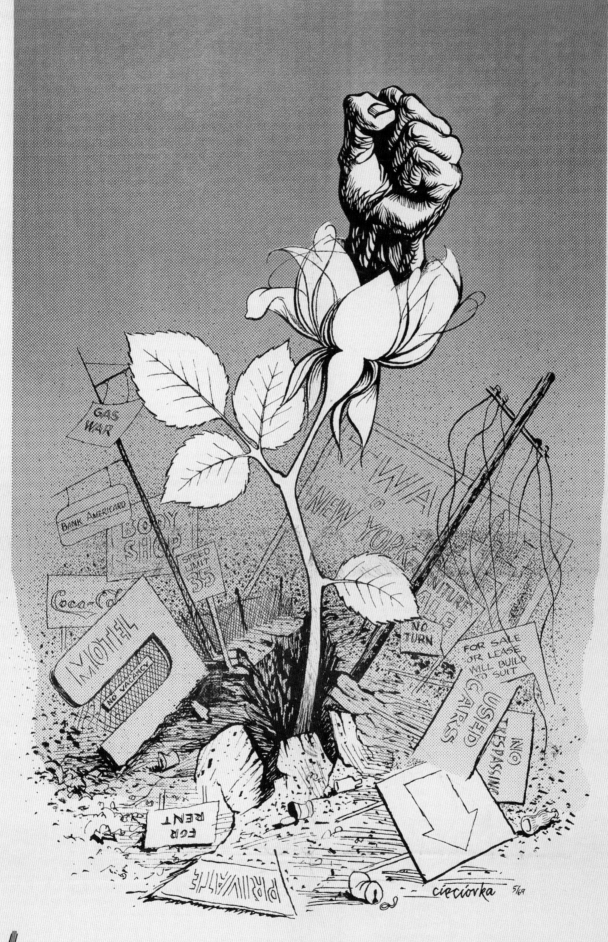

Let a thousand parks bloom...

"Let a thousand parks bloom"

Support for the original vision of the park did not end with the Memorial Day march. Under the banner of Bastille Day, on July 14, 1969, protestors marched to People's Park and used bolt cutters baked into loaves of bread to take the fence down. A battle ensued, after which the fence around the park was rebuilt. It remained in place until May 1972, when a large crowd protesting President Nixon's announcement that the United States would mine North Vietnamese harbors dismantled the fence.

In subsequent years, periodic disturbances arose over the development and use of the park, most notably the 1979 protests over the parking lot on the western end and the 1991 protests over the construction of volleyball courts on the northern end. In August 1992, police shot and killed a park activist named Rosebud Denovo after she broke into the chancellor's mansion on campus. The park's history between 1969 and 2009 is told well in Terri Compost's *People's Park: Still Blooming.*

"Let a thousand parks bloom"—an allusion to the People's Republic of China's Hundred Flowers Campaign, which urged citizens to speak openly about problems besetting the communist government—became a People's Park slogan. A few parks bloomed.

In the summer of 1969, park activists launched the "People's Pad" project in an effort to deal with the expected influx of young people to Berkeley. As part of the program, they convinced the school district to lease a group of World War II navy barracks, known as Savo Island, to the Telegraph Avenue Summer Project, an organization of merchants, clergymen, and street people committed to providing food, shelter, jobs, and medical care to those who needed it. The People's Pad idea ultimately faltered and failed—not because of City pressure but because black neighbors opposed the project, noting that they had not been consulted.

The one lasting People's Park spin-off was the People's Park Annex, part of the strip of land on the north side of Hearst between Sacramento and Martin Luther King Jr. Way. It remained undeveloped after houses were demolished to facilitate completion of the underground Richmond line of the BART (Bay Area Rapid Transit) transportation system. Almost immediately after the university fenced in People's Park, activists began developing several blocks of the strip near McGee and Grant Streets into the People's Park Annex. There were skirmishes with the National Guard and police, but the park was allowed to exist.

The City acquired the land from BART, after which a local effort by neighbors George Garvin, David Axelrod, Martha Nicoloff, Charlotte Pye, and others kicked in. People's Architecture, a group of Leftist architects including Les Shipnuck and Jim Burleigh, published an alternative plan for the Hearst strip in the fall of 1969. Buildings of different shapes and sizes, including a large geodesic dome and an irregular cluster of row houses, suggested a kind of collaborative building effort in which the distinctions between park and city, public and private, dissolved. Those plans were never realized, but the Annex exists today as Ohlone Park. People's Park cofounder and Yippie Judy Gumbo says that "Ohlone Park today is what we had in mind for People's Park. Trees and grass and kid stuff and dog stuff."

Meanwhile, Governor Reagan continued to press his "that mess in Berkeley" narrative. On July 1, 1969, the Governor's Office published a brochure in defense of all that Reagan and law enforcement had done:

EXCERPTS FROM *THE "PEOPLE'S PARK": A REPORT ON A CONFRONTATION AT BERKELEY, CALIFORNIA*

The "People's Park" site is within a block of the 2400 block of Telegraph Avenue, a well-known gathering place long frequented by student and non-student militants, New Left orators, hippies, assorted groups of self-proclaimed revolutionary "street people" and radical activists whose presence and occasional illegal activities have been a source of constant concern to residents, merchants, and law enforcement officials in the area.

In the past 11 months, preceding the "People's Park" crisis, three other major riots erupted in Berkeley. All included so-called "street people" and other militants from the South Campus area. That is the background of violence that preceded the "People's Park" confrontation.

During the period April 28–May 14, Berkeley police received a total of 48 formal complaints regarding "People's Park."

The anonymous developers could not form a responsible group with whom we could deal. The representatives of the "people" refused to accept the basic premise: that the design and use of the area was finally the responsibility of the university, no matter how flexible the design or how liberal the use.

Radical leaders summoned the university hangers-on and compatible students to defend the "park," bringing sticks, stones, steel bars and whatever weapons came to mind and hand. Handbills exhorted, "Kill! Kill!" Thus, the theme of violence was sounded before a single policeman or National Guardsman appeared on the scene.

A young man named James Rector drew the fatal card. He was the victim of the radical leaders' cunning zeal and they compensated him for his life by accounting him a martyr.

The final speaker was Daniel Siegel, U.C. Student Body President-Elect. According to campus police who were present and taped the entire event, the crowd becomes visibly excited during Siegel's speech. Scores of people began screaming, yelling, and raising clenched fists above their heads.

Those on the rooftops had stockpiled a good supply of rocks and other missiles. They kept up a steady barrage. Stockpiles of rocks, steel rods and bottles were also observed in nearby alleys.

As the sheriff's deputies moved in they were showered with missiles from the rooftops. Some deputies responded with shotgun blasts in an effort to clear the rooftops of those who were hurling missiles down into the streets. Shotgun blasts also were fired at street level. Some of the wounded said they were not demonstrating. (California Governor's Office, July 1, 1969)

The grand jury report, released on November 7, 1969, echoed the Reagan administration's version of events:

ALAMEDA COUNTY GRAND JURY REPORT

The action of revolutionists, militant leaders and publications have been determined to have caused a violent confrontation. All the people who became a part of the riotous mass that spearheaded the push toward the Park, without regard for the rights of others, precipitated a street confrontation.

UC: Sufficient leadership was not provided to uphold a firm and unequivocal stand in protecting and maintaining University property.

Law enforcement: There was insufficient coordination of the various law enforcement agencies at the command level. The use of stronger methods of riot control was necessary to prevent the loss of life and property. There were isolated cases of all such weapons being used indiscriminately.

City: The City did not insist upon the complete enforcement of existing laws and ordinances to maintain health and safety standards which were flagrantly violated at People's Park.

The community at large: Many citizens hindered the restoration of order by loitering in the streets because of curiosity.

Recommendation: We do not recommend the use of aircraft for the dispersal of tear gas in highly populated areas.

Reagan's animus had a chilling effect. Because of their political activities in Berkeley, both Art Goldberg and Dan Siegel had to fight the State Bar to get admitted to practice law after passing the bar examination. In the same vein, the university regents fired radical civil rights activist and UCLA assistant professor Angela Davis in part for her "inflammatory" speeches: "We deem particularly offensive such utterances as her statement that the regents 'killed, brutalized (and) murdered' the People's Park demonstrators, and her repeated characterizations of the police as 'pigs.'"

Twelve sheriff's deputies were indicted for their actions on Telegraph Avenue on May 15 and at Santa Rita on May 22. According to the *Los Angeles Times* of February 19, 1970, thousands of law enforcement supporters protested the indictments. Sheriff Frank Madigan said that the indictments were "one of the sickest operations of government I have ever seen. We tried to defend the government, and we tried to get the federal government to assist us, and we never got assistance. In war you are allowed to retaliate."

Not one person from law enforcement was convicted on any charge arising from the violent suppression of the protest or the mistreatment of prisoners at Santa Rita after the May 22 mass arrests. There was extensive civil litigation, which journalist Seth Rosenfeld estimates resulted in more than $1 million paid in settlement of the claims.

On May 4, 1970, almost a year after Bloody Thursday, the Ohio National Guard opened fire on the campus of Kent State University during a demonstration protesting the American invasion of Cambodia. Four students were killed. Jeffrey Glenn Miller was killed instantly. Sandra Lee Scheur bled out where she fell. William Knox Schroeder died from a chest wound an hour later in surgery. Allison Beth Krause was also shot in the chest and died later that day. Eight Guardsmen were indicted; none were convicted.

The band Crosby, Stills, Nash & Young recorded "Four Dead in Ohio" about the Kent State shootings on May 21 at the Record Plant studios in Los Angeles. It was mastered quickly and released by early June, which meant that it was heard on the radio only a few weeks after the killings, a remarkably quick turnaround time for the era.

Donovan Rundle, one of the students who was shot by an Alameda County sheriff's deputy on Bloody Thursday, was then living in Los Angeles and was involved in the rock-and-roll scene. Rundle was friends with Bruce Berry, a roadie for Crosby, Stills, Nash & Young, and it was through Berry and the group's other roadies that Rundle heard the song before its release. Neil Young's lyrics are haunting. It is difficult to imagine their effect on Rundle less than a year after he was shot and almost killed.

Several days after the Memorial Day march, Governor Reagan withdrew the National Guard from Berkeley. People's Park was left empty, desolate, and fenced in.

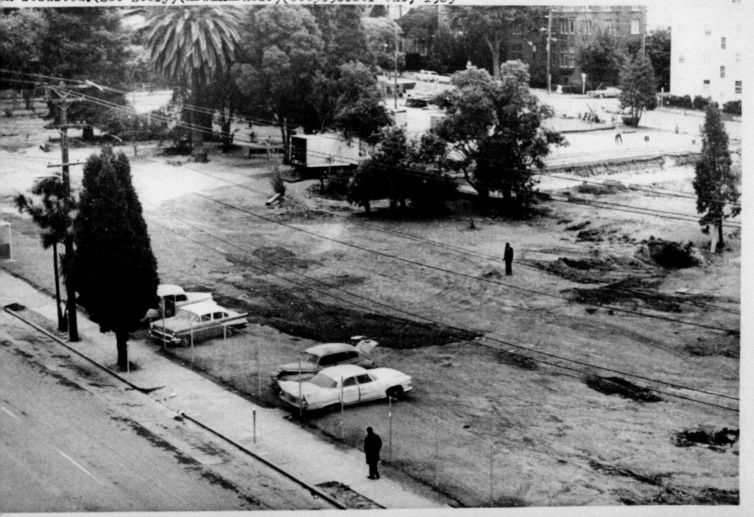

What's Going On?

On May 15, 1969, Renaldo "Obie" Benson, the bass singer for the Four Tops, who were touring in the Bay Area, was struck by the violence taking place at People's Park. Benson told Ben Edmonds, author of *Marvin Gaye: What's Going On and the Last Days of the Motown Sound,* that he had asked himself, "What is happening here? Why are they sending kids so far away from their families overseas? Why are they attacking their own children in the streets?" He spoke of what he had seen with Al Cleveland, a songwriter for the Motown record label. Cleveland wrote and composed "What's Going On?" in response to Benson's observations. The Four Tops decided not to record the song because, Benson said, they saw it as a protest song, and so in 1970 Benson offered the song to Marvin Gaye. The song struck Gaye, whose brother had come back from Vietnam a changed man. Gaye added a new melody and tweaked the lyrics, coming up with the song as we now know it, with its plea for an end to war, brutality, and escalation, and its call for love to conquer hate.

Afterword

Steve Wasserman

Berkeley in the years that I came of age was heady with the scent of night jasmine and tear gas. It whipsawed, sometimes violently, between clichés, from the Age of Aquarius to the Age of Apocalypse and back. Months before the first sod was rolled on the abandoned lot that became People's Park, and long before white kids found themselves in the crosshairs of shotgun-wielding police, Berkeley was rife with rebellion. I well recall the evening in February 1969 when hundreds of us, exhausted from a day of battling cops seeking to break the Third World Liberation Front strike at the University of California, trooped down to the Berkeley Community Theatre on the campus of Berkeley High School, where I was a sixteen-year-old junior, hoping to find relief in the much-ballyhooed provocations of Julian Beck and Judith Malina's Living Theatre.

Much to our surprise, the production of *Paradise Now* was a bust. What was an outrage to mainstream sensibilities elsewhere—nearly nude members of the troupe intoning mantras of prohibition against smoking pot and sexing it up in public—was greeted by the solemn radicals and spirited anarchists of Berkeley as feeble and largely empty gestures. "Super Joel" Tornabene, one of the town's more colorful and ubiquitous characters—and someone who would go on to play a prominent role in founding and fighting for People's Park— stood up and loudly denounced Beck and Malina for their faux-radicalism, then lit a joint and began to disrobe. Others quickly followed. Hundreds surrounded the couple, angrily demanding that their tickets be refunded. Dozens of debates erupted all around—over the nature of drama and the character of revolution. The show did not go on. The audience stormed the stage. Finally, at midnight, the fire marshals arrived and kicked us out. Beck and Malina had inadvertently achieved what had previously eluded them: goading the audience into taking collective action, seizing the moment, arguing over whether to remain passive spectators or become actors in a drama of their own making.

Steve Wasserman, newly elected student body president of Berkeley High School and principal organizer of the school's "sleep-in" to protest the military occupation of Berkeley, waves to friends during the Memorial Day march.

"Bedazzled as we were by the spectacle of our own high ideals and the intoxications of making history, we perhaps might be forgiven for mistaking the theater in the streets as the main event."

It was unforgettable. I also remember the denouement: no sooner had the Living Theatre departed than, the next day, a furious Governor Ronald Reagan arrived and threatened to deploy the National Guard, in addition to the hundreds of police from throughout Northern California that already filled the streets. Reagan would make good on that promise just three months later when he declared martial law and sent troops to occupy our obstreperous town and to crush the fever-dream of Berkeley as Liberated Zone that had so inflamed the imagination of many of us who had helped create and defend People's Park.

Bedazzled as we were by the spectacle of our own high ideals and the intoxications of making history, we perhaps might be forgiven for mistaking the theater in the streets as the main event, while failing to tumble to another high drama taking place, as it were, offstage prior to Bloody Thursday. We were deaf, alas, to the malign fugue that was being played within the inner circles of the old order. For years Berkeley, a small American hamlet, had been a harbor for upstart students who had won for it an outsize international reputation as a magnetic pole of rebellion. And for years the state had waged a two-front struggle—one open and without apology, the other often invisible and illegal—to stamp out opponents, real and imagined, to its rule.

Berkeley called itself the "Athens of the West," a moniker meant to summon its origins and promise as the mid-nineteenth-century site of the fabled first campus of the University of California. The conceit suggested the agora of ancient Greece, where citizens would freely debate the issues of the day and Socratic dialogues would occur about the meaning and purpose of life. Educating citizens to build and manage the expanding American imperium was at the center of this great project, born of the lofty ambitions of California progressivism. This publicly funded university and its eight (now ten) other campuses throughout the state, which any qualified high school student could attend for a paltry annual cost, were the pride of California. The University of California had, by almost any measure, quickly joined the ranks of the private Ivy League institutions that dominated the higher tiers of elite American education. Its students counted themselves among America's best and brightest. Robert McNamara would remember, with not a little nostalgia, the protests

he participated in as an undergraduate during the 1930s—protests he would have occasion to recall decades later when, as a principal architect of the Vietnam War, he would be condemned as a war criminal by students at his alma mater (and not only there).

From the militant longshoremen's strikes and upheavals of the Great Depression through efforts by Communist spies in the late 1940s and '50s to steal the nation's atomic secrets at Berkeley's Lawrence Radiation Laboratory, to the forcing of loyalty oaths upon the campus's professoriat, Berkeley—and San Francisco, too—had long been regarded by the grim men in Sacramento and Washington as breeding grounds of subversion. For years, J. Edgar Hoover and his Federal Bureau of Investigation had sought to stamp out suspected traitors. By the mid-1960s, the FBI's San Francisco Bay Area offices boasted several hundred agents. Hoover's obsessions would keep the hive humming.

The Bay Area was engulfed by multiple and successive student protests. The most notable included the anti-HUAC protests of 1960; the great civil-rights sit-ins of the spring of 1964 at the Sheraton-Palace Hotel in San Francisco, along with the Auto Row demonstrations seeking an end to racial discrimination, which began in late 1963 and continued through the spring of 1964; the Free Speech Movement in the fall of 1964, followed by one of the nation's first teach-ins, organized by the Vietnam Day Committee in May 1965; and, three months later, the efforts to prevent the passage of troop trains through Berkeley. Then came the founding of the Black Panther Party in 1966 and the riotous antidraft demonstrations in Oakland in 1967, then the use of tear gas to disperse the May 1968 demonstration on the corner of Haste and Telegraph to show solidarity with striking French students, followed by the violent effort to break the Third World Liberation Front strike at Cal in February 1969, and culminating in the ruthless suppression of People's Park protestors in May 1969, which saw the death of one onlooker and the blinding of another, the indiscriminate gassing of the campus by a National Guard helicopter, the imposition of martial law, and the month-long occupation of the entire city by thousands of armed troops.

❝It is hard from this remove, fifty years later, to apprehend what Greil Marcus called the 'moods of rage, excitement, loneliness, fatalism, [and] desire' that buffeted Berkeley and the world in those turbulent years.❞

"The stark and brutal smashing of our hopes was a hammer blow."

It is hard from this remove, fifty years later, to apprehend what Greil Marcus called the "moods of rage, excitement, loneliness, fatalism, [and] desire" that buffeted Berkeley and the world in those turbulent years. Upheaval was the order of the day: from New York to London, Paris to Prague, Mexico City to Chicago, Berlin to Berkeley, the zeitgeist seemed to be one of extraordinary possibility. Bourgeois sensibilities were everywhere mocked, as was solemnity; a spirit of ribald anarchy was in the air, and traditional strictures governing postwar life began to fray. The search for authenticity was ubiquitous. Conventions fell. The nature of the drama that was engulfing whole societies became a subject for media frenzy and individual quest. Making history became both an individual and collective imperative. The personal became political and vice versa. Passivity and complacency were out; activism and participation were in. The upwelling of People's Park embodied these yearnings.

The stark and brutal smashing of our hopes was a hammer blow.

The immediate aftermath of People's Park coincided with a growing romance with ideology and a sense that the apocalypse loomed. Despair deepened; extremism beckoned. Berkeley in those years contained less a politics than a collection of extremely seductive moral sympathies. Many people also worried, along with Wendy Schlesinger, one of the park's most committed founders, that the peaceable communitarian idealism that had given birth to the park was sullied by cynical radicals, mostly men, peacocks of the counterculture, seeking to deliberately provoke the authorities to overreact. My high school mates and I had organized a "sleep-in" of several hundred students who refused to leave the high school campus while the city was occupied by police and the National Guard. Watching our friends get arrested, gassed, and beaten pushed us to a dark and foreboding place. Soon some of us began organizing ourselves into "affinity groups" and enrolling in "radical collectives," preparing ourselves for the Armageddon that we feared would soon be upon us. Some of the more radical musketeers cut each other with knives in order to practice sewing up the wounds we were sure would be inflicted upon us as we mounted the barricades. We went to nearby rifle ranges to practice on the M1 carbines and shotguns we thought we would need to defend ourselves against the savageries of the nation's police and agents provocateurs.

I remember vividly the day Neil Armstrong walked on the moon. I had accompanied Tom Hayden and Stew Albert to the United Front Against Fascism conference in Oakland that had been organized by the Black Panther Party. Afterward, we repaired to the stucco home on Ashby Avenue where Tom and Stew lived to watch the historic moon landing. While Walter Cronkite was nearly overcome narrating the descent, depicted in studio animation, Stew smoked a joint, Tom steadily drank cheap red wine, and I spotted, through an open closet door, Stew's .30-06 rifle.

A year later, at Kent State in Ohio, four white students were killed protesting the widening war in Indochina while, two weeks later, two black kids were gunned down at Jackson State in Mississippi. The iron fist of the state played well with an electorate who saw us as little more than petulant brats who ought no longer to be indulged by hardworking taxpayers. The strategy worked. Ronald Reagan catapulted to national prominence and would embark on his ultimately successful campaign to win the White House ten years later and to launch the long counterrevolution to undo the achievements of the New Deal.

People's Park, in the end, could reasonably be regarded as a largely self-inflicted wound—a wound that revealed our naiveté as a noose by which the right wing sought to hang an entire movement opposed to the imperial Moloch that Allen Ginsberg had so eloquently denounced. The entire sorry chapter of its crushing can be seen, in retrospect, to have been part of a familiar story of suppression: police attacks on peaceful demonstrators, the secret (and often successful) efforts to encourage extremism in order to isolate dissenters, and the open campaign to enfeeble resistance by wielding the state's powerful legal truncheon, thus draining the Left's always meager treasury and depriving it of its most able leaders. Such tactics encouraged the politics of paranoia. The result, as the late social critic Christopher Lasch so clearly understood, "imprisoned the left in a politics of theater, of dramatic gestures, of style without substance—a mirror image of the politics of unreality which it should have been the purpose of the left to unmask."

But we did not need Reagan's or Sheriff Madigan's uniformed hooligans to prompt us to embrace the terrible logic of politics as a total art form. We came all on our own to believe that only by increasingly provocative spectacle could we arouse the outrage of our fellow citizens. It is we—and not just the Blue Meanies—who elevated extremism to the level of strategy. It was a dialectic of defeat.

Meanwhile, Lot 1875-2 lay untended for decades, an open, suppurating sore. Fitful efforts to revive it would recur. It became a purgatory for the homeless and the drug-addled walking wounded, a refuge for runaways, and a magnet for dropouts and the deranged. Today Cal's overseers plot its final vanishing, unsentimentally regarding the blood-soaked lot as a site to build much-needed student housing in an increasingly gentrified town whose aging rebels blow hard upon the embers of their halcyon youth. A struggle for memory and against forgetting is reignited amid hopes for a peaceful resolution of a battle that, for some, has never truly ended. A half century after Berkeley's Bloody Thursday, its legacy is still not well understood. A more subtle sense of what a historical moment contains is needed. Perhaps such an autopsy won't mean that the moment of exhausted possibilities is at hand.

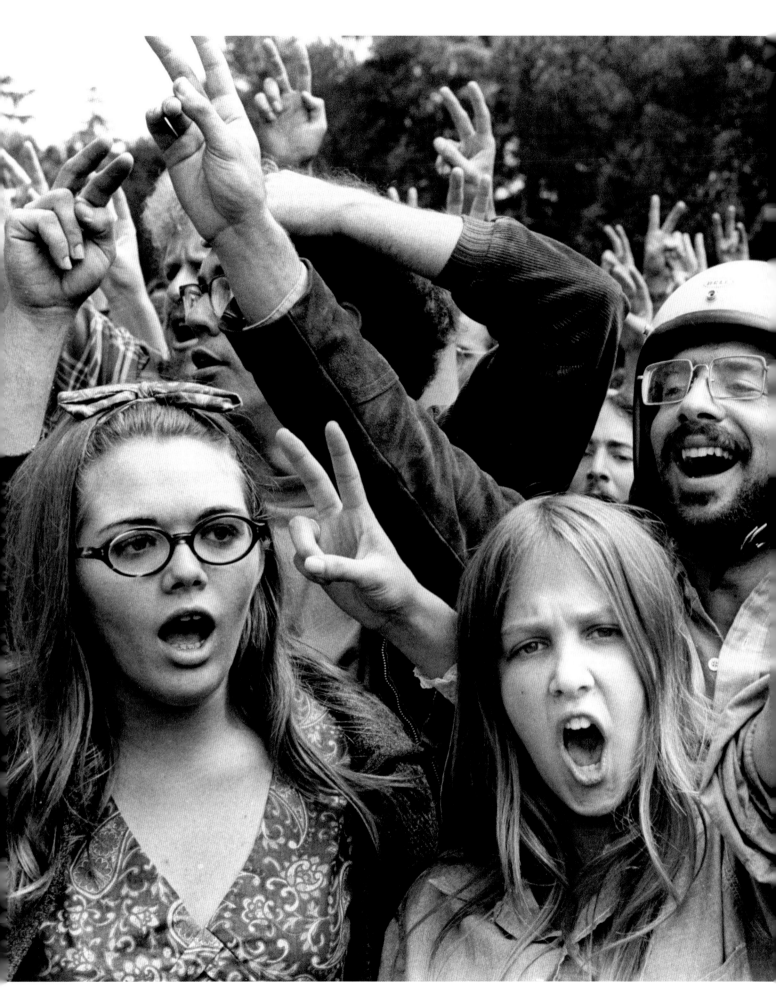

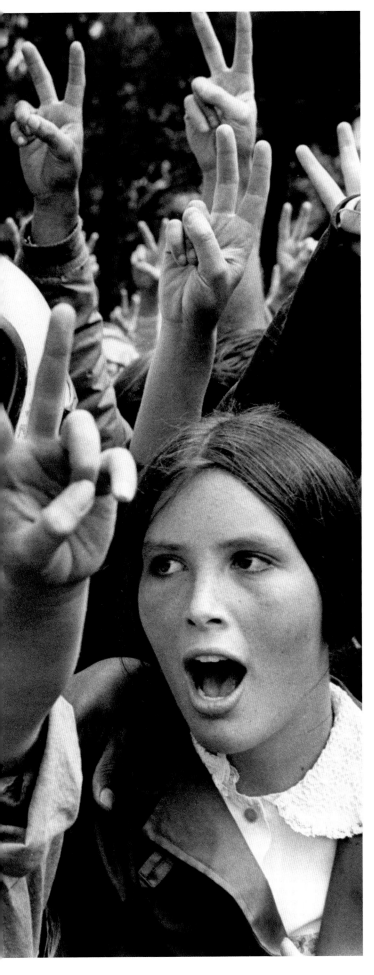

> **"A struggle for memory and against forgetting is reignited amid hopes for a peaceful resolution of a battle that, for some, has never truly ended."**

Berkeley High School students protest. From left to right: unidentified, Kathleen Wasser, and Danza Squire, age sixteen.

Voices

Stew Albert ran for sheriff of Alameda County in 1970, the year after People's Park. He lost to Frank Madigan, the incumbent since 1963, but won sixty-five thousand votes. In 1984, Stew and his partner, Judy Gumbo, moved to Portland, Oregon. They coedited an anthology, *The Sixties Papers: Documents of a Rebellious Decade*, and Stew also wrote a memoir, *Who the Hell Is Stew Albert?* He died of liver cancer at age sixty-six on January 30, 2006; two days earlier, he had blogged, "My politics have not changed."

Bob Avakian was born in 1943 and is chairman of the Revolutionary Communist Party, USA, a Marxist-Leninist-Maoist organization he founded in 1975. The son of a liberal Berkeley judge, Spurgeon Avakian, he is the author of numerous pamphlets and books, including a memoir, *From Ike to Mao and Beyond: My Journey from Mainstream America to Revolutionary Communist.*

Jondavid Bachrach, a litigation attorney, practices law in New York.

Frank Bardacke left Berkeley in 1970 and moved to the Monterey Peninsula to work in an antiwar G.I. coffeehouse. He then worked for six years on a celery-picking crew, taught at the Watsonville Adult School, and now teaches at Cal State Monterey Bay. He is the author of *Trampling Out the Vintage: Cesar Chavez and the Two Souls of the United Farm Workers.*

William P. Beall, Jr., became chief of the Berkeley Police Department in 1966 and left the post on April 30, 1969, succeeded by Bruce R. Baker. He went on to become the chief of the University of California Police Department. He died in 2008.

Peter Bergel lives in Oregon and remains a lifelong social-change activist and song leader.

Alan Blanchard left Berkeley. In the aftermath of his blinding, his marriage collapsed, and several years later he remarried in Northern California, then moved to Oregon and had two children. He died in 1999, never having spoken to his second wife or children about People's Park and the circumstances of losing his sight.

Doug Bogen, now known as Doug Cooper, is a leading authority on the computer programming language Pascal.

Nacio Jan Brown remained in Berkeley and kept taking photographs. He photographed virtually all of the major antiwar and social protest movement activities in the Bay Area. In 1975, he published the book *Rag Theater*, which documented street life on the 2400 block of Telegraph Avenue in Berkeley from 1969 to 1973.

Wendel Brunner earned a Ph.D. and an M.D. and from 1979 until 1983 was a primary care physician in Richmond, California. For the next twenty-five years he was Director of the Public Health Division for Contra Costa Health Services, from which position he recently retired.

Mal Burnstein continued to practice law for more than thirty years after People's Park. In the summer of 1971 he mentored a young intern in the office by the name of Hillary Rodham. He remained steadfast in his defense of civil rights and civil liberties. He lives in Berkeley.

John Burton served in the California State Assembly, the California State Senate, the U.S. House of Representatives, and is a former chairman of the California Democratic Party.

Mandy Carter left California in 1982 for North Carolina, where she worked on behalf of black, lesbian, gay, bisexual, and transgender rights.

Jim Chanin became a civil rights lawyer in 1977. He is best known for his representation of a large number of African American clients who suffered persistent civil rights abuses by members of the Oakland Police Department known as "the Riders." His career has focused on prevention and prosecution of police abuse.

Earl "Budd" Cheit, named vice chancellor of the University of California in 1965, was appointed to serve as dean of UC Berkeley's business school in 1976, during a time of state funding cuts and campus enrollment cutbacks. He retired in 1991 and died in 2014.

Eldridge Cleaver, the author of *Soul on Ice*, among other works, and the former Minister of Information of the Black Panther Party, spent the first half of the 1970s in self-imposed exile in Cuba, Algeria, and France. He returned to the United States in 1975 to a splintered Black Panther Party and spent the later years of his life as a conservative Republican and, in succession, an evangelical Christian, a follower of the Reverend Sun Myung Moon, and a Mormon. He died at age sixty-two in 1998 in Pomona, California.

Pat and Fred Cody sold Cody's Books in 1977 to Andy Ross, a prominent Bay Area bookseller and former clerk for Fred Cody. Fred died in 1983, on the store's twenty-seventh anniversary. Pat died in 2010.

Alan Copeland, photographer, went on to cover environmental and social issues in the American Southwest, as well as local stories including the 1978 assassinations of San Francisco mayor George Moscone and supervisor Harvey Milk. He taught digital photography at Vista College (now Berkeley City College) in the 1990s. He died in 2012.

George Csicsery works as a writer and independent filmmaker, having produced thirty-five documentaries on historical, ethnographic, cultural, and mathematical subjects. He lives in Oakland.

Tom Dalzell first came to Berkeley in the summer of 1968 while working for Cesar Chavez and the United Farm Workers in Delano. He worked for the UFW during the summers of 1968–1971 and then full-time from 1972 to 1980. He is now the elected leader of Local 1245 of the International Brotherhood of Electrical Workers. He has written extensively on slang and is the author of the *Quirky Berkeley* blog and books. The blog includes accounts of various progressive activists in Berkeley from the 1960s and 1970s. He has lived in Berkeley since 1984.

Michael Delacour, now in his eighties, still defends People's Park. Over the past fifty years, he has remained politically active and committed to the park's survival. To pay the bills, he has at times worked as a boilermaker and truck driver. He lives in Berkeley with his daughter, Vanessa, and grand-nephew, Dusk.

George Deukmejian served as attorney general of California from 1979 until 1983, and then as governor from 1983 until 1987. He was a dedicated supporter of the death penalty and a crusader against marijuana. He died in 2018.

Carolyn Dewald is an emerita professor of classical studies at Bard College. Before Bard she taught classics at Stanford, the University of Southern California, and Vassar. She has published books on Herodotus and Thucydides.

Art Eckstein is a professor of history and a Distinguished Scholar-Teacher at the University of Maryland, College Park. He is a specialist in the history of the Hellenistic world and Roman imperialism under the Republic. He wrote *Bad Moon Rising: How the Weather Underground Beat the FBI and Lost the Revolution*. In 2017, he married Judy Gumbo.

Richard Ehrenberger is a practicing architect and active in the Berkeley Architectural Heritage Association.

Reese Erlich is an author and freelance journalist who writes for CBS Radio, the Australian Broadcasting Corporation, and National Public Radio, among other outlets. He has won numerous journalism awards, including a Peabody. His most recent book is *Inside Syria: The Backstory of Their Civil War and What the World Can Expect*.

Marvin Garson was publisher of the *San Francisco Express Times,* which was known as *Good Times* from April 1969 until it ceased publication in 1972. Under the pseudonym Marvin Slobodkin, he wrote a book, *Inside Dope,* about the hopes and fate of the 1960s.

Paul Glusman, founder of Concerned Stalinists for Peace, was admitted to the California Bar in 1975 and has practiced as a labor and employment attorney in Berkeley.

Art Goldberg successfully fought and won admission to the California Bar and eventually left Berkeley for Los Angeles. His law practice, the Working People's Law Center in Echo Park, offers legal counsel on a sliding-scale basis to economically underprivileged members of the community.

Mitchell Goodman, born in 1923, was married to poet Denise Levertov. His 1961 antiwar novel, *The End of It*, was praised by, among others, William Carlos Williams, Norman Mailer, and Gloria Emerson. He is perhaps best known for his role in the Vietnam draft resistance movement that led to the federal prosecution of the Boston Five, of which he was a member. He died in 1997.

Joe Grodin became a labor lawyer, representing unions, and was appointed to the Agricultural Labor Relations Board by Governor Jerry Brown in 1975. He went on to serve as a Presiding Justice of the California Courts of Appeal and as an Associate Justice of the California Supreme Court. Voters removed him from the Supreme Court as part of a large-scale voter revolt based on his opposition to the death penalty. He lives in Berkeley.

Judy Gumbo is one of the few female members of the original Yippies, a satirical protest group that levitated the Pentagon to stop the Vietnam War, brought the New York Stock Exchange to a halt to ridicule greed, and ran a pig for president of the United States at the 1968 Democratic National Convention. She went on to write for the *Berkeley Barb* and *Berkeley Tribe.* She is the widow of Stew Albert and is currently completing a memoir.

Peter Haberfeld worked for the United Farm Workers as a staff attorney, and then in a political private practice, all the while doing community organizing work. He is now retired.

Loni Hancock was elected to the Berkeley City Council in 1971 and later became the city's first female mayor. She went on to serve in the State Assembly, the State Senate, and the administrations of Presidents Jimmy Carter and Bill Clinton.

William Hanley resigned as city manager of Berkeley in December 1971 under pressure from the mayor and four newly elected progressive members of the city council. He was later hired as city manager of nearby Hayward.

Tom Hayden used the summer of 1969 to prepare for his upcoming trial in Chicago on conspiracy charges stemming from the violent police riot that greeted protestors at the 1968 Democratic National Convention. He joined a radical collective in Berkeley called the Red Family and was ultimately

expelled, accused of hubris and misogyny. He fled into internal exile in Venice, California. After marrying actress and antiwar activist Jane Fonda, he founded the Indochina Peace Campaign. In 1976, he started the Campaign for Economic Democracy and ran for state senator, losing to incumbent John Tunney but later winning electoral office and serving for many years in the California State Assembly and State Senate. He died in 2016 at age seventy-six, on the eve of the publication of his book *Hell No: The Forgotten Power of the Vietnam Peace Movement.*

Roger Heyns stepped down as chancellor of UC Berkeley in 1971 and left the city. He returned to teaching for a time before becoming president of the American Council on Education in Washington, D.C. He ended his career by serving for sixteen years as an executive of the William and Flora Hewlett Foundation. He died in 1995.

Lowell Jensen was the district attorney of Alameda County from 1969 to 1981. He held several jobs in the U.S. Department of Justice from 1981 until 1986, when President Reagan appointed him to the United States District Court for the Northern District of California. He retired in 2014.

Wallace Johnson ended his term as mayor of Berkeley in 1971. He led the fight to have the proposed BART subway line through Berkeley built underground, and convinced Berkeley voters to increase local taxes to bury the tracks. He died in 1979.

Jacaeber Kastor lives in New York, where he deals in used record albums and posters from the Golden Age of Rock.

Randy Kehler worked as the Suffolk County reporter for *Newsday* and remained a peace activist. He also has taught religion at Bluffton University, a Christian liberal arts college affiliated with the Mennonite Church.

Roy Kepler, a lifelong advocate of radical pacifism until his death in 1994, had turned his bookstore over to his son in 1980. The store closed in 2005 but reopened several months later, financed by community investments, volunteers, and donations.

Michael Lerner moved to Seattle, where he was indicted as one of the Seattle Seven, a group of antiwar protestors led by Lerner, who was branded by J. Edgar Hoover as "one of the most dangerous criminals in America." He went on to receive a doctorate in philosophy in 1972 from UC Berkeley. He has worked as a teacher, been ordained as a rabbi without seminary training, created a worker center for providing mental health services, and founded the journal *Tikkun: A Bimonthly Jewish Critique of Politics, Culture and Society.* He is currently the rabbi of Beyt Tikkun Synagogue in Berkeley and is the author of numerous books, including *Jews and Blacks: Let the Healing Begin.*

Denise Levertov spent much of her time after People's Park teaching English at Brandeis University, MIT, Tufts University, Stanford University, and the University of Washington. She continued with poetry readings and political activism until her death in 1997.

Hubert Lindsey continued his Bible-thumping street preaching. Late in life he was blind and in a wheelchair, but he persisted in his campus exhortations. He died in 2003.

David Lodge returned to his native England and taught English at the University of Birmingham. He retired in 1987 to become a full-time writer and is the author of many novels, including *Changing Places*, loosely based on his year in Berkeley. Anthony Burgess called him "one of the best novelists of his generation."

Frank Madigan remained Alameda County Sheriff until 1975, having defeated Stew Albert's insurgent campaign for sheriff in 1971. In 1973, he opened the Work Furlough Center in Oakland, the only facility in the state designed specifically for inmate work-release programs. He died in 1979, unrepentant for his role in the events surrounding People's Park.

Greil Marcus became arguably the most influential rock critic in America, going on to write many books, including *Mystery Train: Images of America in Rock 'n' Roll*; *Lipstick Traces: A Secret History of the Twentieth Century*; and *The History of Rock 'n' Roll in Ten Songs*. He lives with his wife, Jenny, in Oakland.

Ed Meese remained an influential member of the inner circle of Governor and later President Ronald Reagan. He served as Reagan's attorney general, was the principal author of the Attorney General's Commission on Pornography, and came under considerable fire for his role investigating the Iran–Contra Affair.

Michael Meo became an adjunct professor of mathematics at Portland State University and is active in the Pacific Green Party of Oregon.

Dave Minkus has been a research associate and coordinator of the graduate fellows program at the Institute for Societal Issues at UC Berkeley for more than thirty years. He has focused on access to employment and training within Latino ethnic enclaves.

Frank Newman was an associate justice of the California Supreme Court from 1977 until 1982, then a professor of international law at the UC Berkeley School of Law until 1988, and a scholar and advocate of reform in the field of international human rights law. He died in 1996.

Wes "Scoop" Nisker continued his career in radio, notably at the San Francisco station KFOG. He wrote several books, including his 1994 work whose title was the catchphrase for which he was best known: "If you don't like the news, go out and make some of your own." He also became a teacher at the Spirit Rock Meditation Center in Marin County, California.

Charlie Palmer graduated from UC Berkeley and went to law school at Yale. He ultimately became a partner in the Los Angeles office of Perkins Coie, handling complex commercial litigation and defending employers against claims of wrongful termination, discrimination, harassment, and wage and

hour violations. He did a great deal of public interest work until 2002, when Governor Gray Davis appointed him to the Superior Court of Los Angeles, where he still serves.

Thomas Parkinson continued teaching English, especially poetry, at UC Berkeley. He wrote extensively about Hart Crane, Yvor Winters, and Robert Lowell. He retired in 1991 and died the next year.

Robert Peckham remained on the bench of the United States District Court until 1988. He presided over a number of high-publicity cases, including the desegregation of the San Francisco Police Department and the use of I.Q. testing in California schools. He died in 1993.

Craig Pyes went on to found the short-lived *Sundance* magazine, which focused on politics and the counterculture. Today, he is a private investigator and a correspondent for the Center for Investigative Reporting, specializing in international investigations. He shared a 2002 Pulitzer Prize for explanatory reporting at the *New York Times* for stories on the threat of Al Qaeda prior to 9/11, and was a member of the small *New York Times* team that won the 1998 Pulitzer Prize for international reporting for articles about the corrosive effects of drug corruption in Mexico. He lives in Ojai, California.

Jon Read worked as a landscape architect in the East Bay until the early 1990s, when he moved to Tucson. He was politically active there, especially with the issue of civilian review of the police. He died in 2008.

Ronald Reagan served as president of the United States from 1981 until 1989. He died in 2004.

Barbara Rhine worked as a staff attorney with the United Farm Workers Union from 1973 to 1975 in Stockton, Merced, Fresno, and Delano. After a stint at a rural commune in Northern California, she taught law for ten years at Golden Gate School of Law in San Francisco. Since 1998, she has had her own law practice in Oakland, California, focusing on legal issues affecting children.

Lawrence Riche resigned from the Alameda County Sheriff's Department in late 1969, before he was indicted for his actions during the battle for People's Park. He continued his career in law enforcement with the Foster City and Belmont police departments. He died in 2009.

Ruth Rosen earned her doctorate in history at UC Berkeley in 1976. She went on to teach at UC Davis and UC Berkeley. She is the author of several books, including *The World Split Open: How the Modern Women's Movement Changed America*.

Michael Rossman spent most of his adult years teaching science to young students, first at the Berkeley School, then at Ecole Bilingue de Berkeley. For twenty-five years he also helped run Camp Chrysalis, a summer program that took children to state parks around Northern California. The author of several books, including *The Wedding Within the War* and *Learning Without a Teacher*, he died of cancer in 2008, at age seventy-eight.

Jerry Rubin went on to write several books, including *Do It!: Scenarios of the Revolution*; *We Are Everywhere*; and *Growing (Up) at 37*, a self-lacerating memoir in which he grappled with his addiction to being a media celebrity and a "movement heavy." He retreated from politics and became an early avatar and booster of what later would be called "networking," creating a precursor to Facebook and LinkedIn, all the while promoting new companies producing solar and other alternative-energy sources. He died jaywalking across Wilshire Boulevard in the Westwood neighborhood of Los Angeles in 1994; he was fifty-six.

Donovan Rundle moved to Los Angeles and graduated from UCLA. He has endured many surgeries since 1969 and has struggled to understand why someone who didn't know him tried to kill him when he was doing nothing wrong. He has found some degree of peace through reading, yoga, and the love of his family.

Mario Savio, who became internationally renowned as the leader of the 1964 Free Speech Movement, taught mathematics, philosophy, and logic at Sonoma State University. He died in 1996 at age fifty-three.

Robert Scheer worked for nearly thirty years as a national correspondent and columnist for the *Los Angeles Times*. He went on to found the award-winning online magazine *Truthdig*. He is the author of many books, including *How the U.S. Got Involved in Vietnam*; *Thinking Tuna Fish, Talking Death: Essays on the Pornography of Power*; and, most recently, *They Know Everything About You: How Data-Collecting Corporations and Snooping Government Agencies Are Destroying Democracy*. He divides his time between Los Angeles, where he teaches at the University of Southern California, and Berkeley.

Dove Sholom Scherr went back to school after People's Park, spending a year at a free school where she could run around barefoot and there were no classes, and then going back to public school. In her twenties, she built schools and houses for peasant farmers during the Contra War against the Sandinista government in Nicaragua. She has two teenagers and lives in Berkeley.

Jane Scherr separated from Max Scherr in the 1970s and initiated one of America's first palimony lawsuits after Max ignored community property laws and failed to pay child support. Jane later married civil rights lawyer Don Jelinek, who died in 2016. She still lives in Berkeley.

Max Scherr was the founder and editor of the *Berkeley Barb,* one of the country's first alternative weeklies. He died in 1981 at age sixty-five.

Wendy Schlesinger earned her master's degree in journalism from UC Berkeley and was a central organizer of the Berkeley Tenants Union. She has remained a committed eco-feminist progressive and is a longtime advocate of martial arts training for women. She is the author of the unpublished *The Creation of the People's Park (and Other Political Events): A Love Story from a Leader's Point of View*, written in the fall of 1969.

Eugene Schoenfeld continued writing columns and books containing medical advice for the hippie generation, and he became a pioneering radio personality on Bay Area stations in the 1970s. He now practices psychiatry in Sausalito.

Dave Seabury has worked for Urban Ore, the East Bay Center for Creative Reuse, and Ohmega Salvage, and for nearly twenty years he has been the Waste Reduction Coordinator for the Presidio Trust in San Francisco, specializing in architectural salvage. He plays in a number of bands, including the Psycotic Pineapple.

Bobby Seale, a cofounder of the Black Panther Party, spent several years after People's Park successfully defending himself on various charges, from conspiring to violently protest the 1968 Democratic National Convention to ordering the murder of a Panther informant in New Haven, Connecticut. He ran for mayor of Oakland in 1973, losing in a run-off to the incumbent mayor. In 1974, disagreement with Panther leader Huey P. Newton led him to quit the Black Panther Party. He has remained politically active, working with youth education programs, teaching black studies, and lecturing at more than eight hundred colleges and universities throughout the country. Most recently, he is the coauthor, with Stephen Shames, of *Power to the People: The World of the Black Panthers*, published in 2016 on the occasion of the fiftieth anniversary of the founding of the party.

Charles Sellers continued teaching at UC Berkeley in the history department, focusing on and writing about the American South. He is a professor emeritus and lives in Berkeley.

Stephen Shames continued to take remarkable photographs and is the author of many books, including *Power to the People: The World of the Black Panthers* (with coauthor Bobby Seale), *Bronx Boys,* and *Outside the Dream: Child Poverty in America.* He lives in Brooklyn, New York.

Dan Siegel was admitted to the California Bar after protracted litigation. He has practiced law for almost fifty years, often representing workers. He has been active in Oakland politics, acting as legal adviser to the mayor, serving eight years on the board of directors of the Oakland Unified School District, and running for mayor.

Denny Smithson was a host and reporter at Berkeley's KPFA radio for nearly fifty years and was a longtime employee of Cody's Books. He died in 2014.

Leigh Steinberg resigned from his position as ASUC president because of a cheating scandal. He graduated from UC Berkeley with a B.A. in political science in 1970 and a J.D. in 1973. He became a high-profile sports agent, representing more than three hundred professional athletes.

Sol Stern left Berkeley for New York and in that migration swung from Left to Right. His collaboration with Ronald Radosh in probing the evidence against Julius and Ethel Rosenberg compelled him to conclude that the Rosenbergs had indeed been guilty of spying for the Soviet Union. He also disagreed with mounting New Left critiques of Israel. He is the author of several books,

including *Breaking Free: Public School Lessons and the Imperative of School Choice,* and is a regular contributor to the *Wall Street Journal.*

Wilmont Sweeney served as a municipal court judge and then a superior court judge. He was a longtime advocate of finding alternatives to detention centers for juveniles, such as rehabilitation and counseling. He died in 1999.

Robert Tracy is an emeritus professor of English and Celtic studies. He lives in Berkeley.

Sim Van der Ryn was appointed California State Architect by Governor Jerry Brown in the late 1970s, and he developed the first U.S. government–initiated energy-efficient office building program and promoted the adoption of energy standards and disability-access standards for all construction in California. He founded the Farallones Institute to create national awareness of "ecologically integrated living design." He is an emeritus professor of architecture at UC Berkeley.

Julia Vinograd continued to write poetry and remained a ubiquitous and beloved Berkeley character until her death at age seventy-five in late 2018.

Steve Wasserman graduated from UC Berkeley in 1974 with a degree in criminology. He went on to become deputy editor of the Op-Ed Page and Opinion section of the *Los Angeles Times* and was later the paper's Book Review editor. He was also editorial director of New Republic Books; Hill and Wang at Farrar, Straus & Giroux; and Times Books at Random House. Most recently, he was editor at large for Yale University Press, until 2016, when he became publisher and executive director of Heyday, in Berkeley.

Henry Weinstein, after thirty years as a legal-affairs reporter for the *Los Angeles Times,* is currently a professor of law and literary journalism at UC Irvine.

Sheldon Wolin left Berkeley in the fall of 1971 for UC Santa Cruz, where he taught until 1972. From 1973 through 1987, he was a professor of politics at Princeton University. He wrote prolifically and was the author of, among other works, *Politics and Vision: Continuity and Innovation in Western Political Thought* and *Democracy Incorporated: Managed Democracy and the Specter of Inverted Totalitarianism.* He died in 2015.

Charles Wollenberg went on to teach history and write several books, including, most recently, *Rebel Lawyer: Wayne Collins and the Defense of Japanese American Rights.*

Ron Yank practiced law for almost fifty years after People's Park, first in a personal injury practice and then as a union labor lawyer, representing police, firefighters, and prison guards. He served as personnel director for the State of California during Jerry Brown's second stint as governor.

Richard York announced he was taking a year off from his work with the Free Church of Berkeley and apparently never went back to the ministry.

Acknowledgments

I want especially to thank Steve Wasserman, Heyday's publisher and executive director. As a high school student, Steve helped to build and defend People's Park. He grokked this project before I finished the first sentence of my pitch, and at every step he has listened to my ideas and made them better. Heyday's tireless and gifted staff and associates helped birth this book, especially Diane Lee, art director; Gayle Wattawa, editorial director; Emmerich Anklam, assistant editor; Ashley Ingram, who designed the cover; and Rebecca LeGates, whose design of the overall book is nothing short of spectacular. And a special shout-out to Lisa K. Marietta, peerless copy editor, whose work is as indelible and invisible as a watermark on every page of this book. Samantha Clark, sent our way by Ken Light of UC's Graduate School of Journalism, did a great job as the photo researcher—part art and part science. Also, big thanks to Andree Abecassis, a member of Heyday's board of directors, for her photographic expertise and support of the project. And to the entire Heyday team: my profound thanks for all your help, large and small, in making this book a reality.

Three park cofounders were generous with their help: Judy Gumbo, Frank Bardacke, and Michael Delacour. I also place Nacio Jan Brown in this category of endlessly helpful central figures in the battle; his camera was his weapon. Twenty percent of the photos in this book are his.

My thanks also go to: Art Eckstein, Seth Rosenfeld, Terri Compost, Don Mitchell, Anthony Raynsford, Greg Castillo, Scott Saul, Charles Wollenberg, Kera Lovell, Barbara Stack, and Frances Dinkelspiel and Tracey Taylor of *Berkeleyside*.

Thanks as well to: The Bancroft Library and the Ethnic Studies Library at the University of California at Berkeley, Jan Grenci at the Library of Congress, Anthony Bruce of the Berkeley Architectural Heritage Association, Bill Roberts and the late Shelley Rideout of the Berkeley Historical Society, the Berkeley Public Library, the Long Haul Resource Center, Robert and Diana Kehlmann of the Berkeley Historical Plaque Project, and Jenny Hurth and the Estate of Eli Leon for witness statements.

My gratitude to Aaron Cometbus for his perspective on People's Park after the 1960s, Lincoln Cushing for the leaflets and posters of People's Park, James Davis for insight on temporary autonomous zones, Lee Swenson for contacts in the pacifist world, Megan Hesterman Thygeson for her research at the Berkeley Historical Society, and Eddie Yuen for his encyclopedic knowledge of modern Berkeley history and access to his father's archives.

A special thanks to the donors who wish to remain anonymous and who made the project possible.

And, finally, to those who understood the big love at the core of this book and who understood that writing it was for me a once-in-a-lifetime chance and encouraged me to trust this crazy idea: you were inspiration.

Image Credits and Permissions

Nacio Jan Brown was a major contributor of photographs for this book. In addition to the photos on the front and back covers, he took the photos on pages 26, 27, 28, 30 (bottom), 33, 34–35, 37 (top left), 41, 44 (bottom), 45 (top), 47 (top), 48, 49, 50, 51, 74, 83, 84, 88, 94 (top), 96–97, 98 (bottom), 102 (all), 103 (all), 130 (all), 131 (all), 140 (top), 158, 168, 171, 172–173, 181 (both), 183, 184 (top), 190–191, 208, 218, 220–221, 224, 226–227, and 301. In all, about one in five pictures in the book were shot by this remarkably talented photographer.

Frontispiece
Page ii: William Jay Warren

Foreword
Page x: Courtesy of Lincoln Cushing/Docs Populi Archives

Chapter One: The Crying of Lot 1875-2
Page xxii: John Jekabson
Page 3: Courtesy of Ecology Action Project
Page 4: Courtesy of Ecology Action Project
Page 5: Courtesy of Ecology Action Project
Page 7: Courtesy of Ecology Action Project
Page 8: Courtesy of the Berkeley Architectural Heritage Association
Page 11, top: Dave Seabury
Page 11, bottom: Courtesy of the Berkeley Architectural Heritage Association
Page 14: Roger Mulkey
Page 15: Alan Copeland
Page 17: Jeffrey Blankfort
Pages 20–21: Alan Copeland

Chapter Two: The Park Is Born
Page 22: Courtesy of Lincoln Cushing/Docs Populi Archives
Page 25: Collection of Tom Dalzell
Page 26, all photos: © Nacio Jan Brown
Page 27, all photos: © Nacio Jan Brown
Page 28: © Nacio Jan Brown
Page 30, top: Victor Wilkotz
Page 30, bottom: © Nacio Jan Brown

Page 31: Jean Raisler
Page 33: © Nacio Jan Brown
Pages 34–35: © Nacio Jan Brown
Page 37, top left: © Nacio Jan Brown
Page 37, top right: John Jekabson
Page 37, bottom: Herb Grossman
Page 38, left: Jean Raisler
Page 38, right: John Jekabson
Page 40: Dhyani Berger
Page 41: © Nacio Jan Brown
Page 42, top: Sean McGrath
Page 42, bottom left and right: Bob Gill
Page 44, top: Henry Jaffin
Page 44, bottom: © Nacio Jan Brown
Page 45, top: © Nacio Jan Brown
Page 45, bottom: John Jekabson
Page 46: William Haigwood
Page 47, top: © Nacio Jan Brown
Page 47, bottom: Barry Jablon
Page 48: © Nacio Jan Brown
Page 49: © Nacio Jan Brown
Page 50, left: Allen Alcorn
Page 50, right: © Nacio Jan Brown
Page 51: © Nacio Jan Brown
Page 52: John Jekabson
Page 54: Dhyani Berger
Page 55: Stephen Shames/Polaris
Page 56, both items: Collection of Tom Dalzell
Page 57, both items: Collection of Tom Dalzell
Pages 60–61, all photos: Bob Gill
Page 62, top: Bob Gill
Page 62, bottom left: Stephen Shames/Polaris

Sources

Interviews

The following interviews were conducted for this book by Tom Dalzell:

Glen Angell (telephone, San Francisco, April 14, 2018)
Jondavid Bachrach (telephone, New York City, June 2, 8, and 17, 2018)
Frank Bardacke (in person, Watsonville, September 8, 2017)
Nikki Baumrind (telephone, Davis, March 3, 2018)
Dhyani (Jennifer) Berger (email, May 3, 2018)
Nacio Jan Brown (in person, Berkeley, October 2, 2017)
Gray Brechin (email, February 9, 2018)
Wendel Brunner (telephone, Berkeley, February 8, 2019)
Mal Burnstein (in person, Berkeley, February 17, 2018)
Mandy Carter (telephone, Durham, North Carolina, February 6, 2018)
Jim Chanin (in person, Oakland, February 21, 2018)
Liane Chu (in person, Berkeley, April 6, 2016)
Wayne Collins (telephone, Pleasanton, April 17, 2018)
Lauren Coodley (telephone, Napa, February 11, 2018)
Bruno Coon (email, March 12, 2018)
Doug Bogen Cooper (email, May 6, 2018)
Jeff Crump (email, February 7, 2018)
George Csiscery (in person, Oakland, April 1, 2018)
David Delacour (in person, Berkeley, June 17, 2018)
Michael Delacour (multiple interviews in person, Berkeley, January through September, 2018)
Vanessa Delacour (in person, Berkeley, June 17, 2018)
Louis J. de Deaux (email, May 5, 2018)
Carolyn Dewald (telephone, New York, April 7, 2018)
Bruce Dodd (in person, Berkeley, May 31, 2018)
Howard Dratch (telephone, May 16, 2018)
Art Eckstein (in person, Berkeley, March 29, 2018)
Richard Ehrenberger (in person, Berkeley, July 14, 2018)
Reese Erlich (telephone, Oakland, April 18, 2018)
Rick Feinberg (telephone, Kent, Ohio, March 29, 2018)
Barbara Garson (telephone, New York, April 8, 2018)
Bob Gill (in person, Berkeley, September 4, 2018)
Paul Glusman (in person, Berkeley, January 23, 2018)
Art Goldberg (telephone, Los Angeles, April 17, 2018)
Jackie Goldberg (telephone, Los Angeles, April 19, 2018)
Carol Gordon (email, May 4, 2018)
Janet Grodin (in person, Berkeley, December 23, 2017)
Joe Grodin (in person, Berkeley, December 23, 2017)
Judy Gumbo (in person, Berkeley; and multiple emails, January through September, 2018)
Peter Haberfeld (in person, Berkeley, March 26, 2018)
William Haigwood (in person, Rohnert Park, September 10, 2018)
Kenneth Haliburton (email, May 16, 2018)

John Jekabson, (in person, Berkeley, September 3, 2018)
Jacaeber Kastor (telephone, New York City, April 14, 2018)
Seth Katzman (email, May 3, 2018)
Randy Kehler (telephone, Springfield, Massachusetts, April 26, 2018)
Steve Ladd (in person, Orinda, February 5, 2018)
Enrique Laroche (telephone, Oakland, April 12, 2018)
Michael Lerner (telephone, Berkeley, April 5, 2018)
Stephanie Blanchard Luna (telephone, Eugene, Oregon, May 8, 2018)
Country Joe McDonald (in person, Berkeley, February 17, 2018)
Wendy Masri (telephone, Sierra Madre, March 3, 2018)
Anita Medal (telephone, Berkeley, July 6, 2018)
David McCullough (email, March 30, 2018)
Dave Minkus (in person, Berkeley, December 19, 2017)
Don Mitchell (email, May 24, 2018)
Paul Moruza (telephone, Charlottesville, Virginia, May 22, 2018)
Wes "Scoop" Nisker (telephone, Woodacre, Marin County, January 26, 2018)
Brian O'Brien (in person, Berkeley, May 27, 2018)
Trudy O'Brien (in person, Berkeley, May 27, 2018)
Charlie Palmer (telephone, Los Angeles, May 7, 2018)
Tony Pigg (telephone, New York City, April 4, 2018)
Andrew Phelps (email, March 27, 2018)
Craig Pyes (telephone, Ojai, May 15, 2018)
Barbara Rhine (in person, Berkeley, February 19, 2019)
Ruth Rosen (in person, Berkeley, January 24, 2018)
Seth Rosenfeld (in person, San Francisco, February 16, 2018)
Fred Ross, Jr. (in person, Berkeley, May 7, 2017)
Donovan Rundle (telephone, Oxnard, April 19, 2018; in person, Oxnard, May
 17, 2018)
Ronda Rundle (telephone, Los Angeles, May 2, 2018)
Dove Sholom Scherr (telephone, Berkeley, April 17, 2018)
Jane Scherr (in person, Berkeley, April 17, 2018)
Charles Schultz (in person, Berkeley, February 13, 2018)
Dave Seabury (telephone, Orinda, April 3, 2018)
John Seabury (telephone, Berkeley, April 3, 2018)
Stephen Shames (telephone, New York, May 22, 2018)
Les Shipnuck (in person, Berkeley, April 6, 2018)
Dan Siegel (in person, Oakland, February 19, 2018)
Durward D. Skiles (telephone, Green Valley, Arizona, June 16, 2018)
Julia Stein (email, May 31, 2018)
Sol Stern (telephone, Tel Aviv, Israel, March 25, 2018)
Jane Stillwater (telephone, Berkeley, April 1, 2018)
Megan Hesterman Thygeson (telephone, Berkeley, February 19, 2018)
Robert Tracy (telephone, Berkeley, May 21, 2018)
Julia Vinograd (in person, Berkeley, April 8, 2018)
Paul Von Blum (telephone, Los Angeles, March 31, 2018)
Nina Wax (telephone, Oakland, May 3, 2018)
Henry Weinstein (telephone, Irvine, June 18, 2018)
Charles Wollenberg (telephone, Berkeley, May 18, 2018)
Ron Yank (in person, Oakland, April 4, 2018)

Witness Statements

The following witness statements, taken in May and June 1969, were conducted by volunteers with the People's Park Defense Fund and are part of the Leon Eli collection of witness statements relating to People's Park and general unrest in Berkeley in 1969. The collection is held at the Bancroft Library, University of California, Berkeley (BANC MSS 99/80 c Box 1; BANC MSS 99/80 c oversize folder 1; BANC MSS 90/80 c).

Jon Andrews, Roberto Bereydiven, Leslie Bergman, Andrew Blasky, Nancy Blum, Michael Bortin, Colin McLeod Campbell, William Chester, Cathy Clark, William Coleman, Kathleen Dailey, James Danse, James Darcey, Sidney Dong, Terry Stephen Doran, Paul Dresher, Richard Drew, Barbara Dudley, Christine Egan, William Escamilla, Robert Feinstein, C. R. Glassey, Gregory Good, Sheila Grant, Gary Hanks, John Franklin Heath, Tom Helbig, John David Hem Jr., Edwin Horowitz, David Jamieson, Scott Johnson, W. R. Johnson, William B. Jones, Doranne Jung, David Karp, Harlan Kessel, Jeffrey Matthew Knox, Lynda Koolish, Laurence D. Korn, Norris Delano Large, Roz Leiser, William Edward Mack, Vince Maning, Terry Markarian, Frank Martin, Robin Matt, Karen Cook McNally, Kate McVaugh, William Meeks, William Menking, Eddie Moore, Albert F. Moreno, Barry Moyer, Mark Musicant, Edmund Burr Nash, Trudy O'Brien, Mary Sue Odegard, Todd Olson, Eric Otzen, Peter Owens, Bill Patten, Belle Peritz, Michael Perlman, Dan Petrich, Dianne Petrich, Dan Porter, Soren Rasmussen, David Ravitch, Christopher Ream, Rosalyn Rolon, Christopher Henry Rombardo, John Rosove, Mike Schewich, Gene Alan Scott, Gilbert Shannon, Pinchus Shapiro, Hank Simpson, Michael Slomich, Phillip St. James, John Stallar, John Sullivan, Diane Sue Thompson, Dave Valory, Linda Meese Vaughn, Stefan Vetlung, Ted Vincent, Derrick Von Schlegell, Errol Waddell, Peter Ward, Steven Weaver, and Steven Eric White.

Written Statements

In addition to the interviews and witness statements, the author relied on contemporaneous written statements by officers of the Berkeley Police Department found in the Bancroft Library, University of California, Berkeley, "People's Park Material Assembled by the Center for Research and Development in Higher Education, 1969-1970," CU-210.3.

Other Sources

Albert, Stew. *Who the Hell Is Stew Albert? A Memoir.* Los Angeles: Red Hen Press, 2004.

American Friends Service Committee. "Perspectives on Berkeley." Newsletter, Summer 1969.

Anders, Jentri. "People's Park." *Berkeley Backlog: Oral History of the 60s Student Movement* (blog). https://berkeley60s.wordpress.com/2017/03/15/chapter-seven-escalation-part-2/.

Ashbolt, Anthony. *A Cultural History of the Radical Sixties in the San Francisco Bay Area.* London: Routledge, 2013.

Avakian, Bob. *From Ike to Mao and Beyond: My Journey from Mainstream America to Revolutionary Communist.* Chicago: Insight Press, 2005.

Berry, Frederick, Thomas Brooks, and Eugene Commins. "A Report on the 'People's Park' Incident." Report prepared for the University of California Academic Senate. University of California, Berkeley, May 26, 1969.

Burch, Claire, dir. *People's Park of Berkeley: Then and Now* (film). 1995.

California Governor's Office. *The "People's Park": A Report on a Confrontation at Berkeley, California, Submitted to Governor Ronald Reagan.* Sacramento: Office of the Governor, 1969.

Camejo, Peter. *North Star: A Memoir.* Chicago: Haymarket Books, 2010.

Cohen, Robert. *Freedom's Orator: Mario Savio and the Radical Legacy of the 1960s.* Oxford, UK: Oxford University Press, 2009.

Compost, Terri, ed. *People's Park: Still Blooming.* Berkeley: Slingshot Collective, 2009.

Copeland, Alan, ed. *People's Park.* New York: Ballantine Books, 1969.

Dallek, Matthew. *The Right Moment: Ronald Reagan's First Victory and the Decisive Turning Point in American Politics.* New York: The Free Press, 2004.

Doyle, Michael. *Radical Chapters: Pacifist Bookseller Roy Kepler and the Paperback Revolution.* Syracuse, NY: Syracuse University Press, 2012.

Draper, Hal. *Berkeley: The New Student Revolt.* New York: Grove Press, 1965.

Freeman, Jo. *At Berkeley in the Sixties: The Making of an Activist.* Bloomington: Indiana University Press, 2004.

Gitlin, Todd. *The Sixties: Years of Hope, Days of Rage.* New York: Bantam Books, 1987.

Glick, Stanley Irwin. *The People's Park.* Ph.D. diss., State University of New York at Stony Brook, 1984.

Hayden, Tom. *Rebel: A Personal History of the 1960s.* Palmdale, CA: Red Hen Press, 2003. Includes pieces first published in *Reunion* (New York: Random House, 1988).

Horowitz, David, Michael Lerner, and Craig Pyes, eds. *Counterculture & Revolution.* New York: Random House, 1972.

Jacobs, Paul. *Between the Rock and the Hard Place.* New York: Random House, 1970.

Jones, John E. "History of People's Park." UC Berkeley Police Department website. Revised August 2006. https://ucpd.berkeley.edu/history-peoples-park.

Kirkpatrick, Rob. *1969: The Year Everything Changed.* New York: Skyhorse Publishing, 2011.

Kitchell, Mark, dir. and prod. *Berkeley in the Sixties* (film). 1990.

KPFA. "People's Park: The Big Four State Their Cases," a live broadcast on KPFA radio and KQED television of a meeting between four representatives of factions debating the future of Lot 1875-2: Charles Palmer former president of ASUC; Frank Bardacke, of the People's Park Negotiating Committee; Wallace Johnson, the mayor of Berkeley; and Roger Heyns, chancellor of the University of California. Pacifica Radio Achives/KPFA, May 26, 1969. Recording available online at http://www.lib.berkeley.edu/MRC/pacificother.html.

Levertov, Denise. "From a Notebook: October '68–May '69." *Caterpillar* 10 (January 1970).

Lindsey, Hubert. *Bless Your Dirty Heart.* Plainfield, NJ: Logos International, 1973.

Lodge, David. "The People's Park and the Battle for Berkeley," in *Write On: Occasional Essays, 1965–1985.* London: Penguin, 1985.

Lyford, Joseph. *The Berkeley Archipelago.* Chicago: Regnery Gateway, 1982.

Marcus, Greil. *Conversations with Greil Marcus.* Jackson: University of Mississippi Press, 2012.

Mitchell, Don. *The Right to the City: Social Justice and the Fight for Public Space.* New York: Guilford Press, 2014.

Pacios, Mary. "Another Piece of Occupied Land: People's Park." *Street Roots News* (Portland, Oregon). November 4, 2011. https://news.streetroots.org/2011/11/04/another-piece-occupied-land-people-s-park.

Parkinson, Thomas. *Protect the Earth.* San Francisco: City Lights Books, 1970.

Rabkin, Anna. *From Kraków to Berkeley: Coming Out of Hiding—An Immigrant's Search for Identity and Belonging.* London: Valentine Mitchell, 2018.

Ritter, Jesse. "Nightmare in a California Jail." *Life,* August 15, 1969.

Rorabaugh, W. J. *American Hippies.* Cambridge, UK: Cambridge University Press, 2015.

———. *Berkeley at War: The 1960s.* New York: Oxford University Press, 1989.

Rosenfeld, Seth. *Subversives: The FBI's War on Student Radicals, and Reagan's Rise to Power.* New York: Farrar, Straus & Giroux, 2012.

Rossman, Michael. *Poem for a Victory Rally in a Berkeley Park.* Berkeley: Self-published, 1969.

Rubin, Jerry. *Do It! Scenarios of Revolution.* New York: Ballantine, 1970.

Samberg, Paul. *Fire! Reports from the Underground Press.* New York: Dutton, 1970.

Schlesinger, Wendy Marian. "People's Park, April 29, 1969–May 15, 1969: 26 Days That Shook Our World," in *The Whole World's Watching: Peace and Social Justice Movements of the 1960s and 1970s.* Exh. cat. Berkeley: Berkeley Art Center, 2001.

———. *The Creation of the People's Park (and Other Political Events): A Love Story from a Leader's Point of View.* Unpublished manuscript, written in fall 1969.

Smith, Gar. *A People's Park Chronology.* N.p.: n.d. Bancroft Library, Berkeley Free Church Collection, 1959–1976, GTU 89-5-016.

Smith, G. Kerry, ed. *The Troubled Campus: Current Issues in Higher Education.* San Francisco: Jossey-Bass, 1970.

St. James, Phillip. "No statute of limitations on murder or civil right violations: I witnessed a homicide on May 23, 1969," email published by San Francisco Bay Area Independent Media Center (Indybay), January 27, 2002, https://www.indybay.org/newsitems/2002/01/27/1145961.php.

Stein, Julia. "Attacking the Non-Violent Berkeley Movement in the 1960s." *CounterPunch*, August 31, 2017. https://www.counterpunch.org/2017/08/31/attacking-the-non-violent-berkeley-movement-in-the-1960s.

Steinberg, Leigh. *The Agent: My 40-Year Career Making Deals and Changing the Game.* New York: Thomas Dunne, 2014.

Unknown. *Quotations from Chairman John K. DeBonis.* Pamphlet. Berkeley: Socialist Workers Campaign Committee, 1971.

Van der Ryn, Sim. "Building a People's Park" and "People's Park: An Experiment in Collaborative Design," in *Design for Life: The Architecture of Sim Van der Ryn.* Layton, UT: Gibbs Smith, 2005.

Van der Ryn, Sim, and Robert Reich. *Notes on Institution Building.* Unpublished report. University of California, Berkeley, 1968.

Vinograd, Julia. "Memories of the 60s." In *Berkeley Daze: Profiles of Poets of Berkeley in the '60s*, edited by Rychard Denner. Guerneville, CA: Big Bridge Press, 2007. Available online at http://www.bigbridge.org/BD-JV-M.HTM.

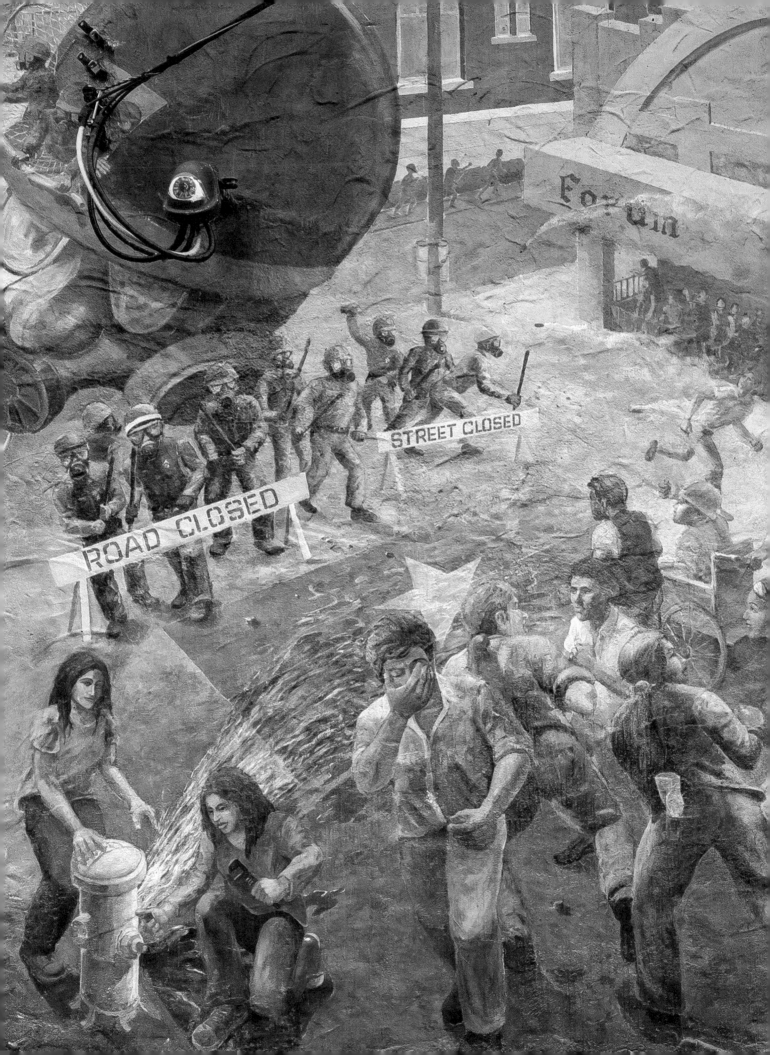